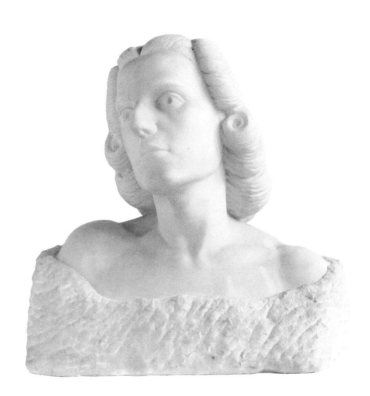

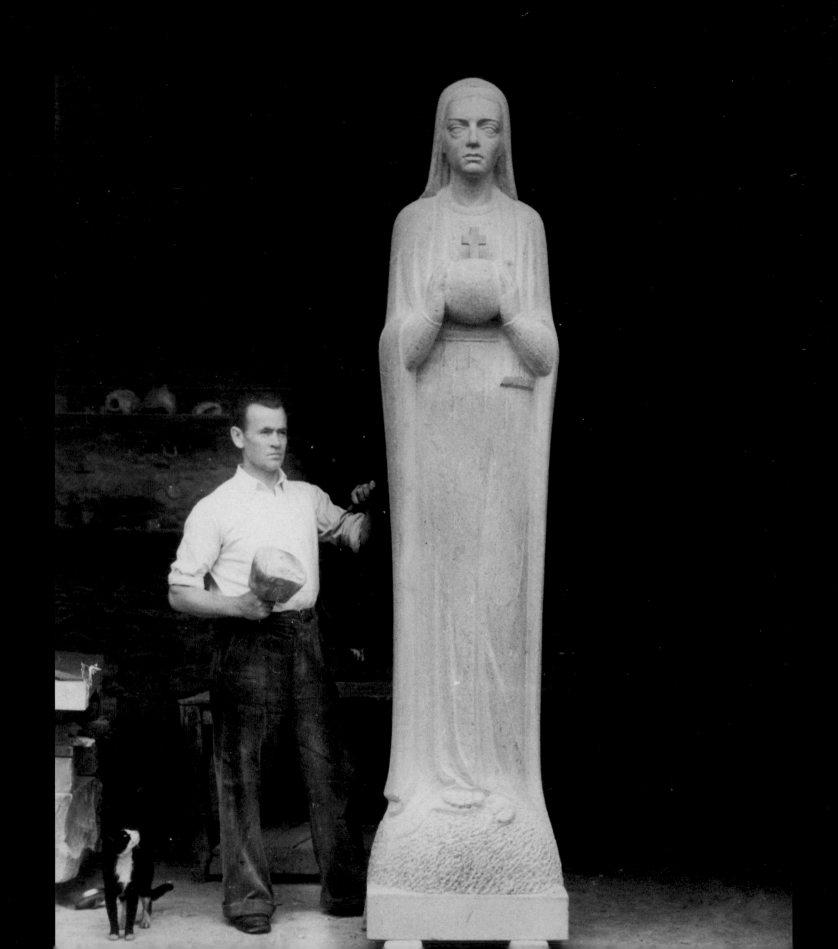

SÉAMUS MURPHY

—— 1907–1975 ——

SCULPTOR

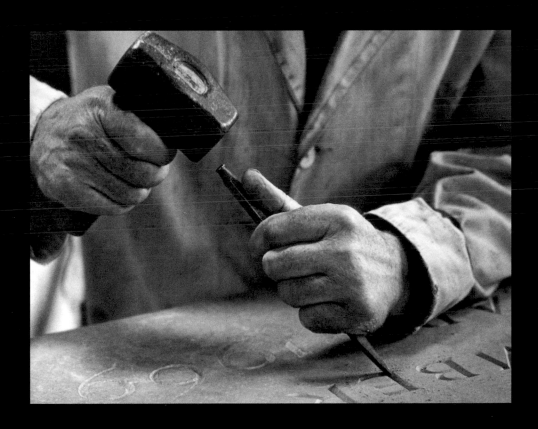

SÉAMUS MURPHY (1907-1975) SCULPTOR

Published by the Crawford Art Gallery and Gandon Editions to coincide with the centenary celebrations of the artist and sculptor Séamus Murphy (1907-1975).

ISBN 978 0948037 504

editor Peter Murray
asst. editor Clare Hennessy

Produced by Gandon Editions
for the Crawford Art Gallery

design John O'Regan
 (© Gandon Editions, 2007)
production Nicola Dearey
 Gunther Berkus
photography Dara McGrath
printing Nicholson & Bass, Belfast
distribution Gandon Distribution, Kinsale

GANDON EDITIONS
Oysterhaven, Kinsale, Co Cork, Ireland
tel +353 (0)21 4770830
fax +353 (0)21 4770755
e-mail gandon@eircom.net
website www.gandon-editions.com

Gandon Editions is grant-aided by
The Arts Council / An Chomhairle Ealaíon

CRAWFORD ART GALLERY
Emmet Place, Cork, Ireland
tel +353 (0)21 4907855
e-mail crawfordgallery@eircom.net
website www.crawfordartgallery.com

EDITOR'S NOTE

While this centenary publication sets out to catalogue a comprehensive selection of Seamus Murphy's gravestones, monuments, portraits and designs, it is not intended as a catalogue raisonnée, or entire listing, of all known and recorded works by the artist. Such a project would be, and the editor hopes will be, properly conducted as part of a doctoral thesis in art history. This centenary publication is intended however, to record the vast majority, and the most significant, of Murphy's works in different media throughout Cork city and county and further afield, and to provide a sound documentary basis for future identification, and attribution, by scholars, of works by Murphy. The comprehensive section of specially commissioned photographs by Dara McGrath, will substantially assist this, as will also the reproduction in the present volume of archival photographs, in some case providing the only extant visual record of works whose current location is unknown.

ILLUSTRATIONS

ACKNOWLEDGEMENTS

The Crawford Art Gallery would like to acknowledge the generosity of Cork City Council and O'Flynn Construction as sponsors of this publication.

– The Murphy family: Maighréad Murphy, Orla Murphy, Bébhinn Marten, Colm Murphy, Prof Ciaran Murphy,
– Lord Mayor of Cork: Cllr Michael Ahern
– City Manager: Joe Gavin
– Séamus Murphy Centenary Working Group: Cllr Máirín Quill (chair), Dan Breen, Morey Bresnihan, Tara Byrne, Stella Cherry, Cllr Catherine Clancy, Joe Kennelly, Liz Meaney, Prof Ciaran Murphy, Liam Ronayne, Nicola Swanton, Pat Talbot
– Cork County Council
– assistance and support: Peter Barry, Louis Marcus, Joe Gavin, Prof John A Murphy, Paul Durcan
– research: Rosarie Harrington, Clare Hennessy, Orla Murphy
– essays and texts: Barry Flanagan, Orla Murphy, Peter Murray, Gearóid Ó Crualaoich, Máirín Quill, Ken Thompson, Ann Wilson
– Nicola Dearey, Dara McGrath, Seán Ó Mórdha, John O'Regan, Silvia Prolunghi, Pádraig Trehy, Dawn Williams

NOTES

Captions are abbreviated in the essay section – for full details, see List of Illustrations.

The use of *séimhiú* (a dot over a letter) in Irish-language inscriptions, is represented here by an 'h'.

Contents

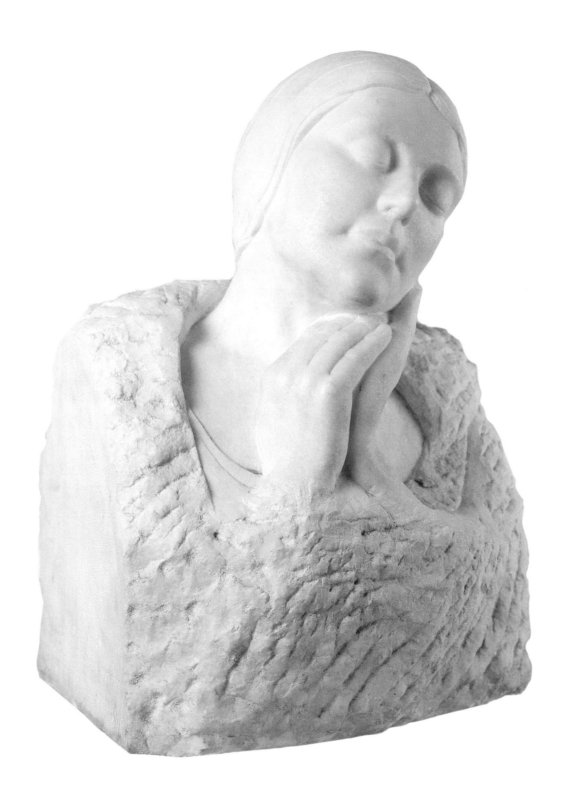

Daydream 1931, white marble, 55 cm h (Crawford Art Gallery, Cork)

Foreword

THE FORTITUDE OF THE CARVER STRIKES ME AS TRULY ADMIRABLE. SÉAMUS MURPHY stands uniquely within that European tradition, not only for the beauty of his lettering and massing, but for delivering authentic work straight from his yard with mastery.

I was introduced as a teenager to Beer Quarry by the fishermen in the bay, nestled between Beer Head and Seaton, south-east of Exeter in Devon. The Romans first worked this quarry, and stone from it was used to build the cathedral in Exeter. The limestone belt crops up in France, Majorca and, finally, Egypt. It was cooked to perfection in Tuscany, where the marble quarries at Pietrasanta produced the stone worked by Michelangelo. I was at Sem Gelladini's atelier briefly, inclined to inscribe runes on the stone I worked. It was Gelladini's atelier who, in the 1960s, carved the copy of Michelangelo's *David* that stands in the square in Florence. All very exciting.

I was introduced to Séamus Murphy's *Stone Mad* around 1980, and it compares so delightfully with the writings of Benvenuto Cellini from all those years ago. May he well serve as an inspiration for the next renaissance. Murphy chronicled the demise of the itinerant worker of the old manner so poignantly that when I came to Ireland I fancied taking up the trail and imagined *Stone Mad* on film, with John Hurt cast among the fabulous characters.

I would say more of Séamus Murphy, yet I would simply emulate him. He is distinguished among carvers and quarrymen, as elemental a worker as the fisherman, the farmer, and the caster in bronze.

BARRY FLANAGAN
sculptor

Remembering Séamus Murphy

'In honouring the memory of Séamus Murphy, the city of Cork honours itself.'

SO SPOKE PROFESSOR JOHN A MURPHY AT THE CRAWFORD ART GALLERY ON 11th APRIL 2007. He was launching the city's commemorative six-month programme of events Remembering Séamus Murphy. It is an honour long overdue. No other artist honoured his city with the same sense of selfless *dílis* delight as Séamus Murphy. The Cork of his day was no Renaissance city. A stagnant economy and a stubborn insularity made it a poor place for creativity to thrive. O'Connor and Ó Faoláin left in a mixture of despair and disdain; Murphy stayed.

Séamus Murphy set up his studio, 'my Skullery', at 20 Watercourse Road, Blackpool, in 1934. From that studio he worked meticulously to realise his artistic vision over the next forty years. His reputation grew, nationally and internationally. Peter Barry tells of the great surge of pride that hit Cork when, after the grim years of the Second World War, Séamus Murphy won a commission to carve statues of the Twelve Apostles for a magnificent granite church in San Francisco. Today, works of his can be found in public parks, churches, boardrooms, offices of state galleries and in private collections. There they serve to animate our spirit and delight our eye.

When Orla Murphy wrote to the City Manager, Joe Gavin, to suggest that the city might like to mark the centenary of her father's birth, the response was generous and wholehearted. A working party led by Cork City Council set to work – its brief, to devise, develop and deliver a fitting tribute. The objective was not merely to revisit and exhibit selections of his works, but also to explore and examine his artistic vision and influence, to celebrate the exquisite quality of his craftsmanship, and to re-animate his classic memoir *Stone Mad*. Above all else, it was to rediscover for this generation, and transmit to upcoming generations, an intelligent appreciation of the manifold genius of Séamus Murphy.

Exhibitions are running right through the summer, at the Crawford Art Gallery, Mayfield Public Library, Cork Public Museum and the new Cork City and County archive building, which will be named in his honour. School programmes, sculpture

trails, residencies, competitions and film screenings are taking place, and a special civic mass will be celebrated in the elegant Church of the Annunciation (designed and embellished by Séamus Murphy) in Blackpool, presided over by the Bishop of Cork and Ross, Dr John Buckley. The centrepiece of all this endeavour is this fine publication of Murphy's work, which provides a critical evaluation of his contribution to the growth and development of the visual arts in Ireland in the twentieth century.

The organising committee would not have been able to build this programme without the gracious assistance of members of the Murphy family, Maighréad, Orla, Bébhinn, Colm, and nephew Ciaran Murphy, or, indeed, without the generous financial support of Cork City Council and O'Flynn Construction, and co-operation from the Cork *Evening Echo*.

Finally it is with deep affection that we salute you, Séamus Murphy, on the centenary of your birth.

MÁIRÍN QUILL
Chairperson, Séamus Murphy Centenary Organising Committee

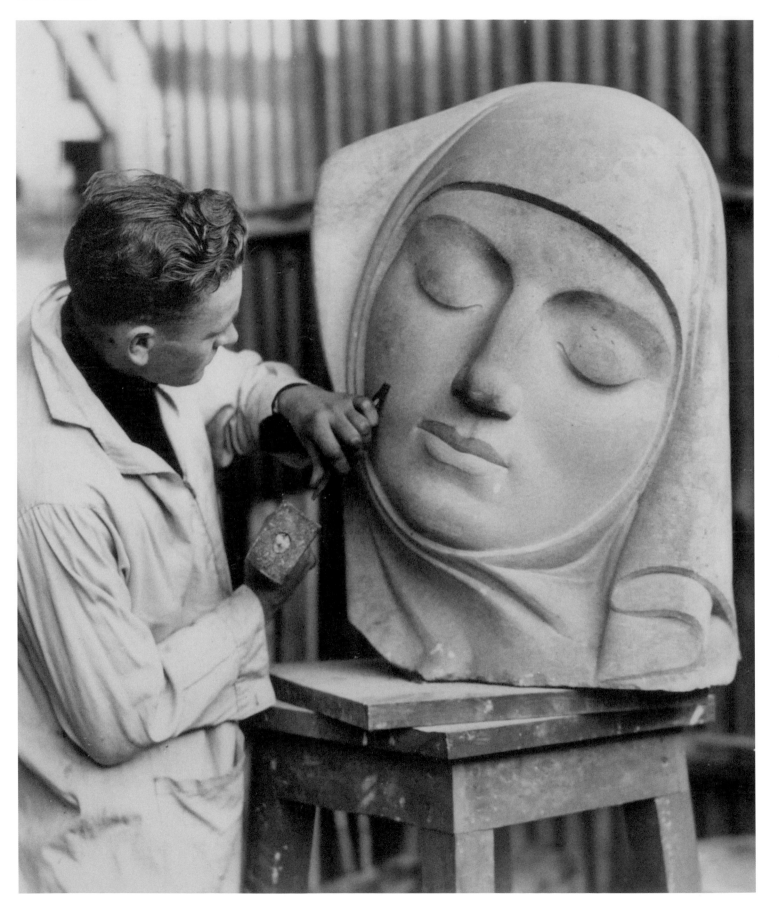

Dreamline 1934, Portland stone, 74 cm h (Fitzgerald Park, Cork)

'til the dust reclaimed him...

PETER MURRAY

FROM THE MID-1940S UNTIL HIS DEATH IN 1975, THE STONECARVER, letterer and sculpture portraitist Séamus Murphy (1907-1975) held a unique position in the Irish art world. Apart from just one year's study in Paris, in 1932, Murphy, who began his career as an apprentice stonecarver, spent his entire life in Cork, but over four decades he transformed himself effectively into an artist of state. His portraits of political leaders include all five presidents who held office during his lifetime – Douglas Hyde, Eamon de Valera, Cearbhall Ó Dálaigh, Seán T O'Kelly and Erskine Childers – as well as portraits of heroes of the struggle for independence such as Constance Markievicz, Michael Collins and Tom Barry. Among the more recent political leaders he sculpted were Jack Lynch, Seán Lemass and Peter Barry. He also sculpted religious and cultural figures as diverse as Archbishop John Charles McQuaid, John Montague, Seán Ó Faoláin and Frank O'Connor. Yet, while his portraits are an iconic, and occasionally ironic, record of the people who shaped modern Ireland, this artist is held

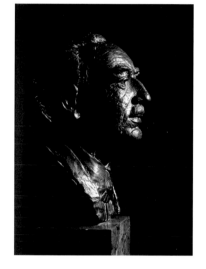

Frank O'Connor, 1957, bronze, 49 cm

by many to have excelled not as a portraitist, but as letterer, stonecarver and designer of monuments, whose gravestones and inscriptions can be found at many locations in Ireland. He was also an outstanding creator of religious sculptures, with his major work being perhaps his least known – a set of twelve life-sized apostles carved in 1948

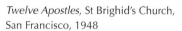

Twelve Apostles, St Brighid's Church, San Francisco, 1948

for the exterior façade of the Church of St Brighid at Van Ness Avenue in San Francisco (currently facing threat of demolition). The Apostles' faces, according to legend, were based on leaders of the 1916 Rising, although, in truth, it seems many were based on friends of the artist, such as 'The Tailor'. With typical Murphy humour, the face of Eamon de Valera was used to represent Doubting Thomas.

Murphy's personality and philosophy played an important role in his career. In 1944 he married Maighréad, an art teacher and daughter of the sculptor Joseph Higgins. They had three children, Bébhinn, Orla and Colm. Although they struggled financially, their house on Wellesley Terrace became a gathering place for artists, writers and musicians, and for visitors to the city. Murphy's personality and humourous self-depre-cating style endeared him to all, but he was also clearly an artist of drive and ambition, who, through many years of economic depression, suc-ceeding in producing important works of art, both in public monuments and also private commissions. He attracted the patronage of academics at UCC and of a number of Cork's leading families, notably the Barrys,

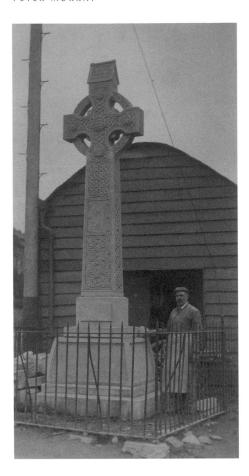

John Aloysius
O'Connell
High Cross, c.1920,
at St Patrick's Art
Marble Works,
Lower Glanmire
Road, Cork

Never radical or experimental, apart from a few early works such as *The Madonna of the Twilight*, Murphy remained firmly rooted in a traditional approach. His contemporaries Oisín Kelly, Edward Delaney and FW McWilliam were more adventurous, although they also are best known for their figurative work. While Murphy sculpted many portraits, along with religious and allegorical figures, he excelled at fine lettering, and some of his best art can be found on gravestones and memorials. Regarding cemeteries and cathedrals as the stonecarver's sculpture galleries, he served as a bridge between the medieval European tradition of sculpture and the modern age. He regretted what he saw as the 'passing of the old crafts', and was generally, albeit gently, critical of contemporary art movements. Although he had admiration for Brancusi and Henry Moore, the work of their imitators did not inspire him, and he professed to have little time for the welded steel sculptures that began to appear in Cork the early 1970s, although he was generous in his support for John Burke. Murphy's approach to art was essentially based on a Ruskinian appreciation of the value of the anonymous craftworker: 'Drawers and painters must observe: that's why the eye of a painter is so important. You see, these days a lot of what's being produced is just nonsense and I don't mind saying so. Too much of it is in a private language that only the drawer or painter can understand.' [1]

Unlike his wife Maighréad, both of whose parents were trained artists, Séamus Murphy's background was of country people who had been forced off the land. He was born on 15th July 1907 at Greenhill near Mallow, the son of Margaret Sheehan and James Murphy, a railway engine driver. James Murphy's own father, a farmer who had been evicted in the 1870s, had secured employment with the railway, and also managed to get a job there for his son.[2] James and Margaret had nine children, five boys and four girls. However all four girls died of diphtheria in infancy, and one boy died in an accident, leaving Séamus and his surviving brothers to grow up in a household dominated by men. It is clear from Murphy's recollections that his father James – 'Long Jim' – a silent and determined man, preferred the life of the countryside to driving steam engines. Perhaps working in an industrialised environment, along with the untimely deaths of five of his children, led to the political radicalisation of James Murphy, who withdrew Séamus from secondary school at the age of fourteen rather than have him educated by the clergy.[3]

Up to that age, Séamus had attended St Patrick's National School in Cork city, where Daniel Corkery had recognised his talent and helped secure a free studentship to night classes at the Crawford School of Art. In 1922 John Aloysius

Kearneys and Dwyers. However, notwithstanding his own skill and talent, his career was also helped by good fortune. Although he finished full-time schooling at the age of fourteen, he was taught by Daniel Corkery, later Professor of English at University College Cork, whose book *The Hidden Ireland* highlighted the forgotten Gaelic literary tradition of Munster and set the stage for an Irish cultural revival. Corkery suggested that Murphy attend evening classes at the Crawford School of Art, which led to an apprenticeship with John Aloysius O'Connell, the well-known Cork monumental sculptor. In similar fashion, fate intervened in the 1940s, when, within a four-year period, a generation of distinguished Irish sculpture portraitists passed away: Oliver Sheppard, John Hughes and Andrew O'Connor died in 1941; Jerome Connor two years later, and Albert Power in 1945. While by no means the only portrait sculptor working in Ireland during these years – talented artists such as Lawrence Campbell, Yann Goulet and the Broe family were producing good work – Murphy established himself as the foremost professional sculpture portraitist, and for the next thirty years lived solely from his art, moving easily between the workaday world of monumental stone-cutters and the 'atelier' of the academically trained artist.

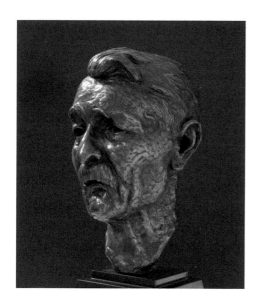

James Murphy
[sculptor's father]
1957, bronze,
45 cm h

Teddy Bucovictz
1932, plaster and
varnish, 46 cm h

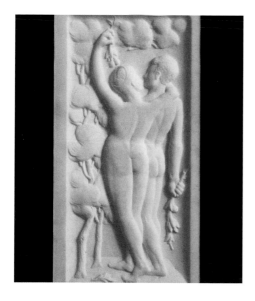

Adam and Eve
1931, white marble,
25 x 38 cm (detail)

O'Connell, of St Patrick's Art Marble Works in Blackpool, visited the School of Art seeking an apprentice. Like most stonecarvers, O'Connell had been a journeyman, and had worked for two years on the Hotel de Ville in Paris. He spoke fluent French and good Italian. Although Murphy was suggested for the apprenticeship, his parents were unable to afford the indenture fee of £80. After a short trial period, O'Connell offered to waive the fee on condition that for one year his apprentice would work for nothing. Murphy accepted, and the other stonemasons, or 'stonies', clubbed together to give him a small income.[4] After seven years Murphy completed his apprenticeship, but with the onset of economic depression there was little work: 'The day you came out of your time was a great day, a marvellous day. At last you were fully fledged. And with your first week's pay as a man, you brought all your workmates to the pub for a drink. One fellow said to me, "You're out of your time. Soon you'll be out of a job. And soon you'll be out of your mind for ever having anything to do with a craft."'[5]

Murphy revealed his talent in early works such as the marble low-relief sculpture *Adam and Eve* (1931). The date 1930, inscribed on an early portrait bust of Roderic ('Roddy') O'Connor, indicates that Murphy was in Paris that year, but this is probably an error as he did not travel to France until two years later, after Corkery had again intervened in his life, putting the young stonecarver forward for a Gibson Travel Scholarship, awarded by the Crawford School of Art to outstanding students. In 1931 Murphy was awarded the Gibson Scholarship, and the following year he made his way to Paris, enrolling at the Académie Colarossi on rue de la Grande Chaumière. 'For the first time I was able to model from life, which wasn't allowed, you know, in Cork. No, the Dean ... ran the School of Art, so no nude models were allowed.'[6] In Paris, Murphy also studied with Andrew O'Connor, the Irish-American sculptor, and was influenced by Ivan Mestrovic, the Croatian artist whose monumental sculptures embodied the nationalist spirit of Croatia in much the same way as Murphy would come to embody the nationalist tradition of his own country. Domhnall Ó Murchadha mentions artists that Murphy admired – Aristide Maillol, Charles Despiau, Joseph Barnard, and, in particular, his teacher, Marcel Gimond.[7] The influence of Gimond can be seen in some works Murphy did in Paris, particularly the portrait of his friend Teddy Bucovictz (1932). The more robust portrait inscribed 'Roderic O'Connor Painter', while bearing a passing resemblance to the Irish painter Roderic O'Conor (coincidentally also living in Paris in these years), in fact depicts the son of the sculptor Andrew O'Connor, who became a close friend of Murphy during his year in Paris,

and who subsequently visited him in Cork. *Daydream*, a marble portrait now in the Crawford Art Gallery collection, also dates from this period.

Paris was a revelation for Murphy, for although he had completed a seven-year apprenticeship in Cork, it had been a sheltered existence, particularly in relation to meeting women on equal terms. He found that being in Paris, and having his own studio, released him from 'blood fetters': 'I was brought up without sisters, so had no contact with girls. That got levelled out. It was all very friendly, because the girls there were regarded with a sort of respect mixed with affection. And they fought like tigers in an argument, which really staggered me. I never thought women could talk like that.'[8] Murphy cast a more sceptical eye on some of the other expatriates in Paris. Ernest Hemingway he found 'so completely and aggressively male that he was horrifying'.[9]

Living in France on slender means was not easy. Murphy shared a small apartment with Kenneth Ripley, a student from Vermont. In winter, they resorted to staying in bed and living on boiled potatoes, while Ripley awaited his remittance and Murphy the next meagre installment of his scholarship. Murphy sculpted Kenneth Ripley in 1932, and the following year exhibited at the Paris Salon. Before returning to Cork, he sculpted in plaster a portrait of Ripley's sister, later translated into the marble *Ruth*, now in the Crawford Art Gallery. These works, with their simplified forms, inspired by Maillol and Gimond, show a reaction – common amongst younger sculptors in the 1930s – against the expressive modelling of Rodin. However, Murphy was also capable of working in a highly expressive vein, as shown in his 1933 sculpture *Deirdre of the Sorrows*, later cast in bronze.

Back in Ireland and confronted by a confined Irish sculptural tradition, Murphy found himself unimpressed with the Neo-Classicism of John Hogan. Having served his own apprenticeship as a stonecarver, he was drawn instead to the surviving remnants of a vibrant medieval Irish stonecarving tradition, preserved in churches such as Cormac's Chapel at Cashel, or the McCarthy memorial at Kilcrea Abbey, Aherla, where the architectonic qualities of sculpture were fully exploited. His contemporary, the sculptor Domhnall Ó Murchadha, explains the qualities they both saw in the carving at Kilcrea:

> Its reticence, its measures, the spatial quality of its surface decoration made us realize that such qualities depended not on an effort to communicate but on the conscious skill of a master. The master-carver was an eighteenth century Hickey from the limestone quarry district of Aherla. Séamus himself set out to achieve a

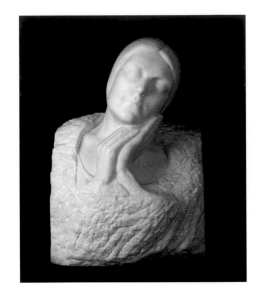

Daydream
1931, white marble,
55 cm h
(Crawford Gallery)

Ruth Ripley
1934, white marble,
50 cm h
(Crawford Gallery)

Séamus Murphy
visiting Kilcrea
Abbey, Aherla,
Co Cork, in 1969
(*Stone Mad*, RTÉ)

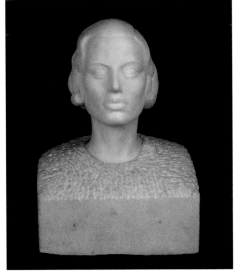

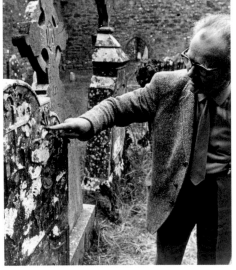

opposite

Michael the Archangel
1934, Portland stone, 122 cm h
(St Carthage's Cathedral, Lismore

Deirdre (of the Sorrows)
1933, bronze, 24 cm h (Crawford)

Man at Bench / Woman Cooking
1935, limestone, 91 x 33 cm
(School of Commerce, Cork)

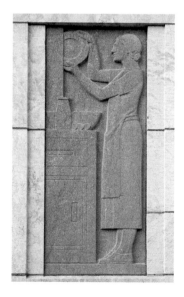

comparable level of creativity in his own work as a sculptor.[10]

Other favourite examples were the columbarium at Ballybeg Friary, the memorial to Myler McGrath in the cathedral at Cashel, and even buildings such as the small oratory at Gallarus in Co Kerry.[11] In Cork's north inner city, Murphy rented a small yard in Blackpool, and had a workshop erected on the site. He set up in business as a monumental sculptor, stonecarver and portraitist. Peter Barry describes the city where Murphy lived and worked in these years:

> There are two great hills on the North of the River Lee in Cork city, one to the East where the streets and names are reminiscent of the British Occupation times, Wellington Road, Waterloo Place, York Hill, Grosvenor Terrace, Egerton Villas and many others, and then somebody going West drops down into the Valley and up the Western hill comes into streets and alleys named after a Nationalist Cause, Thomas Davis Street, Gerald Griffin Ave., John Redmond Street, Wolfe Tone St., and many others. By one of those ironies of fate, or location, or whichever you prefer, those most associated with Ireland and things Irish lived on the hill where the English names were most common and included, besides the Murphy's, Michael O'Donovan who became more widely known as Frank O'Connor, Donal O'Corcora, the MacCurtains, the McSwineys, Seán Hendrick. These are the names that Séamus Murphy grew up with, was friendly with and admired and these were the people who were part of his circle and whom he frequently referred to in his own conversation.[12]

In 1933 Murphy was commissioned by University College Cork to carve a seven-foot-high St Finbarr, to replace the existing statue of Queen Victoria which had stood atop the gable of the Aula Maxima since 1849. The following year he carved a Portland stone St Michael the Archangel for St Carthage's Cathedral in Lismore. In 1935 he received the first of his few church commissions for statuary, carving figures of St Ita and St Finbarr for niches on the western façade of the Catholic church in Bantry, and also carved that year two low-relief limestone panels for the new School of Commerce building in Cork city.

Within a short space of time, Murphy's Blackpool studio workshop became a focal point, with the writer Eric Cross one of the many visitors who called by:

> It was a gathering place for all sorts and conditions of men. It was the focus point for a score of aspects of the vivid, zestful life of Cork in those days. Each morning the news, more particularly the unwritten news, the news

between the lines of print, was discussed, enlarged upon and disputed. Personalities and their hidden motives were ruthlessly and often scurrilously examined. Old history was retold. Family skeletons were taken out of cupboards and made to dance. Old and new scandals were given an airing.[13]

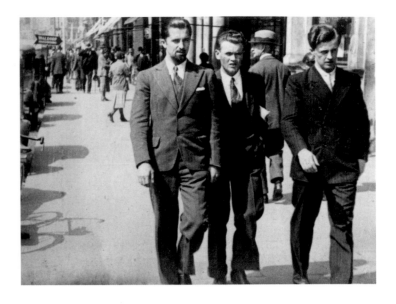

In 1935 Daniel Corkery opened an exhibition at the Aula Maxima at UCC, that included sixteen sculptures by Murphy, as well as works by Marshall Hutson and Michael O'Sullivan. At the Academy that same year, Murphy showed a Madonna and Child, now in the Church of the Holy Family, Military Hill, Cork. *After Mass*, depicting a woman in a traditional west Cork cloak, was carved in limestone in 1936 and shown at the RHA that year. Murphy's statue *Mary Anne* or *The Onion Seller* (1937) was, like many of his plaster portraits, cast in bronze some years later.

In 1939 Murphy's memorial plaque to Pádraig Mac Piarais (Patrick Pearse) was shown in the Irish Pavilion at the New York World's Fair. A plaster model for this plaque is at Scoil na nÓg in Gleann Maighir (Glanmire), Cork. The following year, Murphy carved a set of panels, representing the seasons: three of the panels, *Spring, Summer* and *Autumn*, can be seen at Fitzgerald Park; the panel for *Winter* was broken before the set was installed in the park. In 1941 Murphy exhibited *The Virgin of the Twilight* at the RHA, a six-foot-high polished limestone carving, also destined for Fitzgerald Park and subsequently transferred to the Crawford Art Gallery. A plaque commemorating Thomas Davis, erected in 1942, can be seen at 72 Main Street, Mallow, while the Mallow Historic Society have a portrait of Davis, done at the same time. In the Technical School at Mallow is a plaque inscribed 'THE SCHOOL HONOURS THE MEMORY OF CANON SHEEHAN 1852-1913 PRIEST AND AUTHOR WHO LOVED IRELAND'. Bronze busts of Tomás MacCurtain and Terence McSwiney, sculpted in 1945, are in Cork City Hall.

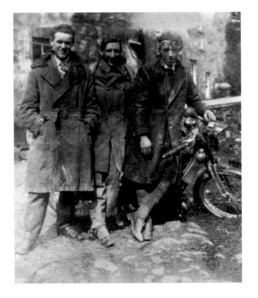

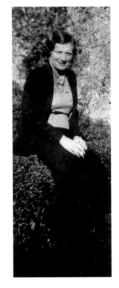

Many sitters were friends and active in Cork's cultural life in those years. Murphy's bust of writer and broadcaster Geraldine Neeson dates from two years later, while his portrait of Prof Denis Gwynn was sculpted in 1952 and his portrait of Terry Barry in 1957. Adding to this sense of Cork as a centre for culture, friends that Murphy had made in Paris gravitated to Ireland. Nancy McCarthy recalled:

> I remember meeting him one day and I told him that I was going down to Gougane Barra for a weekend so he told me that friends of his were down in Gougane, a Ripley, Rip – he called him and Rip's girl friend Betty Blake, and he said: you'll like them, I knew them well in

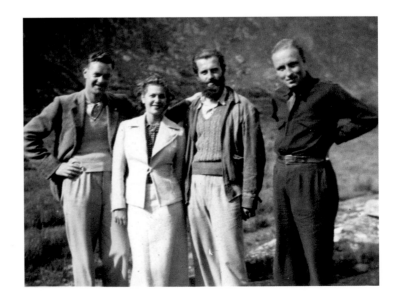

Tadhg Ó Buachalla ('The Tailor') in 1936

Headstone of *Tadhg Ó Buachalla, 'An Táiliúir'* n.d., limestone, 536 x 132 cm

Naomh Gobnait 1950, limestone

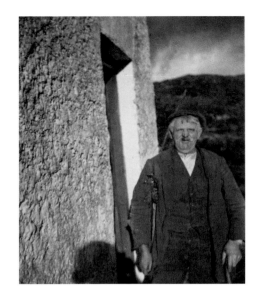

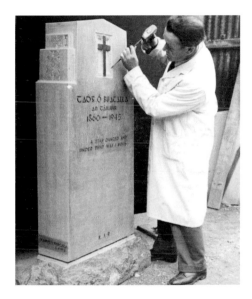

opposite

Roddy O'Connor, SM and Pat O'Connor

SM, Paddy Doody and friend with motorbike, *c.*1930

Nancy McCarthy, 1935

Michael Murphy (SM's brother), Elizabeth (Betty) Ripley, Roddy O'Connor and Ken Ripley in Gougane Barra, 1935

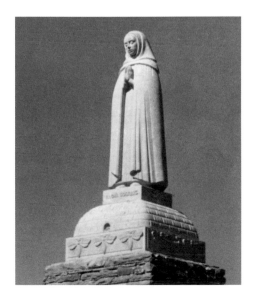

Paris, they were great friends of mine ... They had found Paris used to get too expensive in the summer ... and they asked Séamus if he would mention someplace that would be fairly cheap; Séamus thought of Gougane Barra.[14]

Murphy's friends were, in their own way, all remarkable. Elizabeth Blake Ripley, a graduate of Smith College, went on to become a highly regarded author of monographs on artists. (Her books on Michelangelo and van Gogh were followed by Rubens, published in 1957 by Oxford University Press.) There is no doubt that Blake and Ripley were inspired by the cultural vision of Murphy, and in turn, during summers in the 1930s, they contributed to that eclectic, intellectual group that gravitated between Cork city and the spiritual home of Gougane Barra, the source of the River Lee, where Eric Cross chronicled the tales and wisdom of *The Tailor and Ansty*, and where Daniel Corkery had identified a cultural spirit still surviving and not spoiled by contact with the mass media of the twentieth century. Murphy was inspired by 'The Tailor' (Tadhg Ó Buachalla), and his wife:

> ...he was the most interesting man I have ever met, and also the most exciting. Exciting in as much as he never repeated himself. He had a new wonder every day, or something he had seen or heard and changed into a wonder. He was a very intelligent, very loveable man ... full of the old learning. Ansty was the instinctive woman. Her whole world centred round the animals, the cow, the chickens, the dog, and she was a complete foil to him. They were totally harmless, innocent people.[15]

Murphy sculpted a bronze portrait bust of The Tailor in 1936, and in time carved also a limestone memorial to The Tailor and Ansty at Gougane Barra, where they lie together. The memorial, decorated with herringbone chiselling, is inscribed 'A star danced, and under it I was born'. At nearby Ballingeary churchyard there is a limestone statue of St Finbarr, commissioned in 1952 by Cardinal Manning of San Francisco, and dedicated to the memory of 'the exiles of Iveleary'. Murphy's limestone statue of Naomh Gobnait, at the saint's hermitage in Cúil Aodha, near Ballyvourney, had been erected two years previously. Evoking both nature and human piety, the statue stands high on a plinth, into which is set a limestone slab, inscribed with the Irish prayer.

> Go mbeannuighe Dia dhuit / A Ghobnait naomhtha,
> Go mbeannuighe Muire dhuit / Is beannuighim féin duit.
> Is chughat-sa thánag ag / Gearan mo scéil leat,
> Is a d'iarraidh mo leighis / Ar Son Dé ort.

The statue shows the saint cloaked and hooded, her hands

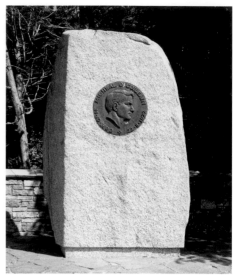

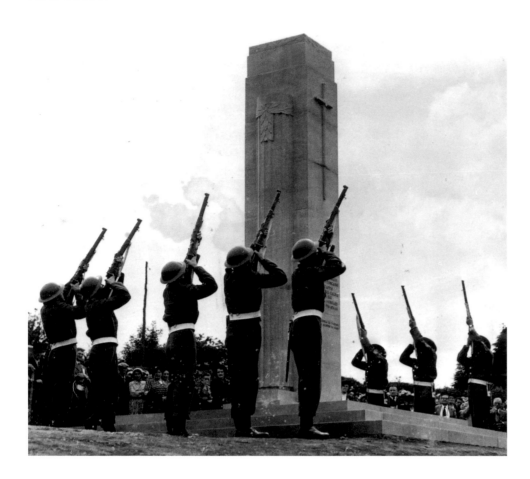

Michael Collins
1965, bronze, 65 cm diameter
(Sam's Cross, Clonakilty, Co Cork)

*War of Independence Memorial, Bandon
– Cork No.3 Brigade*
1953, limestone, 427 x 76 cm
(Bandon, Co Cork)

joined in prayer. She stands on a beehive, below which are carved bees and a deer in flight leaping over a cloud. The bees refer to Gobnait sending a swarm of bees to attack cattle-raiders, while the deer refers to the saint founding her nunnery where she came upon nine white deer grazing, thus fulfiling a prophecy.

In 1950 Murphy's memoir of his days as an apprentice stonecarver, *Stone Mad*, was published to critical and popular acclaim. It is an evocative literary record of the lives of the 'stonies', to whom Murphy was apprenticed and whose portraits and mannerisms were sketched in a tribute to a tradition he saw vanishing in his own lifetime. The character of Danny Melt in *Stone Mad* was inspired by the stone polisher Isaac Forth. In time, Murphy's chisel carved the gravestone marking Forth's burial place in Carrigrohane Church of Ireland graveyard, a stone that bears the apt inscription 'He trod the dust in Cork and Poona as gaily as he polished stone 'til the dust reclaimed him. Lie gently earth, on one who was your own.' In time too, Murphy carved gravestones for friends he had sculpted in life, among them Daniel Corkery, buried in St Joseph's Cemetery, and the composer Seán Ó Riada, buried at Cúil Aodha. There are many fine examples of his work at St Finbarr's

Cemetery in Cork, including memorials to Sir Arnold Bax and Aloys Fleischmann, and to members of the Hegarty, Condon, Aliaga-Kelly families and others. These gravestones, with clear and beautiful lettering, and with emblems relating to the interests and occupations of the deceased, are among his best works. A harp is forever silent on the grave of Carol Gilbert Hardebeck in Glasnevin cemetery in Dublin, but the inscription '*oibrí do-sáraithe ar son ceoil ar sínsear*' (he made our songs live again) brings him to life in an apt tribute, while a mackerel and a currach (a *naomhóg*) are carved on the headstone of Tomás Ó Criomhthain (an tOileánach) in the old graveyard in Dún Chaoin, Co Kerry, where also lies Peig Sayers, again under a stone cut by Murphy.

As well as gravestones, Murphy carved a considerable number of memorials, many of them to members of the IRA who had died during the War of Independence and the Civil War following. At Godfrey's Cross, a half-mile west of Dripsey bridge, on 28th January 1921, an IRA Flying Column engaged in a gunfight with British Auxiliary troops from the barracks at Ballincollig. Eight IRA men were captured. A month later, five were executed at Cork Military Barracks. One died of wounds received during the battle.[16] In 1938 Séamus Murphy's five-and-

a-half-metre-tall memorial was erected at Godfrey's Cross. Made of cut limestone in the form of a truncated obelisk, it is set on a paved and stepped plinth facing the road. The front face of the obelisk is embellished with a relief carving of a broadsword, a form clearly reminiscent also of a cross. The inscription is carved in Gaelic script under the point of the sword. There are similar memorials by Murphy at other locations throughout Co Cork. The obelisk at Midleton, over ten metres in height, is located on a traffic island in front of the courthouse. Although an impressive memorial, in design terms it is not Murphy's most successful work and compares unfavourably with his monuments at Dripsey and Bandon. A Celtic cross motif is incorporated into the top of the tapering shaft of the obelisk. It is probable that the sculptor was, to an extent, constrained by the commission. The inscription on the north face reads:

IN MEMORY OF THE DEAD

THIS MONUMENT HAS BEEN ERECTED
TO THE MEMORY OF
THE OFFICERS AND MEN OF THE
4TH BATTALION CORK NUMBER 1 BRIGADE
THE IRISH REPUBLICAN ARMY
WHO GAVE THEIR LIVES
IN DEFENSE OF THE IRISH REPUBLIC

FROM 1916 TO 1922
REQUISCANT IN PACE

Grateful thanks to you
For placing this monument
At the entrance to this town

Where we speak with affection.
Of the men who died
In the battle for freedom

On the outskirts of Bandon, Murphy's 'West Cork Irish Republican Army Memorial' is an impressive Classical monument, more correctly a cenotaph, in that it commemorates the dead who are buried elsewhere. Like the Dripsey memorial it is inspired in part by Edward Lutyens' cenotaph in Whitehall. The plain, square-sectioned central shaft, flanked by two fluted half-columns, is decorated at the top with bands of laurel. A double-edged sword decorates the front face. Wide, shallow steps provide a platform at the base. The inscription on the front face records the unveiling of the memorial by President Seán T O'Kelly in August 1953:

Arm / Poblacht na h-Éireann
Briogáid Iar-Chorcaige / I ndíl chuimhne
Ar na hóglaigh chalma / A fuair bás
Ar son na hÉireann / Ón mblian 1916 anuas

Suaimhneas siorraí dá n-anam
Go mairidh a gcuimhne go suan

Nochtadh ag / Seán T Ó Ceallaigh
Uachtarán Na h-Éireann / 2-8-1953

Murphy was also responsible for the large plaque memorial on the wall on the old Cork jail (now part of University College Cork), recording the names of men who died in the War of Independence. Not far from the Clonakilty farm where Michael Collins grew up, a large rough-hewn stone at Sam's Cross serves as a memorial to this hero of the War of Independence.

War of Independence Memorial, Cork 1947, detail of inscription

War of Independence Memorial, Cork 1947, limestone with bronze surround, 221 cm h (Gaol Cross, UCC)

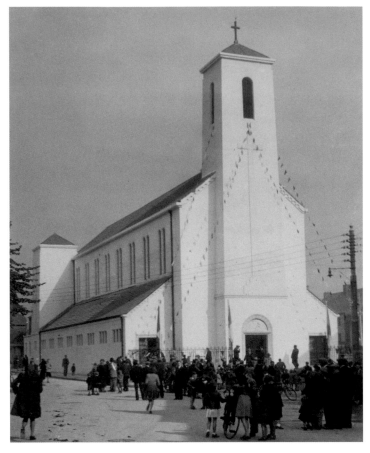

Church of the Annunciation,
Blackpool, Cork, 1944-45
design: Séamus Murphy
architect: Eddie P O'Flynn
patron: William Dwyer

SM's drawing of south elevation
c.1944, 39 x 36 cm

Madonna
1945, Portland stone, 167 cm h
(Our Lady's Altar)

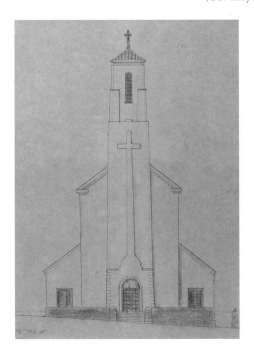

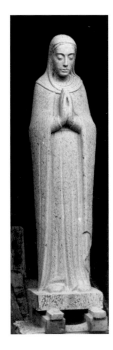

Unveiled by General Tom Barry at Easter 1965, it features a circular bronze plaque with a profile portrait of Collins by Murphy. It was inevitable that as a working stonecarver, much of Murphy's work was concerned with death, gravestones and memorials. John Montague observed that this perhaps made the sculptor ultimately 'more responsive to the living individual', a quality attested in many accounts by writers and artists of visits to his studio and home.[17]

In the late 1930s, the Cork industrialist William Dwyer organised a pilgrimage to Rome for workers from his Sunbeam Wolsey woollen factories, and invited Murphy to accompany the group. Dwyer, a great admirer of Murphy's work, offered to set up a studio for the artist at Millfield and pay him an annual salary, but Murphy's independent spirit made this impossible. In 1945 Murphy designed a church for Dwyer at Blackpool, in the north inner city. The Church of the Annunciation, an accomplished architectural essay in its own right, was enhanced with a Madonna in Portland stone, as well as a tabernacle, font, inscriptions and altars, all designed and carved by the artist. With characteristic Cork humour, Dwyer referred to this church as his 'fire escape'. Murphy received many other commissions from the Dwyer family. His portrait bust of the young Robin Dwyer (*Robin*) dates from 1946, while in Youghal a panel records the gratitude of the town to William Dwyer 'who brought the first textile industry to the town in 1947'. In that year, Murphy had carved a large low-relief allegorical panel, *Weaving*, for the exterior of the Seafield Fabric factory, also in Youghal, while a similar panel, *Spinning*, adorned the Worsted Woollen Mills at Midleton. This latter panel was moved to Sunbeam Mills in Cork when Worsted Mills closed.) Murphy also did gravestones for the Dwyers in St Finbarr's Cemetery.

Murphy's polished limestone portrait bust *Naomh Pádraig* (St Patrick) was carved in 1949. Three years later, he exhibited *Madonna and Child* at the RHA, and the following year showed *Prayer*. In 1954 he was represented by *Head of Christ*. However, in spite of this clear interest in religious sculpture, and notwithstanding a surge in the building of new churches in these same years, Murphy received very few commissions from the Catholic Church. In a vain effort to jolt Bishop Lucey into an awareness of Murphy's art, a group of UCC academics led by Prof Denis Gwynn commissioned Murphy in 1954 to sculpt a Madonna and Child which they presented to the bishop. At the ceremony, Gwynn quickly came to the point:

> We have combined, my Lord, to present you with this carving in stone ... Your Lordship will soon be opening the first of the new churches, and we know that you must

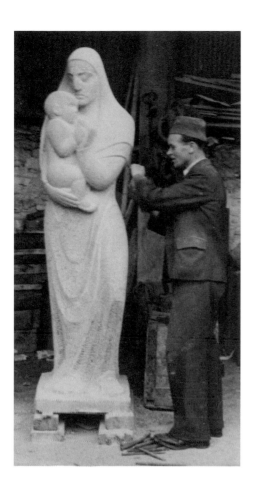

Virgin of the Twilight 1941, polished Kilkenny limestone, 198 cm h (Crawford)

Opening of SM exhibition at Cork City Library, May 1956. The artist's daughters, Orla and Bébhinn, are in front, with Gerald and Sheila Goldberg on right.

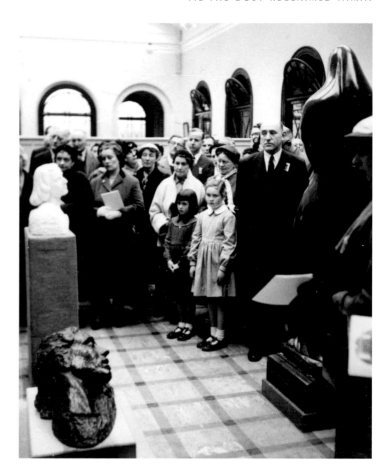

be already considering the problem of furnishing and decorating them...[18]

Although Lucey's response was polite, no commissions followed. This pattern of clerical indifference to Murphy's work perhaps stemmed from an incident in the early 1940s, when friends of Archbishop John McQuaid had commissioned a portrait to be presented as a gift. However, McQuaid rejected the sculpture, saying, unfairly, that it bore little resemblance to him, and causing deep hurt to the artist.[19] Murphy's own views on religion perhaps echoed closely those of his father's, as revealed in an interview in 1971 with Maureen Fox:

> 'I have no use at all for the appalling regimentation that they call religion today', commented Séamus. 'It doesn't matter a damn to what sect you belong so long as you're Christian' – Séamus' philosophy on religion. A thinking and sincere Christian, he is decidedly skeptical of the various 'Trade Unions', as he puts it, that vie with one another in the name of God. 'Break the rules and you're out' does not conform to his idea of Christianity.[20]

Official recognition was slow enough in coming. In 1943 the success of Murphy's *Virgin of the Twilight* led to him being elected an Associate of the Royal Hibernian Academy, and

eleven years later he was elected a full Academician. An exhibition of his sculpture was held at Cork City Library in May 1956, due mainly to the energy of Anthony Barry, chairman of the Cork Library Committee. The exhibition was held in the Periodicals Room, from which, with some difficulty, all bookshelves and reading desks had been removed. The centrepiece of the exhibition was a white marble portrait bust of Michael Collins, undertaken by Murphy in 1948 without a commission. The presence of this monumental sculpture attracted much comment, particularly when President Seán T O'Kelly visited the exhibition. A bronze copy, made in 1966, is sited in Fitzgerald Park, Cork. In 1964 Murphy was appointed Professor of Sculpture at the RHA, and five years later received an honorary LL.D from the National University of Ireland. In 1973 he was appointed to the Arts Council.

During these years of increasing national fame, Murphy came to embody the spirit of Cork as a cultural city, as recalled by art critic Hilary Pyle:

> One of my memories of Séamus Murphy is of a visit to his studio, not long before he died. We walked up the hill to his house in Wellesley Terrace, and he talked all the time about the buildings we passed: the history of the

more remarkable ones, who had inhabited them, and the materials from which they were made. We leaned on a wall and looked out over the city below us. He knew the kind of stone that had built each part of it, knew most of the stonemasons, and his hands seemed to move every element sculpturally as he talked. This was a typical occasion with that warm-hearted and cultural man. He liked people, and he loved the stone that was an integral part of their lives.[21]

This notion of Cork as a cultural city had been enthusiastically promoted by Daniel Corkery, who in turn had been inspired by Professor Stockley, Professor of English at UCC, and his Munich-born wife. Corkery resented the novelist Frank O'Connor's leaving the city to move to Dublin, but, in truth, during these lean years there was little artistic patronage in Cork, and more often than not the arts were supported by arts practitioners themselves, with the encouragement of like-minded people such as accountant Seán Hendrick, physician JB Kearney, or solicitor Gerald Goldberg.

The Murphy house, overlooking the city, became something of a refuge for artists and literary people, and is eloquently described by Louis Marcus:

> The vast upstairs room where we sat, with its tall windows overlooking the lights of Cork, encouraged a sense of detachment from the quiet desperation of the city below. It was a rare house, in the Cork of that time, in its strong but natural sense of artistic presence. The walls were covered with paintings, there were acres of crammed bookcases and there was sculpture everywhere – heads by Séamus and by Maighréad's father Joseph Higgins – on pedestals, side-tables, the piano. The upstairs room was dominated by a long polished table littered with the paraphernalia of Séamus' work – drawing tools, paper sheets with headstone lettering in progress, photographs of completed jobs or of dead men to be modeling, business letters, the typewriter, newspaper cuttings, the books he was currently reading.[22]

Murphy's studio workshop in nearby Blackpool was equally well organised, and was described by John Behan, the sculptor and foundryman who organised the casting of many of the Cork artist's portrait busts, 'as neat and well-ordered' with good light available:

> There were plaster casts, bronzes and stone carvings all around the atelier on different levels; some were on shelves, others on the ground and a number of pieces resided on sculpture stands. The clay figures he was presently working on were draped with damp cloths and

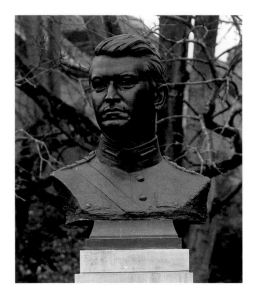

Michael Collins
1966, bronze copy of 1948 marble bust, 104 cm h (Fitzgerald Park, Cork)

Daniel Corkery
1936, bronze, 42.5 cm h (Crawford)

Seán Hendrick
n.d., limestone, 160 x 76 cm (St Finbarr's Cemetery, Cork)

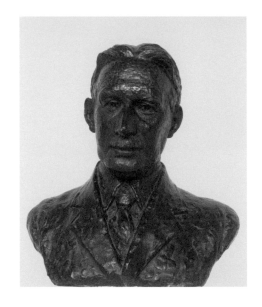

opposite

SM working in his studio workshop in Blackpool, Cork, c.1938

View of studio in the 1950s

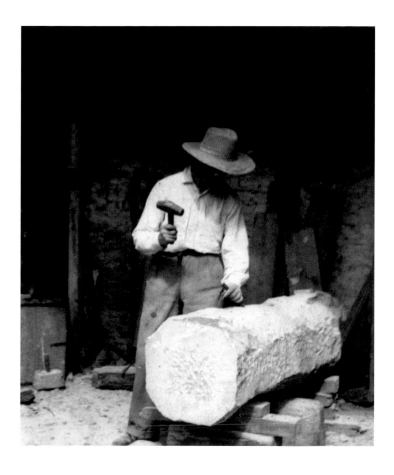

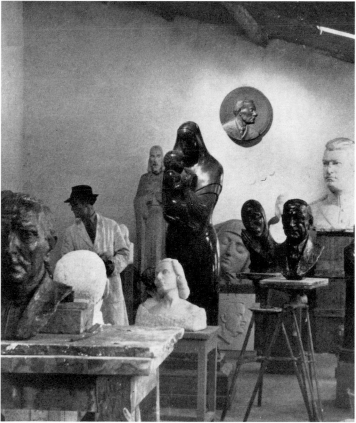

covered with polythene. A couple of headstones lay banked on the floor, awaiting inspections; his old craft of carving was inescapable and a bread and butter necessity at that late date in his career.[23]

In Murphy's later years, commissions for portraits were more frequent – in 1965 a portrait of Tomás Ághas (Thomas Ashe) for the De La Salle College in Waterford, and the following year portraits of Frank O'Connor, Tomás MacDonagh and Michael Collins, the latter sponsored by the Cork Sculpture Park Committee. Murphy had done a bronze portrait bust of O'Connor in 1957, with the writer wearing a distinctive silver and turquoise pin in place of a tie. In February 1967 members of staff at UCC presented a bust of Daniel Corkery to the college, while in July of that year a portrait of Peadar Clancy, deputy commandant of the Dublin Brigade IRA, was erected on a limestone pedestal in Kildysart, Co Clare.[24] In 1970 a portrait of the tenor Count John McCormack was unveiled in Athlone, and two years later Murphy completed busts of William Wallace and of the novelist Leon Uris, who described Murphy as 'a self-made genius, the sweetest human being ever to come our way'.[25] In 1973 Seán McEntee unveiled a portrait of An Taoiseach Jack Lynch at a dinner at Leinster House in Dublin. One of the last portraits Murphy sculpted was that of John A Murphy, an academic and historian who sustains the cultural connection between Ballingeary and Cork city to the present day. The artist also carved portraits of members of his family, including his wife Maighréad, and children Bébhinn, Orla and Colm. These family portraits, in bronze, stone and plaster, tend to have a sensitivity of expression and handling that is sometimes absent in Murphy's more 'official' work. The 1957 bust of his father James is a sensitive portrait that does not attempt to flatter the subject, but is full of warmth and compassion. Similarly, the bronze portrait of stone-cutter Mick Brew is full of empathy and feeling.

Yet, in spite of a growing reputation, Murphy remained dependent mainly upon commissions to act as a spur to creating work. He initiated few of his own projects, preferring to work within a brief set by others:

> No, I don't resent having a brake put on me by architects or people like that. Often I find that it is a good thing, stops me running all loose. And I am still able to say what I have to say and be quite satisfied with it … Yes, I do want to disagree with them some times. But I have to be very positive, very sure, before I argue. And I waver a great deal I am afraid. There are times when I am not at all sure what I am at, whether I should go one way or another. I hate to take refuge in reflection, in thinking it out, working it out. This I feel, is only an excuse: it's stalling.[26]

In conversation, he would often describe himself simply as 'a very good foliage carver', harking back to a skill perhaps most respected amongst traditional stonecarvers.

In October 1975, after having suffered ill-health for many years, Séamus Murphy died unexpectedly, and was buried in Rathcooney graveyard, where seven graves are marked by his stones. In an appreciation, Edward Delaney described him as one of the last stonecutters and an outstanding craftsman. 'He did not get involved in theory. He was very simple in his work. You could not have learned from a better man ... He will be a great loss to Cork, as the people there supported him...'[27] Murphy was buried beneath a headstone he had carved forty years before for his mother and brother. Speaking at the graveside, the film-maker and literary editor Louis Marcus described him as 'a rock against all that was fleeting and shallow'. At the funeral mass at St Patrick's Church, the piper Eoin Ó Ríabhaigh played the lament *Caoineadh Luimní*.[28] Murphy bequeathed his stonecutting tools to the sculptor Ken Thompson, who completed a number of inscriptions left unfinished at the artist's death, and who took into storage the collection of over one hundred of the artist's original plaster portrait busts, removed from the studio in Blackpool after his death. Over thirty years later, in December 2006, Séamus Murphy's widow Maighréad presented this collection, a total of 134 works, to the Crawford Art Gallery.

At the opening of the retrospective exhibition at the Crawford Art Gallery in 1982, organised by his daughter Bébhinn Marten and her husband Robert, and a committee led by the late Denis Murphy, An Taoiseach Jack Lynch spoke of the tender, expressive simplicity of the artist's language, and his love for and pride in his craft.

> Many people, I among them, who had only a casual or passing interest in stone-cutting and carving and in sculpture, were literally, and I use this word in its true meaning, catapulted into a full appreciation of the craft and of the art, on reading *Stone Mad*. The book gives an illuminating and absorbing insight into the men of the dust and the stonies.[29]

Lynch went on to remark that Murphy's true position in relation to Irish stone sculpture of the twentieth century had never been fully evaluated, a comment still true, in the year of the centenary of his birth.

———

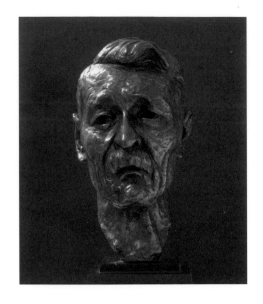

James Murphy
[sculptor's father]
1957, bronze,
45 cm h

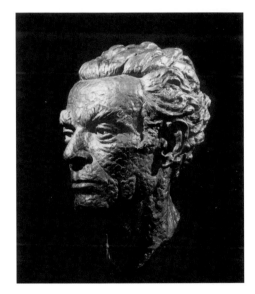

Bat Murphy
[sculptor's brother]
1973, bronze,
51 cm h

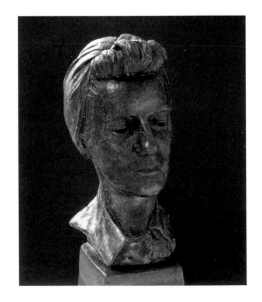

Maighréad
[sculptor's wife]
1945, bronze,
50 cm h

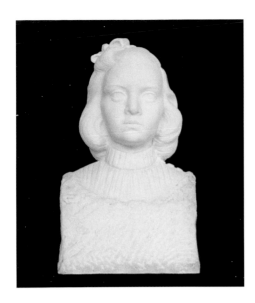

Bébhinn [daughter]
1955, white marble,
52 cm h

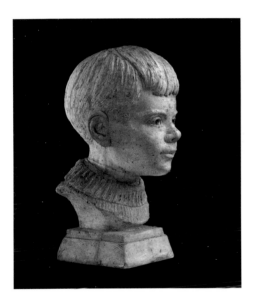

Colm at 6 [son]
1965, bronze,
44 cm h
(plaster illustrated)

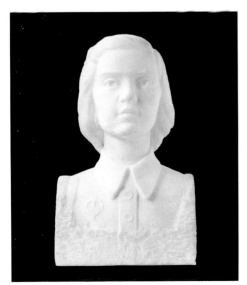

Orla at 8 [daughter]
1956, white marble,
45.5 cm h

PETER MURRAY is Director of the Crawford Art Gallery, Cork. He has written extensively on art, and is author of *George Petrie – The Rediscovery of Ireland's Past* (Crawford / Gandon, 2004) and *Maritime Paintings of Cork 1700-2000* (Crawford / Gandon, 2005).

ENDNOTES

1 Henry Kelly, interview with Séamus Murphy, 2nd October 1975, published in 'Cork Special Report', *Irish Times*, 4th November 1975
2 Mary Leland, 'Interview with Séamus Murphy, August 1975' in Paul Durcan (ed.), *Cork Review*, 4 (1980) p.52
3 *ibid.*
4 Marion Fitzgerald, 'The Artist Speaks: 6 – Séamus Murphy', *Irish Times*, 21st November 1964
5 *ibid.*
6 Leland, 'Interview with Séamus Murphy'
7 Domhnall Ó Murchadha, 'The Making of a Sculptor', *Cork Review*, pp.4-5
8 Leland, 'Interview with Séamus Murphy'
9 *ibid.*
10 Ó Murchadha, 'The Making of a Sculptor'
11 Eilís Dillon, 'The form where it had lain', *Cork Review*, p.22
12 Peter Barry, 'The Boy from the Cross', *Cork Review*, p.48
13 Eric Cross, 'A Tribute of Memory', *Cork Review*, pp.14-15
14 Paul Durcan, 'Interview with Nancy McCarthy', *Cork Review*, pp.6-13
15 'Tatler's Parade', *Irish Independent*, 2nd October 1968
16 Liam Milner, *The River Lee and its Tributaries* (Tower Books, Cork, 1975)
17 John Montague, 'A Quiet Drink', *Cork Review*, p.37
18 *Cork Examiner*, 8th December 1954
19 *Irish Press*, 27th May 1974; see also John Behan 'The Real Thing', *Cork Review*, pp.57-58. In 1974 the portrait of Archbishop John McQuaid was purchased by the Blackrock College Union, who presented it to the college chapel.
20 Maureen Fox, 'Interview with Séamus Murphy, August 9th 1971', *Cork Review*, p.38
21 Hilary Pyle, undated press cutting, *c.*1982
22 Louis Marcus, 'Séamus Murphy and Cork in the Fifties', *Cork Review*, pp.32-33
23 Behan, 'The Real Thing'
24 *Cork Examiner*, 13th May 1967
25 Leon Uris, 'No Two Leaves are Alike', *Cork Review*, p.54
26 Fitzgerald, 'The Artist Speaks: 6 – Séamus Murphy'
27 Edward Delaney, *Irish Press*, 3rd October 1975
28 *Irish Times*, 6th October 1975
29 Dick Hogan, *Irish Times*, 22nd October 1982

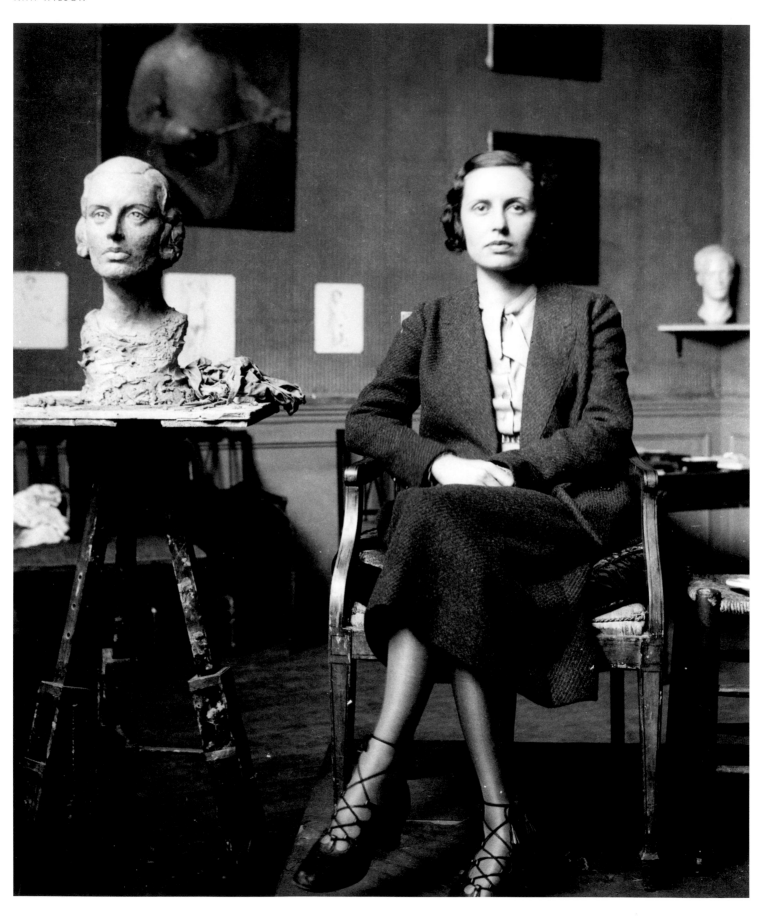

Ruth Ripley 1934, white marble, 50 cm h, signed S Murphy (Crawford Art Gallery, Cork)

Séamus Murphy in Paris
1932-1933

ANN WILSON

I N 1932, WHEN HE WAS TWENTY-FIVE, SÉAMUS MURPHY TRAVELLED TO PARIS for a year's study. Three years previously he had completed an apprenticeship in stonecarving with the Cork firm of JA O'Connell, and he had also been attending night classes at the Cork Crawford School of Art since he was fourteen. The Paris trip, which would both broaden and deepen his knowledge of sculpture, was made possible by a bequest from Joseph Stafford Gibson to the Crawford College in 1919, from which a travelling scholarship fund was established.[1] Murphy was awarded this scholarship in 1931.

The young sculptor sailed on the *Inisfallen*, from Cork to Fishguard, and spent a day in London, where he diligently pursued his education by visiting the National Gallery and the Tate. 'I liked the sculpture section in the Tate, but I'm afraid even that did not interest me anything like the carving on the public buildings.'[2] At Victoria Station he got the train for Dover and arrived in Paris Gare St-Lazare late in the evening. He later recalled the shock he felt at being confronted for the first time with a barrage of posters and signage which he could not understand, as he did not read or speak French. He managed to make his way by taxi to Montparnasse, where he stayed in a hotel on the rue Delambre.[3]

He had a letter of introduction to the Irish-American sculptor Andrew O'Connor (1874-1941), and visited him the following day in his studio on rue Campagne Première in Montparnasse – a street where he might have encountered such well-known figures as Man Ray and Lee Miller, who shared a photography studio there at the time. O'Connor made him welcome, invited him to lunch with his sons, and advised him to start life-drawing at the Académie de la Grande Chaumière, one of the

A series of photographs of Paris in the 1930s from Murphy family albums

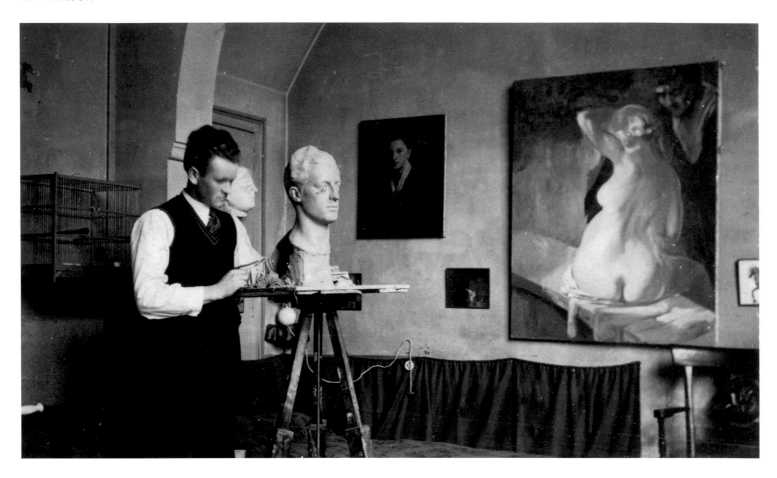

independent academies which catered primarily for foreign art students in Paris.[4] O'Connor's welcome and advice must have been hugely comforting and reassuring to the newly arrived young Irishman, and the four O'Connor sons – Hector, Owen, Roddy and Pat – quickly introduced him 'to the Left Bank, the Luxembourg Gallery and the various schools'.[5]

From the mid-nineteenth century, the perceived superiority of French art meant that students from all over the world travelled to Paris, and exposure to its heady atmosphere was seen by many as necessary for the completion of a fully rounded art education. From about 1900, Montparnasse was the area of Paris most densely populated by artists and sculptors, and a community developed there which acquired a reputation for social and artistic freedom. After the First World War, Montparnasse's reputation as a centre for avant-garde experimentation and openness resulted in even greater numbers of foreign artists and tourists flooding into the area, and also in the establishment of a network of dealers, galleries and collectors, all of which ensured prosperity as well as an attractive Bohemianism.[6] Murphy arrived in Montparnasse just towards the end of this golden age, just before economic depression caused massive desertion of its streets, cafés and galleries.

In the Montparnasse community, foreigners tended to mingle with other foreigners rather than with French people, and indeed among the people remembered by Murphy from his time there were, for instance, O'Connor and his family, the Americans Ken (Rip) and Ruth Ripley, Ken's girlfriend Betty Blake, and Teddy Bucovictz, with whom he shared a studio. Montparnasse during this period was also an important centre for writers, especially Americans; Ezra Pound, F Scott Fitzgerald and Ernest Hemingway all famously gathered there, self-conscious exponents of what the latter recorded as 'the lost generation', the generation of hard-drinking, fast-living young men who had fought in the First World War.[7]

Reportedly, Murphy in Paris was 'shy, quiet, and a hard worker'.[8] As O'Connor had advised, he studied clay-modelling and life-drawing at the Académie de la Grande Chaumière, which was located at number 14 rue de la Grande Chaumière in Montparnasse, and he also attended the Académie Colarossi at number 10 on the same street. In these ateliers students could practice their drawing and sketching from a model for a reasonable fee, and receive weekly critiques on their work from established artists and professors. Both academies had facilitated a great number of subsequently famous students: Sir John

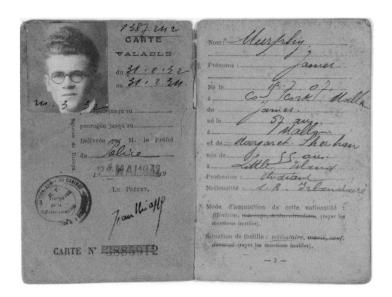

SM's *carte d'identité*

Teddy Bucovictz,
at the bar in Rue
Belloni

Kenneth Ripley and
friend, Paris 1933

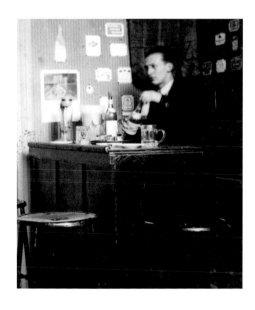

opposite

SM working on head
of Roddy O'Connor,
Paris, 1932

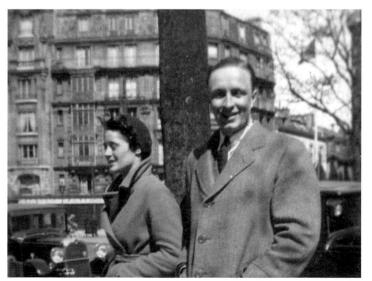

Lavery (1856-1941) had studied at Colarossi's in the 1880s, for instance; Modigliani enrolled there in 1906; and George Grosz (1893-1959) spent several months studying there in 1913. Murphy also attended the Académie Ranson, another independent studio on the rue Joseph Baras. He was not unusual in studying at so many different academies; many of the Montparnasse artists studied at more than one academy for many years.[9] According to Wayne, the training offered at these independent academies was similar to that of the prestigious, state-supported, but largely inhospitable and inaccessible (to foreigners) École Nationale Supérieure des Beaux-arts, and the instruction was often given by École professors also.[10]

As in the École de Beaux Arts, there was a significant emphasis in the independent academies on drawing from life, especially from the naked female model – a traditional component of art education that was still seen as important, even in those Modernist times. A set of drawings from Murphy's stay in Paris shows very competent representations of nude female figures. The young Corkman would not have had such access to female models in the Crawford College; the rather restricted atmosphere of the place was expressed by his friend the writer Frank O'Connor, who wrote that in his own brief period as a Crawford student 'I spent my time copying casts, drawing from the male model, and arguing like mad with my teacher, who said that Michelangelo was 'very coarse'.[11] Murphy himself mainly commented on the contrast between the routine in the academies and the workshop life he was used to. It was 'all very exciting and new and different', and 'there was a rarefied atmosphere and I soon understood all the art jargon'.[12]

While continuing his drawing and modelling classes, Murphy decided that he would also like to do some work on his own – 'model heads of my friends' – for which he needed a studio.[13] As rents were high, he decided to share costs and accommodation on the rue Belloni with a Russian student called Teddy Bucovictz. Bucovictz had good French and had been in Paris for years, so the lease and rental arrangements were left to him.

> We set up a small bar with three red bar stools in one corner of the studio which was very big, with a balcony and two bedrooms. We gave a marvellous house-warming party and Teddy gave another to celebrate St Nicholas's Day. A great crowd of Russians came and drank vodka and did all sorts of dances.[14]

Murphy modelled Bucovictz's head, and he also produced likenesses of other friends, such as Roddy and Olga O'Connor. One night, however, Bucovictz and all his belongings disappeared, leaving behind him unpaid rent.[15] To avoid being sad-

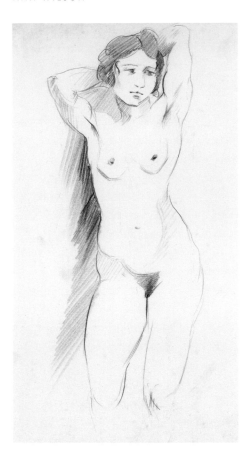

Half-length female with hands behind head
1932, pencil on paper, 42 x 22 cm

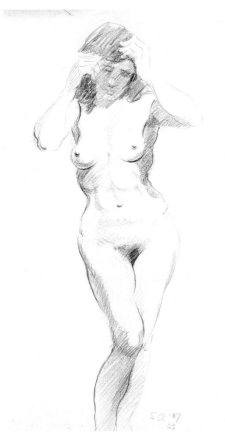

Contraposto female with hands on head
1932, pencil on paper, 42 x 36 cm

dled with with the Russian's debts, Murphy decided that he had no option but to jump into a taxi and also disappear into the night.[16]

Murphy enjoyed the evenings in the cafés, where students, artists and writers gathered and 'where the talk was good. I used to shift around from one to another and walk along the boulevards where there was always something happening, something to see.' [17] Like Ernest Hemingway, he particularly liked sitting at the famous Closerie des Lilas café on the corner of Boulevard du Montparnasse and Boulevard St Michel, 'drinking demi blonde and looking at the fine statue [by François Rude] of Marshall Ney'.[18] In this he also resembled George Orwell's Russian writer friend, Boris, described by him in *Down and Out in Paris and London*: 'His favourite café was the Closerie des Lilas in Montparnasse, simply because the statue of Marshal Ney stands outside it.' [19] According to Wayne, the Montparnasse cafés 'played an important role in the development of artists, since they went there to congregate, to socialize, and to meet models for hire. The cafés also acted as their offices and received messages for them.' [20]

There is evidence that Murphy had very little to live on in Paris for periods of time when his payments from the School of Art were delayed. His friend Nancy McCarthy remembered being told that Murphy and Ken Ripley shared a flat,

> ...and at one time they had practically no money at all ... so they bought a big sack of potatoes and they stayed in bed for the entire month and they used to get up at night and they used to boil potatoes, and then they used to go back to bed to keep warm. Betty wasn't married to Rip at the time and Betty's mother came over from America; Betty was attending a studio, she was a painter, and the mother used to bring Betty out to meals and then Betty used to try and bring back what she could to the starving pair who lay in bed.[21]

Despite such intermittent hardship, Murphy liked Paris and found it 'full of life', but he eventually tired of the intellectualised arguments of the Montparnasse cafés. He found that his attitude to art, and sculpture in particular, differed from that of his companions:

> One of my greatest difficulties was that I was not able to talk about abstract art, and my fellow students seemed to know all about it. I used to make great efforts to talk about stonecutting and carving, but they did not seem interested, and I was told on several occasions that it was craft work, and not art! This would annoy me, and I felt instinctively it was not true.[22]

When he visited Notre Dame de Paris, Sainte-Chapelle, Saint-

Finbarr can be usefully compared to a small Madonna and Child executed in 1931, before he left for France. The latter shows a sensitivity to underlying forms and volumes, but is softly rounded and not nearly as daringly reductive as the UCC piece. Murphy, in fact, did very few pieces with the level of geometric stylisation of *St Finbarr*; the eight-foot-high *St Brighid*, commissioned along with twelve statues of the apostles for the façade of St Brighid's Church in San Francisco, shows a similar approach as late as 1948, although the features appear more generalised and idealised. He normally used a less abstract style for his portrait heads, although the smooth symmetry of *Ruth Ripley*, which he brought back from France to Ireland in plaster form, has an elegant formality about it that is reminiscent of portrait heads from ancient Egypt.

Although geometric stylisation only really appears in Murphy's own figurative work after his stay in Paris, he had been exposed to it in Cork in the monumental *Christ the King* (1931) on the façade of the Church of Christ the King at Turner's Cross. John Storrs, a Chicago sculptor, designed this work, which was executed by Cork carver John Maguire from plaster models shipped from America. Storrs' sculpture can be described as Art Deco in style, as can some of Murphy's post-France work. The Art Deco style in sculpture is characterised by the use of the geometry and reductive forms of Modernism, but tempered by a degree of naturalistic representation. The style became widely popular in all forms of art and design after the 1925 Paris Exposition Internationale des Arts Décoratifs et Industriels Modernes, and remained so until the outbreak of the Second World War. Eric Gill's work has also been placed within this category, and indeed Art Deco was an attractive style for any artist who was aiming at communicating to a wider public: clear communication and accessibility were maintained, but Cubist-derived geometry conferred formal clarity and conveyed a sense of order and modernity.

Cubist-inspired Modernism was not the only reason that Murphy's post-France figures often looked formally simplified, however. It is clear from his interviews and writings that the Chartres statuary also exerted a powerful influence on him, and the ethnographic collections in the Louvre allowed him to examine carved work from a broad range of historical and geographic sources. Ó Murchadha recognised the emergence in Murphy's work after Paris of 'elements that are the basis of the sculptor's language: the unity of structure that gives universal significance to the particular and that controlled expressiveness that was known in the era of carved crosses and sculptured metal forms.'[35]

Without exception, Modernist artists in the early twenti-

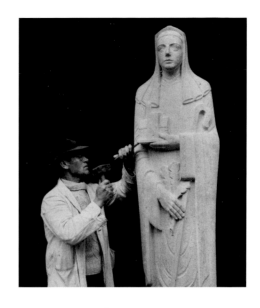

St Brighid
1948, limestone,
259 cm h
(St Brighid's Church,
San Francisco)

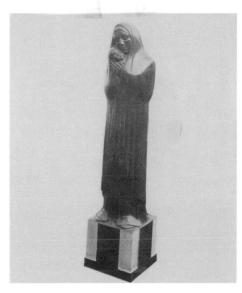

Madonna and Child
1931, polished
limestone, 140 cm h
(private collection)

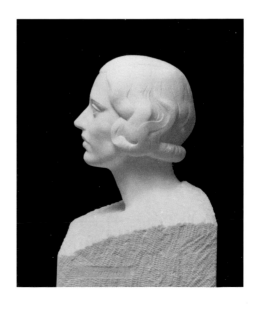

Ruth Ripley
1934, white marble,
50 cm h
(Crawford Gallery)

eth century, in their efforts to escape the stranglehold of Renaissance naturalism, turned for inspiration to what they regarded as 'primitive' art – essentially art produced outside the traditional European art establishment. 'Primitive' influences, as they saw them, could be from the sophisticated cultures of Japan and China; they could be American pre-Columbian; they could be African, as with Picasso and Matisse, or Tahitian, as with Gauguin. They could also, as with Paul Klee, be children's art or folk art, or European work produced before the Renaissance (but after the fall of the Roman Empire) – mediaeval sculpture, for instance. Nineteenth-century Europeans had found it very difficult to appreciate the level of expressive distortion and geometric simplification, especially of the human body, seen in Romanesque and early Gothic painting and sculpture, despite the vogue throughout that century for neo-gothic and, later, neo-romanesque architecture. The Symbolists at the end of the century, however, and then the Expressionists, the Fauves and, of course, the Cubists of the early twentieth century embraced distortion of natural form and colour as more eloquent, more expressive of deeper, non-visible truths. Anatomically accurate, classically beautiful and ideally proportioned human figures began to seem bland and mute, and what was previously perceived as ugly, and evidence of inability to draw or model correctly, began to appear powerful and full of 'primitive' expression.

Murphy must have looked at original medieval carvings in Ireland – he would certainly have come across examples during his apprenticeship years. The quality and extent of surviving French work seems to have been a revelation to him, however, and some of its characteristics began to appear in his work. It is evident in pieces like his Bantry statues that he became thoroughly proficient early on in the use of formal distortion and simplification as an effective means of expression. This is particularly noteworthy in *St Ita*, whose body forms an elegant fluted column which still manages to convey both reassuring strength and steadfast piety through the disproportionally large, slightly tilted head, broad clasped hands and tidily symmetrical pose. *The Virgin of the Twilight*, carved 'just to be doing something'[36] during the lean war years of 1941 to 1943, is his most ambitious exercise in expressive formal reduction and distortion. It has been described by Peter Harbison as 'almost ugly in its monumental simplicity', although he acknowledges that it is 'far more satisfying to look at than the simpering prettiness of the conventional plaster Madonna'.[37] As with *St Ita*, the large, clearly described facial features suggest strength, and the simplified curved lines of the arms and robe framing the body of the child, and the large hand supporting it,

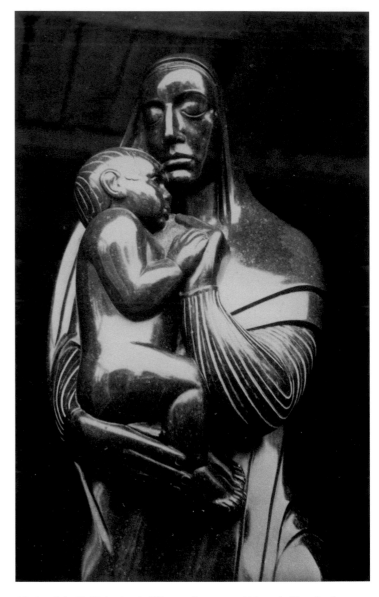

Virgin of the Twilight, 1941, Kilkenny limestone, 198 cm h (Crawford)

are wonderfully expressive of a gentle protectiveness: 'I finished the big statue in 1943,' Murphy recalled. 'It was black when polished and its mood was very sombre, the result probably the effect of the war in Europe, and also an attempt to convey that the mother was aware of the road her child would go.'[38] This statue was certainly a challenging interpretation of the Madonna and Child theme – far too challenging for most Irish clergy and laity. Exhibited at the Royal Hibernian Academy in 1943, it excited sufficient interest in artistic circles for Murphy to be elected an associate member, but it was returned unsold to his studio, where it languished until 1960 when it was bought by the Cork Sculpture Park Committee, on behalf of the people of Cork, to be displayed in Fitzgerald Park.

Paris honed and changed Murphy's sculptural style, but

it only reinforced his attitude to technique and process. He was puzzled by the fact that 'most of the students at the Académie Ranson knew nothing about stone carving as they all had come out of schools of art where modelling in clay was the usual training for sculptors'.[39] Murphy, like the American Jacob Epstein, used modelling for portrait work, but he always claimed that direct stonecarving was his true passion. In this preference he was very much in step with avant-garde sculptural opinion of the time.

In the early twentieth century, a desire for what was seen as a more direct, authentic approach to sculptural practice emerged as a reaction against the increasingly mechanised production of the nineteenth century. Designing or modelling a piece in one material (clay, wax, plaster) and transposing it to another (marble or bronze) had been the normal sculptural procedure in the nineteenth century. It often involved more than one person in the production of a work, as the design could be completely separated from the execution, and different stages in the execution process separated from each other. This raised questions about authorship: Rodin, in particular, came under severe criticism for delegating aspects of his production to studio assistants (and still signing the work as his own). The translation of a piece conceived in one material into another medium also resulted in questions about truth to materials. It was felt that evidence of the beginnings of a piece, the interaction between the artist and the natural shape, texture and character of a block of stone or a piece of wood, needed to be preserved right through to the finished work. By the late 1920s the insistence that sculptural products and practice be 'unmediated' had become dogma in some artistic circles, and the debate acquired a moralistic subtext:

> Not only should direct carving ensure authenticity (in that the named sculptor did all the work him- or herself), but also honesty, in that stone was revealing of every decision, whereas clay allowed endless effacement and revision ... Carving could be promoted as honest in every way. As a result, clay assumed somewhat 'decadent' associations.[40]

Direct carving was also seen to be closer to the 'real' tradition of sculptural practice. Eric Gill saw his carving activity as in line with that of the medieval stonemason on England's churches,[41] and, indeed, so did Séamus Murphy. Brancusi decided that 'direct cutting is the true road to sculpture',[42] and, according to Curtis,

> Joachim Costa, who published a book contrasting modelling and carving in 1921, used the Louvre to provide illustrations for the two traditions. In this binary history

the lineage of stone carving, as represented in Egyptian and Assyrian relief-work, Cambodian, archaic Greek, and mediaeval French carving, represented the only true path.[43]

Domhnall Ó Murchadha considered the revived interest in direct carving to be 'the re-establishment of true sculptural expression' in reaction against the 'broken surface' and 'the vibrant but seductive modelling of Rodin'.[44] And, certainly, Rodin seems to have cast a long shadow, especially in the French academies. Murphy, whose comments on Rodin often indicate that he was not particularly impressed with his work, recalled showing a fellow student at the Académie Ranson, a young Spaniard, how to carve from a block:

> I often wondered if he ever finished it. After a month at it he began to tire of it, and then he told me 'twas a waste of time, as you could always employ a professional carver to do the work for you 'as Rodin used to do'.[45]

Murphy absorbed and formulated, and sometimes reformulated, a rich variety of ideas while he was in France, and his sculptural style and practice developed accordingly. Probably the most significant result of his Paris trip, however, was the crystallisation in his mind of his concept of the sculptor's role in society. His training as an artisan carver had familiarised him with the idea of the sculptor as a skilled provider of a service, carrying out agreed tasks as instructed in a practical, efficient way. His book *Stone Mad* gives a picture of life in the stoneyard, and expresses his affection and admiration for the men who worked there. On the other hand, Murphy's art school training and then his experience in Paris exposed him to a completely different model of the sculptor, one who was educated in academies, who discussed art theory, and who made self-initiated works for exhibition at venues such as the Paris Salon and the Royal Irish Academy.

Murphy himself had been both of these sculptor types. From the start, he seems to have genuinely loved working in the stoneyard, and greatly valued the skills acquired there and the atmosphere of camaraderie, despite the physical hardships, which, again, he described graphically in *Stone Mad*. The stonecarver, however, was required to follow instructions and not bring too much creativity to the job. He was not recognised as an artist, and this must have been a problem for Murphy, as he seems to have had, from the beginning, an urge to be exploratory in his work. In *Stone Mad* he comments on the stylistic conservatism of his fellow carvers:

> They had a way of carving all detail – a way they had inherited – and they would not tolerate any deviation from it. This is the way it was done on such-and-such a

job and the architect was an authority ... and architects are always right! It was not long, therefore, until I learned that there was a conventional way of carving all kinds of foliage, a fact which subsequent visits to churches confirmed.[46]

And yet, the alternative role of the autonomous artist-sculptor did not wholly appeal to him either, or certainly not that of the artist-sculptor in the twentieth century. He wanted the sculptor to be an active participant in society, not a commentator on its margin. He wanted to produce work which satisfied specific social needs and which became a part of people's lives, rather than 'enlarged ornaments' destined for gallery exhibition.[47] He also felt that sculpture should be primarily about making and doing rather than theorising, as evidenced by his irritation at the dismissive attitude of his fellow students towards stonecarving skills and at the extended discussions on abstraction in the Montparnasse cafés.

The medieval sculpture which he saw in France suggested to him a more valid model of practice than the two just described. Aesthetically, he saw that the portal statuary of Chartres, for instance, was powerful, individual and expressive – the result surely of creative freedom as well as skill. Yet it had been produced by teams of anonymous stonecarvers, and was made to fulfil the specific needs of society. It might be argued that twentieth-century Ireland was very different to medieval France, but like Pugin, Ruskin, Morris, Gill and countless others before him, Murphy was entranced by a vision of the medieval craftsman whose work was needed and meaningful, and of a model of production which valued skill and material as well as concept and creativity. He therefore happily returned to Ireland from France with a new pride and a strong sense of belonging to a long and prestigious tradition:

> Some artists such as painters or musicians may well feel that when they leave the big centres they are coming home to exile, but I was fortunate to belong to a company and a tradition so widespread that when I left Paris I left little that was not all the time waiting for me among the stonecutters' sheds of Ireland.[48]

He also returned with a strong sense of the possibilities for sculptural practice in his home country. Ireland was a young state, with a poor economy and very few opportunities for visual artists. It was, however, also a country with an unusually high number of practising Roman Catholics and a constant demand for religious imagery. In the 1930s, the church usually either imported mass-produced religious figures or ordered or bought them from stonecarving firms, and the work was generally somewhat hackneyed. Murphy thought it might be possible to

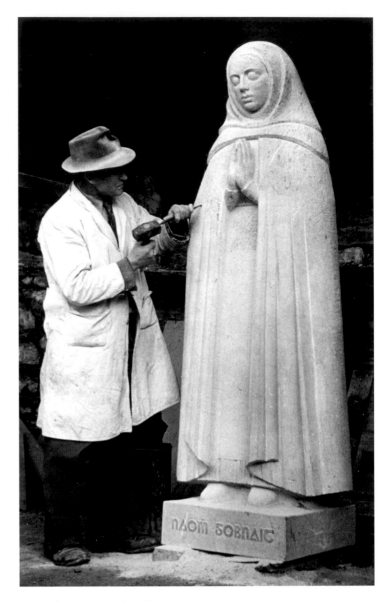

SM working on *Naomh Gobnait*, 1950

establish a business providing one-off sculptural pieces for religious institutions. He seems to have felt that there was an opening for a group of sculptors to get together, and eventually replace much of the existing generic statuary with individual, hand-carved modern work. In the 1939 edition of the *Capuchin Annual*, which included a feature on his work, he was described as 'keenly interested in the development of a Christian School of Sculpture in Ireland'.

Unfortunately, the Christian School of Sculpture never materialised in Ireland; it proved impossible to wean the clergy and the faithful from the religious imagery with which they were comfortable. There were some church commissions for Murphy, although very few local ones. Cork did not turn out to be the ideal location for establishing any kind of sculptural

practice, and Murphy needed to be very adaptable. The closest he came to realising his vision of the sculptor's role was when he made the statue of St Gobnait (1950) for the saint's shrine in Ballyvourney in west Cork. This figure is very different from the smooth, pink-cheeked naturalistic statues generally associated with the numerous shrines which are common sights around Ireland. Her features are strong and clearly rendered, and no attempt is made at mere prettiness. The symmetry and simplification of the figure convey a sense of solemnity and dignity, and the texture of the limestone and the sculptor's marks on it are left visible. These qualities might have made the statue unpopular with a conservative Irish rural population used to a very different type of image – people sometimes did find Murphy's unusual interpretations of Madonnas and saints difficult to accept – but this was not the case. The figure of *St Gobnait* became the focal point for popular devotional practices in Ballyvourney, and remains so to this day. People interact with the statue. They walk around it, kneel to pray in front of it, and hang rosary beads around the saint's neck; it is a meaningful part of their lives. This is exactly the sort of work that Murphy wished to devote his time and energy to, and it is a pity that he was not given more opportunity to do so.

———

Ann Wilson is a lecturer in Visual Culture at Cork Institute of Technology. She has published papers on the design and building of St Colman's Cathedral, Cobh, and on Séamus Murphy, and co-authored (with Dr David Lawrence) a book on St Fin Barre's Cathedral, Cork. She is currently carrying out doctoral research on religious imagery in late 19th- and early 20th-century Ireland.

ENDNOTES

[1] www.crawfordartgallery.com/gibson, accessed 13th Feb 2007
[2] Séamus Murphy, account of France, unpublished notebook (undated), p.2
[3] *ibid.*, p.3
[4] *ibid.*, p.4
[5] Séamus Murphy, *Self Portrait*, unpublished document (1966), p.4
[6] Billy Kluver and Julie Martin, *KiKi's Paris, Artists and Lovers 1900-1930* (Harry N Abrams, New York, 1989) p.11
[7] Ernest Hemingway wrote *A Moveable Feast* (1964) about Paris in the years 1921-26. 'The Lost Generation' was described by Hemingway in the chapter 'Une Generation Perdue'.
[8] John Behan, 'The Real Thing' in Paul Durcan (ed.), *Cork Review*, 4 (1980), issue dedicated to Séamus Murphy, p.57
[9] Kenneth Wayne, *Modigliani and the Artists of Montparnasse* (Harry N Abrams, New York, 2002) p.23
[10] *ibid.* The École Nationale Supérieure des Beaux-arts was located in the Saint-Germain-des-Près area, just across from the Louvre.
[11] Frank O'Connor, *An Only Child and My Father's Son* (Penguin Classics, London, 2005) p.138
[12] Murphy, *Self portrait*, p.4
[13] *ibid.*, p.5
[14] *ibid.*
[15] *ibid.*
[16] *ibid.*
[17] *ibid.*
[18] Murphy, account of France, p.6. The Closerie des Lilas was at 171 Boulevard du Montparnasse.
[19] George Orwell, *Down and Out in Paris and London* (Harcourt Brace Jovanovich, New York, 1933), p.24
[20] Wayne, *Modigliani*, p.20
[21] Paul Durcan, 'Interview with Nancy McCarthy Allitt 25 July 1980', in Durcan (ed.), *Cork Review* (1980)
[22] Murphy, account of France, p.6
[23] *ibid.*, p.4
[24] Murphy, *Self portrait*, p.4
[25] *ibid.*, p.5
[26] *ibid.*
[27] Murphy, account of France, p.6
[28] Domhnall Ó Murchadha, 'The Making of a Sculptor', in Durcan (ed.), *Cork Review* (1980) pp.4-5
[29] Murphy, account of France, p.4
[30] Murphy, *Self portrait*, p.6
[31] Durcan, 'Interview with Nancy McCarthy Allitt', p.6
[32] Ó Murchadha, 'The Making of a Sculptor', pp.4-5
[33] Murphy, *Self portrait*, p.6
[34] Seán Ó Faoláin, *Vive Moi!* (Sinclair-Stevenson, London, 1993) p.126
[35] Ó Murchadha, 'The Making of a Sculptor', p.4
[36] Murphy, *Self portrait*, p.9
[37] Peter Harbison, Homan Potterton and Jeanne Sheehy, *Irish Art and Architecture from Prehistory to the Present* (Thames and Hudson, London, 1978) p.258
[38] Murphy, *Self portrait*, p.10
[39] Murphy, account of France, p.8
[40] Penelope Curtis, *Sculpture 1900-45, After Rodin* (Oxford University Press, 1999) p.77
[41] *ibid.*
[42] *ibid.*
[43] *ibid.*, p.78
[44] Ó Murchadha, 'The Making of a Sculptor', pp.4-5
[45] Murphy, account of France, p.8
[46] Séamus Murphy, *Stone Mad* (Collins Press, Cork, 2005) pp.10-11. First published by Golden Eagle Press in 1950; revised version (with new illustrations) published by Routledge Kegan Paul in 1966.
[47] Murphy, *Self portrait*, p.4
[48] Murphy, account of France, pp.9-10

Séamus Murphy with portrait bust of his father, James (still from *Stone Mad*, RTÉ, 1969)

Joining the Dots

ORLA MURPHY

There are established personal places
that receive our time's heat
and adapt in their mass, like stone.

— Thomas Kinsella, from *Personal Places*[1]

Still from *Stone Mad* (RTÉ, 1969)

WHAT DOES A CHILD SEE OF ITS FATHER? THE COR-duroy trousers with turn-ups that harbour stone dust, the plaited leather buttons on a tweed jacket, the small waistcoat pocket, and the blue knitted purse from which the smooth-faced watch with ribbed winder is conjured, its arrow-heads pointing to graceful Roman numerals, a carefully knotted tweed tie, a collar soon frayed by the stubble left by a barber after game attempts to prune the thicket of hair, clear glasses unlike the ones he wore at work that were cross-hatched from years of resting on gritty surfaces: all are details. To attempt a portrait from such small memories is akin to trying to show a live elephant by drawing a line from point to point on the rough paper of a child's puzzle book. The reality recedes with every stroke of the pencil, and memory with its profound and unsettling emotions assists and obstructs by turns, until one is left with an oddly coloured image, like a photograph of a painting of an elephant, or a chair or any other familiar being or object, recognition becoming more difficult with each layer. The writer has little choice but to call on the imagination of the reader and to say: 'this is how it was, this is how I *think* it was'.

In a house of owls, Séamus was a lark. Dawn on summer mornings would see him in the kitchen, looking up above the whitewashed retaining wall of the back garden to the eyelet of sky beyond the sycamore tree. He could hear the reveille of the army bugler in the barracks that topped one of the hills from which the terraces of Cork's northside are carved. He made the breakfast, squeezing oranges, stirring in boiling water and sugar, making toast. (It took the ashen-faced intervention of an American visitor, a specialist on Michael Collins and, it seems, unnecessary risk, to end his habit of wangling the slices of Mother's Pride out of the machine with the bread knife.) While the eggs boiled he brought marmalade, butter and cereal from the red-painted cupboard in the corner. There was no fridge: houses built into the cliff-face had pantries where no sun ever entered, and tiled floors ensured permanent chill. The single window leaked grey light from the yard where meat was kept fresh in the safe, a wood-and-mesh box on four tall legs beyond the reach of cats whose unsanctified surplus was donated to the distillery in Blackpool – donated, not sold, as Séamus, citing

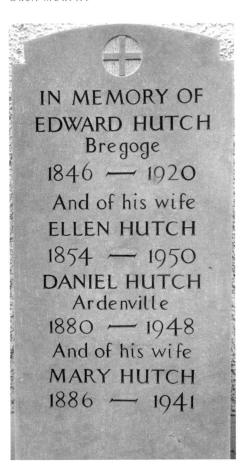

Example of Roman lettering on Edward Hutch's headstone (St Mary's Cemetery, Buttevant, Co Cork)

IN MEMORY OF
EDWARD HUTCH
Bregoge
1846 — 1920
And of his wife
ELLEN HUTCH
1854 — 1950
DANIEL HUTCH
Ardenville
1880 — 1948
And of his wife
MARY HUTCH
1886 — 1941

Myles na gCopaleen's cautionary tale about the woman who sold kittens, would not risk prosecution by the Vice Squad for living off the immoral earnings of a cat.

A convent garden behind Wellesley Terrace separated the redbrick Bellevue Park and the stuccoed Wellesley Terrace. Its high walls shielded from view the curved rows of vegetables and, bent over them, the gardener who occasionally brought gifts of cabbages and potatoes, the surplus of the convent, and helped Séamus (whose twin brother John had inherited their father's love of gardening) to put order on our garden – the sheltered one at the back, where a flight of stone steps, usually damp, always green, came level with the slope of grass, the washing line and the lilac, and the long narrow strip bordered by trees and hedges across the terrace at the front of the houses, where bluebells spread their careless random flame in spring, and, later, roses scrambled along the fence that topped the wall bordering the road. There were few cars, and the children of the three linked terraces met on the safe space between the houses and the gardens, played football on the short steep hill, or ran their trolleys down it to swerve around the corner or make calamitous stops at the pole on the junction.

The uncurtained living room windows on the first floor looked down on this hill and past it to the roofs of Charlemont Terrace, and beyond them to the city, the far hills and the southern skies. It was here that Séamus had his drawing board, set at a slight tilt on one end of the long table, covered with papers, correspondence, research literature and – second only to the drawing board in importance – the typewriter that Maighréad used to type his business letters, the correspondence of the Cork Arts Society (of which they were founder-members), occasional letters to the papers enquiring after the fate of a cherished building, scripts for radio programmes, book reviews, and, of course, drafts of *Stone Mad*. Space was cleared for us children to practice handwriting when the book of italic lettering and the little yellow boxes of brass nibs, shaped to suit the right- and left-handers, arrived by post from Windsor & Newton.

In a corner of the room next to the door stood two rolls of paper, one for tracing and the other opaque, from which he sliced a neat rectangle which was pinned to the pock-marked drawing board with thumbtacks. The ruler, the compass, a rubber, a selection of pencils and a penknife were laid out neatly to hand, just as at a later stage of the work, in his studio, chisels, a horsehair brush (for whisking away the ubiquitous dust), hammers and mallets were laid on a cloth to prevent rolling and to protect the surface of the stone. Summer evenings, with their bonus of light, were a favoured time for hours of meticulous drawing of inscriptions: each O having the pinprick of the compass at its centre, the angles of the Ws and Ms precise as the diagonal struts on a bridge, the uprights of Ts and Is as strong as columns on a classical building, and though he admired the sans serif of Eric Gill, his own preference was for Roman lettering, each serif a counterpoint as well as a support to the structure, each letter designed to stand alone and to work also in relation to its neighbouring shape – a perfect miniature streetscape. His feeling for letters was as intense as his feeling for words, the spaces between them as important as the letters themselves – spaces, like punctuation, to add clarity, to strengthen the meaning, while, like punctuation, going almost unnoticed themselves.

The pencils, like the chisels, were frequently sharpened; the discovery of the Stanley knife hailed, its neat cache of blades snug in their waxed paper within; the workmanlike heft of the handle, solid, strong, reliable, its appeal obvious. It was one of the 'new' things that amused and intrigued him, yet another foolproof tin-opener, or the yellow and gray transistor radio that he gave us to allow us to play noisy music out of earshot in that house of stairs, or the radiogram that stood to his left on a cupboard built by his brother Bat to house the collec-

Joseph Higgins
(1885-1925)
Nana or *Study of an Old Woman*
1910, bronze,
42 cm h

Séamus Murphy
Daniel Corkery
1936, bronze,
42.5 cm h
(Crawford)

Séamus Murphy
Old Murphy's Farm
1929, watercolour,
19 x 26 cm

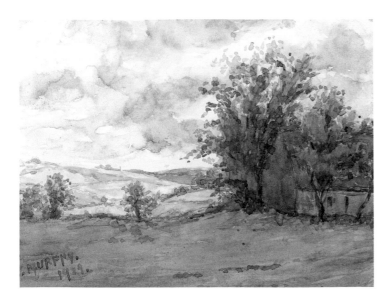

tion of records (Paul Robeson, Kathleen Ferrier, Seán Ó Riada), which were played after the work was finished, not as an accompaniment. The background sounds in that room where so much work was planned and drawn up were the crackle and hiss of the fire behind him, the hollow emphatic strokes of the typewriter, intermittent notes from Síle MacCurtain's great gilded concert harp positioned like a diva in the centre of her sitting room next door, its flourishes muted by the party wall. City noises rose from afar – the hoot of the trains, the siren of Douglas Woollen Mills, the chimes of the City Hall clock on the south bank of the river below. On summer evenings the lower sash of the centre window was raised to allow a drift of children's voices, songs from the small birds which nested in the gardens, and the sharp but distant voice of seagulls which, as dusk drew in, could be seen flying downriver to their night roosts, and when the wind was from the west, irregular marking of time from the bells of Shandon.

When he lifted his head he could see, facing him on the end wall, a portrait of his mentor Daniel Corkery by William Sheehan (the first holder, in 1923, of the Gibson Bequest Travelling Scholarship), and near it two bronze heads by Joseph Higgins,[2] Séamus's father-in-law, a sculptor whose work Séamus admired saying that Higgins was a better sculptor than he himself was. The bronzes and the portrait were placed not as prompts to effort or duty, but for the pleasure their presence gave to him and Maighréad, and to anyone who came into the living room. Behind him, over the fireplace, was a painting in oil of Cahirmee Fair by Sylvia Cooke-Collis; a still-life of scarlet flowers by Jack Hanlon to the left; three engravings by Robert Gibbings to the right; elsewhere, drawings by William Harrington and Seán O'Sullivan; a watercolour of his own and one by his mother-in-law, Katherine Higgins; a nude study from one of his Paris student friends, and a small landscape by Walter Verling. His own sculpture – portrait heads in bronze, often, or plaster – stood on bookshelves, birds of passage awaiting a buyer or owner. There were no sculptures other than those and Joseph Higgins' because sculpture was beyond his pocket. Books lined the remaining wall space.

Friends and people visiting or passing through Cork were welcomed; the front door stood open all day and well into the evening. Ben Kiely wrote

> Séamus and his wife Maighréad must have suffered a fair amount, not only from the continual intrusion of their friends but from the tendency of their friends to say to visiting strangers: 'And you can't pass through Cork without meeting the Murphys.' The wastage of time of two busy people must have been considerable.

William Harrington, illustration from SM's *Stone Mad* (1966)

Séamus Murphy and Seán Ó Ríordáin in Blackpool, Cork

The Farmer
n.d., red sandstone,
47 x 39 cm
(RHA, Dublin)

opposite

Staff from P Costen in Waterford, with stonework for new bank, *c*.1935

The sage of Omagh was for once wrong. His visits were, like the others', occasions of celebration, opportunities to connect with the wider world. The living room welcomed them with their news, stories, laughter and sometimes song; they were, after all, what made that large quiet working space live. Most made their way to his studio in Blackpool to view the work in progress, and inevitably, at least on a first visit, have a tour of what Seán Ó Ríordáin called 'the Skullery'.

Stepping from the bright light out of doors into the studio at Blackpool, people were faced with something resembling a stage filled with immobile figures that, as ones eyes grew used to the oblique, somewhat veiled light, were shown to be heads on pedestals. Then the recognition game of well-known faces began. Most were made to commission, others he invited to sit for him – composer Fred May, journalist Liam Robinson, the Stone Cutter, the Farmer, people whose identity was known in other spheres and who interested Séamus – or, in that tradition among artists of recording their fellows when

commissions were scarce and, hence, sitters were lacking, although of those, the people whom Séamus invited to sit for him (mostly men) were usually ones who had, as he said, 'a fine head'. Some portrait heads appeared for a short time, and others – the Tailor, Douglas Hyde, the family – who, while the bronze went to its permanent home,

stayed on in plaster as mute observers of the entries and exits of the rest. By the time the guessing game and introductions were over, it was clear that Séamus enjoyed their company and his words animated the throng in the way that a scene from a film begins with a still shot that then transforms a necropolis into an agora. It was a little disconcerting, though, to read the words: 'This is how I like to see my family.'[3] – a mild rebuke or a hint of the perennial anxiety that he hid from us children?

Ó Ríordáin's own portrait was among the permanent gallery in the studio for years, and while the medium of bronze excludes colour and movement (he had very bright blue eyes, a high colour and a very lively expression), it captures the qualities of intense listening and seriousness that were part of the true foundations of the poet.

By the time visitors arrived at the studio, Séamus would have achieved most of a day's work. He left the house, manoeuvring his bicycle along the hall out across the terrace, and, balanced on one pedal, freewheeled down the hill onto Wellington Road, past the schools, across Patrick's Hill, and down the steep drop to the Watercourse Road where ten minutes brisk cycling brought him to the big wooden gate with its little wicket, next door to O'Connell's yard. His association with O'Connell's (formally titled Art Marble Works but always known as O'Connell's yard) lasted from the first day of his apprenticeship until they closed, many years later. Their premises was cleared to make way for a bank, though not the type of building which in former times had provided the stonies with work. O'Connell's had the machinery and manpower to lift heavy blocks of stone, and Séamus had their training in foliage, figure and letter-carving, as well as his own hard-practised and continually extending skills, or, as he said himself, his 'little bit

of talent' with which he sometimes made inscriptions for them. This practical barter, enjoyed by both parties, and an awareness of the value of such an ancient exchange must have enriched that warm and respectful bond. O'Connell's is gone, but the tradition of hand-carving inscriptions is still continued by a few craftsmen and women. McCarthys (monumental sculptors) and Ken Thompson take pains to observe the style and proportion of lettering demonstrated by Séamus so many years ago in their additions to gravestones of his design.

A horse trough stood on the pavement at the entrance to Séamus's yard to water the thirsty animals that hauled goods around the city, or carted in produce from the fields of north Cork. The red sandstone Farmer was one of those whose horse drank from the elegantly decorated trough while he and Séamus talked. The large gate to Séamus's yard was usually open so that passersby could see past the gravel-grass strip to the three-sided corrugated iron shed on the right, where larger work – the carving of statues and inscriptions on memorials – was done by daylight in the open air. The sound of chisel on stone told them where to find him, even before he came into view. To the left was the studio proper, which housed finished work and provided space for sitters whose portrait heads he modelled in clay. The next stage after clay modelling – the casting in plaster of Paris – was done here too, swathes of the wet material lifted from a bucket of water and wrapped around the moist clay head in two halves, then left to harden overnight. Next day the clay was scooped out of the mould (to be reused for the next head), a thick release layer of yellow vaseline was smeared onto the inner surface of the plaster, and fresh plaster was poured in and left to dry. Then came the moment of excitement when, like the controlled cracking of an egg, the outer mould was levered off with a heavy chisel and the complete head was revealed. Minor touches with small tools or sandpaper finished the job, though, as he remarked, 'a plaster cast is nothing more than a means to an end', that end being bronze or, less often because of its cost, marble, sandstone or Portland stone. (A sculpted head in stone was unique. Bronzes were traditionally produced in a limited edition, each made on request, but no more than seven in all.) If the plaster head was to be cast, it was sent, packed in straw wool and crated in wood, to a foundry.

Foundries have almost mythological magic – the great heavy implements, the noise of the smelting, the vibration of the furnace and its terrifying exhilarating heat-becoming-light

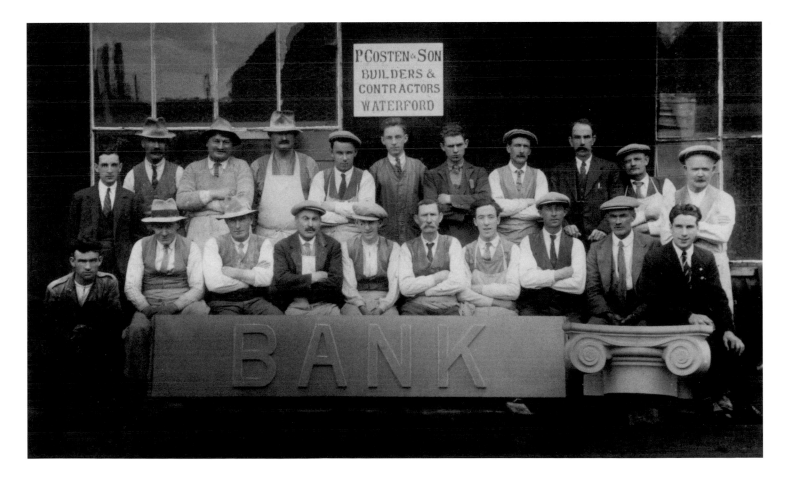

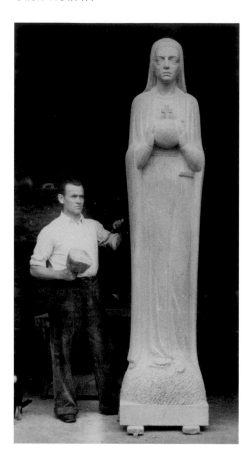

Madonna of the Globe
1949, limestone,
259 cm h
(St Vincent's Church,
Sunday's Well, Cork)

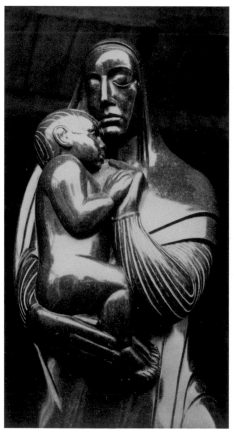

Virgin of the Twilight
1941, polished
Kilkenny limestone,
198 cm h
(on long-term loan
to Crawford Gallery)

as the door is opened. The whole complex chemistry of *cire perdu* and the processes by which different colours are created fascinated him, and when he no longer had to send his work to Fiorini and Kearney and other great English foundries because casting was being done in Ireland, he enjoyed many visits. 'Visits' hardly describes those voyages; perhaps pilgrimages bearing precious offerings to the den of Vulcan would better describe that elemental completion of the making of a work of art in bronze. Sculptors Edward Delaney and Werner Schürmann (who was also a composer and a professional singer with a beautiful bass voice), cast the Finbarr statuettes which Séamus made for the Cork Film Festivals awards, but in latter years the Dublin Art Foundry was the principal agent of rendering into bronze, and its originator John Behan and his successor Leo Higgins cast the majority of Séamus's works, and also those portrait heads and smaller pieces made by Séamus's father-in-law which he had cast to ensure the survival of the work of Joseph Higgins who had died many years earlier at the age of forty.

All the large statues and many of the smaller ones were carved direct in stone, but when he made a portrait head in stone the plaster cast acted as a template and its contours were transposed by a three-dimensional mapping process followed by fine detailing and finishing to bring the likeness and spirit of the sitter to its final form. The carving, of course, was not a mechanised process: it was done entirely by hand, and variations from the plaster cast could be made at every stage. His portraits in marble, sandstone, Portland stone and limestone have a matte finish, unlike the highly glazed appearance of some of the statues. Even the 'heroic' size (heroic indicates that a work is larger than life, in this case 104 cm high) of the Michael Collins, now in Dublin City Gallery – the Hugh Lane, has its plaster cast 'template', which was also used for the bronze now in FitzGerald Park. The original commission for a religious work had been cancelled when the block of Carrara marble was en route from Italy, and Séamus took the opportunity to make a head of Collins, who he admired for his looks and for his energy, though he accepted commissions from almost any source, and made two heads of de Valera. In 1956, eight years after its completion, the Collins was bought for the nation by public subscription, initiated by President Seán T O'Kelly, as a gesture of reconciliation when the memory of the civil war was still potent. This symbolism pleased the many friends and supporters who had contributed to the purchase. It was also a relief to at last be paid for this very large work whose material costs he had borne for so long.

At a time when the Catholic Church was still an impor-

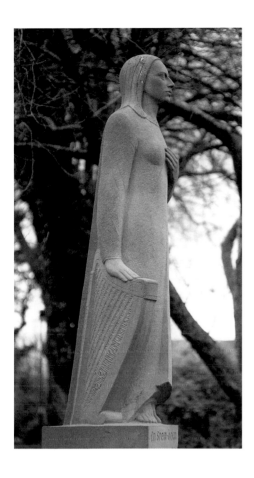

*An Spéir-Bhean
(Kerry Poets
Memorial)*
n.d., limestone,
183 cm h
(Killarney, Co Kerry)

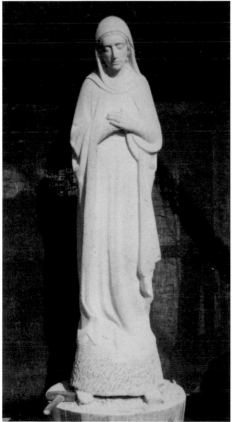

Mother of Sorrows
[or *Virgin of the
Sorrows*]
1938, limestone,
163 cm h
(Ursuline Convent,
Ballytruckle Road,
Waterford)

tant patron, it is remarkable that Séamus, when he had the choice, looked outside of the religious art with which, inevitably, his work is linked. Once, when asked which of his statues was his favourite, he chose the *spéirbhean*, the mythological Muse of poets, whose limestone figure celebrates the Kerry Poets in Killarney. And even if the Bishop of Cork was unable to see any merit in the work of Irish artists when he built a 'rosary' of churches in the 1950s (*The Virgin of the Twilight* remained a darkly gleaming fixture in the studio for over twenty years until it was bought by subscription, organised in 1960 by the Sculpture Park Committee, for the people of Cork, stipulating that it never be placed in any church), others were more enlightened: twelve apostles and *St Brighid* found their way to San Francisco in the late 1940s, *St Patrick* to Minnesota in 1952, and closer to home and to official censure, the Drishane nuns commissioned a limestone statue of the Virgin for their convent at Millstreet, Co Cork (1954); a Madonna and Child in Portland stone was erected at the Bons Secours Hospital in Cork (1958); and the Ursuline nuns in Waterford still treasure their *Virgin of the Sorrows*, which was completed in 1938. It is impossible not to guess that its extreme simplicity of line and discreet grace were expressive of his own sorrow at the death of his mother the year before. A polished limestone, *Madonna and Child* (1939) eventually found a place in the Church of the Holy Family, Military Hill, Cork, bought by the parish priest at the instigation of a parishioner, Frances O'Higgins. The courage of all these people must be admired: they too had to live in a city where the poverty of spirit of a powerful bishop had practical consequences. Séamus's letter to the bishop enquiring if he should emigrate with his wife and family went unanswered, and thus he was one of the few artists and the only sculptor who stayed in Cork and made a living solely through his work. He never taught, or engaged in work unrelated to sculpture or architecture, and though he welcomed students at the yard, his appointment as professor of sculpture at the Royal Hibernian Academy (RHA) was titular.

Another life was possible. He was offered a job working in York on the 'unfinished Cathedral', as it is sometimes unkindly called. Had his local attachment been less profound, he might have spent the rest of his life high above the Foss and the Ouse doing battle with York stone, coaxing it, learning its nuances and flaws. It is pleasant to speculate who might now thrust a gargoyle face from the tower of York Minster if he had accepted the rejection of *The Virgin of the Twilight*, which had been, on its first appearance in 1942 at the RHA, acclaimed both by his fellow artists (among them Patrick Hennessy, Mainie Jellett, Seán Ó Faoláin, Francis McManus) and by the critics,

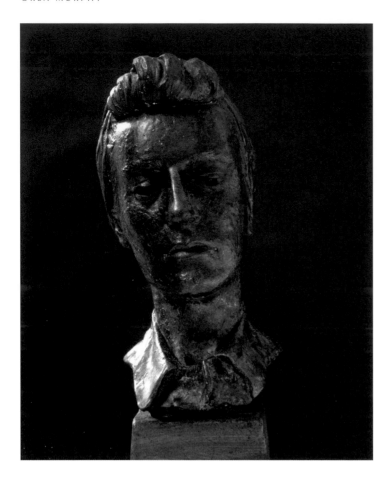

and later described by Oisín Kelly as 'the most important carving made in Ireland this century'.[4] He remained in Ireland because the support of friends and of his wife enabled him to stay. Though he used to joke that he married Maighréad because she knew how to cook cabbage, he was grateful for her other talents. She taught painting for fifty years (*painting*, they insisted, saying that art could not be taught), sometimes in two schools, designed posters for commercial artists, reviewed detective fiction for the *Irish Press*, illustrated books (among them a music book with Geraldine Neeson and a children's book *An Choill Beo* by Eilís Dillon), and even on one financially hard-pressed occasion (he was frequently ill, and spent weeks, sometimes months in hospital almost every year), typed the manuscript of a novel for Dillon. Had Maighréad not put her talents and energy at the service of his work, Séamus – and, by obvious extension, the family – would not have survived. He discussed every piece of work with her, and from the start her opinion was vital to him. One of his earliest gifts to her was a book inscribed: 'To Maigread because we agree on the importance of good lettering.' The fact that her work was an essential part of the foundation of his gratified, but did not surprise him: a wife was an equal, without the acclaim.

Children were dear to him, whether his own, his brothers' or his friends. All were beings with whom he empathised. He knew how to play, and the arrival of a son, Colm, when Séamus was 52, extended the world of football and adventure into the later years of his life. The severe face that sometimes is glimpsed in photographs was never seen at home, and discipline was confined to very mild rebuke or well-feigned amazement. The thoroughness with which he recorded his family in stone and bronze seemed unremarkable, just an intermittent part of our lives. Perhaps it derived from that same sense of purpose that caused him to write *Stone Mad*, a narrative of the lives of others – not an autobiography, more a history told from the inside. It was his friend Seán Hendrick who suggested that he assemble his accounts of the stonecarvers in book form. Seán it was who edited *Stone Mad*, and it is dedicated to him. The voice of *Stone Mad* is, in the descriptions of the camaraderie of the yard, an accumulation of the voices of the stonies rather than the one that we heard at home. He spoke of the book as a work of documentation rather than art or autobiography, and in those passages where he gives meticulous accounts of technique, the tone is neither that of the stonies nor of the person we knew, being more formal – the result of a determination to achieve precision. When we see old churchyards with their gently listing tombstones, it is a sight, perhaps, romantic or sentimental – the long grasses waving, the wild flowers, the stooping trees, the inclination of the monuments themselves towards the earth, as if in some vague way gravity and mortality conspire to make even those attempts at marking the spot subject to decline. On holidays in the west of Ireland, we spent many sunny hours among the warm lichened stones of forgotten graveyards. But Séamus was more practical, and in one short paragraph in *Stone Mad* he gives a guide to the laying of foundations which will ensure that the stone stays upright. The Seán Ó Mórdha film is the closest record we now have of him speaking at his most thoughtful and expressive.[5] It was the subtlety of the director that allowed Séamus (always self-conscious before recording equipment) to forget the paraphernalia of film and communicate his thoughts in a natural and unforced way. It also shows him to be, as he always was, the most receptive and courteous of listeners.

Elsewhere he describes the correct way to sharpen chisels. He had his own anvil and tongs. The fire of coke was heated in a metal barrel until it turned red, the chisel was wedged into the coke until it too reddened, then dipped straight into a tin of water, rubbed quickly on sandstone, then dipped again. The heat, the hissing of the chisel boiling the water at its mere touch, the tapping with a hammer on the anvil, itself like a

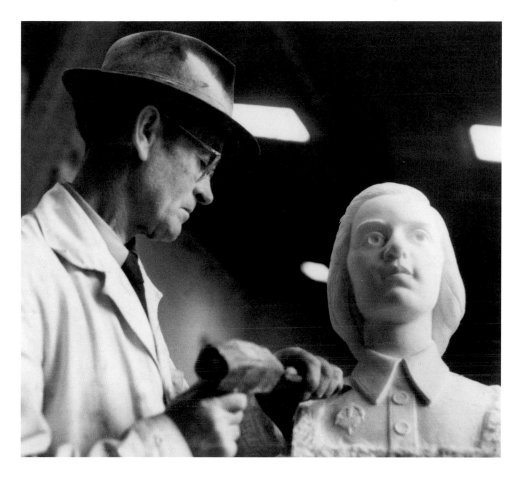

Robert Gibbings (1889-1958)
Mallet and chisel, n.d., ink on paper

SM working on *Orla at 8*
1956, white marble, 45.5 cm h

opposite

Maighréad
1945, bronze, 50 cm h

sculpture of a stern-profiled knight, all had a dangerous magic. And then the little chisel, almost consumed by his hand, would glid through stone, leaving only white powder in its V-shaped wake. Oh it looked so easy, the taming of one element by another, where the chink chink of the chisel sounded the refrain in a game of merry craft over solid mass. And when the inscription was finished he would paint it with oil paint of an earth-red colour, saying that that colour showed the depths of the carving better than black, and made the work more distinctively his. Using an ordinary brush he quickly covered each line of inscription with paint, blurring all the words to invisibility. When the paint was dry he rubbed the whole surface briskly with a soft stone, then flushed away the detritus of paint with a generous dash of cold water. The letters then shone with a sharp crisp edge, as though each had been painted individually with the finest of brushes and laborious care.

Speed and skill made sculpting a lively process, and the constant use and careful conditioning of tools until they looked as though they had grown out of their elements rather than themselves been cast or carved were a history lesson without words. But that is in retrospect as one tries to draw together occasional moments from the past. What stands out, perhaps

because it really did seem like a toy, was the fiddle-drill. This instrument (it had to be medieval, surely) consisted of an awl and a bow. The narrow leather thong of the bow had to be wrapped around the shaft of the drill and pulled taut. The drill was held vertical on the stone and the bow pulled back and forth on the horizontal to drive the point of the drill down. In a few strokes, a little hole, neat and circular, was delved from the stone. Suddenly the spell was revealed: anyone could be a sculptor. But Séamus never used the fiddle-drill, preferring the instant results he could gain with chisel and hammer to perfect a full-stop, an eye on a snake or a pattern of dots as textural decoration. The carved statues retained their magic, the sheer slog and sheer imagination that produced them remained a thing of mystery and wonder.

Clay was easier – warm, smooth and malleable. He put an apple-sized lump on the wooden table in the studio and patiently watched as we tinkered, offering spatulas or scrapers and encouragement. We could remember how it was done; we had seen it at home during those long summer evenings. It must have been summer as the attic where he shaped our skulls or recreated us was unheated. A kitchen chair was placed on the low square platform of unpainted wood under the light from the

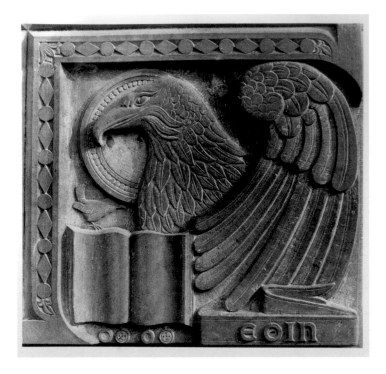

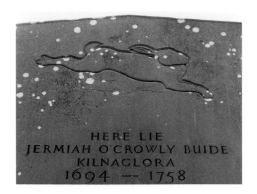

Four Evangelists
1955, 4 limestone
panels, 196 x 173 cm
(Church of Our Lady
& St John, Carrigaline,
Co Cork)

Jermiah O'Crowly
limestone headstone,
238 x 95 cm
(Waterfall graveyard,
Co Cork)

Edward Conor O'Brien
limestone tablet,
53 x 84 cm
(former Church of
Ireland, Foynes)

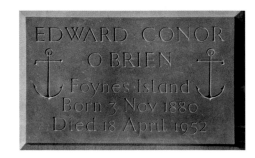

north-facing skylight. The tripod's revolving platform was topped by a loop of lead on which he had stuck several fistfuls of clay to make a humanoid shape, grey and featureless. There was talk, but there must also have been silence because we could hear the army band, this time practising marches in the barrack square. There weren't many sittings, there was not time to become restless, and there was no sense of close scrutiny. He stood about four feet away, with his back to the light, and held a lump of clay in his left hand, asking questions about school or music or anything he knew to be of interest, as he added small pieces to the work. It was a short interlude of sensations – intermittent sounds of the band, small movements of the platform as he turned it slightly left or right for comparison and the cool touch of the callipers ear to ear, the tip of the nose to the back of the head, forehead to chin as he checked dimensions. The surface was built up with tiny pieces of clay, rolled between finger and thumb, and then pressed on with the most elegant of all the tools, a wooden spatula, double-ended, slender and light, polished with age and use. He didn't seem to need either stillness or silence. Interruptions never bothered him. He concentrated all of his effort on the head itself, but took care over detail – a bow in Bébhinn's hair or a Cork brooch below the collar for me, saying that the Cork brooch was like the Tara brooch but that the pin was placed vertically.

At last, when the light started to wane and the clay head was wrapped in wet towels, he washed his hands and went down the four flights of stairs to the living room to work on a drawing or, at last, to read. Reading was, after sculpture, perhaps his second greatest passion. History, biography, poetry – the bookcases were constantly being added to, and room made for more by the lending of books to visitors with the phrase, 'you must read this'. He particularly loved poetry. Kavanagh, Yeats, Kinsella and Montague were perennials, and then one day he arrived home waving the green and pink cover of *Death of a Naturalist* and turned the familiar enthusiasm on all of us saying 'you must read this'. What he especially loved about Heaney was a sense that history was so close that it was sometimes literally underfoot, that the poems were complex but not obscure, and that they and the man himself embodied connections that lived and made passionate enquiry of our lives and attitudes.

He had less interest in fiction, though Gogol, Tolstoy and *Tristram Shandy* found a permanent place on the shelves, but he mainly read living writers, people he knew – Benedict Kiely, Maurice Walsh, Eilís Dillon and Elizabeth Bowen, whose *The Last September* was his favourite of her novels, perhaps because she too connected history and place with such exactitude. Books on art and architecture were acquired for reference or for their beauty, like the Robert Gibbings travel series and EA Poe stories illustrated by Harry Clarke. Commissions led to research, especially in folklore and history. David Thompson and GE Evans' *The Leaping Hare* provided illustrations from 1500BC Egypt to nineteenth-century Ireland, together with myths from all over the world. In it he read that the hare in

China was believed to be a symbol of resurrection, and so, unusual at it might seem in this country, it appears on a gravestone where it can be seen running from its many enemies and from mortality. He returned again and again to Aesop's fables; a delay in the collection of the *Four Evangelists* panels for Carrigaline church enabled him to include a small bestiary of pre-Christian symbolism. Tickner Edwards *The Lore of the Honeybee* and Napoleonic imagery were trawled during the making of the hive that forms the base for his statue of Gobnait, though in the end it was the worker bee that he chose. The salmon he carved several times, as much for its perfect shape (such a thing of joy for carvers and designers always) as for its central place in mythology and, at that time, in ordinary life; the neat fit of its curve on the *florin* coin (common in the pre-decimalisation era) delighted him. Nature, with its patterns of mystery, ingenuity and surprise, was a constant pleasure. His family lived on the cusp of city and country, and he could identify birds in the hedgerows by their song as easily as the quarries from which the carved stones on Cork' buildings came.

The books he read to us at bedtime were tales of natural history. Sunday walks to Ballyvolane to visit our cousins often extended out to Gouldings Glen and the fields beyond to collect wild flowers, which were examined closely for shape, colour and natural symmetry. Even while he was educating us so pleasantly he was doing research for his own work: the carving of *prima rosa* is the symbol on a child's gravestone in north Cork. The wild rose he selected for the tombstone of his friend Seán Hendrick, with whom he shared many interests, from politics to literature and, less well-known, a belief that children should be introduced to the beauty of the countryside through games of identification.

The sea he regarded with much more circumspection. Visits to islands were a huge adventure, but after six weeks marooned by bad weather on Aran Mór, he was very cautious. Eyeing the landing point at Rathlin O'Birne, Co Donegal, as the small boat rose and fell on an eight-foot swell, we could understand his relief when we gained the solid cut steps. But he had hours of pleasure in researching the perfect anchor to embellish the plaque for Conor O'Brien and in O'Brien's adventures through the pages of his books on ocean voyages.

Travel outside of Ireland was, as it was for most people then, an impossibility. After his year in Paris in 1932, Séamus made only one more visit to Europe, and that was a few days spent in Rome, after which, he said, he felt for a time despondent because 'it had all been done'. *Ionia*, Freya Stark's 1954 book, gives an idea of a place where nature, architecture, history, mythology and the practicalities of a sculptor's daily work were more integrated – the temples and amphitheatres, even in ruin, still magnificent in their settings, their use and beauty in perfect companionship. And underneath all, of course, the foundation of all things natural and man-made – the stone. As he and Maighréad read their books, they could hear far below in the tunnel of sandstone and limestone, the late train making its way through north Cork to Dublin and to the world beyond.

Orla Murphy is a writer whose work has been published and broadcast in Ireland and abroad. Her book, *The Sway of Winter,* was published by Lilliput Press in 2002, and she was editor of *Joseph Higgins 1885-1925 – Sculptor and Painter* (2005). She is a daughter of Séamus Murphy and a granddaughter of Joseph Higgins.

ENDNOTES

[1] Thomas Kinsella, 'Personal Places', *Peppercanister*, no. 14, 1990

[2] Orla Murphy (ed.), *Joseph Higgins 1885-1925 – Sculptor and Painter* (Cork Public Museum / Gandon Editions, Kinsale, 2005)

[3] Seán Ó Mórdha, *Stone Mad – A Portrait of Séamus Murphy* for *Anthology* series (RTÉ, 1969)

[4] Oisín Kelly, 'Allegorical Figures and Madonnas' in Bébhinn Marten (ed.), *Séamus Murphy 1907-1975* (Cork, 1982) pp.15-21

[5] Ó Mórdha, *Stone Mad – A Portrait*

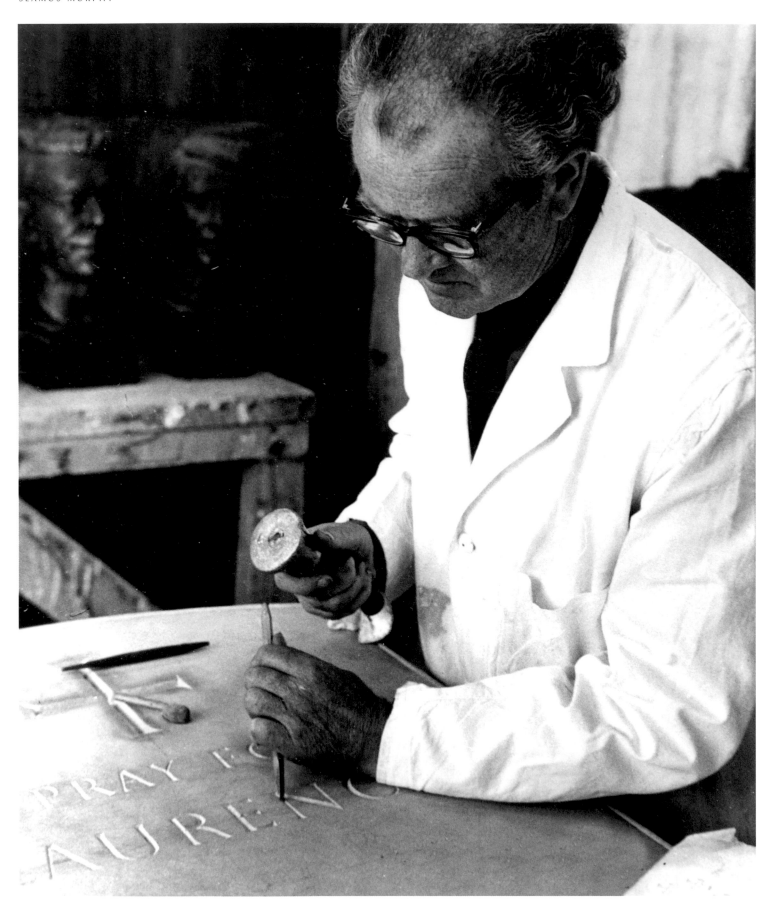

Letter Carving

SÉAMUS MURPHY

FEW PEOPLE REALISE THE IMPORTANCE OF GOOD LETTERING IN MONUMENT design, and our cemeteries reveal many instances of past lack of appreciation of the possibilities of lettering. On the majority of stock monuments the addition of letters has either detracted from or not improved the design. The name in most cases has been mis-placed, or is out of scale, being generally too large. It would appear that the majority of stock monuments are complete in their design without letters, and intended to give a good impression when sold in blank. Comparatively few are made with the idea that the design will be improved by the inscription.

From the practical view-point, one would imagine that the mon-umental masons would insist on good lettering. Apart from its artistic value, it should be considered from its importance as a business propo-sition. There must, of course, be some sort of lettering, and a discrimi-nating buyer can be sold more easily a design with a refined inscription; and a thing to be remembered is that a fine piece of lettering will elim-inate the cost of more expensive ornament.

Unlike lettering produced by mechanical processes, the work of the craftsman is individual in the sense of its interpretation. In the arrangement he is free to choose the lay-out most suited to each particular piece of work. The type of word composi-tion adopted – which is the personal contribution of each craftsman – directly affects the style of interpretation. This individuality has wider possibilities than lettering of a purely practical nature, because it is through this same individuality that the finest qualities in lettering can be conveyed. Evenly spaced lettering is often difficult to read, and that which is devoid of a sense of composition in words and passages is necessarily even more difficult. Moreover, emphasis in movement from left to right has to be stressed in the composition of words to facilitate reading. An example of what I mean can be seen at St Finbarr's Cathedral, Cork. Anyone interested in good lettering should see The Heroes Column in this church. There you have Roman letters designed by the late George Jacks and cut with care and delicacy by William Donoghue. The whole lay-out of the inscription shows a fine sense of spacing. The letters are cut on Johnstown Puce marble with a surrounding moulding of dove.

The Roman is the best general-purpose letter. A fine example is given in the accompanying illustration of the slate

George Jacks / William Donoghue
The Heroes Column
(St Fin Barre's Cathedral, Cork)

The Heroes Column, detail of carved lettering
(St Fin Barre's Cathedral, Cork)

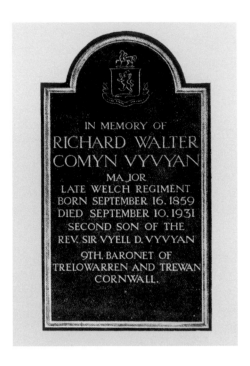

an A B C
DEFGHIJKL
abcdefghijklmnopqr
MNOPQRST
stuvwxyz 123456789
UVWXY & Z

Eric Gill (1882-1940)
Roman alphabet cut on Hopton Wood stone

Major Richard Walter Comyn Vyvyan
slate headstone
(St Fin Barre's Cathedral, Cork)

headstone of Major Vyvyan. The Roman is composed of two weights of lines, corresponding to the down-stroke and the up-stroke of the broad reed pen with which it was originally written. From this can be formulated a rule which will prevent the inexcusable fault of shading a letter incorrectly. With twenty centuries of established form as precedent, it is as bad, from the standpoint of design, to shade a letter on the wrong stroke as it would be to mis-spell the word in which it occurs. All horizontal strokes are light, and all vertical strokes are heavy except in the case of letters M, N, and V. In these letters and in all letters with slanting lines, trace the shape of the letter from left to right: all the up-strokes are light, and the down-strokes heavy. The second illustration shows a Roman alphabet cut on Hopton Wood stone by the late Eric Gill. I corresponded with him on monument letter-forms and he considered this the best type for that purpose.

The beauty of Roman letters depends to a great extent upon the serifs and spurs which terminate every free end. These originated, no doubt, with the stone-cutters who made the chisel-cut at the extremities wider than the stroke of the letter to prevent over-cutting, and to emphasise the shadow at the end, and were then copied by the penmen because of the finished appearance they gave the letters.

Hand-cut incised letters are practically always V-cut, and in good work the depth should be equal to the width of the body-stroke. The practice of cheapening work by using a shallow gouge is to be seen everywhere. Such lettering, especially on coarse-grained limestone, is impossible to read in some lights, and is gone for good after a few years. In letter-cutting on stone, it is a distinct advantage to work in situ whenever the occasion permits it. If this is done the scale, weight and effects of the light can be better considered than when the work is completed in the workshop. It is also possible for the general features bearing on legibility to be stressed effectively.

The Roman lower-case (illustrated in the Eric Gill stone, i.e. the smaller letters) is an important type for anyone interested in inscription-work. The Classic forms of the old Roman consist of capitals only, and in design calling for stateliness of composition,

capitals should be hard to read: we read words by their word-shapes, distinguishing a whole word or even a group of words at a glance, and are accustomed to these shapes in lower-case letter combination in which the ascending and descending letters give the variety of form to the words. If this page, for instance, were set out in capitals, the words would literally have to be spelled out by the reader, and it would be so tiring that all the pleasure of reading would be lost. Whereas set as it is in lower-case letters (apart from 'capital' letters), the reader has probably up to this point not noticed the style or the shapes of the letters forming the words he is reading.

There are two reasons why lower-case letters are not used much in monument design. First, the Roman capitals have more dignity and formality: consequently they fit in the formal style demanded by the monument, and since the usual inscription consists of only a few words the ease of reading is not a factor. Second, the lower-case is more difficult to cut as most letters are made up of curved lines. The place for lower-case is obviously not for names or headings, but for secondary inscriptions, quotations, or epitaphs, where ease of reading is the important consideration. One need only recall one such work done in block letters, clumsy and hard to read, to appreciate the advantages of lower-case.

Good letter-cutting is an exacting art: the drawing of the Roman letter is almost as subtle an art as the drawing of the human figure, and the width of a line one way or the other will improve or injure it. If the chisels are stiff the edge of the letter will be ragged, and then in paring down one is apt to get the body stroke too wide. The best way I find of avoiding that danger is to mark in the letters exactly, and then chop them in with a sharp (splinter) chisel, a little inside the actual line. The next thing I do is to rub the face of the stone with some lamp-black on a piece of wet rag; this darkens the face of the stone. Then I can start to cut the letters. The parts which the chisel cuts then appear grey compared to the face of the stone, all of which is a great help to keep the letters straight and in their right proportion.

But the first essential is a good eye, since the letters must be cut directly if they are to look sharp and crisp. In sum, anyone can cut an inscription that can be read. To make it beautiful as well as legible requires artistic perception and an intimate knowledge of letter forms.

———

This article originally appeared as 'Letter Cutting' in *The Bell*, vol. 7, Feb 1944. Reprinted here from *The Cork Review*, no. 4 (Triskel Arts Centre, Cork, 1980) – a special issue devoted entirely to the life, work and times of Séamus Murphy, edited by Paul Durcan.

Stone Carver

KEN THOMPSON

SÉAMUS MURPHY WAS PRIMARILY A STONECARVER AND LETTER CUTTER. THIS IS OFTEN FORgotten when one considers that he has made bronze heads of practically every eminent Irishman of his day. His early talent for clay modelling developed alongside his much more crucial carving apprenticeship, which he describes so vividly in *Stone Mad*. This latter training in the stoneyard had a profound spiritual effect on his development. Apart from many essential skills, his training and discipline with the 'stonies' gave him a sensitivity to material, a relationship to tools and concern for quality that he never lost. It also gave him a serious and workmanlike approach to the business of making things, and provided him with an identity and genuine culture; thereafter his language and humour was that of the stoneyard, not that of the sculptor's modelling studio.

Séamus Murphy belonged to the centuries-old tradition of stone sculptors, to a tradition where artists (or artisans, there was little distinction) were mostly anonymous, though nonetheless good. Ironically Séamus' name will survive because he belonged to a remnant, for, like monks, stonecarvers have become a curiosity! The highly skilled and creative stonecarvers have metamorphosised over the years into either busy machinists or rarefied sculptors whose work is sold in art galleries. Séamus' work was almost always commissioned and he lived entirely from his work as a sculptor. This helps to explain the extraordinary number of friendships he made.

His work brought him into contact with all strata of society. The professional,

Archive photos of Séamus Murphy working in his studio workshop in Blackpool, Cork, *c.*1938

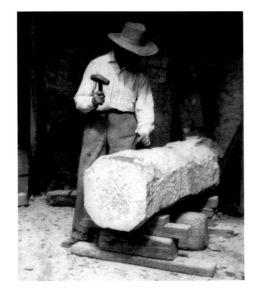 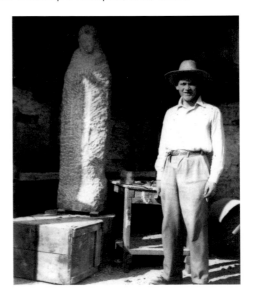

political, business and clerical world all called (though, alas, not often enough) on his services. He accepted all commissions, however humble; whether an inscription or carving on a building, a statue for a church, a tombstone, a sculpture for a private patron or a bust, all were undertaken as long as he had more or less control of the design. This traditional approach which appealed so much to Séamus and is now unfashionable in the art world is essentially a means of setting the artist free to be creative and inventive within a narrowed field, while answering a definite need on the part of the client with whom the artist establishes a fruitful relationship. It helps to establish the artist as tradesman in the economic life of the community, encourages him to keep self-indulgence from his work, while giving rein to personal exuberance and humour where appropriate.

A happy consequence of Séamus accepting commissions is the work we now see in public places throughout the country. Even the work that is less obviously in the public eye, such as his innumerable gravestones, which help to redeem our cemeteries, is not lost. It adds to our heritage and gives all the more pleasure when stumbled upon. I remember the delight on Easter Sunday last when I climbed Galtimore and found a Séamus Murphy inscription at the summit. It is precisely this disinterested passion for quality that is so inspiring in the artist: the impulse, for example, that drove the mediaeval sculptor to work lovingly and with exquisite detail on a carving to be positioned high in the cathedral where no-one would see it.

While his love for his trade was passionate, Séamus had little patience for those who idealised and sentimentalised the stonecarver's job. Indeed when I spoke once of William Golding's *The Spire* and referred to his description of the wind on the slowly ascending stone, he showed impatience and said it sounded like the exaggerations in *The Agony and the Ecstasy*. 'One wants to finish the current carving as fast as possible and begin the next', he said, and added with a smile, 'while naturally doing a better job that the man before one!' He had a wholesome sense of his own worth. His wife Maighréad tells how when asking him before he set off on a job if he had all he needed, he would assure her he had... 'and my bit of talent'!

All his life Séamus stood for values and judgements that were qualitative, and, therefore, in acute contrast to the more beastly side of our consumer society. He was never dogmatic however, for he was blessed with a delightful and compassionate sense of humour. He was a workman with pride, a craftsman with imagination and an artist without any of the tedious art nonsense we are so familiar with.

———

Reprinted from *The Cork Review*, no. 4 (Triskel Arts Centre, Cork, 1980) – a special issue devoted entirely to the life, work and times of Séamus Murphy, edited by Paul Durcan.

KEN THOMPSON is a sculptor working mostly in stone but also in wood and bronze. He lives and works in Ballycotton, Co Cork.

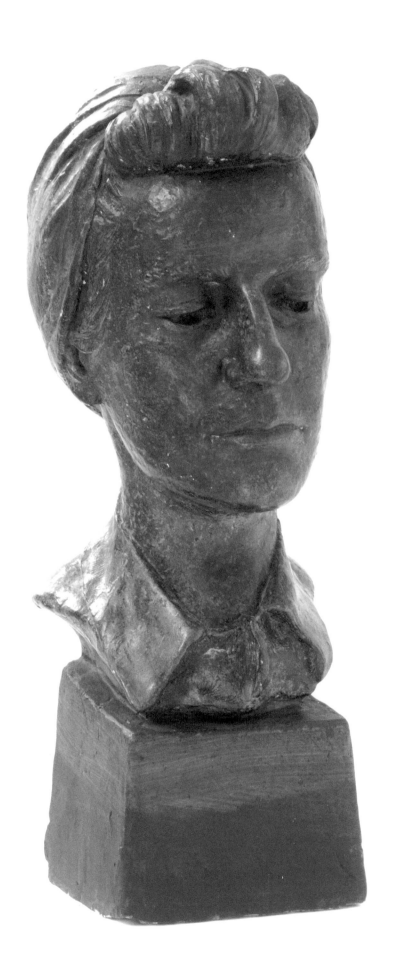

Maighréad [sculptor's wife] 1945, bronze, 50 cm h

Maighréad [bean an dealbhóir] 1945, dealbh chré-uamha, 50 cm ard

Séamus Murphy
Clochadóir nua-aoiseach Chorcaí

GEARÓID Ó CRUALAOICH

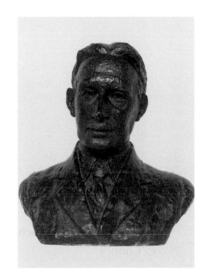

GLACTAR COITIANTA LEIS GUR MÍNIÚ AR SHÉAMUS MURPHY AGUS AR A SHAOTHAR IS ea gur tháinig sé faoi anáil Dhomhnall Uí Chorcora le linn dó dul ar scoil agus gur oileadh é ina shaor cloiche go ceann seacht mbliana ina dhiaidh sin. Cinnte tá tábhacht ag baint leis an dá rud san i scéal Shéamuis ach ní leor iad in aon chor iontu féin chun an fear álainn agus a éifeacht iontach a thuiscint. Is féidir a rá fiú, gur rudaí dromplacha tionóisciúla ab ea iad suas leis an éirimiúlacht aigne agus an luathlámhas ealíona a tháinig chun cinn ann agus a chuaigh i bhfeidhm chomh mór san ar a cháirde agus ar a chathair. I mbliain seo an chéid aige caithimíd a bheith ag súil go raghaidh an scéal amach ó Chorcaigh go raibh anso againne, faoi cheilt, geall leis, pearsa mhór ealaíona agus cultúir a raibh agus a bhfuil tábhacht thar na beartaibh lenar dhein sé maidir le féiniúlacht a mhuintire a chruthú, a chaomhnú agus a chosaint – i bhfocail agus i ngníomh – agus a shaothrú go follasach agus go flúirseach ar bhonn a ard-acmhainne cruthaithí fhéin.

Mar ómós dó agus mar iarracht ar mhéadú beag a chur lenár dtuiscint ar a raibh i gceist ag Seán Ó Ríordáin, file, nuair a scríobh seisean mar gheall ar Shéamus san *Irish Times* cúpla lá tar éis a bháis gur thug sé 'seirbhís mhór', is mian liom plé a dhéanamh san alt seo ar Shéamus Murphy faoi na cinn teidil seo a leanas:

a) an garsún a cuireadh le ceird agus a tháinig in inmhe mar ealaíontóir
b) an t-ealaíontóir a chaith dul ar a phá lae ag snoíodóireacht sa reilg
c) an saoi ar eagna agus ar chleacht a riailigh i bPálás na beatha laethúil

———

a) Rugadh Séamus Murphy i naoi déag is a seacht láimh le Mala agus ba de shliocht feirmeoireachta a briseadh as a bhfeirm dá athair – cé go raibh 'Long Jim' ag obair mar thiománaí traenach le linn don teaghlach bheith ina gcónaí ar imeall na cathrach ó thuaidh. Dhearbhaigh Eilís Dillon go raibh Séamus an-bhródúil as sinsir leis ó thaobh na máthar a shaothraigh sna coiréil in Inis Mhic Néill (Little Island). Bhí ceathrar deirfiúr aige a d'éag go hóg leis an diftéire agus dearthár leis (de cheathrar acu san leis) a maraíodh i dtimpist. Ní foláir nó d'fhág na rudaí seo go léir rian air ina chroí istigh. Chuir sé féin in iúl don Diolliúnach gurbh é an chéad saothar ealaíona gur thug sé féin faoi ná iarracht a dhein sé, agus é ina gharsún beag i dteaghlach garsún, culaith éadaigh a cheapadh le haghaidh bábóige. Leanbh cruthaitheach goilliúnach ní foláir a chuaigh ar scoil chuig Scoil Náisiúnta Naomh Pádraig mar a raibh Domhnall Ó

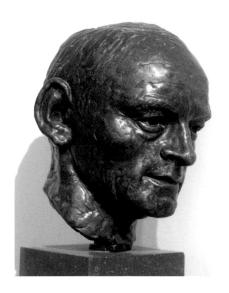

Seán Ó Ríordáin
1957, dealbh chré-
uamha, ar nós na
beatha

Seán Ó Ríordáin
1957, bronze,
life-size
(University College
Cork)

Corcora ar dhuine den bhfoireann múinteoireachta.

Cuirtear i leith an Chorcoraigh go raibh sé ar an intleachtóir ba chumasaí díobh siúd ar fad a chreid i bhfís fhorógra na Cásca agus in aisling Chonradh na Gaeilge.[1] Chuaigh sé i bhfeidhm go rí-láidir orthu siúd a tháinig faoina svae – go háirithe lucht litríochta ar nós Sheán Ó Faoláin agus Frank O'Connor, Donnchadha Ó Céilleachair agus Seán Ó Tuama. Cuimhnigh ar an gcúntas ag Frank O'Connor faoin bhfear beag bacach ag scríobh 'Múscail do mhisneach, a Bhanba' ar chlárdubh na scoile an chéad lá riamh gur tuigeadh don gConchubharach go raibh a leithéid de rud agus Gaeilge in aon chor ann. Ag féachaint siar dó na blianta fada i ndiaidh laethanta na scoile dúirt Séamus Murphy ina thaobh: *'I have no doubt that Daniel Corkery was the greatest single influence not only on Anglo-Irish literature but on all subjects important to Ireland since Davitt.'* [2] Mar sin féin chulaigh Frank O'Connor agus Seán Ó Faoláin go mór uaidh in imeacht aimsire – thugadar droim láimhe dhó, geall leis – ar an mbonn go mba laincis idéolaíochta orthu an dílseacht a d'éiligh sé dá leagan féin den náisiúnachas Éireannach agus dá léiriú litríochta. Agus féach go ndúirt Seán Ó Ríordáin ina thaobh: 'Ní rabhas riamh im' dheisceabal, mar mhothaíos go ndúradh leat áit éigin t'aigne a dhúnadh.' [3] Deinim amach ná raibh Séamus Murphy ina 'dheisceabal' ach chomh beag cé gurbh é an Corcorach a sheol é ar bhóthar na healaíona míne an chéad lá, d'féadfá a rá, sa mhéid is gur stiúirigh sé ar ranganna múnlóireachta na Scoile Ealaíona Crawford é agus é fós ina dhalta bunscoile. Toisc gur ag saothrú san ealaín mhín a bhí sé in ionad sa litríocht, ní raibh an laincis idéolaíochta úd ag luí chomh trom ar an Murchadhach agus a luigh sé ar leithéid Uí Fhaoláin agus O'Connor. Rud eile, bhí deis ag Séamus Murphy imeacht ó Chorcaigh agus ó Chorcorachas ar feadh tréimhse – más tréimhse an-ghairid féin a bhí ann – le linn dó bheith fós óg agus úr agus oscailte.

Cathair Victeoiriach i saol Victeoiriach, ar mhórán slí, an Corcaigh gur tógadh Séamus Murphy ann. Timpeall ar sheacht mbliana d'aois a bhí sé nuair a thosnaigh an Cogadh Mór amuigh a chuir an saol san ar tuathal. Ní raibh naoi mbliana fós aige le linn Seachtain na Cásca. Cogadh na Saoirse, le Dúbhchrónaigh, le hArm na Poblachta, le loisceadh na cathrach an tionlacan a bhí lena aistriú ón scoil náisiúnta go dtí an clós snoíodóireachta cloiche agus go dtí príntíseacht a ghairme. Samhlaítear dúinn gur le linn na hoiliúna gairme sin, le linn dó bheith ina ábhar ceardaí i mbráthaireachas na cloiche isea a snaoimeadh le chéile ann na tuiscintí ar thraidisiún agus ar chruthaitheacht a bhí le fáil aige ní hamháin ón gCorcorach ach anois ó dhomhan na healaíne agus ó dhomhan na hoibre. Ba thráthúil, agus a phríntíseacht ag druidim chun deiridh, go bhfuair sé an deis imeacht leis go Páras na Frainnce chun barr feabhais a chur ar a ghairm – agus a chur ar fhéin mar fhear óg. D'ainneoin chomh gearr agus a bhí a sheal ann agus chomh cruaidh bocht agus a bhí a shaol ann, bhlais sé den domhan mór, bhlais sé de mhílseacht agus de dhomhain na beatha – agus dhein sé tomhais dá neart féin mar dhuine agus mar cheardaí sa domhan mór milis domhain sin. Is ann a tháinig sé in inmhe mar fhear agus mar ealaíontóir. Tugann sé féin eolas dúinn ar conas gur shúigh sé isteach ann féin an bheatha phléisiúrtha agus an bheatha spioradálta ealaíne a bhí go raidhseach ar fáil timpeall air. Féadfaimíd a cheapadh gur sásaíodh é, idir chorp agus anam, ar mhodh domhain, diamhair a sheas leis an chuid eile dá shaol. Bhí aimsithe aige i bPáras – agus, níos tábhachtaí – ann féin, an leibhéal san den bheatha ar a bhfuil sámhnas le fáil laistiar nó laistíos den bhroid agus den bhfuastar. Toisc é bheith imithe chomh fada ar aghaidh ón mbuachaill beag a nocht chucu lá i gclós Uí Chonaill a chuireann ar a chumas, níos mó ná fiche bliain ina dhiaidh sin, cúntas chomh fírinneach, chomh beo, chomh gealgháiriteach san a dh'fhoillsiú ar a thréimhse mar ábhar clochadóra. Insan radharc a chruthaíonn sé dúinn ar shaol agus ar eachtraíocht lucht snoíodóireachta tá mar a bheadh saontacht bheannaithe ag baint leo go léir i dteannta leis an gcamastaíl agus leis an ngearradh. Ag sní amach as a chroí agus a shamhlaíocht féin atá cáilíocht seo *Stone Mad* dar liom agus tugann sé léiriú ar an meas a bhí aige i gcónaí ar cheardaíocht agus ar thraidisiún an chlocadóra. Bhí an meas seo ag teacht cuid éigin leis an méid a bhí le cloisint aige ó Dhomhnall Ó Corcora maidir le feabhas ceardaíochta agus ealaíona an tseanshaoil ach ba mheas é faoin am seo a bhí ag seasamh go neamhspleách aige ar thaithí

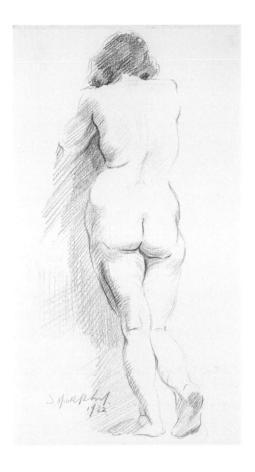

*Radharc ón gcúl
den bhaineann os
coinne falla*
1932, peann luaidhe
ar pháipéar,
32 x 19 cm

*Rear view of female
against a wall*
1932, pencil on
paper, 32 x 19 cm

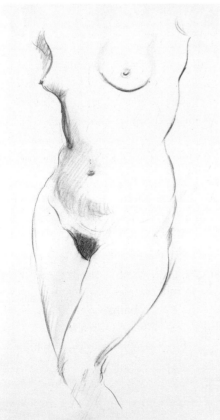

*Cabhail agus sliasta
bhaineann*
1932, peann luaidhe
dearg agus donn ar
pháipéar, 43 x 24 cm

*Female torso and
thighs*
1932, red and
brown pencil on
paper, 43 x 24 cm

saoil agus ar fhorfhás samhlaíochta agus cruthaitheachta an ealaíontóra.

Dúirt Seán Ó Ríordáin gur bhraith sé go raibh gach focal den Réamhrá a chuir Séamus le *Stone Mad* ag réiteach leis an dtuiscint a bhí ag Dómhnall Ó Corcora ar an ealaíontóir clasaiceach agus ar fhear an traidisiúin.[4] Ach thuig an Ríordánach chomh maith gur rud eile seachas so a bhí i gceist leis an leabhar féin. Mheas Seán go raibh leabhar Shéamuis glan i gcoinne feallsúnacht saolta an tsaoil agus go raibh sé chomh mór ina ionsaí ar an saoltacht san agus atá i gceist sna Ceithre Soiscéal. 'Bíonn an té a thuigeann ag gáirí agus ag déanamh meala ina chroí le linn dó an leabhar a léamh'.[5] Tá an ceart ag Seán anseo, déarfainn. Tá blas neamhshaolta, blas beag de *chommedia divina* ar talamh á leanúint; commedia ina bhfuil maithiúnas agus íocshláinte ar thaobh amháin, duthaine agus dul faoi ar an láimh eile. *'Stone cutting is finished. There's no living in it for anyone now.'*[6] Bhí cinniúint chúirteanna filíochta an *'Hidden Ireland'* roimis an clós snoíodóireachta anois. Ach bhí *'living'* eile curtha roimis fhéin ag Séamus Murphy ón lá ar fhill sé ar Chorcaigh ó Pháras – saol dealbhóra. Tá sé againn ó Mhaighréad, Bean Shéamuis, go raibh fhios aige go luath ina shaol gurb é an dealbhóireacht mian a chroí; gur chuir sé i leat-taobh uaidh líníocht na peannaireachta cloiche agus gurb é is mó a thabharfadh sásamh dó bheith ag gabháil do *'bulky four-square heads ... based on his thorough knowledge of anatomy and his feeling for solid form'.*[7]

I bPáras, deinim amach, a tháinig an bláthú tuisceanna ar a ghairm fhéin chuig Séamus Murphy – tuiscint go raibh sé dílis di chomh mór in Éirinn agus a bhí ar a chumas fir. Cúig bliana fichead a bhí sé nuair a chuaigh sé ar bord loinge don Mhór-Roinn. Timpeall an ama céanna bhí Éireannach eile tar éis triall ar Pháras chomh maith – file agus fear litríochta a thaithnigh caiféanna Montparnasse, an dúthaigh díreach chéanna den gcathair ina raibh staidéar ar an Murchadhach. George Reavey an tÉireannach eile seo agus é ina chomhaois chruinn le Séamus. Éireannach ab ea Reavey a tháinig ar an saol, ní in Impireacht na Banríona abhus, ach in Impireacht an tSáir thall mar a raibh a athair ag obair i dtionscal an línéadaigh agus é pósta le Rúiseach mná. Tá comhthreormhaireacht áirithe i luathshaol na beirte acu sa mhéid go bhfaca Reavey Éirí Amach na Rúise agus gur briseadh ar a mhuintir le linn an chogaidh chathartha a lean é. Cuireadh abhaile go hÉirinn Reavey agus d'fhreastail sé ar Ollscoil Cambridge sar ar thug sé Páras ar fhéin. Mar sin féin tá sé le rá gur le hoidhreachtaí pearsanta ina raibh cur ó dhoras na muintire agus muirtheacht sóisialta agus cultúrtha ag dul ar an saol poiblí a thángadar beirt chuig Páras.

Túr an tSeandúna
1956, scláta snasta, aolchloch,
43 x 93 cm

Shandon Tower
1956, limestone plaque,
43 x 93 cm

Is éagsúil mar ar chaitheadar a dtréimhsí i bPáras. Bhí saol an-chomhluadarach ag Revey agus é suas is anuas le pearsain mhóra litríochta – Beckett agus na filí Éireannacha Coffey, Devlin agus MacGreevy ina measc. Bhí sé féin ag cumadh filíochta agus ag foilsiú saothar liteartha dá cháirde agus dá lucht aitheantais. Áirítear gur fheidhmigh sé mar dhroichead do litríocht Bhéarla na hÉireann agus í ar a slí *avant-garde* isteach san saol Nua-Aoiseach. Dúrthas i dtaobh bheith i láthair Reavey: *'There was always the feeling that we were at the center of things.'*[8]

I gcás Shéamus Murphy de, bheifeá den dtuairim gur aonaraí go mór fada a thréimhse siúd in ard-chathair *avant-garde* na dtríochadaí. Ag faire is ag foghlaim a bhí sé de réir deallraimh. É ag faire ar an saol mór agus ar lucht ealaíona – an cineál baineann ach go háirithe! – á chaitheamh go rábach faoi gheit na samhlaíochta ealaíne. É ag foghlaim ó mháistrí agus ó mhic léinn dealbhóireachta de réir mar a bhí teacht aige orthu. Thug sé faoi ndeara an *t-avant-garde* agus an Nua-Aois timpeall air, an réabhlóid chomhfheasa agus anama a bhí ar siúl sa tsaol agus sa tsamhlaíocht ealaíne. Dhein sé a chuid féin den réabhlóid san ar a choinníollacha fhéin. Bhain adhmad as i slí a chuir bonn feallsúnachta agus praitice faoi don chuid eile dá shaol, bonn ar fhéad sé feidhmiú mar dhealbhóir agus mar ghearrthóir cloiche i dteannta. San chleachtas san aige, ar ais i gCorcaigh, d'fhan sé dílis, is dóigh liom, do luachanna na réabhlóide comhfheasa gur theaghbhaigh sé leithi i bPáras. Bhí sé féin, ó thaobh a chleachtais, agus bhí a chuid saothar i gcónaí ina dhiaidh seo ar tinneall le cruthaitheacht – ón gcuimhneachán míleata go dtí an dealbh naofa go dtí an leac ar uaigh. Iarracht ealaíonta as an nua is ea gach ceann deireannach acu go bhfuil anáil agus allus, anam agus tallann ealaíontóra ann.

Mara bhfuil teibíocht nó osréalachas ag roinnt leo tá *avant-garde* an tsean-nois ag baint leo. Ní sean-nós ceoil ná amhránaíochta ná filíochta atá anseo ach sean-nós saothraithe na cloiche – sean-nós go raibh Séamus Murphy ina rí air as a dhúchas, as a oiliúint agus as a fhreagairt don réabhlóid chomhfheasa ealaíne a bhí roimis thar lear. In Éirinn agus i gCorcaigh trí 'n a shaol amach go deireadh ina dhiaidh sin bhí sé Nua-Aoiseach ina theacht i láthair, ina mhachnamh agus ina chleacht le cloch. An úire, an bheocht, an leochaileacht, an áilleacht ealaíonta agus daonnach atá in *Dreamline* níl sé in easnamh ar aon iarracht a tháinig óna láimh, fiú nuair is líníocht na peannaireachta cloiche atá i gceist. I gcás na peannaireachta cloiche seo tá againn céird traidisiúnta an chlochadóra ag feidhmiú ar leibhéal na healaíne míne ar nós mar a fheidhmíonn an chuid is fearr de lucht láithrithe na hinsinte béil agus iad ag sroisint don leibhéal feabhais a aithnítear mar 'litríocht'.[9] Cineál seanchaíocht ábharga cloiche is ea mórán de tháirgí Shéamuis Murphy a bhfuil an ealaín bainte amach ionnta laistigh den gcoitiantacht. Dúirt John Biggs go mba eiseamláir é Séamus den *'blessed Ordinariness of which Eric Gill spoke'*,[10] agus go mba samplaí a chuid leacanna uaighe de *'some widespread school-of-art'* – ach gan a leithéid a bheith ann. Aithníonn Biggs chomh maith gur cruthú úr, as an nua, is ea gach leac acu ar nós gach dealbh dá chuid agus arís anseo táimíd ag plé le buntréithiúlacht na healaíne coitinne gur fearr aithne uirthe in Éirinn i bhfoirm na scéalaíochta; samhlaíocht agus cruthaitheacht bheo ag obair an t-am go léir san insint agus sa tsaothar laistigh d'fhuirmeacha traidisiúnta. Ní haon ionadh, dár le Biggs arís, *'that his inscriptions are always so perfectly set on each particular stone and his carved decoration always so just'*. Tuigeann Biggs ná fuil roinnt le déanamh i gcás Shéamus Murphy idir ealaíontóir agus ceardaí; gurb é an fear iomlán ann féin atá ar fáil agat le dealbh leis nó ar leac dá chuid agus gur cuid dlúth dílis den bhfear iomlán san i gcónaí an chruthaitheacht ealaíonta.

———

b) Séamus Murphy nua a tháinig ar ais go Corcaigh ó Pháras i dtreo dheireadh naoi déag tríocha agus a trí. Bhí fear déanta den ógánach: iomlánú agus domhainiú déanta ar a sheasamh sa tsaol mar dhuine, mar cheardaí agus mar ealaíontóir. Feasta bheadh sé teann as fhéin ina mheon agus ina chleacht; siúráil mhachnaimh agus siúráil láimhe ag baint leis ar gach taobh, bunaithe ar a raibh de aibíocht ann de thoradh a bhfaca sé agus a bhlais sé i gcaitheamh a thréimhse i gceann de láthaireacha móra na healaíne. Corcaigh éagsúil chomh maith an Corcaigh gur tháinig sé thar n-ais chuici – éagsúil go háirithe leis an gcathair gur fhás sé aníos innti. Bhí taoide tuille na réabhlóide tráite le fada, nimh agus traochadh an chogaidh chathartha fós

Constantin Brancusi (1876-1957)
Muse endormie
1910, ceann, cré-uamha (bronze),
18 x 27 x 19 cm
(Centre Georges Pompidou, Paris)

Séamus Murphy
Muse de chuid Brancusi
gan dáta, sceitse
Muse by Brancusi
n.d., sketch

Dreamline
1934, cloch Portland, 74 cm ard
(Páirc Mhic Gearailt, Corcaigh)
Dreamline
1934, Portland stone, 74 cm h
(Fitzgerald Park, Cork)

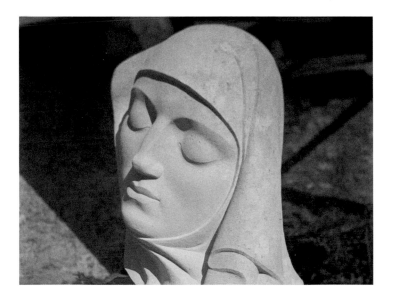

mar ualach ar an saol. Bhí rialtas nua i réim ag iarraidh feabhas a chur ar chúrsaí ó thaobh na heacnamaíochta agus misneach éigin náisiúnta a mhúscailt. Ach bhí bochtannas agus imirce go flúirseach i measc an phobail agus bhí meon cúng bocht béalchráifeach ag roinnt leis na húdaráis maidir le hoideachas agus le cúrsaí ealaíne i gcoitinne. De thoradh ar seo bhí an chathair le tréigint ag an dá scríbhneoir Ó Faoláin agus O'Connor. Ina choinnibh sin, sheas Séamus Murphy an fód.

Tugann Nancy MacCarthy an cúntas is loime ar na cúrsaí seo nuair a deir sí *'Séamus stayed and Séamus starved'*.[11] Cinnte bhí misneach neamhchoitianta laistiar den bheart aige a chlós féin a bhunú agus a oscailt i naoi déag tríocha agus a cheathair go luath tar éis dó filleadh. Cineál dushláin ar easpaí an tsaoil timpeall air is ea gur chruthaigh agus gur shaothraigh sé *Dreamline* sa bhliain sin – píosa a bhfuil macalla beo ann de mhórán den ealaín dar theagmhaigh sé leis i bPáras, ón Mheánaois go dtí Brancusi. Agus an Tarna Cogadh briste amach seacht mbliana ina dhiaidh sin, tagann uaidh an *Virgin of the Twilight* go ndúirt Oisín Kelly ina thaobh go bhféachann sé siar ar an traidisiún Hiberno-Romanesque ag an am céanna go bhféachann sé amach go *'Mestrovic in Croatia, Barlach in Germany and Epstein in England'*.[12] Mhol Arthur Power é mar *'major work of art ... the only fine religious work I have seen'*.[13]

Idir an dá shaothar san, *Dreamline* agus *Virgin of the Twilight*, d'oibrigh Séamus Murphy leis ina chlos, ag tuilleamh a bheatha tré'n a cheardúlacht a chleachtadh i mórán genres den snoíodóireacht – dealbha cráifeacha, dealbha cuimhneacháin, leaca uaighe. Má bhí súil ag leithéid Dhomhnall Uí Chorcora le saothair a léireódh féiniúlacht Ghaelach thraidisiúnta na hÉireann i dtéarmaí shiombalachas laochúil agus reiligiúnda na Meánaoise b'é fírinne an scéil é gur chaith an ceardaí ealaíontora so a bheatha a thuilleamh ar pé taobh go bhfaighfeadh sé seans. Chuir sé a chás in iúl go han-simplí agus go han-díreach do Mhaureen Fox: *'When I returned from Paris and finished my apprenticeship I set up on my own ... I thought about going to England. I know a lot of sculptors there, but the War spoiled that and after it was over things were too unsettled so I stayed here...'*[14] Deir sé léithi go bhfuair sé fostú leis an dream a raibh cúram na British War Graves orthu, fostú timpeall ar leaca uaighe a sholáthar agus a athnuachaint dóibhsan. Baineann sé seo go mór de aon tuairim rómánsúil a bheadh againn féachaint ar an Murchadhach mar ghiolla idéolaíochta ag leagan cúng de náisiúnachas culturtha an Chorcoraigh. Ach tá sé againn ó Sheán Ó Tuama gur lean Séamus ar na cáirde is dlúithe dá raibh ag Dómhnall Ó Corcora.[15] Agus ní raibh an Corcorach mall ná faillíoch ag teacht i gcabhair ar Shéamus go praiticiúil. D'órdaigh sé dó dealbh chinn dó fhéin a dhéanamh

i ndóchas go ndíolfaí é dá thairbhe agus bhí seo críochnaithe ag Séamus sa bhliain naoi déag tríocha agus a sé, an bhliain chéanna gur tháinig uaidh dealbh chinn den scoth – dealbh chinn An Táilliúra, Tadhg Ó Buachalla.

Tigh scoraíochta agus seanchaíochta ab ea tigh An Táilliúra is a bhean Ansty i nGarraí na Péice, láimh le Guagán Barra Uíbh Laoghaire, in Iarthar Chorcaí agus ba mhinic Séamus Murphy ar an gcomhluadar agus an seanchas ar siúl. Fé mar a thuigimíd go glégheal ó *Stone Mad* ina dhiaidh sin b'aoibhinn riamh le Séamus comhluadar agus cur is cúiteamh na scoraíochta agus d'fhéadfaimís fiú Garraí na Péice a shamhlú mar láthair scoraíochta a bhí ag leanúint ar aghaidh ó chlós snoíodóireachta laethannta a dhéagaibh. Tá cur síos bríomhar grinn tugtha dúinn ag Eric Cross ar dhéanamh dhealbh chinn An Táilliúra i gcaibideal a cheathair déag dá leabhar cáiliúil siúd [16] agus sa mhéid is gur píosa is ea é dealbh chinn An Táilliúra go ngéilltear dó mar scothshompla dá ndealbha cinn ar fad féadaimíd féachaint air mar léiriú eiseamlárach amháin den ealaín mhín ar fheabhas á shaothrú ag Séamus Murphy go rialta as cúinsí na coitiantachta.

Pósadh Séamus Murphy agus a bhean chéile Maighréad Higgins (iníon leis an dealbadóir Joseph Higgins) sa bhliain naoi déag daichead agus a ceathair. Go dtí seo bhí ocht gcinn de dhealbha iomlána agus fiche a trí dealbha cinn nó brád déanta aige i dteannta le hobair ar leacanna agus ar phainéil. Cuid des na dealbha níos luaithe san bhíodar ag teacht uaidh sar ar chuaigh sé go Páras in aon chor agus is fiú a thabhairt faoi ndeara – mar iontas beag – go raibh ceann des na dealbha iomlána ba luaithe uaidh (*Madonna* is ea í) déanta aige de choincréad! Ó bhliain a phósta amach bhí, gan amhras, cúram teaghlaigh agus cúraimí clainne ar Shéamus agus chaith sé an fhéith chruthaitheach den ealaín mhín a bhí ann a réiteach leis an saoirseacht chloiche a thuillfeadh tuarastal agus teacht isteach.

Tá cúntas ag Diarmuid Ó Donnabháin a léiríonn conas gur tharla do Shéamus Murphy an dá thráigh a fhreastal. Lá gur chuaigh sé ar bord bus chun dul go Droichead na Banndan tháinig sé ar Shéamus Murphy sa bhus roimis agus a ghiúirléidí snoíodóireachta ar a ghlúin aige i mála. Mhínigh Séamus dó gur ag dul siar go Drom Dhá Liag a bhí sé le litreacha a ghearradh ar leac uaighe. B'ionadh leis an Donnabhánach ealaíontóir aitheantúil, a raibh RHA lena ainm, fear deartha Eaglais na Linne Duibhe, a raibh dealbh cáiliúil dubh na Maighdinne agus dealbh 'náisiúnta' Mhichael Collins tagaithe uaidh, bheith ag snoíodóireacht ar a ghlúine sa reilig. Nuair a chuir sé an méid sin in iúl do Shéamus isé freagra fuair sé: *'Renown doesn't buy bread and butter, but headstones do.'* [17] Tá clárú ar chéad go

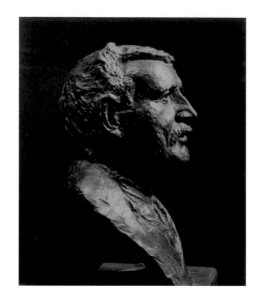

An Táilliúir (Tadhg Ó Búachalla) 1936, dealbh chré-uamha, 43 cm ard (AIB; Oif. Oib. Poiblí: Farmleigh)

The Tailor (Tadhg Ó Búachalla) 1936, bronze, 43 cm h (AIB; OPW / Farmleigh House)

Madraí 1950, umar uisce na ngadhar, aolchloch, 12 x 61 cm (Stráid Pádraig, Corcaigh)

Madraí 1950, limestone drinking trough, 12 x 61 cm (Patrick Street, Cork)

leith díobh ar a laghad óna láimh. Níor dhá thráigh éagsúla in aon chor ag Séamus Murphy an cheardaíocht choitinn, shíorraí chloiche agus an dealbhóireacht chruthaitheach. Chleacht sé iad araon go dílis agus go réidh mar aon ghairm aontaithe amháin.

I gcaitheamh na ndeich mbliana idir an bhliain a phós sé agus an bhliain gur dhein ball iomlán den RHA de, aon cheann déag de dhealbha iomlána agus sé cinn déag de dhealbha cinn agus brád a tháinig uaidh. Ina dhiaidh sin, idir naoi déag caoga is a ceathair agus an bhliain go bhfuair sé bás níor tháinig uaidh ach trí cinn de dhealbha iomlána ach tháinig timpeall ar ocht is trí scór de dhealbha cinn agus brád. Ortha san, is ceart a thabhairt faoi ndeara, tá saothair gur thug Séamus fúthu ní toisc go raibh commisiún aige dóibh ach toisc go raibh sé gan obair ag an am agus gur mheas sé go raibh gá ó thaobh staire agus oidhreachta leo. Is é tuairim Mhaighréad Murphy bean Shéamuis é, go bhfuil roinnt des na dealbha cinn is fearr dár tháinig uaidh ina measc siúd – *'done to keep himself occupied'.* [18] B'ionann bheith beo do Shéamus Murphy agus bheith ag clochadóireacht. B'í gairm a anama í agus roinn sé go fial toradh cruthaitheach ealaíonta na gairme sin ar an saol agus ar an bpobal timpeall air. Bhí sé go speisialta ceanúil ar an taobh

dúchais Ghaelach de thraidisiúin agus de chultúr na hÉireann agus thug sé sásamh ar leith dhó a cheird a imirt ar mhaithe le gnéithe Gaelacha den dúchas agus den chultúr san a chommoradh e.g. Naomh Gobnait, Seán Clárach Mac Domhnaill, Tomás Ó Criomhthainn, Seán Ó Riada. Níor lú é, áfach, a dhíograis maidir le ceardúlacht na healaíne timpeall ar shaothair 'bheaga', 'neafuiseacha' eile ar nós Eilifint Elvery's nó Umar Uisce na nGadhar.

Fear ab ea é ná raibh aon teorainn lena shuím sa bheatha go hiomlán ná lena bháidh le créatúirí an tsaoil, ard is íseal. Chuir sé é féin ar fáil, mar fhear agus mar ealaíontóir, mar oibrí agus mar intleachtóir i slí iontach gur deacair a shamhailt a fháil.

————

c) I gcaitheamh an dá scór bliain ó d'oscail Séamus Murphy a chlós féin sa Linn Dubh go lá a bháis, chuir sé a thallann snoíodóireachta ar fáil go hoscailte agus go fial don uile shórt, ón Stáit agus ón Eaglais anuas go dtí an teaghlach agus an duine aonair. Ar feadh tréimhse i ndiaidh an Tarna Cogadh is aige a bhí an t-aon ghnó gairmiúil dealbhóireachta in Éirinn agus thánathas chuige as gach earnáil den saol. Ní móide gur chuir sé éinne ó dhoras agus bhí sé chomh sásta saothrú i gcomhpháirt le húdaráis na hEaglaise ag glóiriú Dé agus a bhí sé saothrú i gcomhpháirt le Poblachtaigh agus iad ag glóiriú na gaiscíochta míleata. Tá piosaí eile uaidh ag glóiriú na tionsclaíochta ar thaobh amháin agus ag glóiriú saol tíosaigh na cistine ar an dtaobh eile. Tá leaca uaighe agus leaca cuimhneacháin déanta aige do gach cineál, ón duine príobháideach go dtí an phearsa nótálta i gcúrsaí spóirt nó i gcúrsaí polaitíochta. Is fíor le rá, áfach, is dóigh liom, go raibh sé féin saor ón bpairtíonacht le dream ar bith i gcúrsaí creidimh nó polaitíochta. As a óige, deallraíonn sé go raibh neamhspleáchas ciúin, cinnte ag baint leis agus i gcaitheamh a shaoil labhair sé amach ar bhonn a thuairimí féin ar gach ábhar – tuairimí a bhí bunaithe ar a fheabhas a bhí sé mar eagnaí agus mar ealaíontóir a d'fhan dílis do luachanna daonna agus daonnachtúla.

Ó thaobh stíle dhe tá an neamhspleáchas agus an bhunúsacht chéanna ag baint le saothair snoíodóireachta agus dealbhóireachta Shéamus Murphy agus a bhaineann leis an bhfear féin. Tá tagairt déanta cheana ar conas gur féidir cáilíocht na seanchaíochta a shamhlú le saoirseacht chloiche Shéamuis. Bhraith Seán Ó Tuama go mba áireamh cóir é an samhlú seo chomh maith. I ndán leis luann an Tuamach an 'ceathrar fear im chathairse/a éiríonn romham sa tost'. Ó Corcora, Ó Riada, Ó Ríordáin agus Séamus Murphy atá i gceist aige: ceathrar, dar leis, a mhúscail luisne ard sa tsaol – agus ina

shaol féin. Seo mar a luann sé an Murchadhach: 'an dealbhadóir chuir clocha ag rinnce/lena sheanchaíocht'.[19] Is féidir a rá go bhfuil cúpla rud i gceist leis an tagairt don seanchaíocht anseo. Go mba fhear mór seanchaíochta é Séamus, cuirim i gcás; eolas thar na beartaibh aige ar fhoirgintí agus ar thraidisiúin saoirseacht chloiche na cathrach agus é i gcónaí ag roinnt an eolais sin mar sheanchas lena lucht éisteachta. Arís, go mba fhear é Séamus ar bhreá leis an chomhluadar seanchais – i dtigh An Táilliúra, mar shampla – láthair ar ar shaothraigh Séamus ceann dá dhealbha cinn a b'fhearr (ceann An Táilliúra) – ionas go b'fhéadfaí a rá gur toradh ábharga, clochach ar an seanchas a bhí ar siúl timpeall air san am is ea an dealbh san. Arís eile, is féidir a thuiscint anseo go bhfuil an Tuamach ag rá go bhfuil nádúir na seanchaíochta le haimsiú i gcleacht snoíodóireachta Shéamus Murphy agus in a thoradh clochach. Agus tá an fhírinne sa mhéid sin, dar liom, toisc gur cineál úrlabhra chlochaí tíre (*stone vernacular*) í stíl sníodóireachta an Mhurchadaigh. Díreach sa tslí gur ghnáth-urlabhra togtha go leibhéal neamhchoitianta feabhais is ea insint fhoclach an mháistirsheanchaí, tá ealaíon Shéamus Murphy tógtha ar ghnáth-thraidisiúin choitianta cheardaithe na gclochchlós siar go dtí na meánaoiseanna.

Stíl fhréamhaí, raidiceach atá aige ina bhfuil cruthú beo ealaíonta ar siúl an t-am go léir láimh le ceardúlacht traidisiúnta. Ní bhaineann torthaí ealaíona na stíle seo le Traidisiún ar bith: ní oireann dóibh lipéidí aon ghluaiseacht nó aon scoil den dioscúrsa critice faiseantachta. Go háirithe níl taidhseacht ná tromchúis ag baint le saothair Shéamus Murphy ná níl sé dírithe dá laghad ar an nGailearaí Ealaíona. Ní hionann agus péintéirí a linne – Armstrong, Campbell, Dillon… – níor bhall de aon bhuíon aitheanta ealaíontóirí é.

Sórt aonaráin ab ea é, dírithe de shíor ar chur-i-bhfeidhm a físe ealaíontóra. Ceapadh dó sa bhfís sin an ealaín a bheith ina bhláth ar an gceardúlacht chóir – nuair a bhíonn ealaín le lua le haon saothar ar leith. Ach níor fhág an t-aonaránachas cleachtaidh sin i leataobh in aon tslí é ón ngnáthshaol ná ón ngnáthmhuintir. Bhíodh sé féin agus Maighréad gníomhach i gcúrsaí na ngluaiseachtaí cultúrtha; ag caomhnú oidhreacht na timpeallachta nó ag eagrú chumann na scannán, cuirim i gcás. Pearsa phoiblí ab ea Séamus sa tsochaí i gCorcaigh agus an-chion air i measc na coitiantachta. Bhíodh sé breá sásta páirt a ghlacadh go rialta i gcomhluadar poiblí an tigh tábhairne, i dteannta le cáirde agus lucht aitheantais, chun cúrsaí an tsaoil a chíoradh agus a chogaint. Séamus agus Seán Hendrick na réalta móra intleachtúla sa chomhluadar éigse seo a thaithigh ostáin Shráid an Churtáinigh. Bhíodh Séamus ar a rí-shuaimhneas i dteannta leis an dream a thagadh le chéile go rialta i

Clúdach chatalóg
Catalogue cover
Séamus Murphy
1907-1975 (1982)

cré-umha James Murphy (a athair fhéin, 'Long Jim'). Ag féachaint uaidh go meabhrúil atá Séamus, a bhéal iata go daingean agus iarracht de chraptheannas ar íochtar a aghaidhe. Tá idir dhéine agus shó i dteannta a chéile á léiriú anseo i gceannaithe agus i leathéadan atá ag pléascadh le gaois agus le grámhaireacht. B'aoibhinn leat bheith i dteannta an duine daonna seo len a athairiúlacht uasal cneasta agus len a fhéith ghrinn. Tá ar taispeáint anseo, dar liom, an *'wholeness of which most of us fall short'* a luann John Biggs le Séamus.[21] Tá ar taispeáint ann chomh maith, is dóigh liom, a raibh i gceist ag daoine eile – *'seemed to burn with vitality despite ill-health'*, a dúirt John Horgan;[22] *'joyously creative in his work and in his life'* a dúirt Louis Marcus.[23] Bhí mar a bheadh *gravitas* ceolmhar ag baint le Séamus Murphy. Féach cad dúirt sé le greann grámhar uair le Geraldine Neeson tar éis di a shocrú leis go bhfágfadh sé spás dá hainm féin ar ball ar an leac uaighe a bhí órdaithe aici uaidh: *'I'll put it in for you. I won't go till you're down!'*[24]

Ach d'imigh Séamus Murphy roimpi, faraoir, agus bhí Seán Ó Ríordáin ag fiafraí arbh fhiú bheith beo in Éirinn a thuilleadh. Dar leis 'go raibh croí na cathrach stopaithe'.[25] Cé nárbh aon Ghaeilgeoir é Séamus sa mhéid is ná raibh cumas líofa aige sa teanga labhartha, bhraith Gaeilgeoirí na cathrach go mba dhuine acu féin ab ea é. Thuig sé go soiléir áit na Gaeilge agus an tsaibhreas chultúrtha a bhí inti agus timpeall uirthi, i saol na hÉireann. Dhein sé a dhícheall lena bheo ligint isteach don saibhreas sin i ndioscúrsa úd na cloiche gur dó a bhí sé fhéin ceapaithe agus gur leis a bhí sé ceangailte. Tuigtear go mbeadh sé sásta ná dearmadfaí an méid sin agus commóradh a chéid ar siúl againn air.

———

dtigh tábhairne an Pháláis i gcaitheamh na seascadaí mar a bhíodh sé ina saoi ar eagna ag plé cúrsaí litríochta agus ealaína agus feallsúnachta. 'Mionphobal a sheasaíonn dos na healaíona agus leis na healaíona i gCorcaigh is ea iad so' aduirt Seán Ó Ríordáin i dtaobh an ghrúpa seo d'intleachtóirí a thagadh le chéile sa Phálás oíche nó dhó den tseachtain.[20] Ba mhinic a bhean Maighréad i dteannta le Séamus ar na hóicáidí seo agus is go ciúin, réidh gan deabhadh a cuireadh sé é féin in iúl. Ba léir comhacht agus fairsinge a éirim aigne dá lucht éisteachta agus ba mhinic ba thógáil croí agus meanama dhóibh an fhéachaint amach a roinn sé leo. Is amhlaidh a bhí sé ag iarraidh an t-aontacht san idir an ealaín agus beatha an tsaoil mhóir – mar a bhí le blaiseadh aige féin fadó i bPáras – a bhunú agus a chur i bhfeidhm i saol na cathrach abhus. Nó ar a laghad bhí sé ag tarraingt aird de shíor ar an aontacht san mar rud a d'fhéadfadh a bheith fíor – agus a bhí fíor ar fad ina shaol gairmiúil féin. Ba thaca riachtanach leis an saol aontaithe gairmiúil sin riamh a bhean chéile, Maighréad, bean a bhfuil an t-iomlánú daonnachta agus tallann chumasach ealaíona ag baint léithi féin. Thug an aontacht san agus a dheimhne agus a bhí Séamus di cosaint éigin dó, ní foláir, ar chruatan a cháis mar ealaíontóir geall leis ar an iargcúl, nach bhfuair a chothram de phátrúntacht riamh ó údaráis eaglasta ná síbhialta, ó chléir ná ó thuath. Is féidir spléachadh a fháil, is dóigh liom, ar an suaimhneas domhain go raibh sé i ndán tarraingt air – amach as an bhfírinne físeach – i roinnt des na grianghrafanna a mhaireann de.

Tóg mar shampla an grianghraf atá mar mhaise ar chlúdach tosaigh na catalóige dá shaothar a foillsíodh i ndiaidh a bháis fén dteideal *Séamus Murphy 1907-1975*. A chloigeann beo féin agus a leathaghaidh atá le feiscint in aice le cloigeann

Gearóid Ó Crualaoich – Ollamh Emeritus le Béaloideas in Ollscoil na hÉireann (Corcaigh). É ina údar ar *The Book of the Cailleach* (Cló Ollscoile Chorcaí, 2003). Tá foillsithe aige go hidirnáisiúnta, as Gaeilge agus as Béarla, ar ghnéithe éagsúla de chultúr traidisiúnta na hÉireann – ar nós an mhiotaseolaíocht, deasghnátha thimthriall na beatha agus cruthaitheacht liteartha na hinsinte béil.

Gearóid Ó Crualaoich is Emeritus Professor of *Béaloideas*/Folklore and Ethnology at University College Cork. Author of *The Book of the Cailleach* (Cork University Press, 2003), he has published bilingually on aspects of Irish tradition, including myth, life-cycle ritual and literary creativity in vernacular narrative.

ABSTRACT

This article, written in Irish as a tribute to Séamus Murphy's enduring love of the Irish language and its culture, treats of him under three topics:

a) the child of cultural revolutionary times in Cork who serves his time to stonecarving gets the opportunity to train in sculpture in Paris and is profoundly transformed thereby.

b) the sculptor/carver who vitally marries fine art with the exercise of his craft tradition. It is suggested that his work is marked by an avant-garde quality akin not to that of Modernism, but to the radical creativity of vernacular verbal art (seanchas).

c) the master-practitioner giving constant and compelling expression in his work and in his social circles to the revolutionary ideals of the unification of art and life to which he remains loyal and to which his own life, with that of Maighréad, bears noble witness.

Much is made of Daniel Corkery's influence on Séamus Murphy. What Séamus brought to their relationship was a young sensibility formed by his experience of the death of his siblings and his pride in a family tradition of craftsmanship. Through a time of world war outside, and rebellion and civil war at home, Séamus Murphy grew to young manhood engaged primarily to art as manual activity. Distanced, thus, by his medium from the critical oppression some writers felt in relation to Corkery's literary influence, Séamus Murphy got away altogether from the narrow Cork scene while he was still fresh and fully open to life.

If his time in Paris was brief, it seems, nevertheless, to have enabled a profound development to take place in him that resulted in the 'wholeness of which most of us fall short' that John Biggs refers to. In particular, Séamus Murphy seems to have consolidated at this time that balance between the feminine and the masculine – in himself and in his engagement with the world – that is a cornerstone of creativity. Henceforth, back in Cork, neglected, relatively speaking, by patrons of Church and State, he was able to devote himself to realising, as far as humanly possible in his own lifework, an artistic vision, formed, in his case, of the revolutionary intensities of a nationalist Corkery and a Modernist Paris. To this end he balanced his chosen vocation as sculptor with the practice of his stonecraft, to a degree dictated by humble subsistence as much as by his belief that art always grows out of work-in-hand.

Séamus Murphy channelled his abundant and abiding artistic creativity not into the abstraction and the surrealism of mainstream Modernism, but into the heads and the headstones that instantly yield up his unmistakable 'voice' as an artist. This is a 'voice' whose basis of articulation is the ageless vernacular of the 'stonie', but which, in each 'speaking', in each work, achieves afresh that original and masterful harmony of substance, form and meaning that always constitutes the avant garde.

Master-practitioners of traditional arts, verbal or manual, have always aspired to this end, and with an increased appreciation today of the richness of this aesthetic – as, for instance, in the case of ethnic music – we can understand in a renewed way the artistic achievement of Séamus Murphy in his creation of a high art rooted in a traditional vernacular, and in his life's faithful witness to radical aesthetic integrity.

ENDNOTES

1. Seán Ó Mórdha (eag.), Scríobh 4 (1979), réamhrá
2. ibid.
3. ibid.
4. Seán Ó Ríordáin, 'Séamas Ó Murchú', Irish Times, 5.8.1969
5. Seán Ó Ríordáin, 'Séamus Murphy', Irish Times, 9.10.1975
6. Séamus Murphy, Stone Mad (1950; athchló 1966; Collins Press, Chorcaí, 2005) 226
7. Bébhinn Marten (eag.), Séamus Murphy 1907-1975 (Chorcaí, 1982) 42-43
8. Julian Trevelyan de réir Sandra A O'Connell, Irish Times: Weekend Review, 21.4.2007
9. Féach Gearóid Ó Crualaoich, 'An t-Avant Garde sa Traidisiún' san Ó Mórdha (eag.), Scríobh 4 (1979)
10. Marten (eag.), Séamus Murphy, 56
11. Paul Durcan (eag.), Cork Review, 4 (Triskel Arts Centre, Cork, 1980)
12. Marten (eag.), Séamus Murphy, 20
13. Seán Ó Faoláin (eag.), The Bell, Meith. 1943
14. Durcan (eag.), Cork Review
15. Ó Mórdha (eag.), Scríobh 4, 100
16. Eric Cross, The Tailor and Ansty (1942)
17. Marten (eag.), Séamus Murphy, 73
18. ibid., 43
19. Ó Mórdha (eag.), Scríobh 4, 23
20. Ó Ríordáin, 'Séamas Ó Murchú'
21. Marten (eag.), Séamus Murphy, 56
22. Durcan (eag.), Cork Review
23. ibid.
24. ibid.
25. Ó Ríordáin, 'Séamus Murphy'

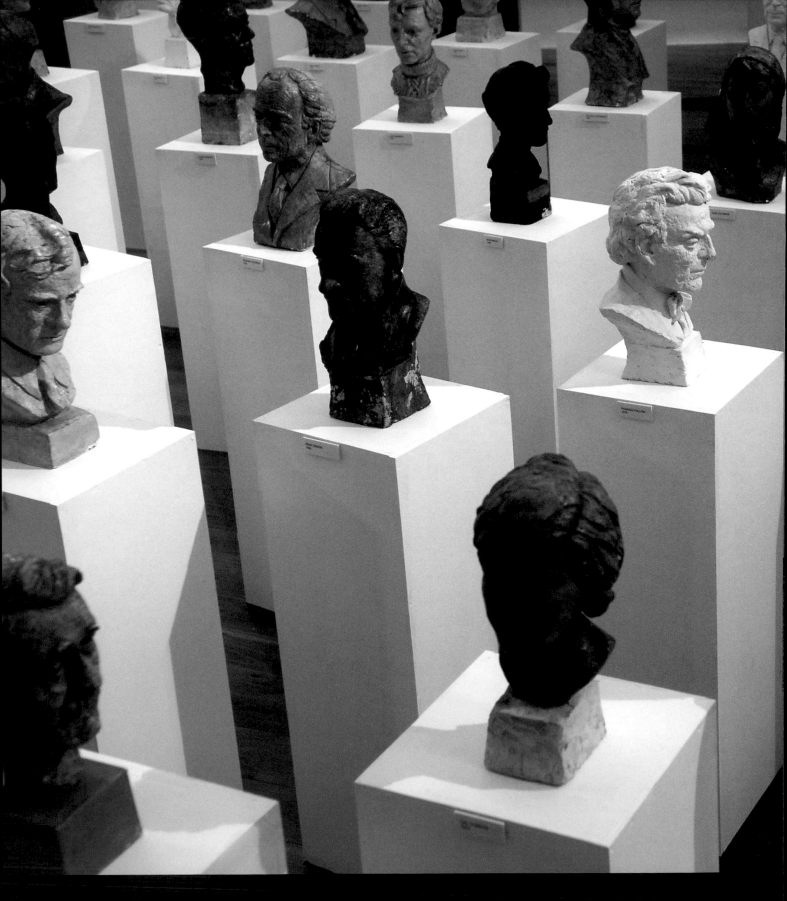

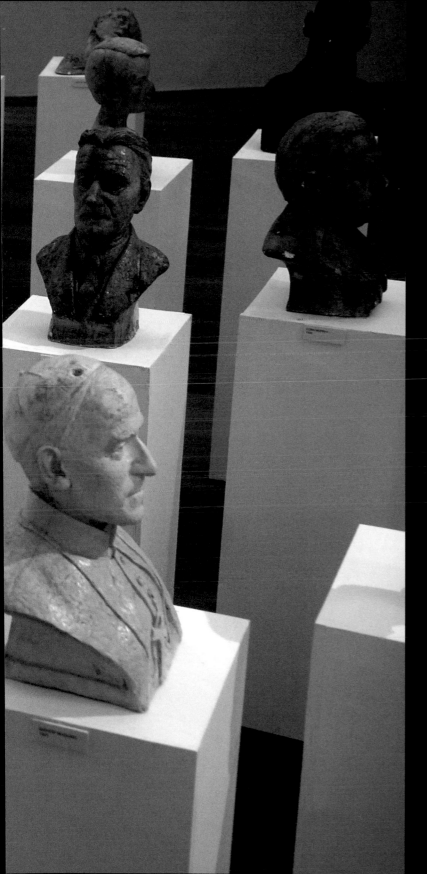

WORKS

Installation photo of the Séamus Murphy Studio Collection, bequeathed by
the Murphy family to the Crawford Art Gallery, 2006

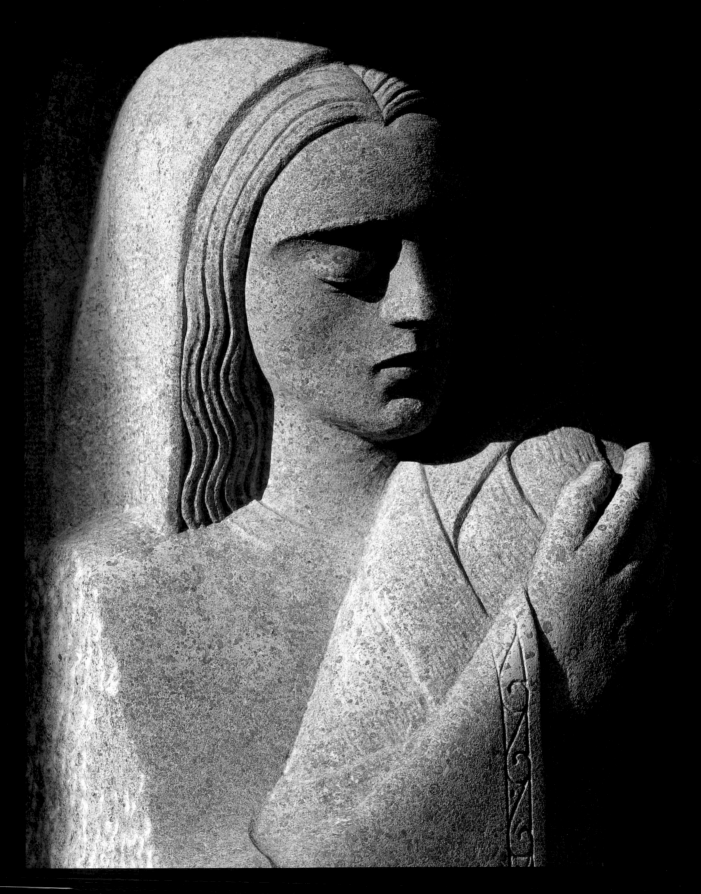

Madonna and Child 1952, limestone, 88 cm h (Church of the Descent of the Holy Ghost, Wilton, Cork)

RELIGIOUS FIGURES

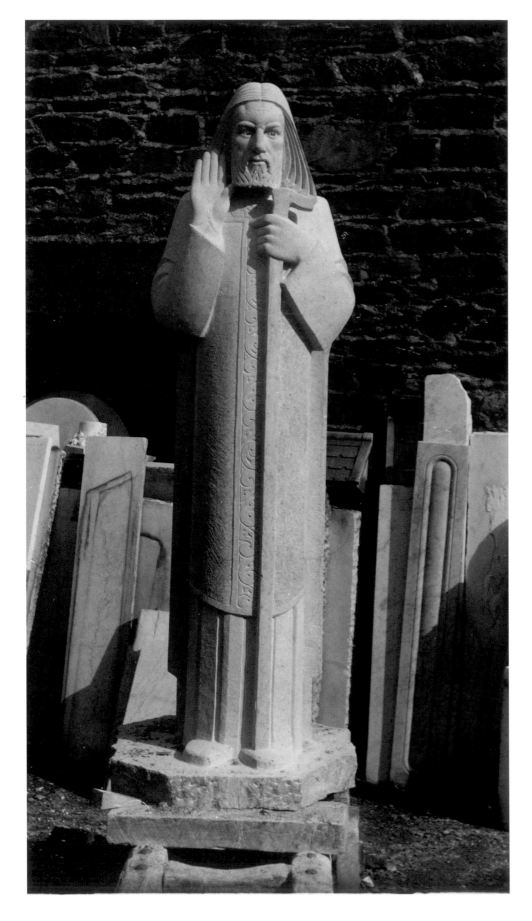

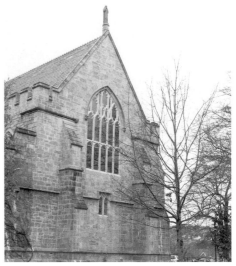

St Finbarr
1933, limestone, 213 cm h
(University College Cork)

opposite

St Finbarr's Church, Bantry, Co Cork

St Finbarr
1934, limestone, 244 cm h

St Ita
1934, limestone, 229 cm h

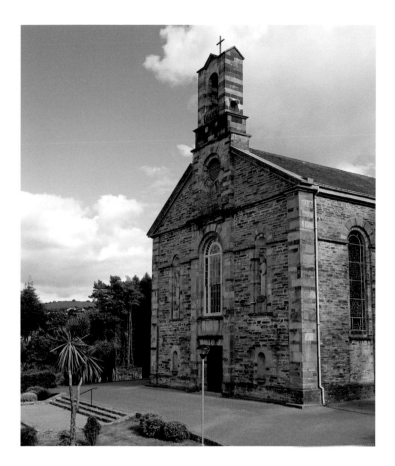

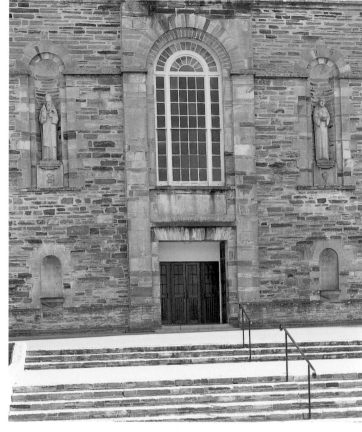

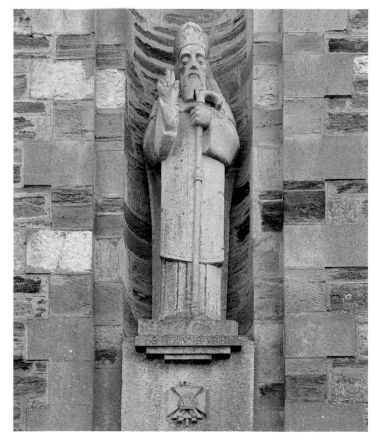

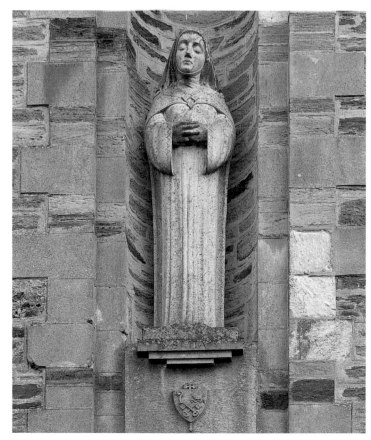

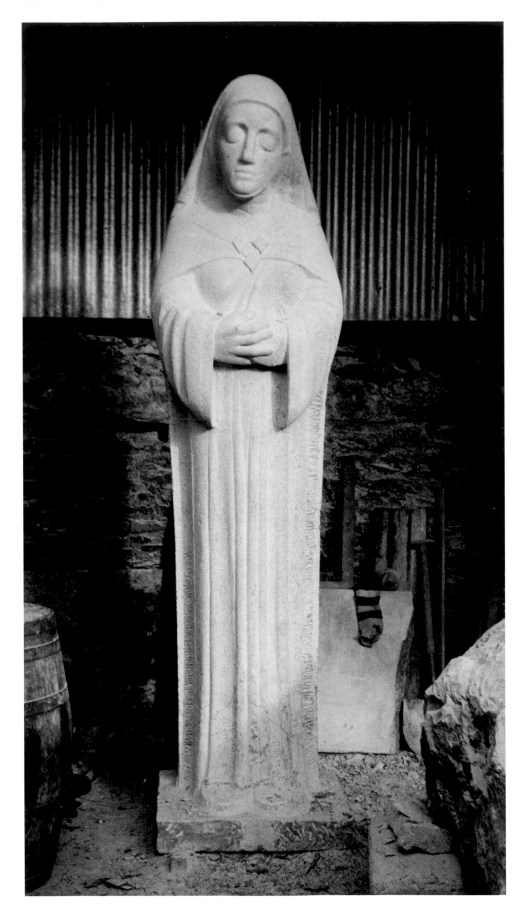

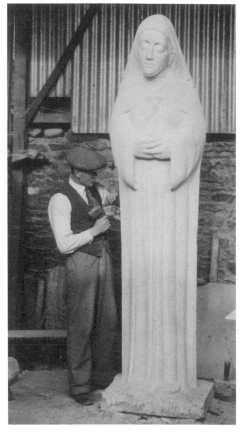

St Finbarr's Church, Bantry, Co Cork

St Ita
1934, limestone, 229 cm h

opposite

St Finbarr
1934, limestone, 244 cm h

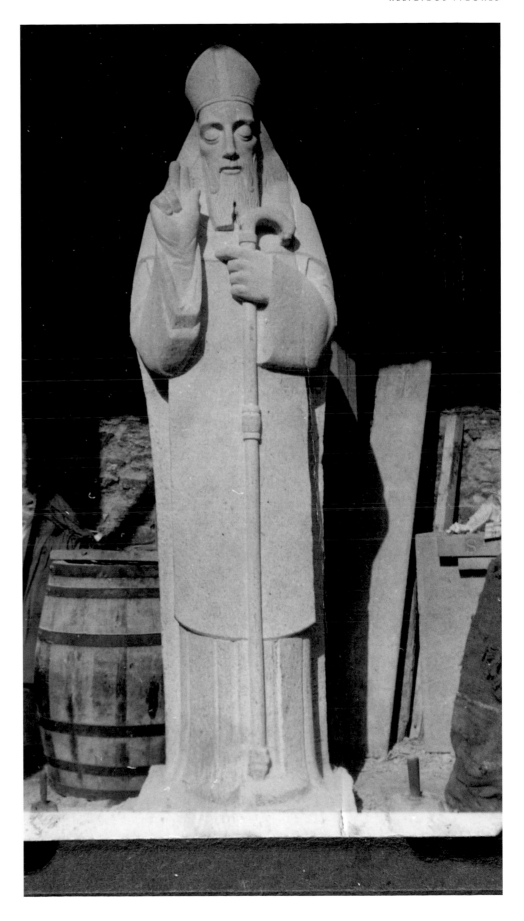

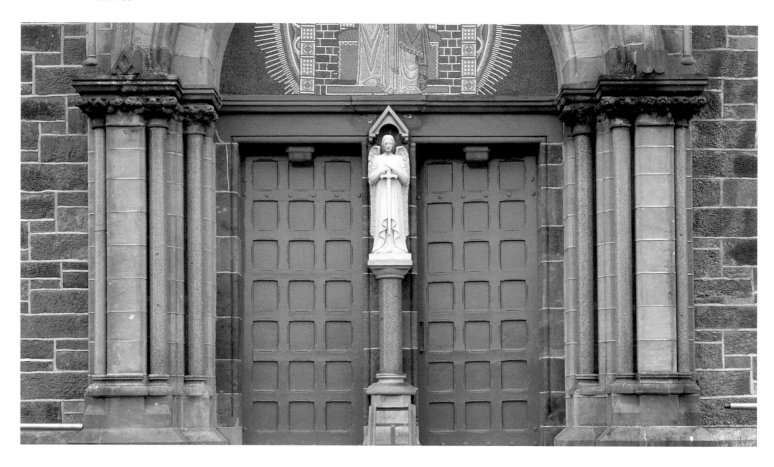

Michael the Archangel
1934, Portland stone, 122 cm h
(St Carthage's Cathedral, Lismore, Co Waterford)

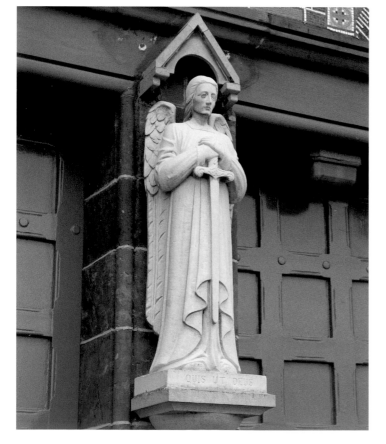

St Columba
1935, plaster and varnish, 72 cm h
(Crawford Art Gallery)

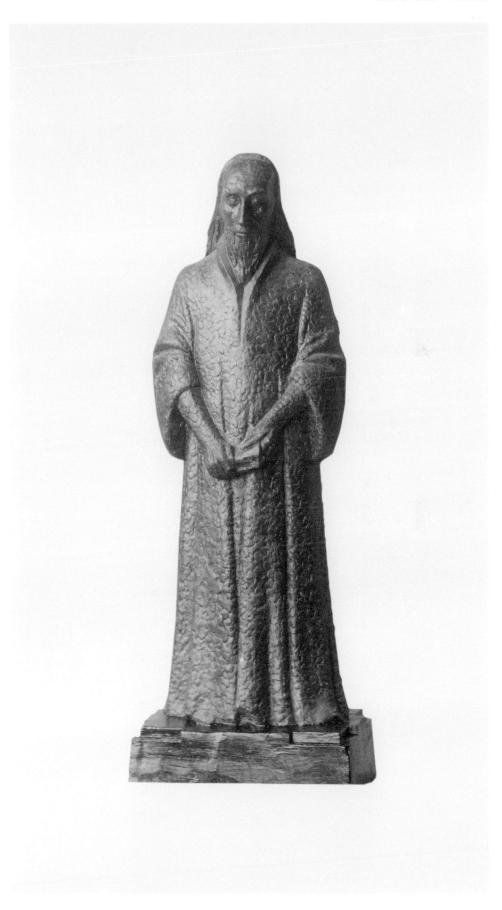

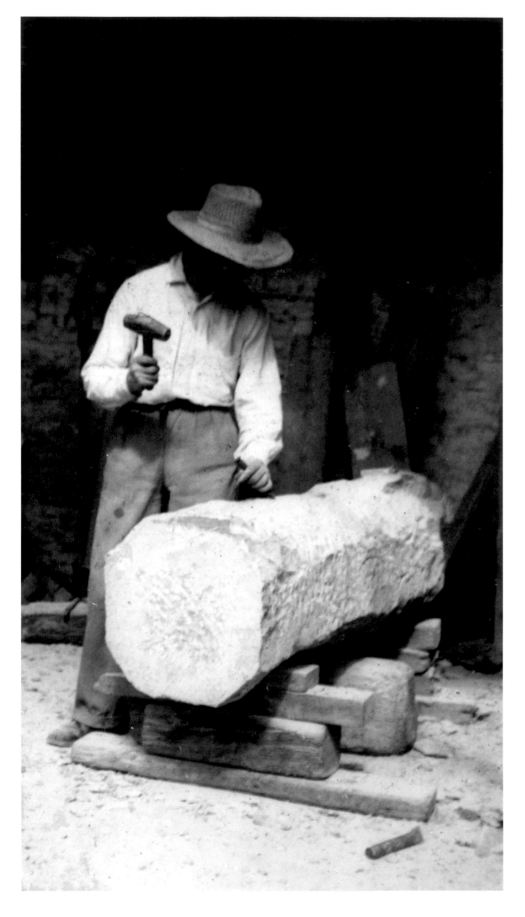

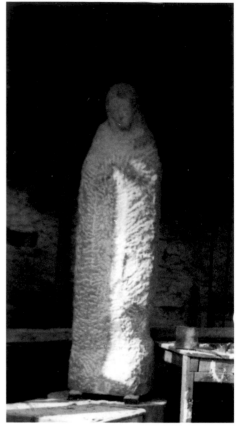

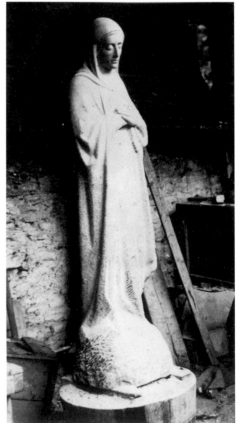

Mother of Sorrows
[or *Virgin of the Sorrows*]
1938, limestone, 163 cm h
(Ursuline Convent, Waterford)

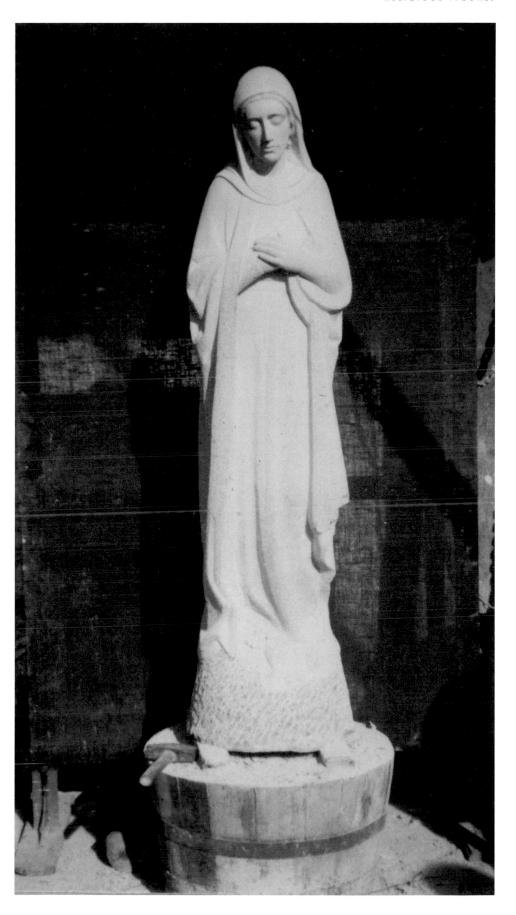

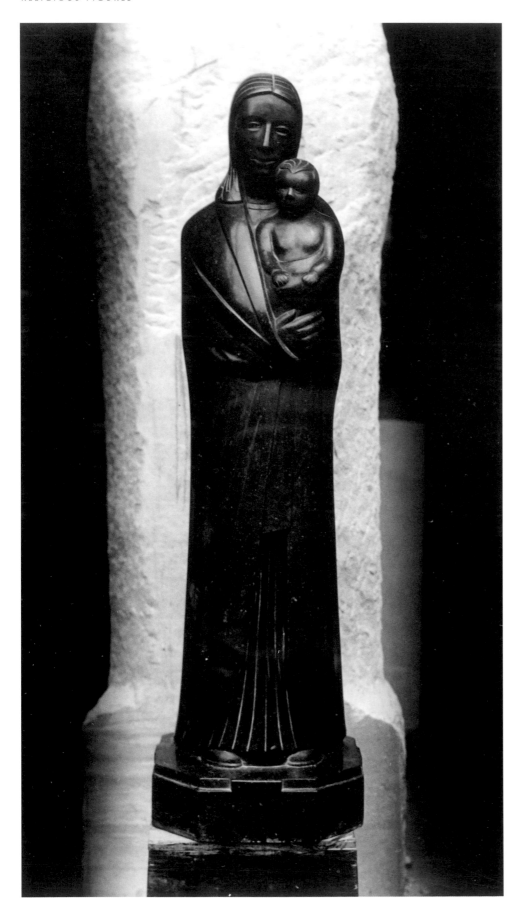

Madonna and Child
1939, polished limestone, 112 cm h,
signed and dated
(Church of the Holy Family, Military Hill, Cork)

Virgin of the Twilight
1941, polished Kilkenny limestone, 198 cm h,
signed
(on long-term loan to Crawford Art Gallery)

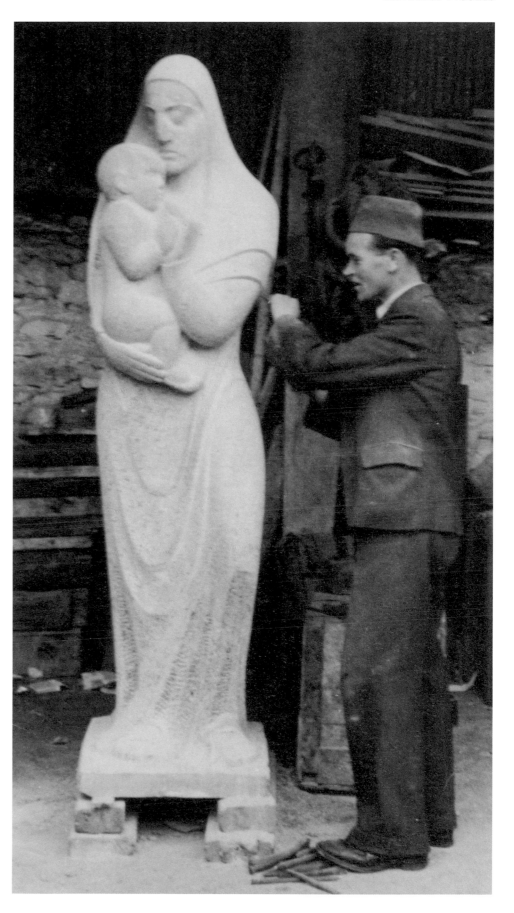

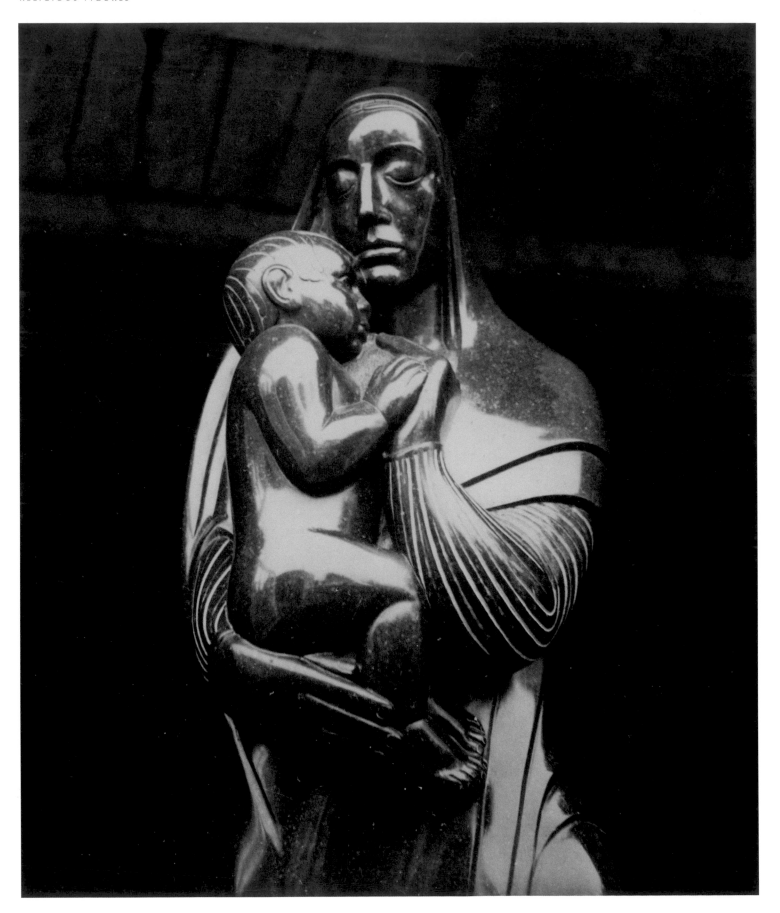

Virgin of the Twilight
1941, polished Kilkenny limestone, 198 cm h,
signed
(on long-term loan to Crawford Art Gallery)

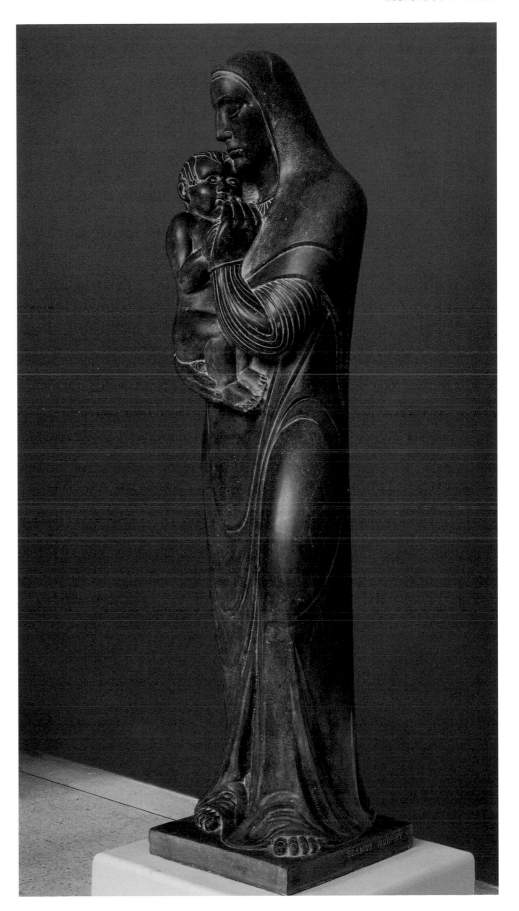

Madonna
1945, Portland stone, 167 cm h, signed & dated
(Church of the Annunciation, Blackpool, Cork)

opposite

Twelve Apostles
1948, limestone, each 153 cm h
(St Brighid's Church, San Francisco)

St Brighid's Church, San Francisco
before and after installation of statues

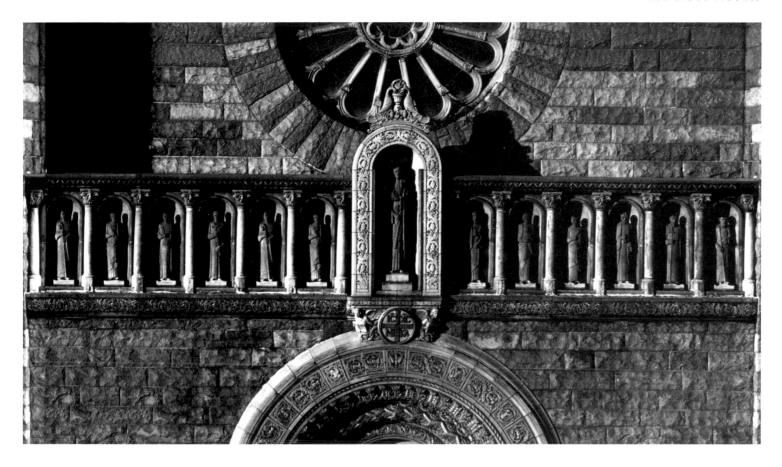

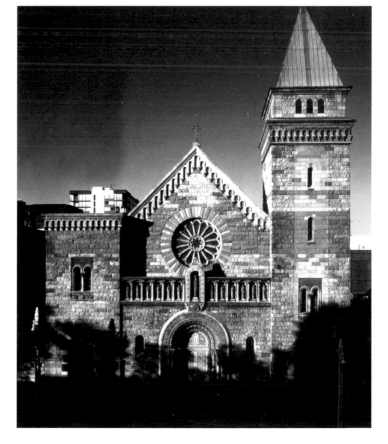

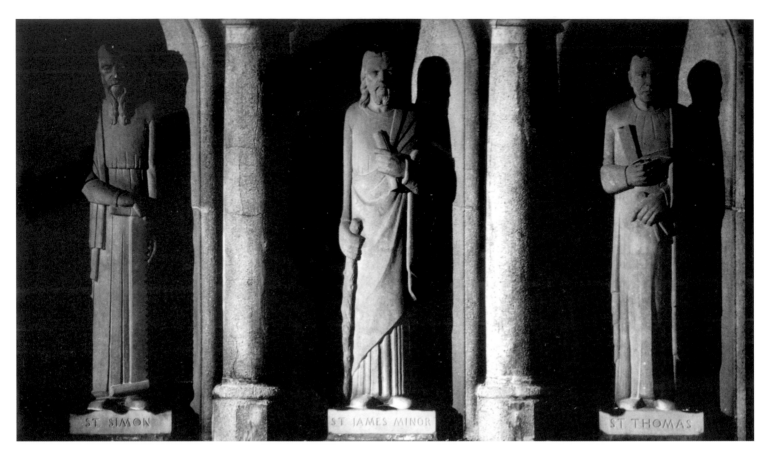

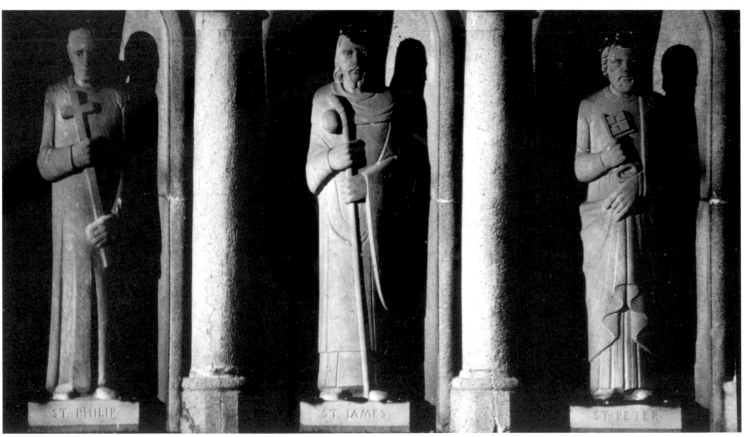

Twelve Apostles 1948, limestone, each 153 cm h (St Brighid's Church, San Francisco)

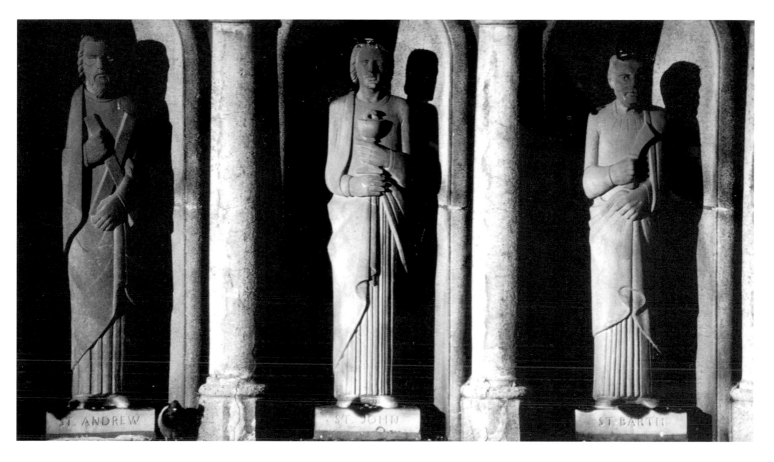

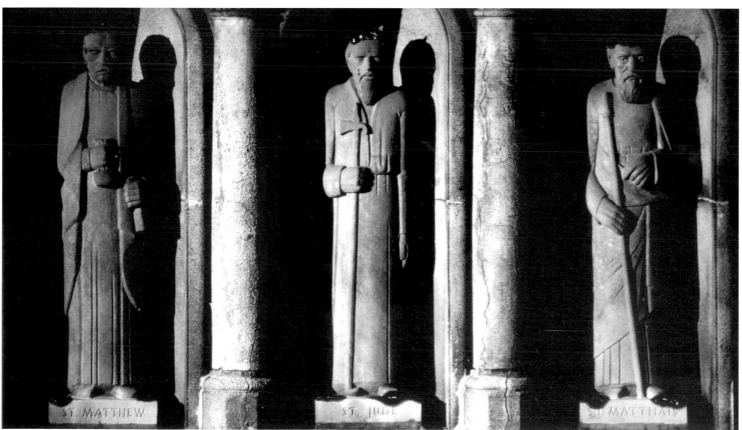

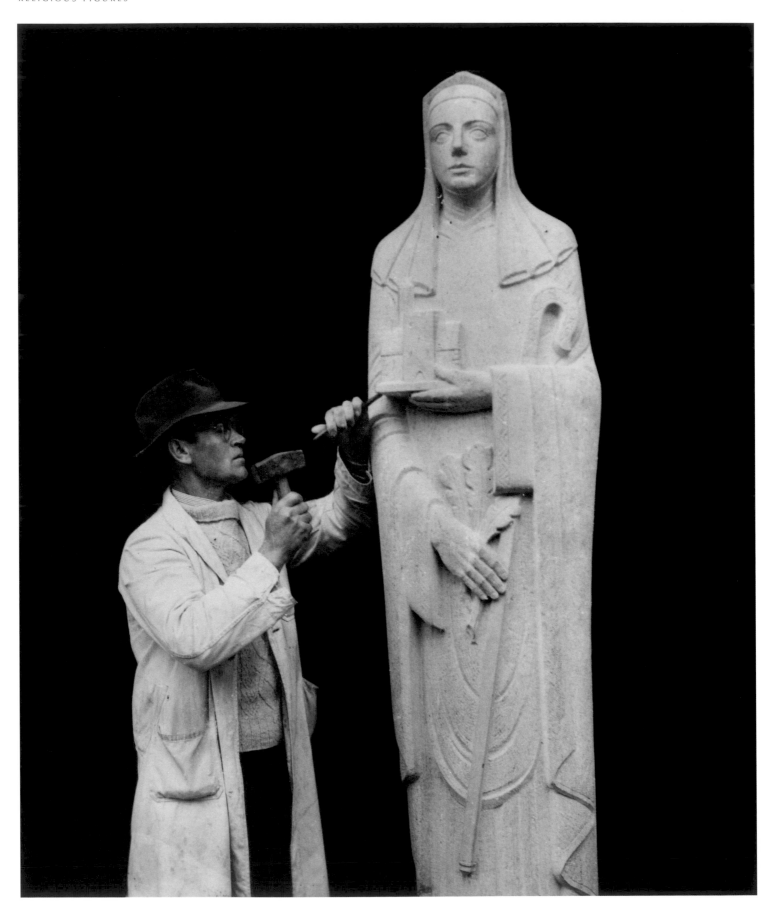

St Brighid 1948, limestone, 259 cm h, signed & dated (St Brighid's Church, San Francisco)

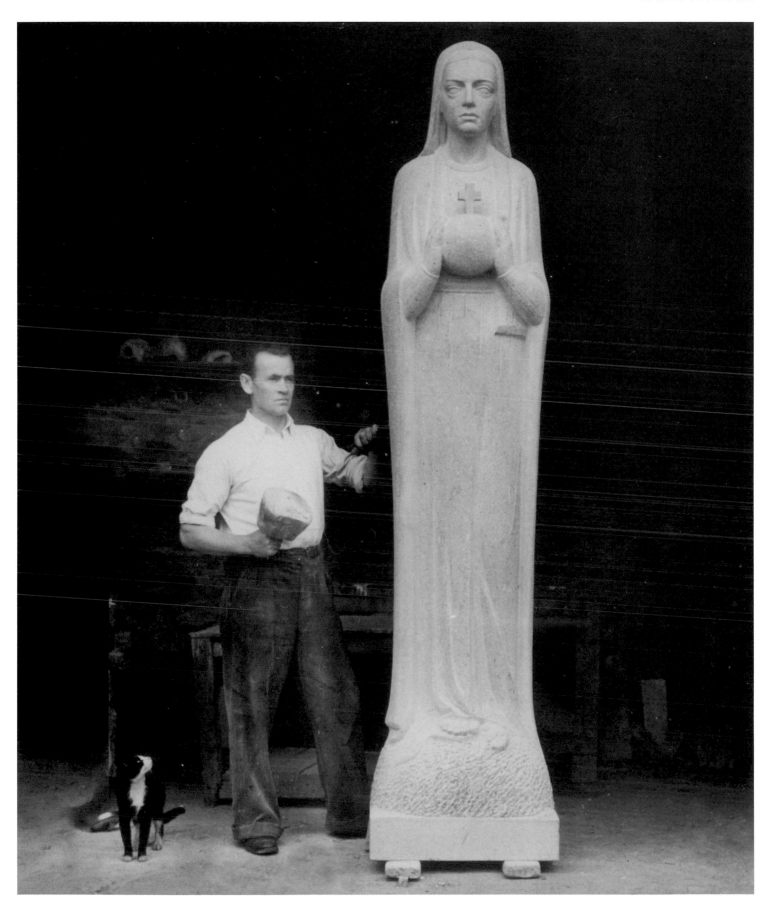

Madonna of the Globe 1949, limestone, 259 cm h (St Vincent's Church. Sunday's Well, Cork)

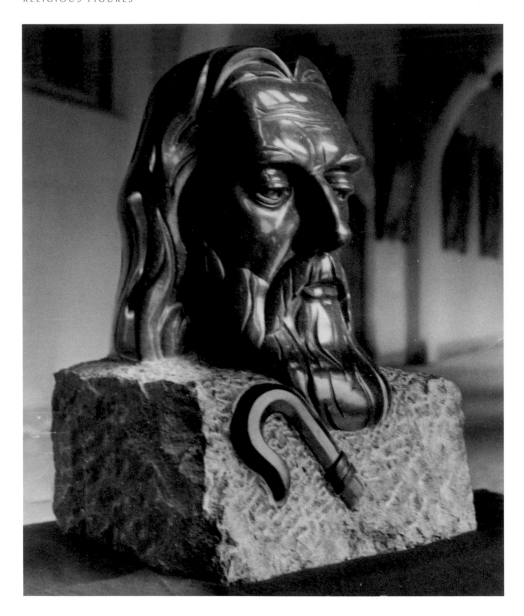

Naomh Padraig
1949, polished limestone, 91 cm h, signed
(St Patrick's College, Maynooth)

SM with *Naomh Padraig*

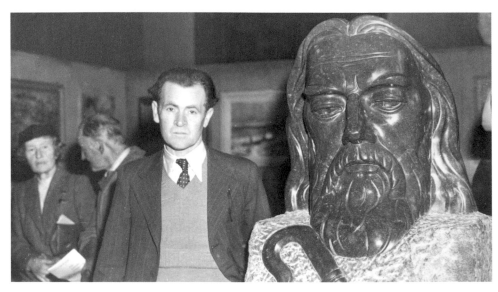

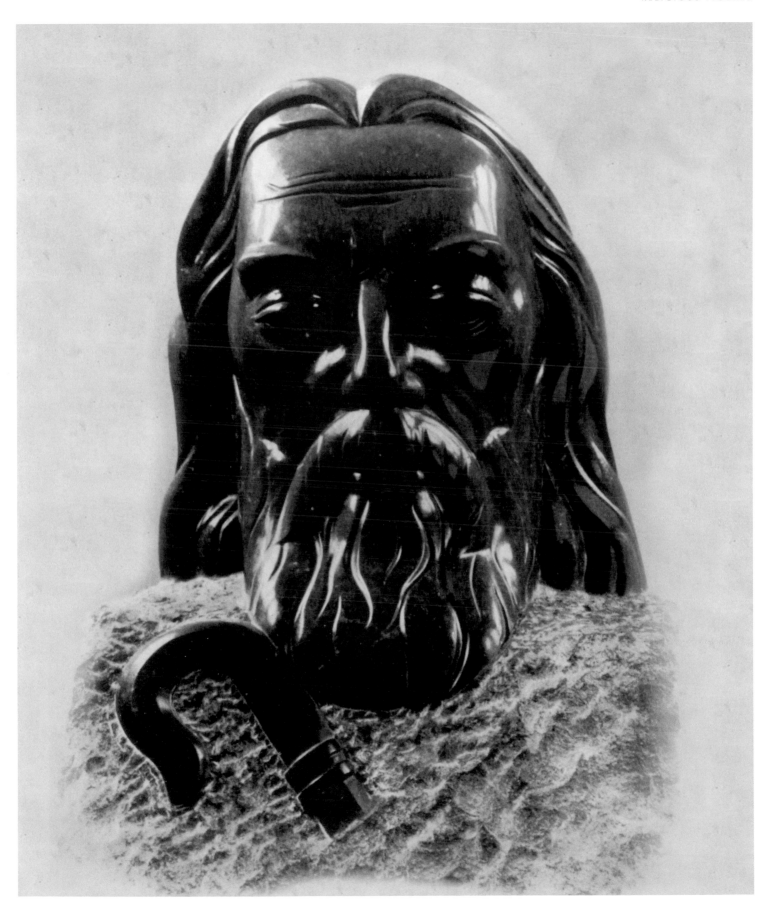

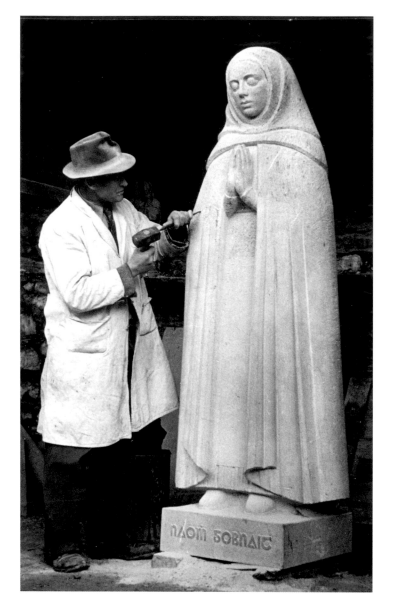

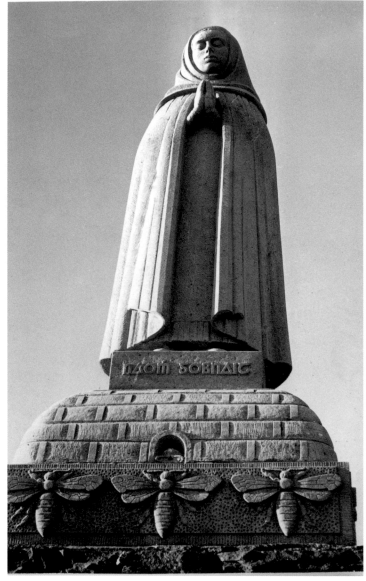

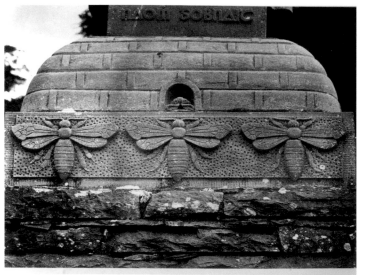

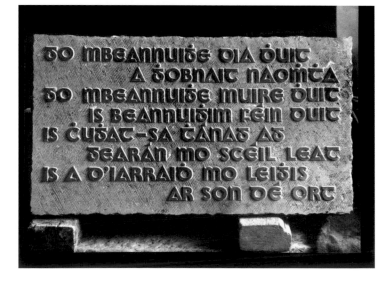

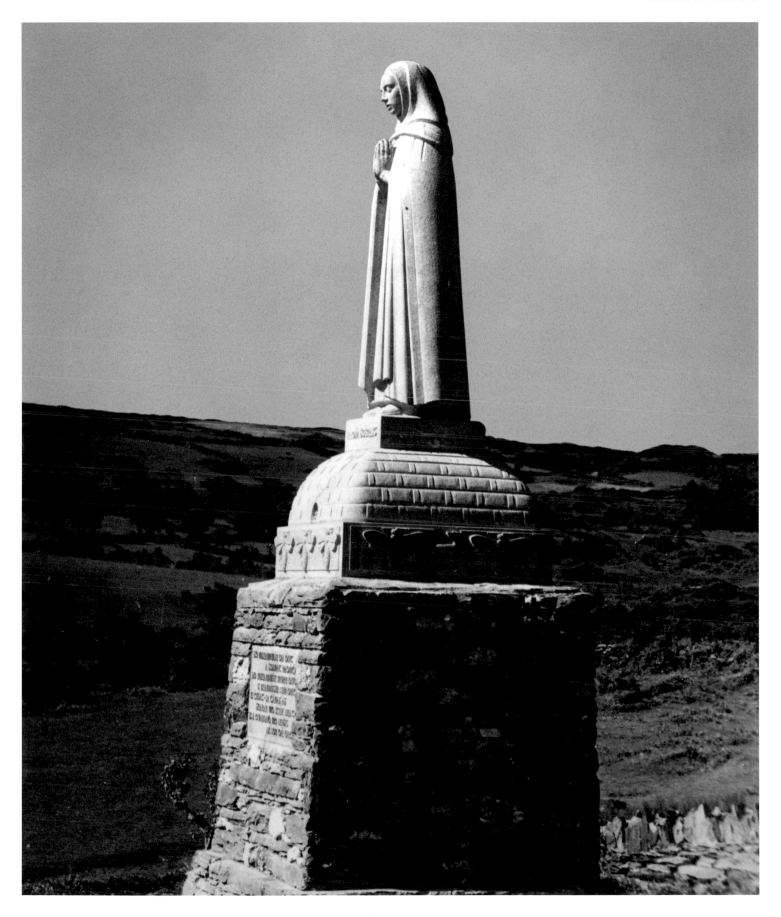

Naomh Gobnait 1950, limestone, signed & dated (Cúil Aodha, Ballyvourney, Co Cork)

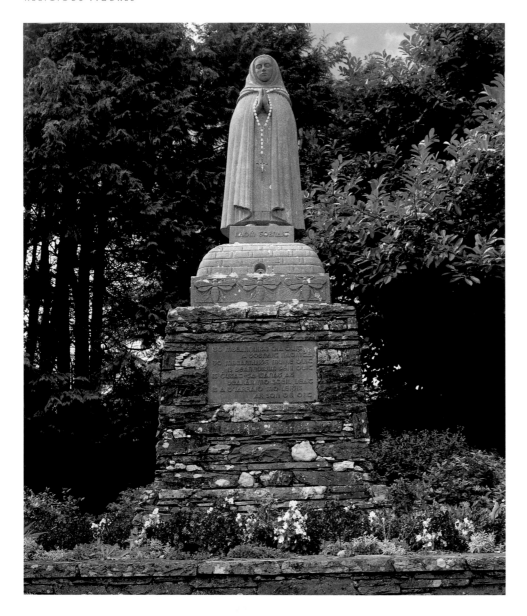

Naomh Gobnait
1950, limestone, signed & dated
(Cúil Aodha, Ballyvourney, Co Cork)

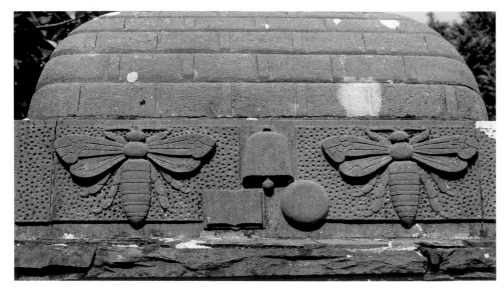

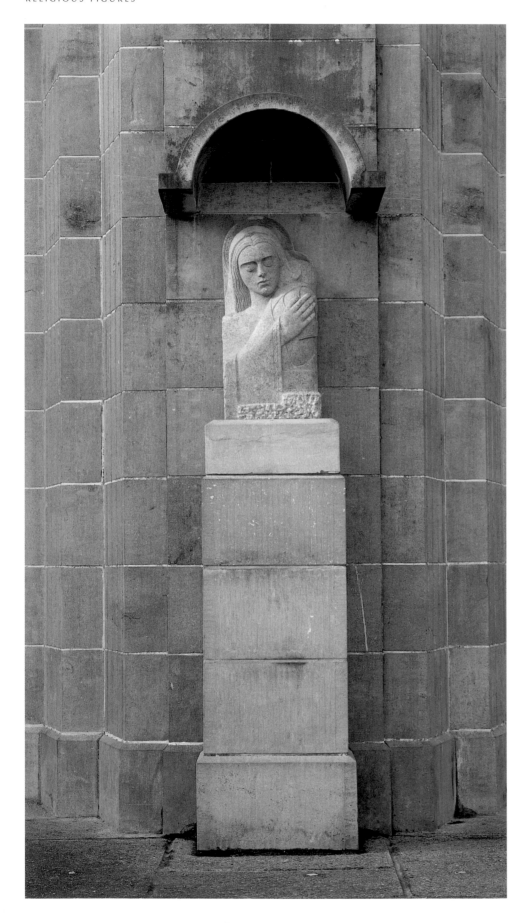

Madonna and Child
1952, limestone, 88 cm h
(Church of the Descent of the Holy Ghost,
Wilton, Cork)

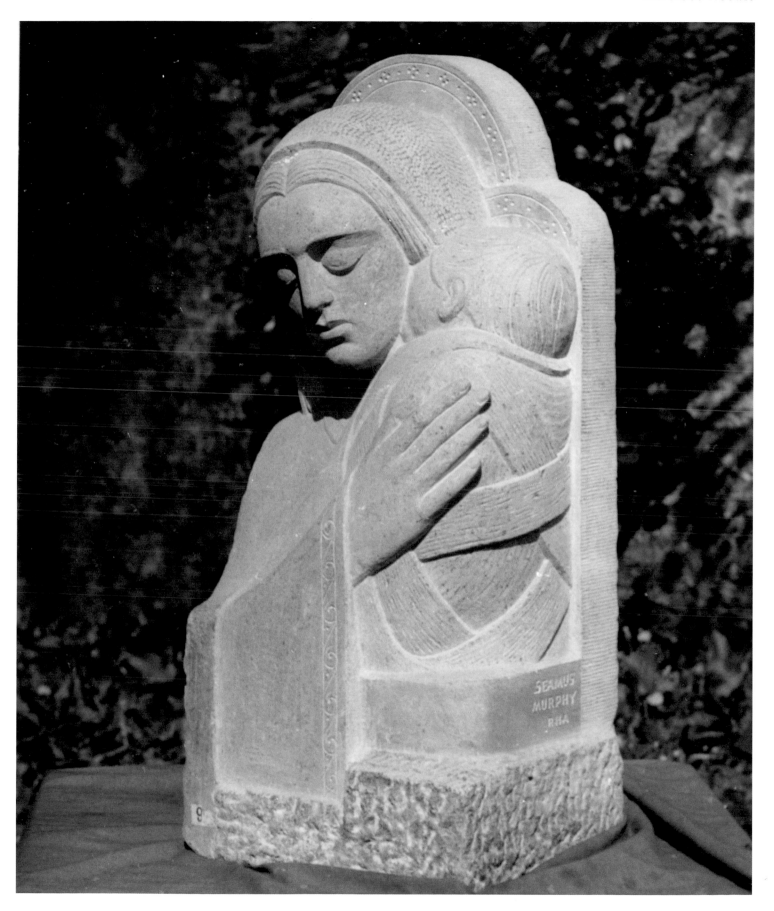

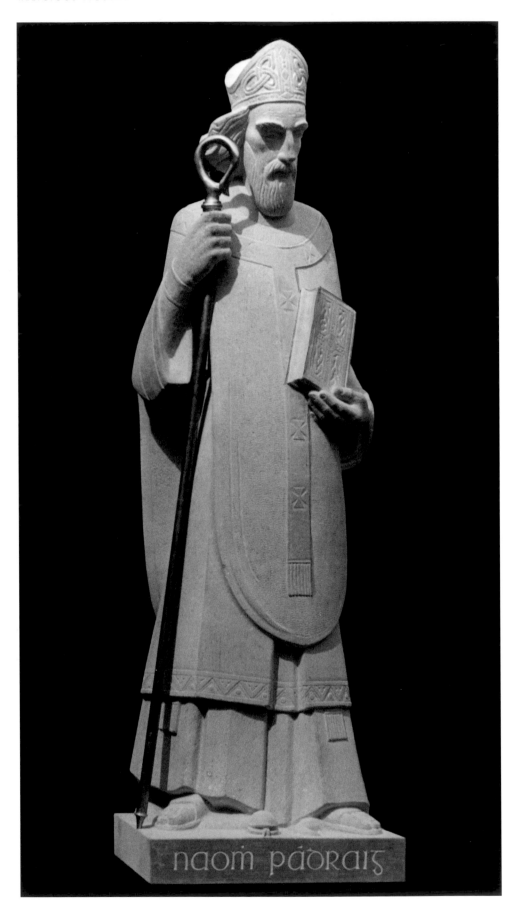

Naomh Padraig
1952, limestone, 180 cm h
(Church of St Columba, St Paul, Minnesota)

Naomh Fionbarr
1952, limestone, 183 cm h, signed
(Ballingeary churchyard, Co Cork)

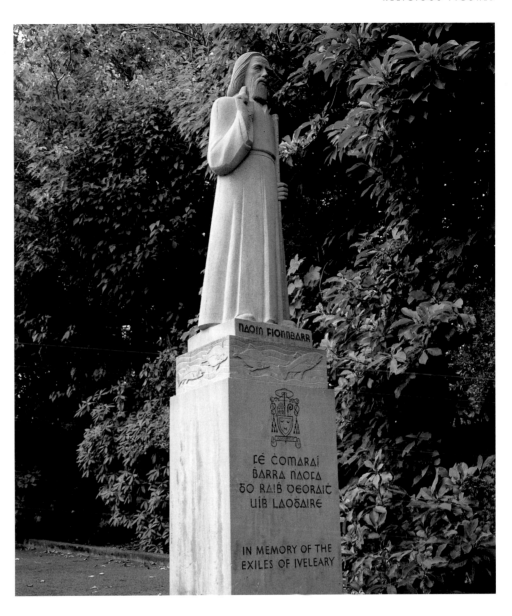

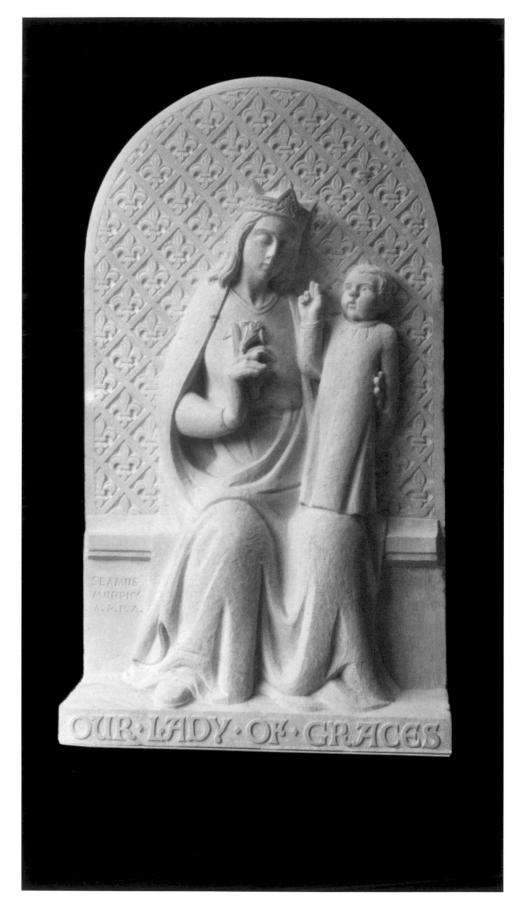

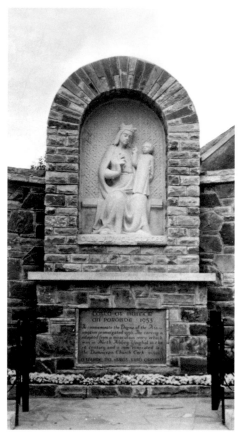

Our Lady of Graces
1953, Portland stone, 168 cm h, signed
(Youghal town centre, Co Cork)

St Finbarr
Cork Film Festival Award
1956, silver and bronze on wooden base,
30 cm h (Cork City Hall)

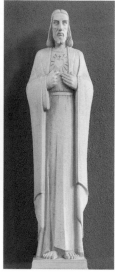

3, 26

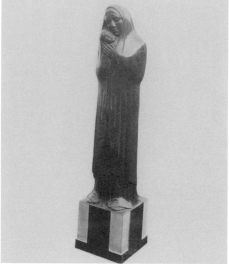

8

RELIGIOUS FIGURES

(locations in parentheses)

* illustrated here
** plaster version in Crawford Gallery collection

1
Figurine with arms crossed
n.d., limestone, 60 cm h
(Crawford Art Gallery)

2
Madonna
1945, bronze, 68 cm h
note: maquette of Madonna for Our Lady's altar,
Church of the Annunciation, Blackpool, Cork

3 *
Madonna
1945, Portland stone, 167 cm h, signed & dated
(Church of the Annunciation, Blackpool, Cork)
[see pages 82, 108, 116]

4
Madonna
1946, white marble panel, 60 x 46 cm, signed

5 *
Madonna
1948, red sandstone, 91 cm h, signed

6
Madonna
1954, limestone, 169 cm h, signed
note: bears small copper plate inscribed
ORIGINALLY COMMISSIONED BY THE WORKERS AT
GREENVALE WOOLLEN MILLS 1954
(Sion House, Kilkenny)

7 *
Madonna and Child
n.d., Portland stone panel

8 *
Madonna and Child
1931, concrete, 74 cm h
note: 4 plaster versions extant **

9
Madonna and Child
1931, polished limestone, 140 cm h

10 *
Madonna and Child
1939, polished limestone, 112 cm h,
signed & dated
(Church of the Holy Family, Military Hill, Cork)
[see page 78]

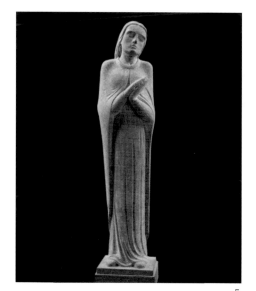

5
7

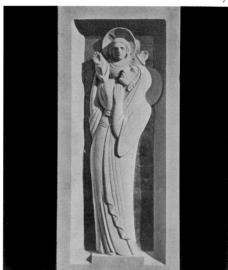

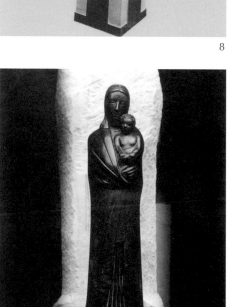

10
12

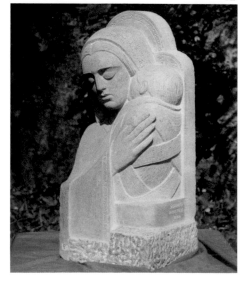

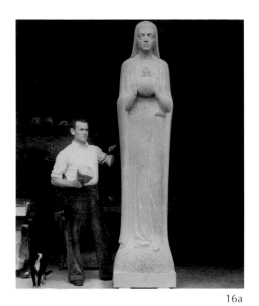

16a

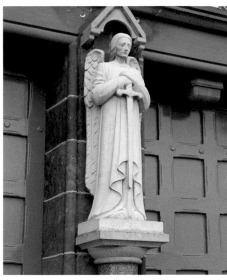

18

11
Madonna and Child
1946, Carrara marble

12 *
Madonna and Child
1952, limestone, 88 cm h
(Church of the Descent of the Holy Ghost,
Wilton, Cork)
[see pages 68, 94-95]

13
Madonna and Child
1958, Portland stone, 183 cm h, signed
(Bons Secours Hospital, Cork) **

14
Madonna and Child
1967, bronze panel, 91 cm h
(Holy Chapel of the Church of English Martyrs,
Stroud, Kent)

15
Madonna and Child
1968, Carrara marble panel, 45 x 30 cm, signed
inscription: TO MAIRE AND MARIANNL
– CHRISTMAS 1968
(location unknown)

16 *
Madonna of the Globe
1949, limestone, 259 cm h
(St Vincent's Church, Sunday's Well, Cork)
[see page 87]

17 *
Mary (Morning Star)
1961, limestone, 152 cm h, signed
(Listowel National School, Co Kerry)

18 *
Michael the Archangel
1934, Portland stone, 122 cm h
(St Carthage's Cathedral, Lismore, Co Waterford)
[see page 74]

19 *
Mother of Sorrows
[or *Virgin of the Sorrows*]
1938, limestone, 163 cm h
(Ursuline Convent, Waterford)
[see pages 76-77]

20 *
Naomh Fionbarr
1952, limestone, 183 cm h, signed
inscription: NAOMH FIONBARR FE CHOMARAI
BARRA NAOFA GO RAIBH DEORAI UIBH
LAOGHAIRE,

16b
17

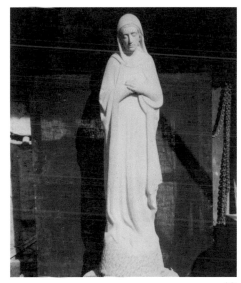

19
20

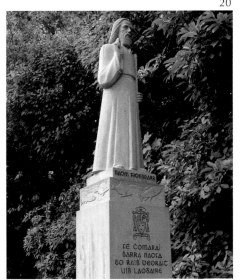

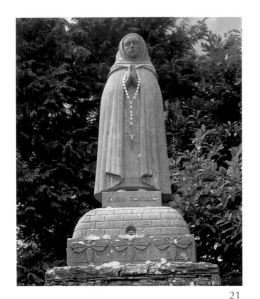

21

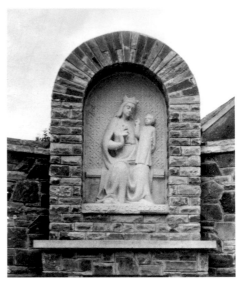

25

note: commissioned by Cardinal T Manning,
San Francisco, USA
(Ballingeary churchyard, Co Cork)
[see page 97]

21 *
Naomh Gobnait
1950, limestone, signed & dated
carving: panel inset in plinth carrying traditional
prayer in Irish; decorative carving on base
(Cúil Aodha, Ballyvourney, Co Cork)
[see pages 90-93]

22 *
Naomh Padraig
1949, polished limestone, 91 cm h, signed
(St Patrick's College, Maynooth)
[see pages 88-89]

23 *
Naomh Padraig
1952, limestone, 180 cm h
inscription: NAOMH PADRAIG
(Church of St Columba, St Paul, Minnesota) **
[see page 96]

24
Our Lady of Fatima
1949, limestone, 175 cm h, signed Séamus
Murphy A.R.H.A
(Holy Cross Cemetery, Charleville, Co Cork) **

25 *
Our Lady of Graces
1953, Portland stone, 168 cm h, signed
(Youghal town centre, Co Cork)
[see page 98]

26 *
Sacred Heart
1945, Portland stone with a marble base,
182 cm h
(Church of the Annunciation, Blackpool, Cork)

27 *
St Brighid
1948, limestone, 259 cm h, signed & dated
inscribed with saint's name and carving of
traditional symbols
note: Commissioned (together with *The Twelve
Apostles*) by Mgr J Cantwell for 13 niches on the
façade of this Hiberno-Romanesque church
(St Brighid's Church, San Francisco) **
[see page 86]

28 *
St Columba
1935, plaster and varnish, 72 cm h
note: 1 plaster version extant **
[see page 75]

27
28

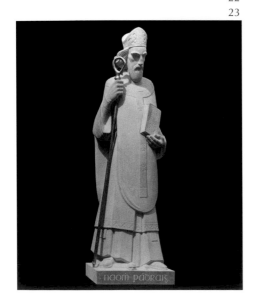

22
23

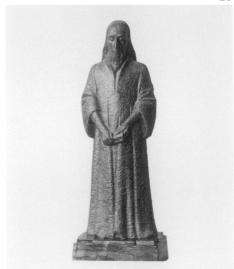

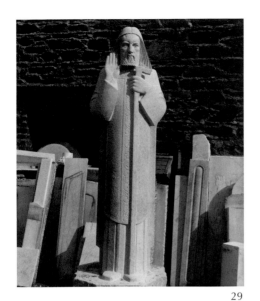

29

29 *
St Finbarr
1933, limestone, 213 cm h
note: plaster version in Visitor Centre, UCC
(University College Cork)
[see page 70]

30 *
St Finbarr
1934, limestone, 244 cm h
(St Finbarr's Church, Bantry, Co Cork)
[see pages 71, 73]

31 *
St Finbarr
1956, silver and bronze, 30 cm h
note: designed as Cork Film Festival award
(Cork City Hall)
[see page 99]

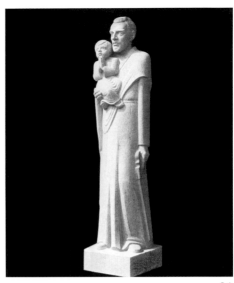

34

32
St Francis
1953, Portland stone, 168 cm h
(Church of Adam & Eve, Merchant's Quay,
Dublin)

33 *
St Ita
1934, limestone, 229 cm h
(St Finbarr's Church, Bantry, Co Cork)
[see pages 71, 72]

34 *
St Joseph and the Child
1950, limestone, 178 cm h, signed
(Servite Priory, Benburb, Co Tyrone) **

35 *
Twelve Apostles
1948, limestone, each 153 cm h
(St Brighid's Church, San Francisco)
[see pages 83-85]

36
Virgin
1954, limestone, 168 cm h, signed
(Drishane convent, Millstreet, Co Cork)

37 *
Virgin of the Twilight
1941, polished Kilkenny limestone, 198 cm h,
signed
(on long-term loan to Crawford Art Gallery)
[see pages 79-81]

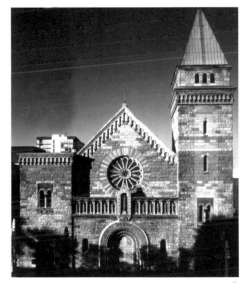

35
37

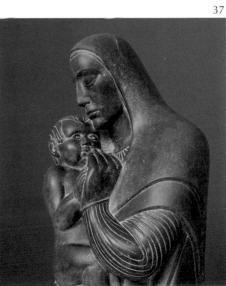

30, 33
31

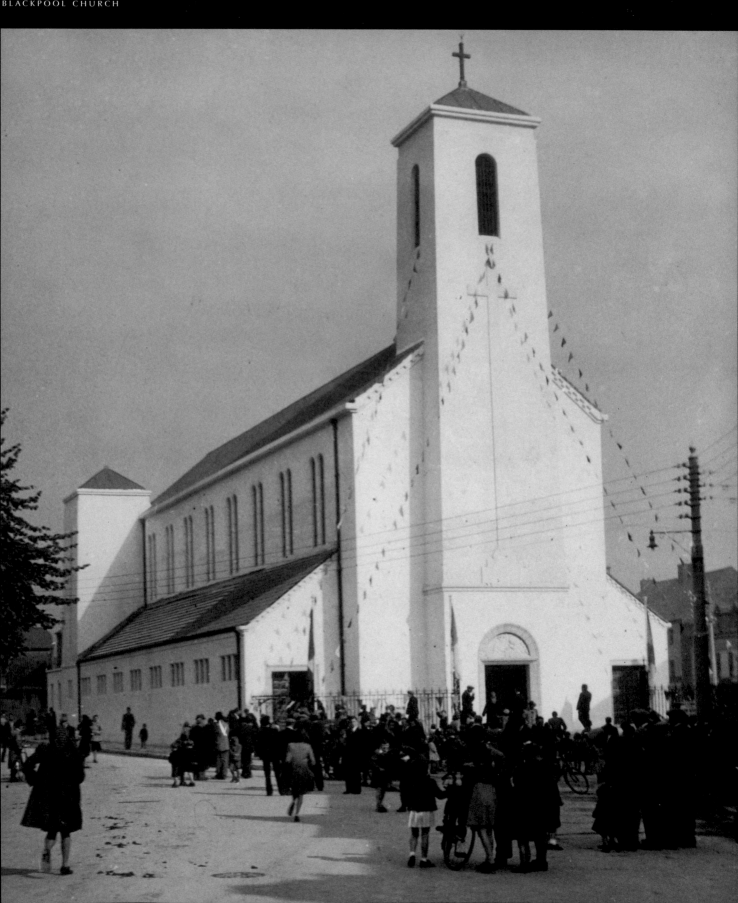

BLACKPOOL CHURCH

CHURCH OF THE ANNUNCIATION, BLACKPOOL, CORK, 1944-1945

design: Séamus Murphy / architect: Eddie P O'Flynn / patron: William Dwyer

Plan
*c.*1944, drawing, 43 x 74 cm

South Elevation (early version)
*c.*1944, drawing, 38 x 37 cm

East Section-Elevation
*c.*1944, drawing, 40 x 55.5 cm
inscribed: "Section showing pillars to carry trusses"

opposite

South Elevation (later version)
*c.*1944, drawing, 39 x 36 cm

(all Blackpool Church drawings by Séamus Murphy © Cork City & County Archives, 2007)

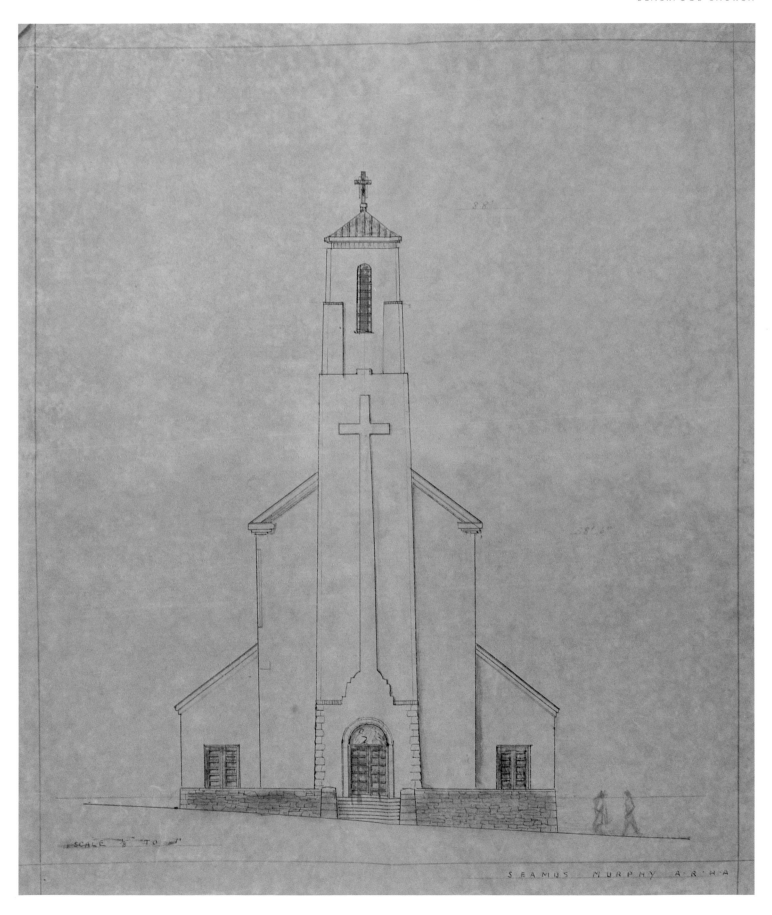

SCALE ½" TO 1'

SEAMUS MURPHY A·R·H·A

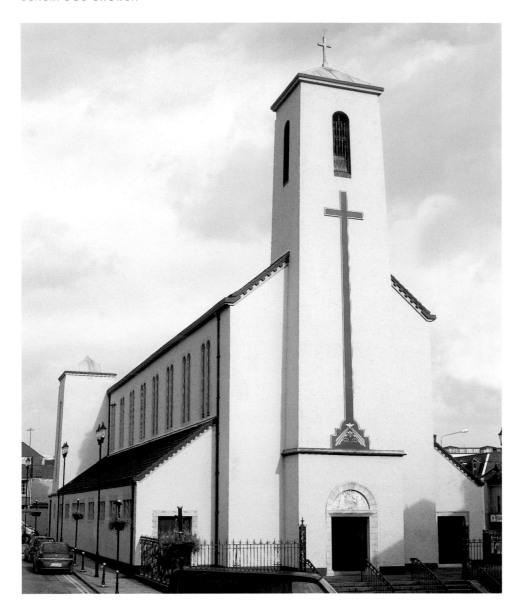

Church of the Annunciation
Blackpool, Cork, 1944-1945

Madonna
1945, Portland stone, 167 cm h, signed & dated
(situated between Main Altar and side altar)

Annunciation panel
1945, Portland stone, 91 x 182 cm
(situated over front door of church)

opposite

Candlestick
1945, brass, 1 of 6 (situated on Main Altar)

Main Altar
1945, Connemara marble and white marble,
224 x 348 x 128 cm

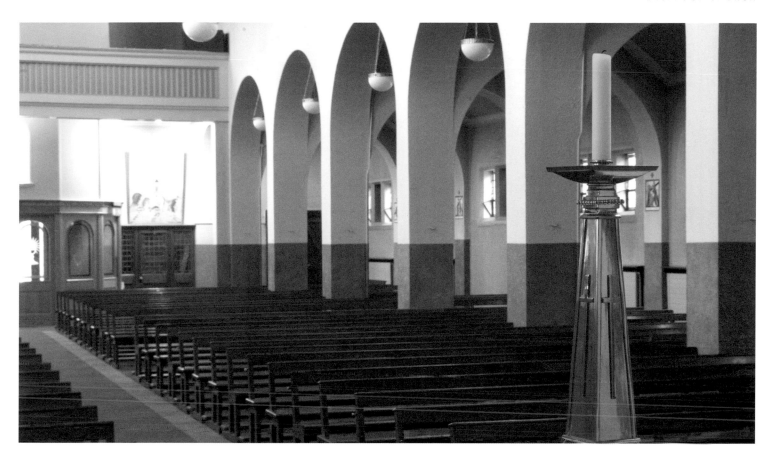

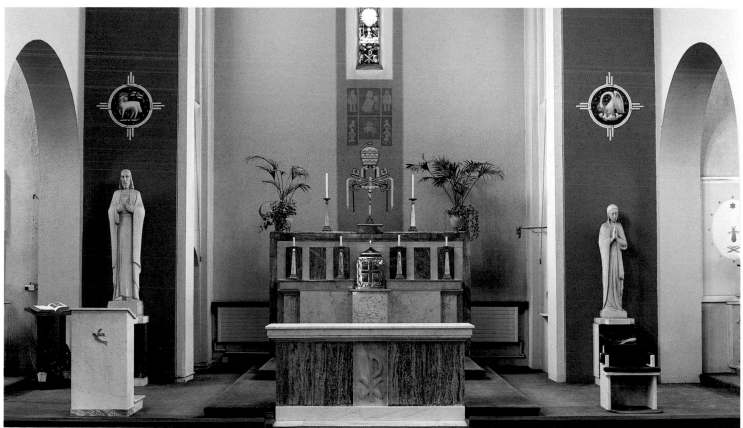

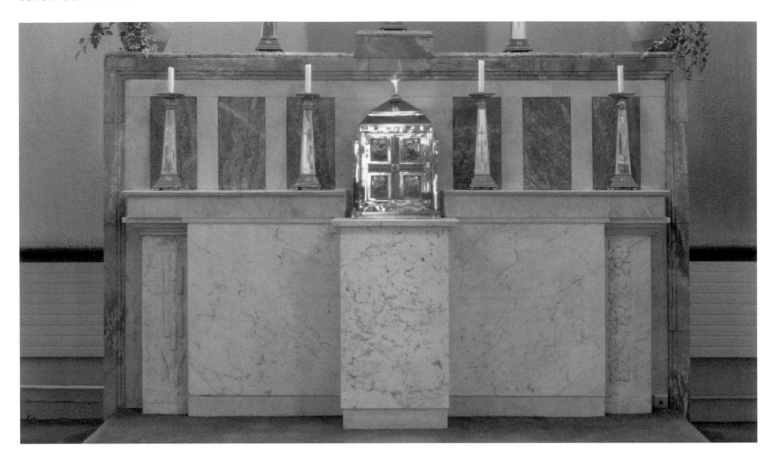

THE HOLY SACRIFICE WILL BE
OFFERED ONCE A MONTH FOR
WILLIAM DWYER
WHO BUILT THIS CHURCH AND
FOR THE OTHER BENEFACTORS
JANUARY 1946

Main Altar
1945, Connemara marble and white marble,
224 x 348 x 128 cm

Baptismal font
1945, marble, 101 x 60 cm

Dwyer plaque
1945, marble, 30 x 63 cm

Holy Water fonts
1945, 4 polished black limestone,
29 x 17 cm (x2), 40 x 22 cm (x2)

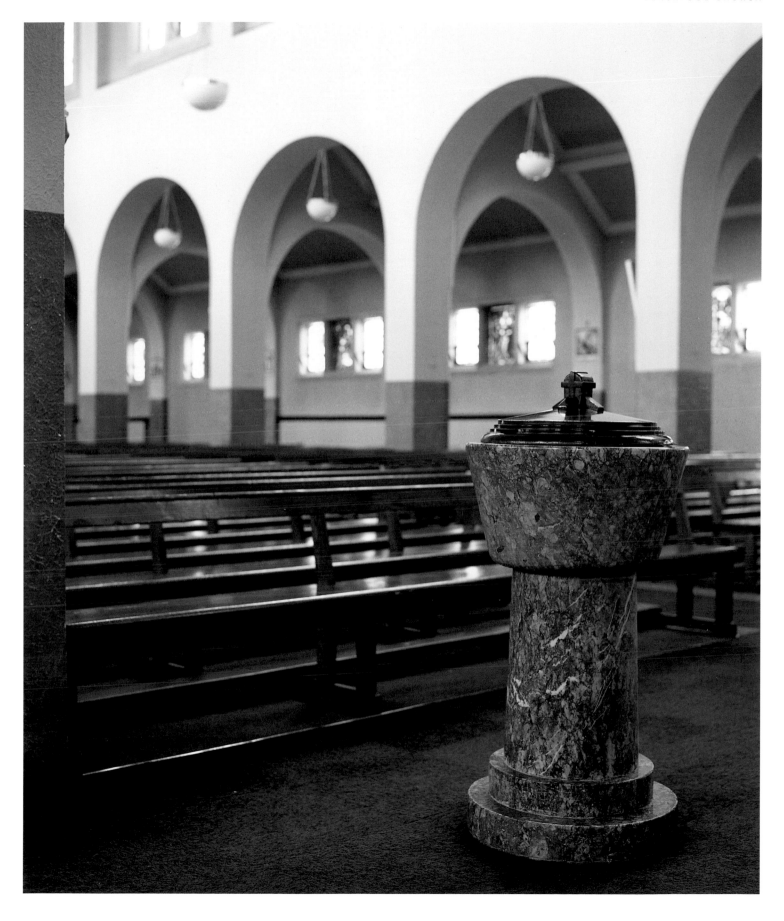

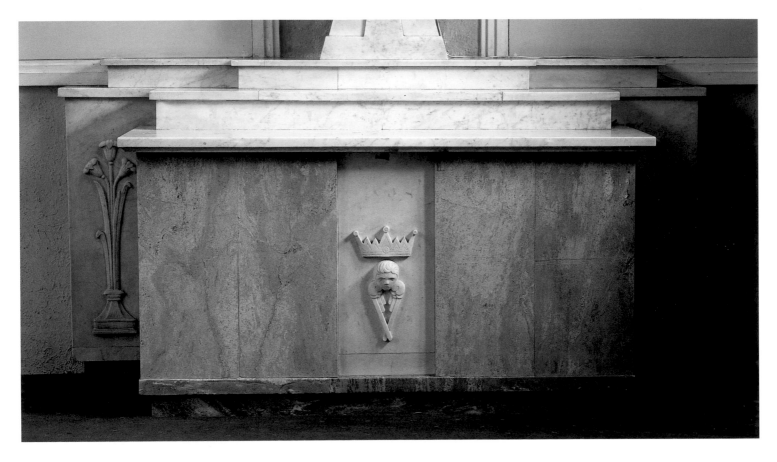

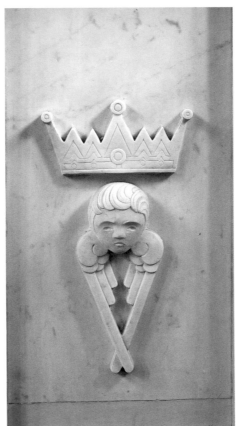

Our Lady's Altar
1945, Connemara marble and white marble,
121 x 223 x 79 cm

opposite

8
Children's Altar
1945, Connemara marble and white marble,
243 x 178 x 81 cm

Angels for Children's Altar
n.d., pencil on paper, 76 x 28 cm

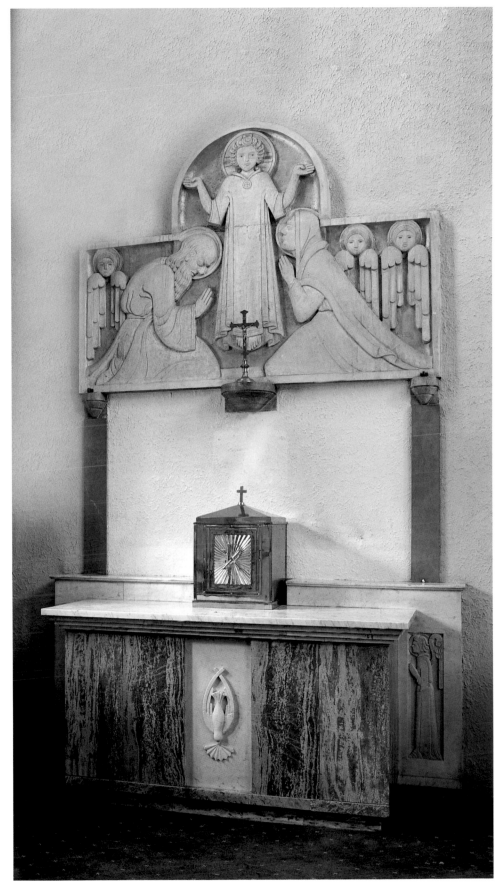

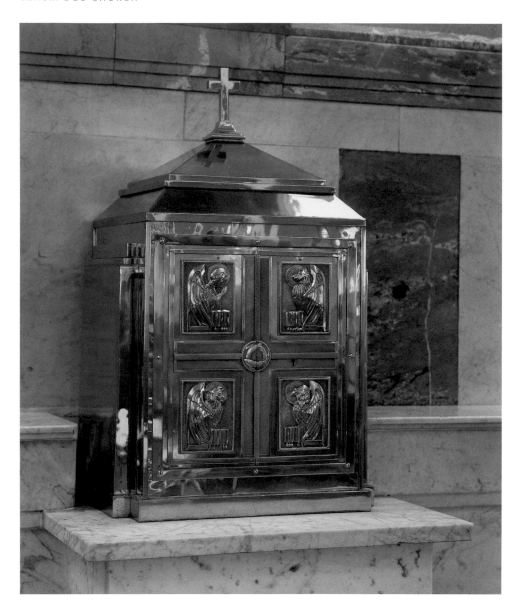

Tabernacle door
1945, brass, 84 x 49 x 42 cm
(situated on Main Altar)

Candlestick
1945, brass, 1 of 6
(situated on Main Altar)

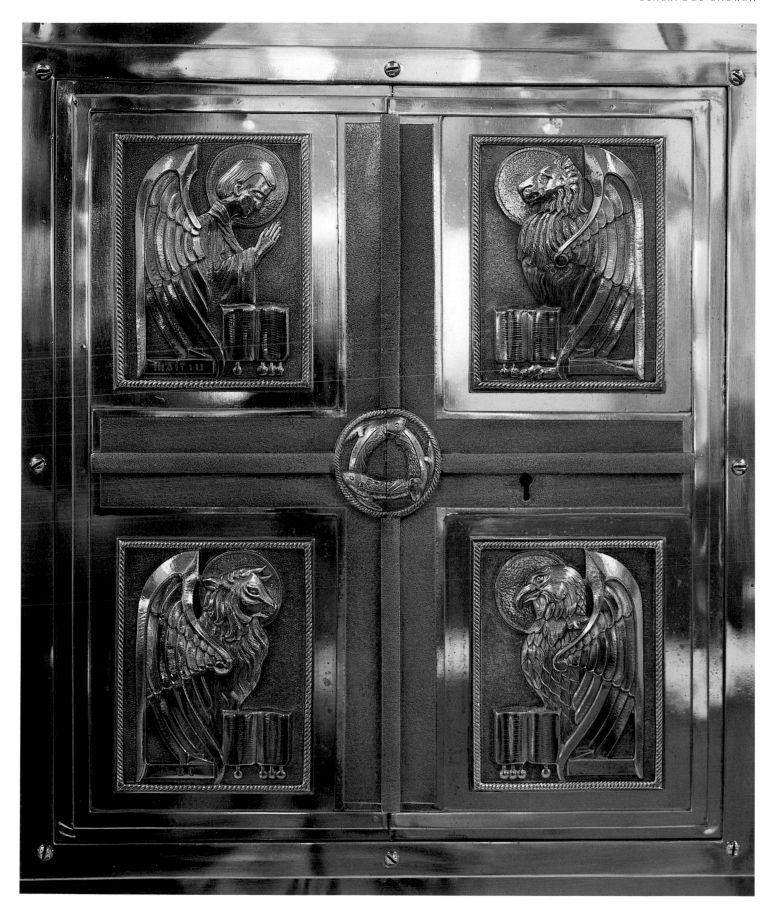

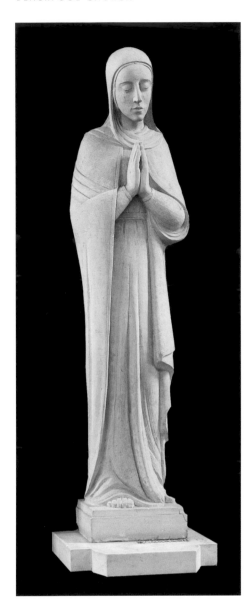
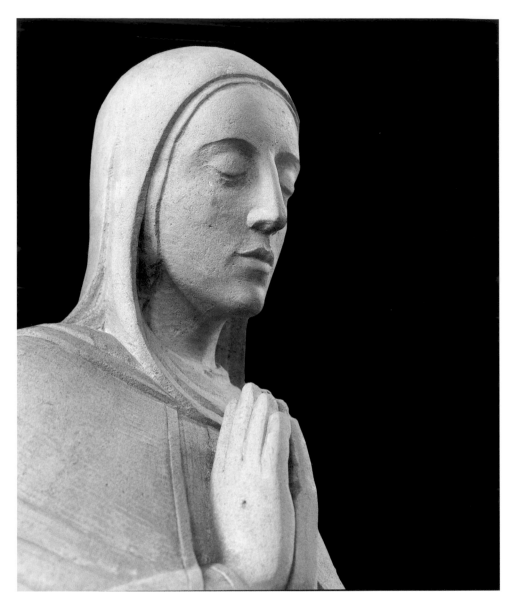

Madonna
1945, Portland stone, 167 cm h, signed & dated
(situated between Main Altar and side altar)

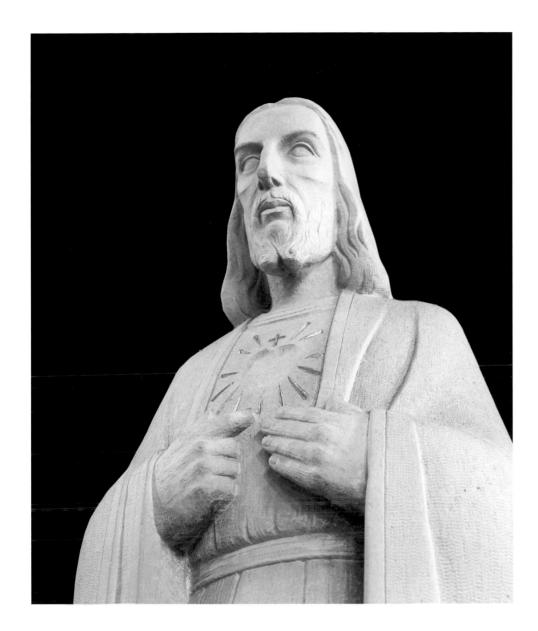 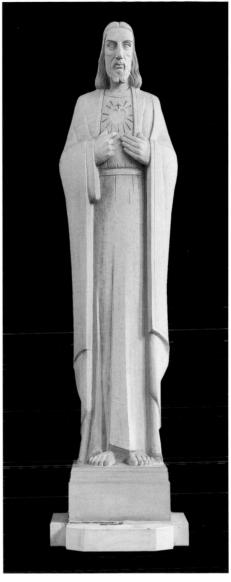

Sacred Heart
1945, Portland stone with a marble base, 182 cm h
(situated between Main Altar and side altar)

38

BLACKPOOL CHURCH

* illustrated here
** plaster version in Crawford Gallery collection

38 *
Church of the Annunciation
Blackpool, Cork, 1944-1945
design: Séamus Murphy
architect: Eddie P O'Flynn
note: The church was donated and built by
William Dwyer in memory of his daughter
Meave. Dedicated 7th October 1945 by the
Bishop of Cork, Most Rev Dr Cohalan
[see pages 104, 106-107, 108]

39 *
Annunciation panel
1945, Portland stone, 91 x 182 cm
note: situated over front door of church
[see page 108]

40
Annunciation plaque
1945, limestone foundation stone, 50 x 76 cm
note: situated on outer front wall of church on
left-hand side
inscription: A.M.D.G. IN HONOUR OF THE
ANNUNCIATION OF THE BLESSED VIRGIN MARY.
THE FOUNDATION STONE OF THIS CHURCH WAS
LAID ON THE 10 JANUARY 1945 BY MOST REV.
DANIEL COHALAN D.D. BISHOP OF CORK

41 *
Baptismal font
1945, marble, 101 x 60 cm
note: wooden lid designed by SM's brother, Bat
[see page 110, 111]

42 *
Children's Altar
1945, Connemara marble and white marble,
243 x 178 x 81 cm
note: designed by SM; made by Messrs Maguire
of Kilnap; Portland stone plaque over this altar
by SM, depicting Holy Family in high relief with
gilded background
[see page 113]

43 *
Dwyer plaque
1945, marble, 30 x 63 cm
note: situated at entrance porch
inscription: THE HOLY SERVICE WILL BY OFFERED
ONCE A MONTH FOR WILLIAM DWYER WHO
BUILT THIS CHURCH AND FOR THE OTHER
BENEFACTORS

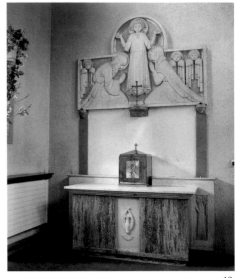

42

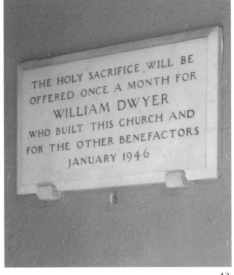

43
44

39
41

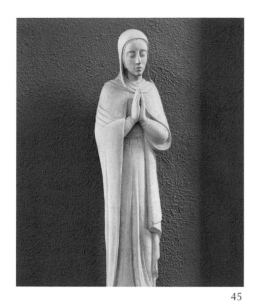

45

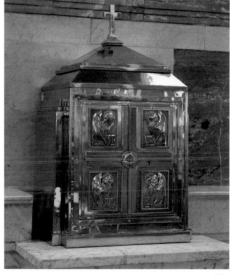

48

44 *
Holy Water fonts
1945, 4 polished black limestone, 29 x 17 cm
(x2), 40 x 22 cm (x2)
[see page 110]

45 *
Madonna
1945, Portland stone, 167 cm h, signed & dated
(situated on between Main Altar and side altar)
[see page 108, 109, 116]

46 *
Main Altar
1945, Connemara marble and white marble,
224 x 348 x 128 cm
note: designed by SM; made by Messrs Maguire
of Kilnap; 2 panels of decorative carving by SM
depicting corn and grapes
[see page 109, 110]

47 *
Our Lady's Altar
1945, Connemara marble and white marble,
121 x 223 x 79 cm
note: designed by SM; made by Messrs Maguire
of Kilnap; decorative carving by SM depicting
crowned angel and foliage
[see page 112]

48 *
Sacred Heart
1945, Portland stone with a marble base,
182 cm h
note: situated between main and side altars **
[see page 109, 117]

49 *
*Tabernacle door, sanctuary lamp,
candlesticks, vases, etc*
1945, brass, tabernacle 84 x 49 x 42 cm
note: designed by SM; made by Messrs
Gunning, Dublin
[see pages 109, 114, 115]

———

46
47

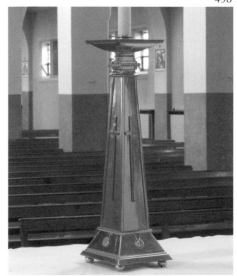

49a
49b

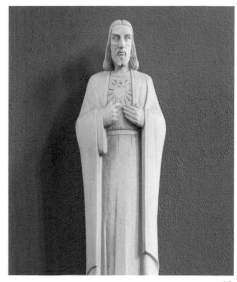

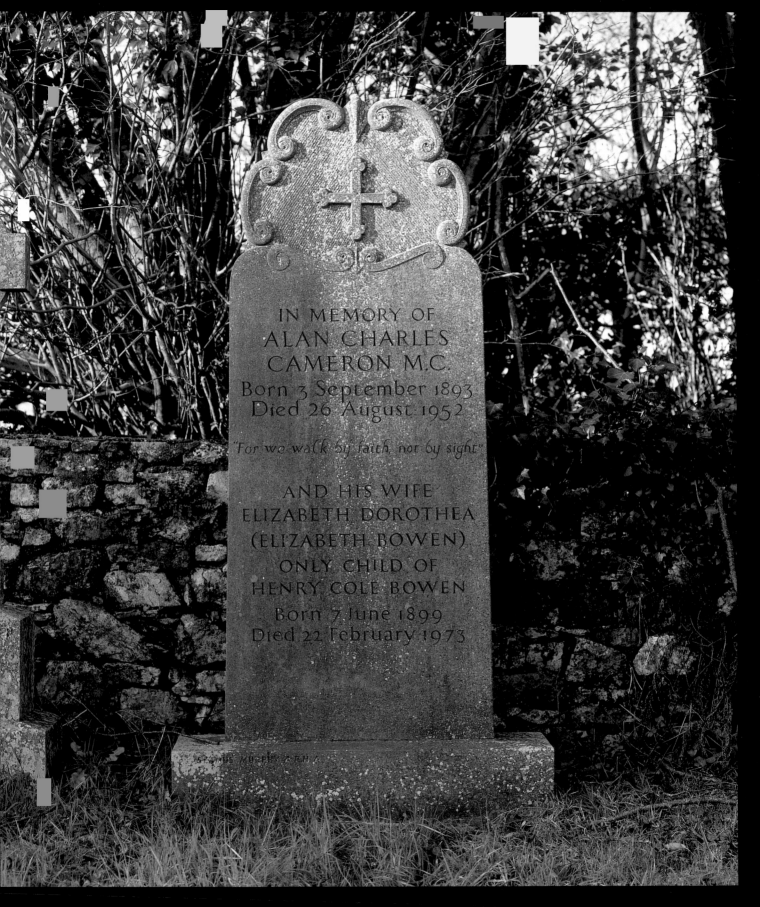

IN MEMORY OF
ALAN CHARLES
CAMERON M.C.
Born 3 September 1893
Died 26 August 1952

"For we walk by faith not by sight"

AND HIS WIFE
ELIZABETH DOROTHEA
(ELIZABETH BOWEN)
ONLY CHILD OF
HENRY COLE BOWEN
Born 7 June 1899
Died 22 February 1973

Alan Charles Cameron M.C. limestone, 183 x 72 cm, signed (Faraghy graveyard, near Kildorrery, Co Cork)

HEADSTONES AND MEMORIALS

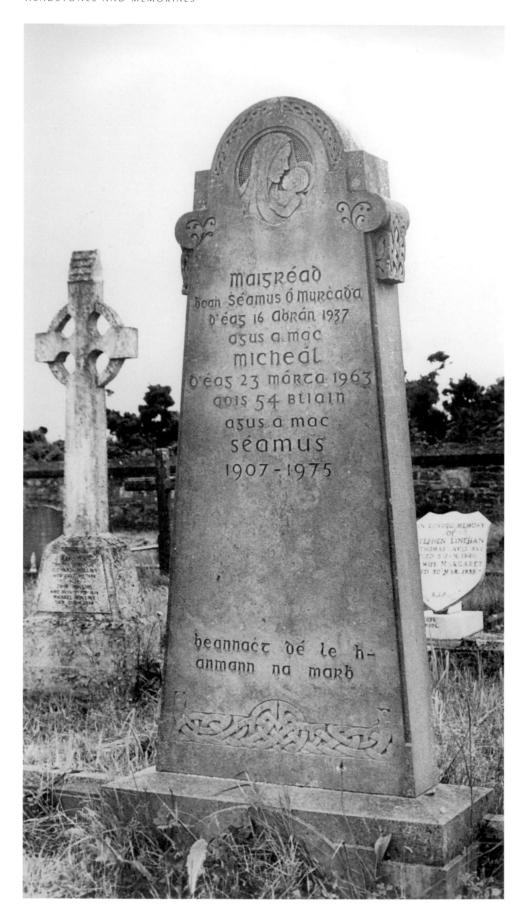

Maighréad Ó Murchadha
[also Séamus Murphy]
limestone, 163 x 69 cm, signed
(Rathcooney graveyard, Cork)

Emily Blair
limestone
(St Finbarr's Cemetery, Cork)

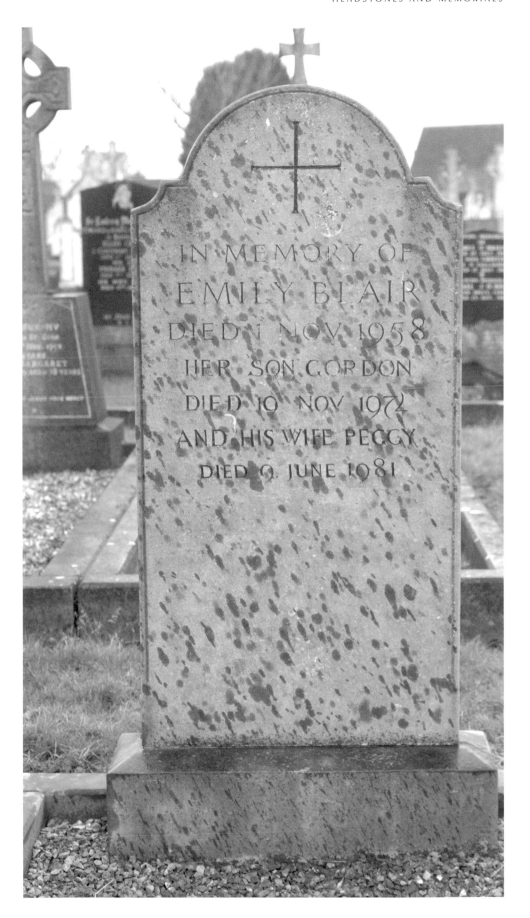

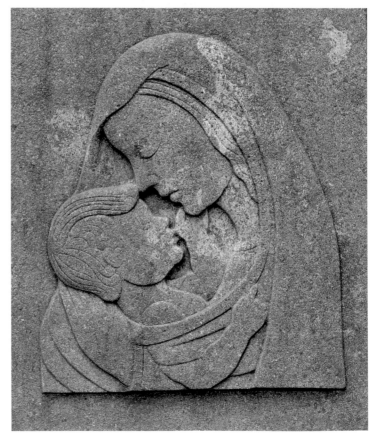

opposite – Details of headstone

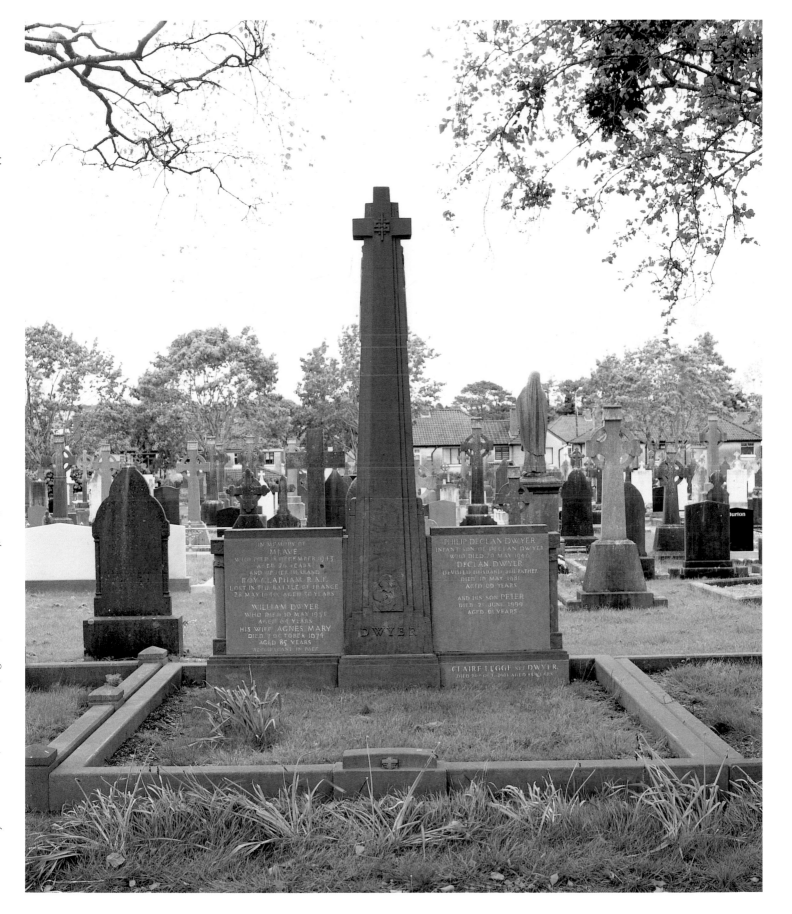

Meave Dwyer limestone, 365 x 279 cm, signed (St Finbarr's Cemetery, Cork)

✠ IN MEMORY OF ✠
WILLIAM D. HAMILTON M.D.
BRUMANA RUSHBROOKE
WHO DIED 25 JUNE 1966
HIS BELOVED WIFE CLAIRE
WHO DIED 28 OCT. 2001

R.I.P.

Henry Patrick Hilser
limestone, 157 x 56 cm, signed
(St Finbarr's Cemetery, Cork)

opposite

William D Hamilton M.D.
limestone, 85 x 91 cm, signed
(St Finbarr's Cemetery, Cork)

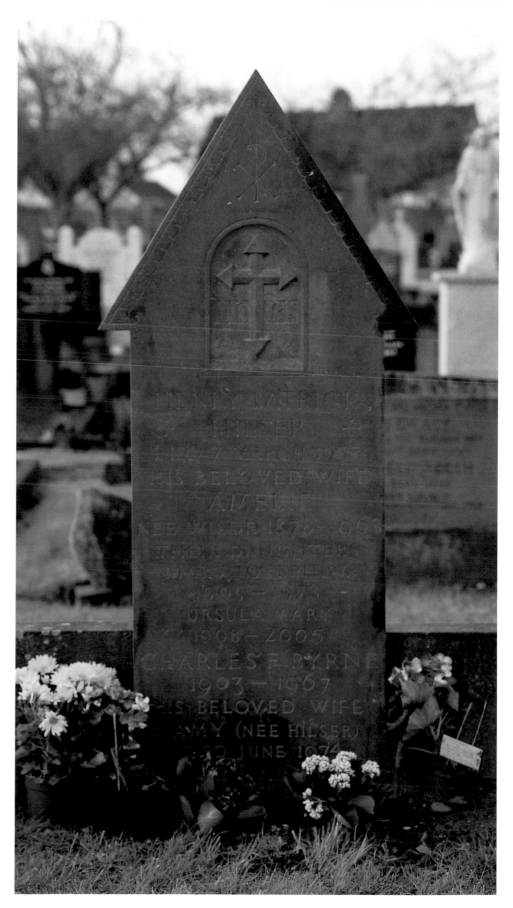

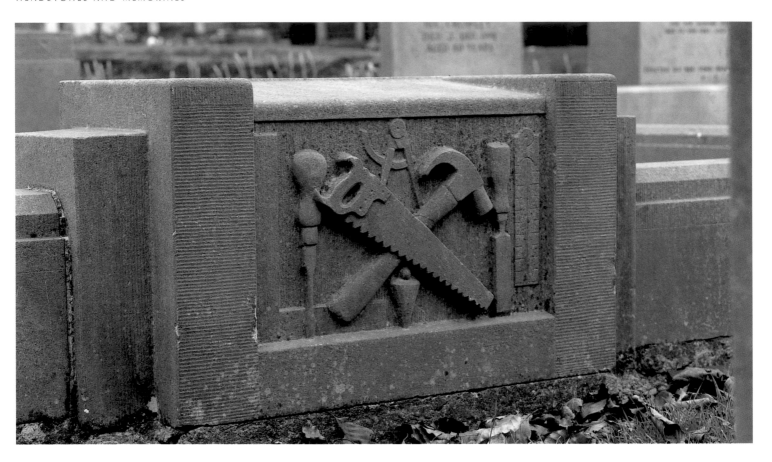

Patrick Joseph Hegarty
limestone, 173 x 74 cm, signed
(St Finbarr's Cemetery, Cork)

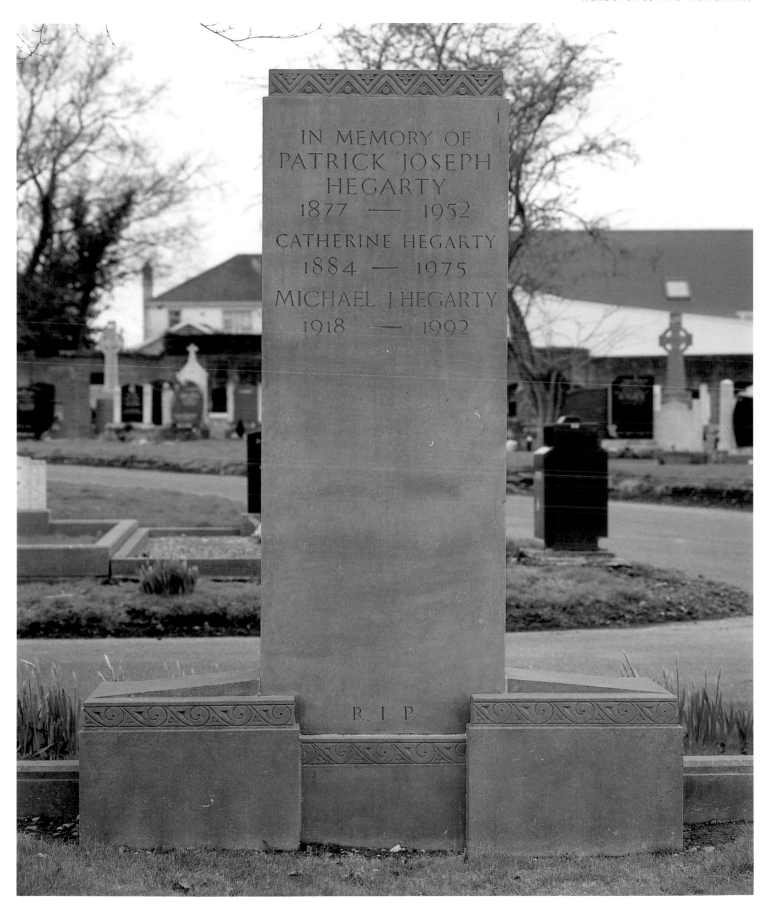

IN MEMORY OF
PATRICK JOSEPH
HEGARTY
1877 —— 1952
CATHERINE HEGARTY
1884 —— 1975
MICHAEL J. HEGARTY
1918 —— 1992

R. I. P.

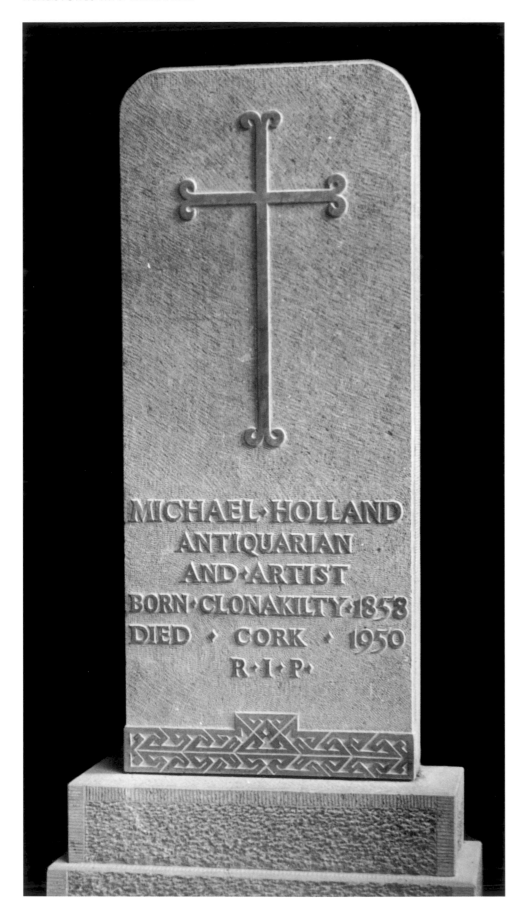

Michael Holland
limestone, 127 x 53 cm, signed
(St Finbarr's Cemetery, Cork)

opposite

John J Horgan
limestone, 129 x 91 cm, signed
(St Finbarr's Cemetery, Cork)

IN MEMORY OF
JOHN J. HORGAN LL.D.
BORN 26 APRIL 1881
DIED 21 JULY 1967
HIS DAUGHTER
JOAN JOSEPHINE
BORN 18 JULY 1926
DIED 25 OCTOBER 1967
AND HIS WIFE
MARY
BORN 6 OCTOBER 1895
DIED 22 OCTOBER 1972

R.I.P.

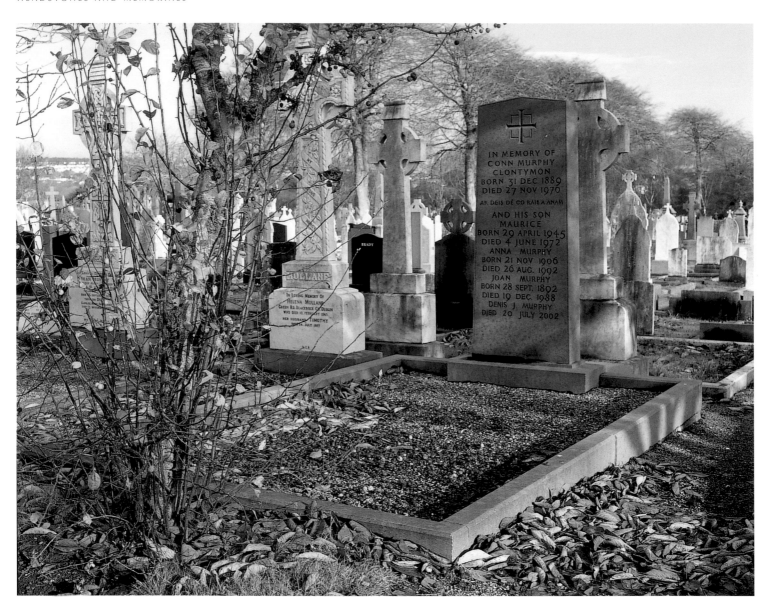

Conn Murphy
limestone, 152 x 74 cm, signed
(St Finbarr's Cemetery, Cork)

Patrick A ('Weesh') Murphy
limestone, 147 x 74 cm, signed
(St Finbarr's Cemetery, Cork)

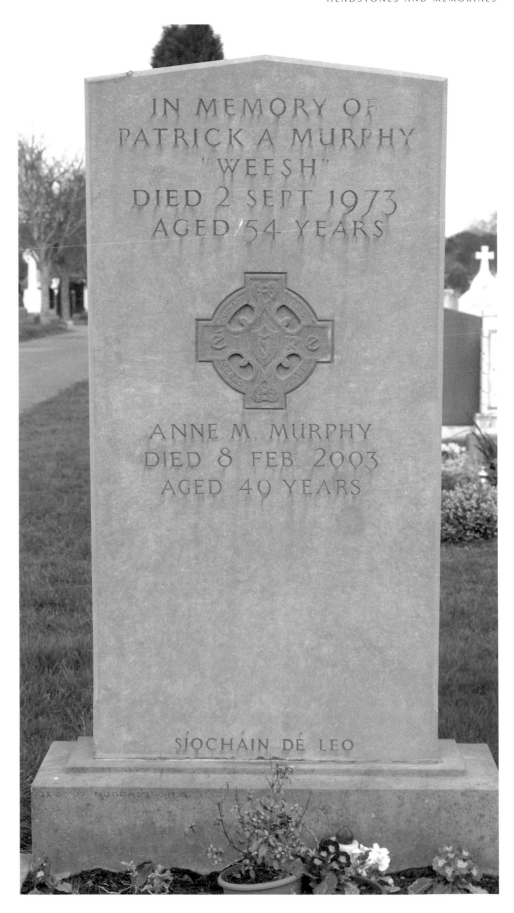

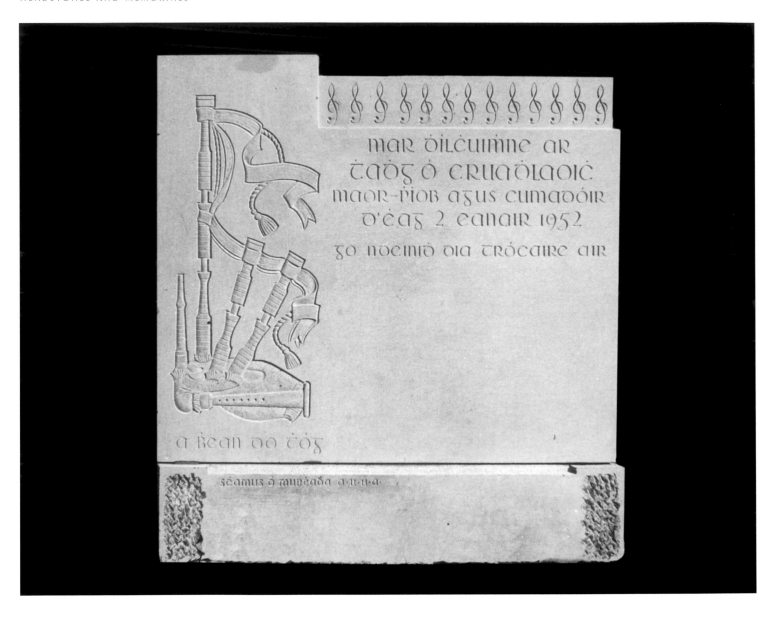

Tadhg Ó Cruadhlaoich
limestone, 99 x 71 cm, signed
(St Finbarr's Cemetery, Cork)

Párthalán Ó Murchadha
limestone, 99 x 71 cm, signed
(St Finbarr's Cemetery, Cork)

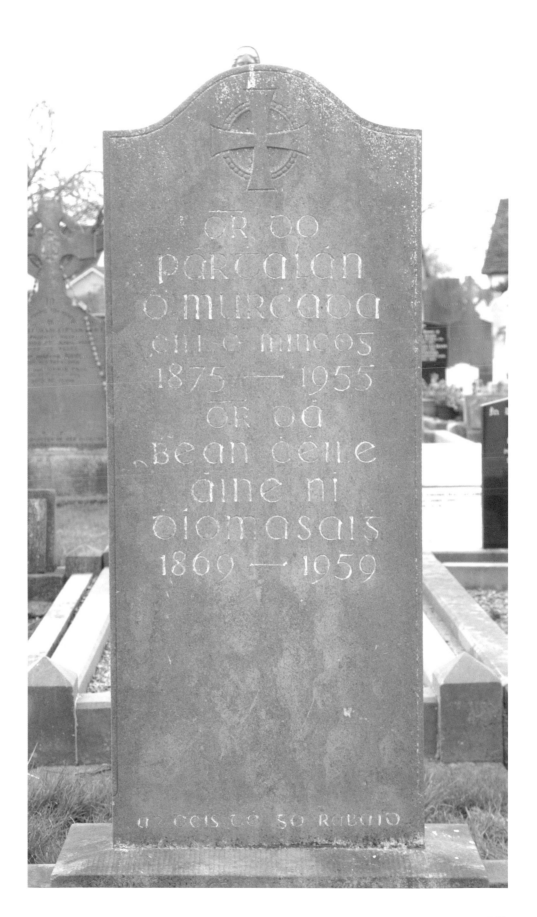

Michael O'Riordan
limestone, 137 x 61 cm, signed
(St Finbarr's Cemetery, Cork)

opposite

Domhnall Ó Corcora [Daniel Corkery]
limestone, 152 x 69 cm, signed
(St Joseph's Cemetery, Ballypheane, Cork)

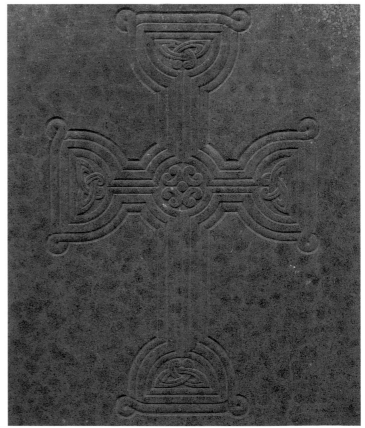

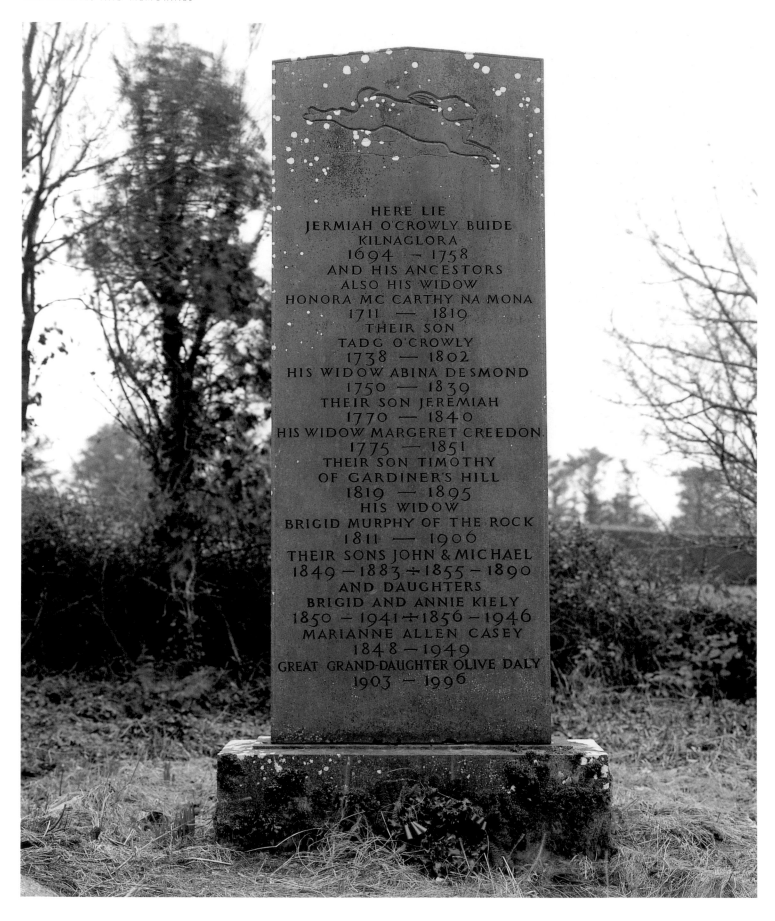

HERE LIE
JERMIAH O'CROWLY BUIDE
KILNAGLORA
1694 — 1758
AND HIS ANCESTORS
ALSO HIS WIDOW
HONORA MC CARTHY NA MONA
1711 — 1819
THEIR SON
TADG O'CROWLY
1738 — 1802
HIS WIDOW ABINA DESMOND
1750 — 1839
THEIR SON JEREMIAH
1770 — 1840
HIS WIDOW MARGERET CREEDON
1775 — 1851
THEIR SON TIMOTHY
OF GARDINER'S HILL
1819 — 1895
HIS WIDOW
BRIGID MURPHY OF THE ROCK
1811 — 1906
THEIR SONS JOHN & MICHAEL
1849 — 1883 ÷ 1855 — 1890
AND DAUGHTERS
BRIGID AND ANNIE KIELY
1850 — 1941 ÷ 1856 — 1946
MARIANNE ALLEN CASEY
1848 — 1949
GREAT GRAND-DAUGHTER OLIVE DALY
1903 — 1996

Seán Ó Riada [composer]
limestone, 170 x 74 cm, signed
(St Gobnait's graveyard, Cúil Aodha, Co Cork)

opposite

Jermiah O'Crowly
limestone, 238 x 95 cm, signed
(Waterfall graveyard, Cork)

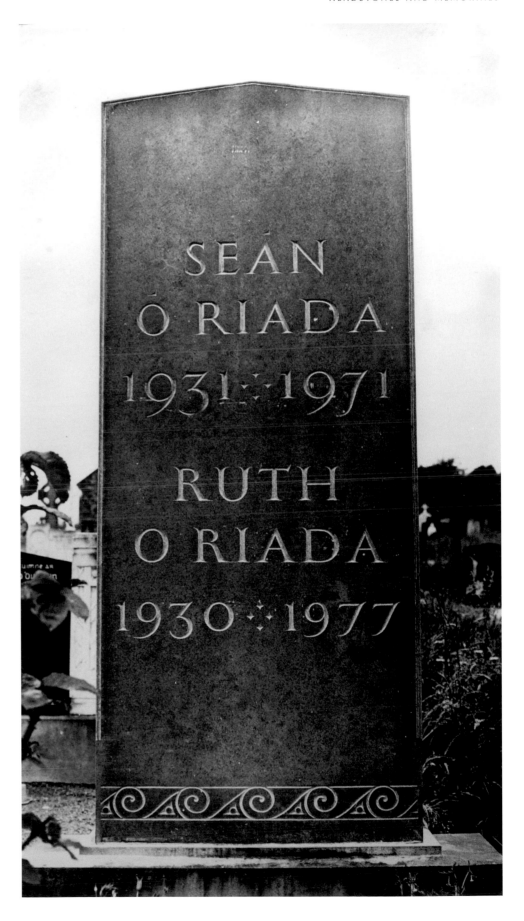

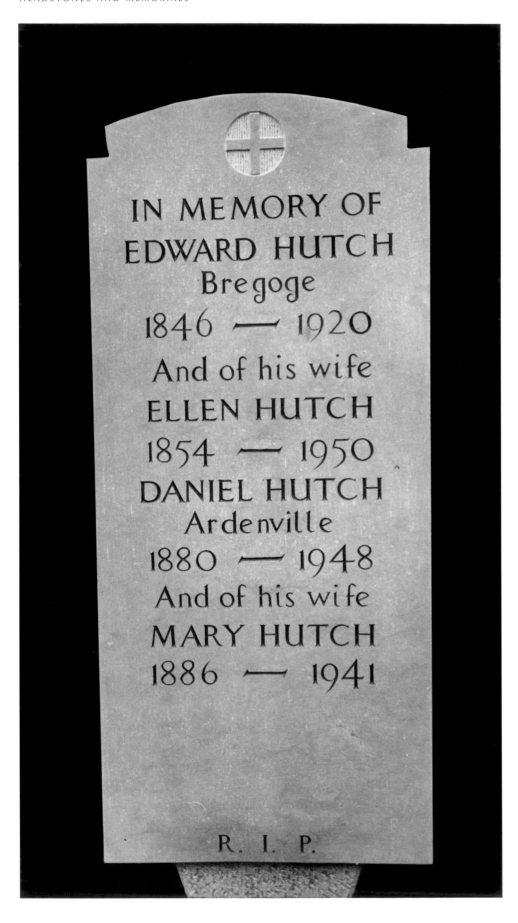

Edward Hutch
limestone, 136 x 61 cm, signed
(St Mary's Cemetery, Buttevant, Co Cork)

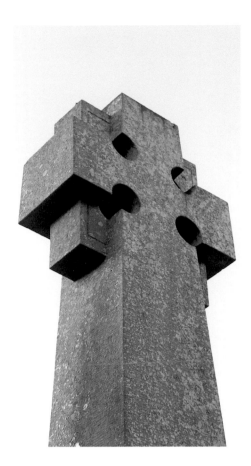

Seán Clarach Mac Domhnaill
limestone cross, 304 cm h
(Holy Cross Cemetery, Charleville, Co Cork)
`

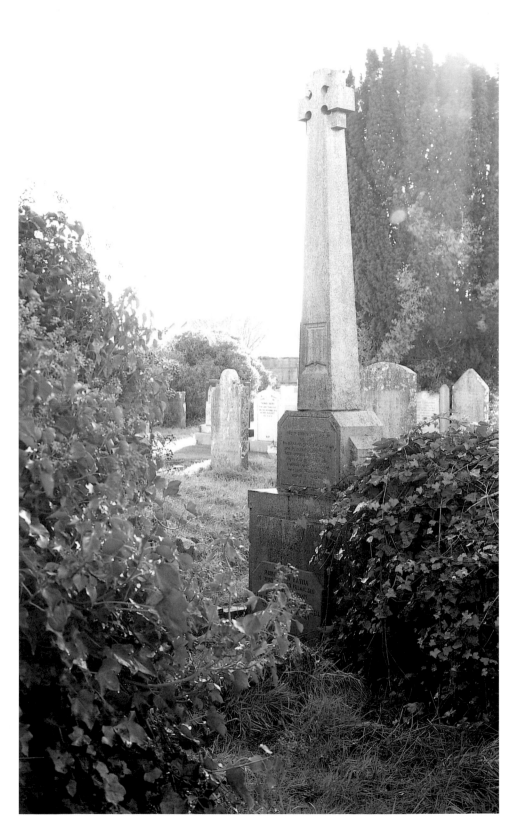

William Bernard Nagle
limestone, 135 cm; 2 side stones 99 cm (total
length 267 cm), signed
(St Mary's churchyard, Buttevant, Co Cork)

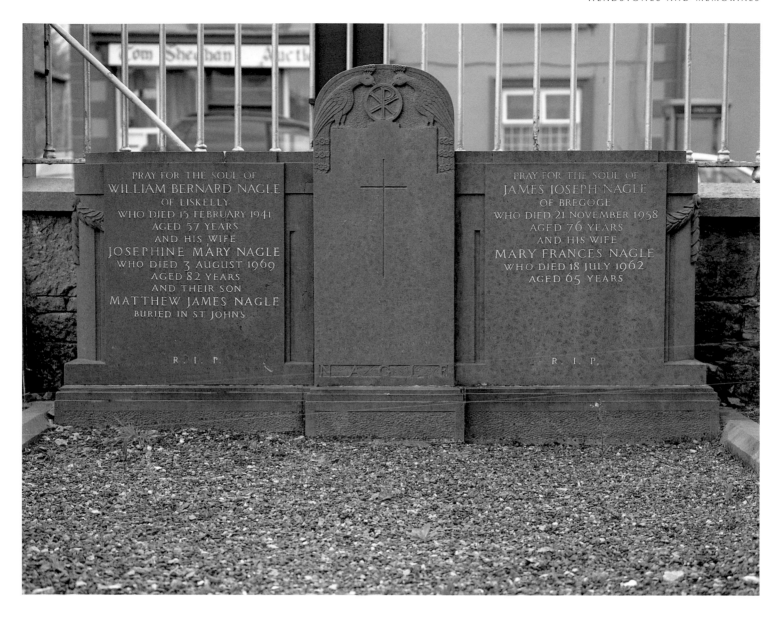

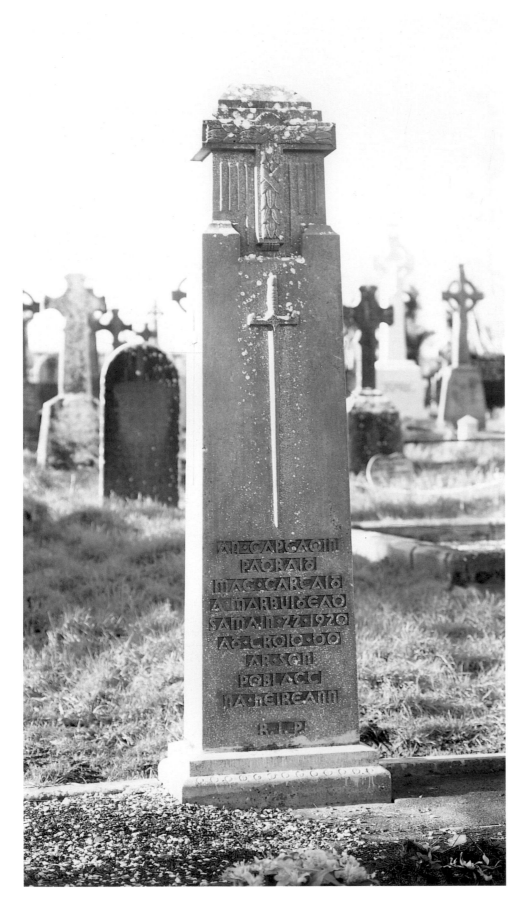

Captain Pádraig Mac Carthaig
limestone, 244 x 61 cm
(Newmarket graveyard, Clonfert, Co Cork)

Dan Mehigan
limestone celtic cross, 167 x 60 cm, signed
(St Patrick's Cemetery, Kanturk, Co Cork)

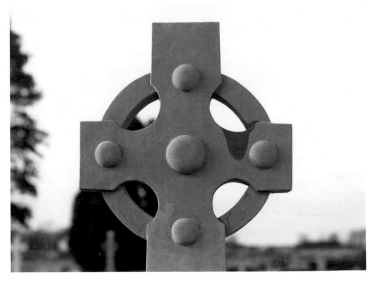

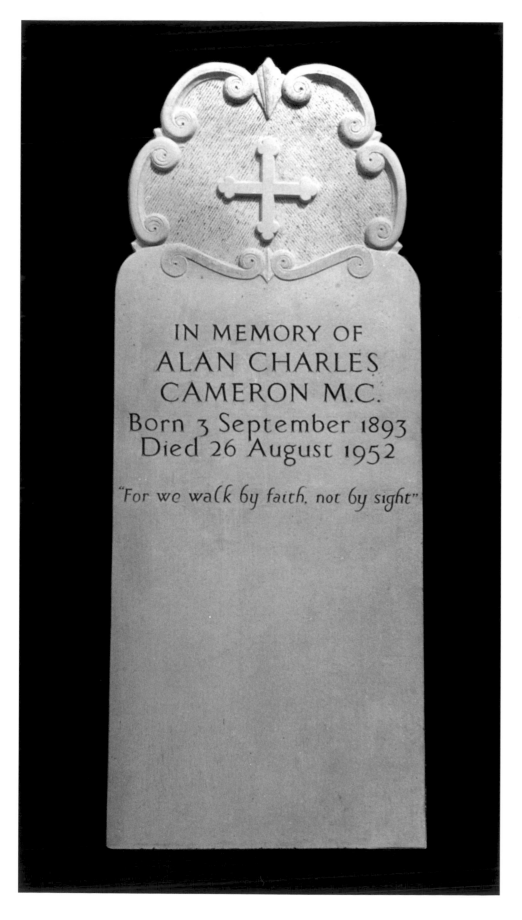

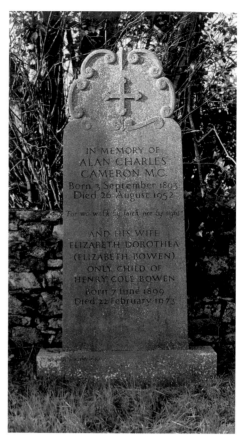

Alan Charles Cameron M.C.
limestone, 183 x 72 cm, signed
(Faraghy graveyard, near Kildorrery, Co Cork)

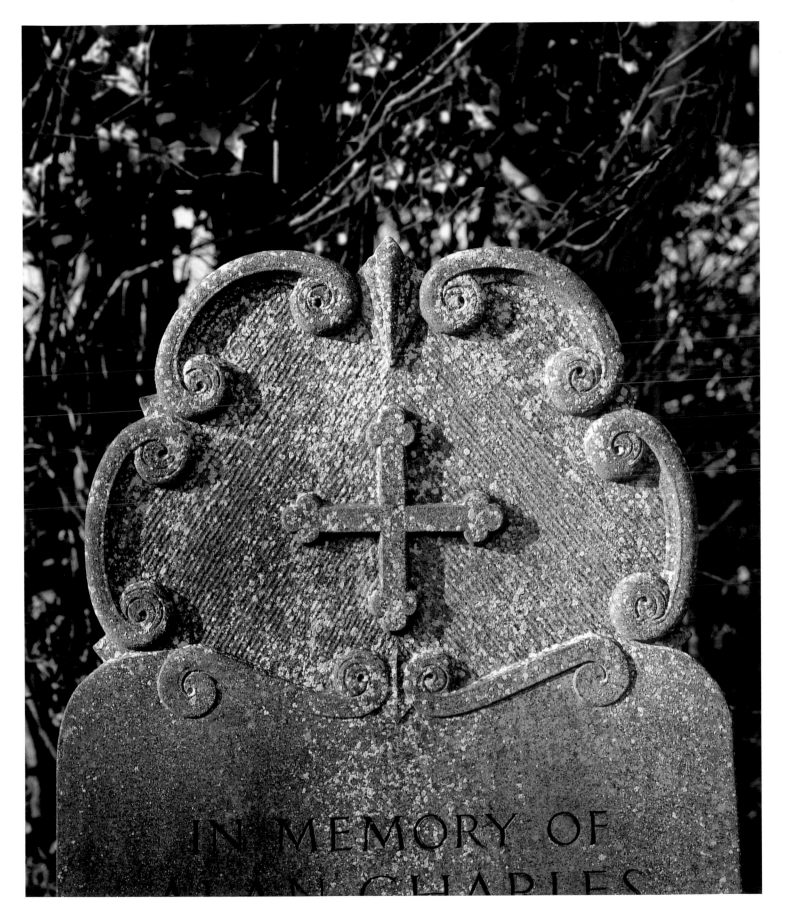

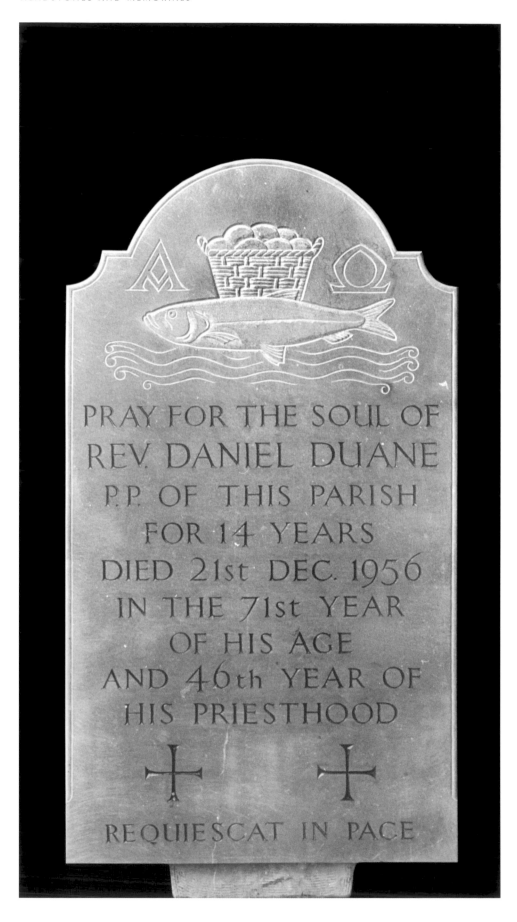

Rev Daniel Duane
limestone, 127 x 70 cm, signed
(Milford churchyard, Co Cork)

opposite

Bridget Fitzgerald
limestone, cross 182 cm h, signed
(Mitchelstown RC graveyard, Co Cork)

Paddy Browne
limestone, 91 x 58 cm
(near Kilshehane, Listowel-Tralee Road, Co Kerry)

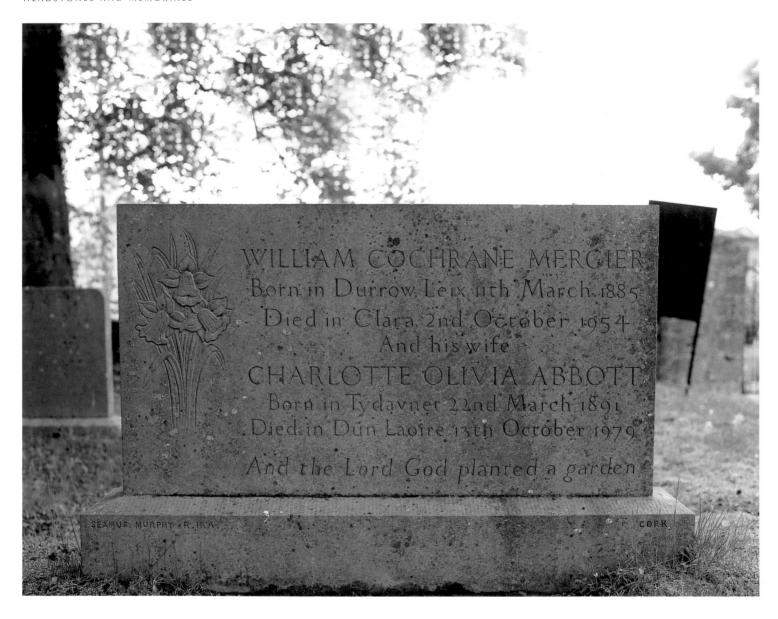

William Cochrane Mercier
limestone, 68 x 127 cm, signed
(St Brigid's Church of Ireland graveyard, Clara,
Co Offaly)

opposite

Daniel Breen 1894-1969
Irish Republican Army
limestone, 169 x 76 cm, signed
(Donohill graveyard, Tipperary town)

Eleanor Lucy [wife of John Keane]
limestone, 84 x 76 cm, signed
(St Declan's graveyard, Ardmore, Co Waterford)

opposite

Sir John Keane, Baronet of Cappoquin
limestone, 84 x 76 cm, signed
(St Declan's graveyard, Ardmore, Co Waterford)

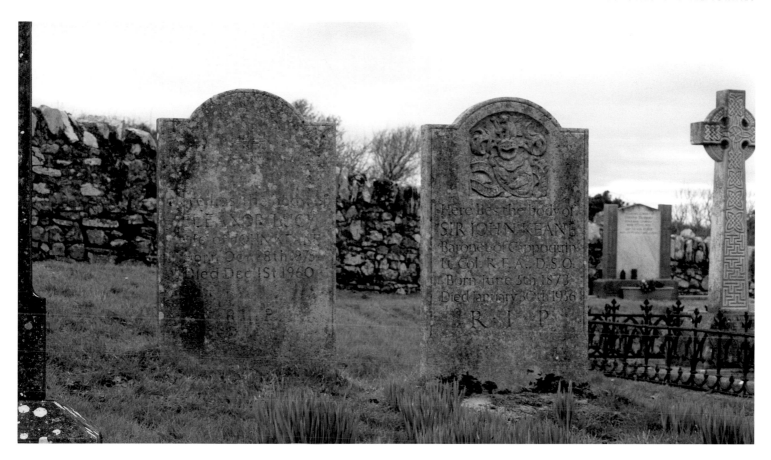

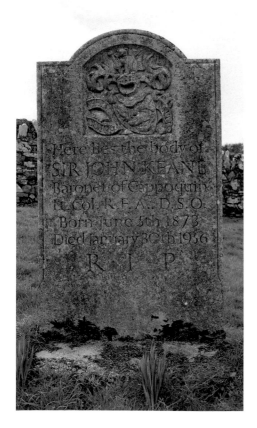

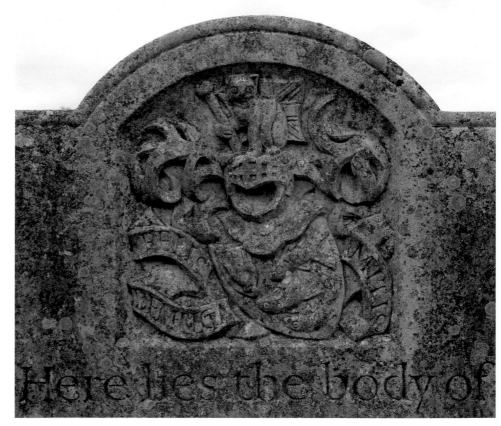

MEMORIALS

St Eltin's graveyard
– Gateposts and Cross
n.d., limestone
(St Eltin's graveyard, Kinsale, Co Cork)

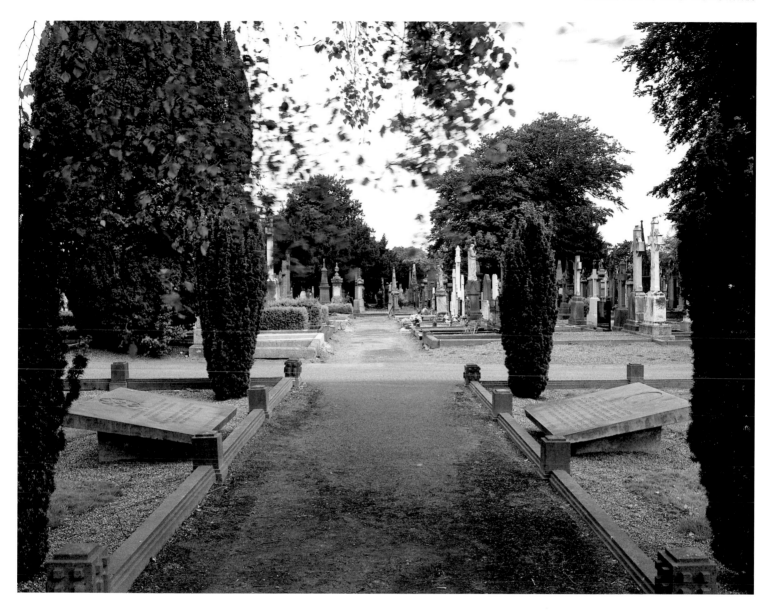

United Nations Memorial
1970, limestone, 2 tablets, each 127 x 122 cm
(Glasnevin Cemetary, Dublin / commissioned by
Dept of Defence)

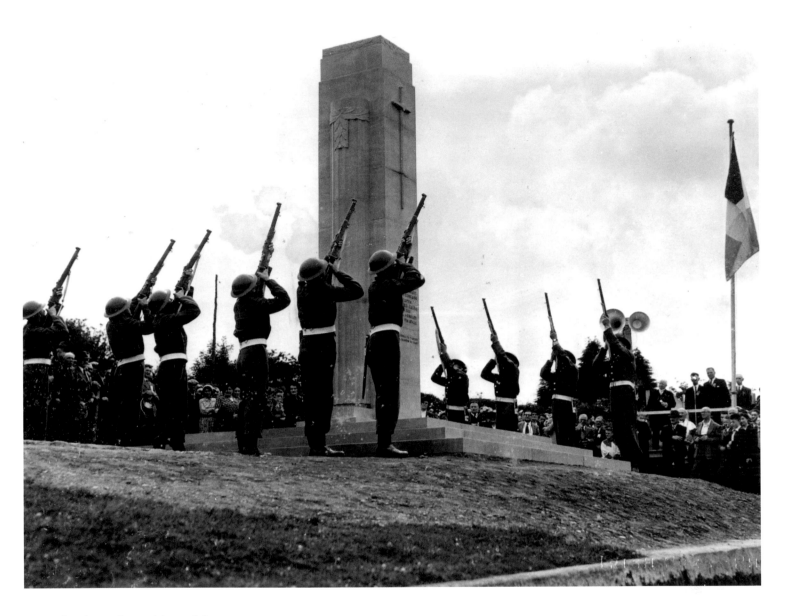

War of Independence Memorial,
Bandon – IRA, Cork No.3 Brigade
1953, 427 x 76 cm, signed

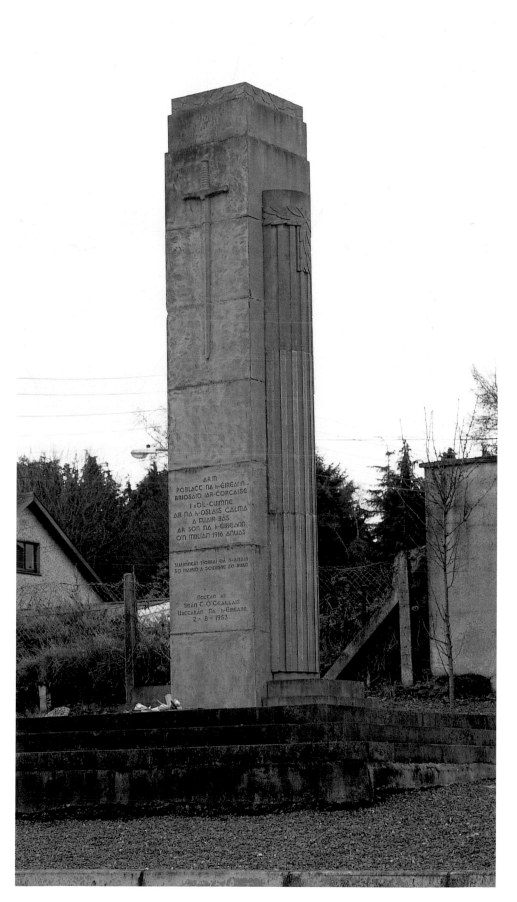

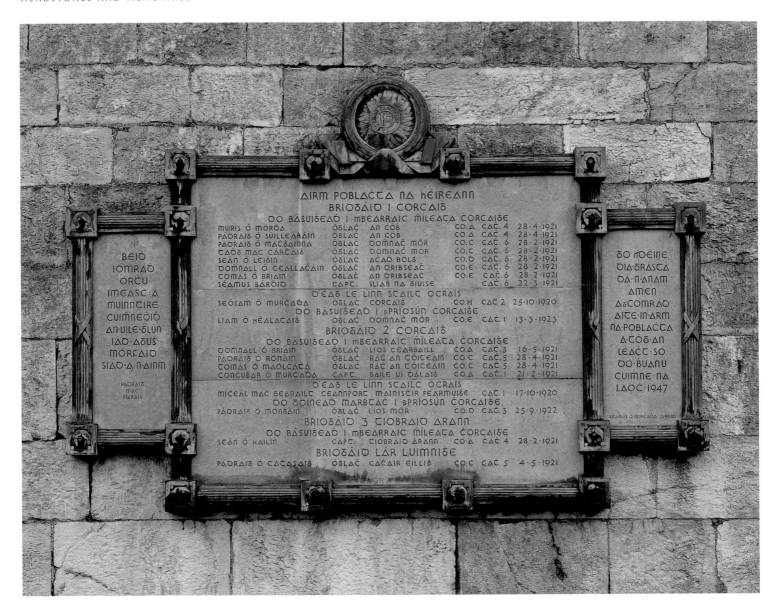

War of Independence Memorial, Cork
1947, limestone with bronze surround,
221 x 323 cm, signed
(Gaol Cross, University College Cork)

opposite

War of Independence Memorial,
Leemount
n.d., limestone cross, 260 cm, signed
(Leemount, Cork)

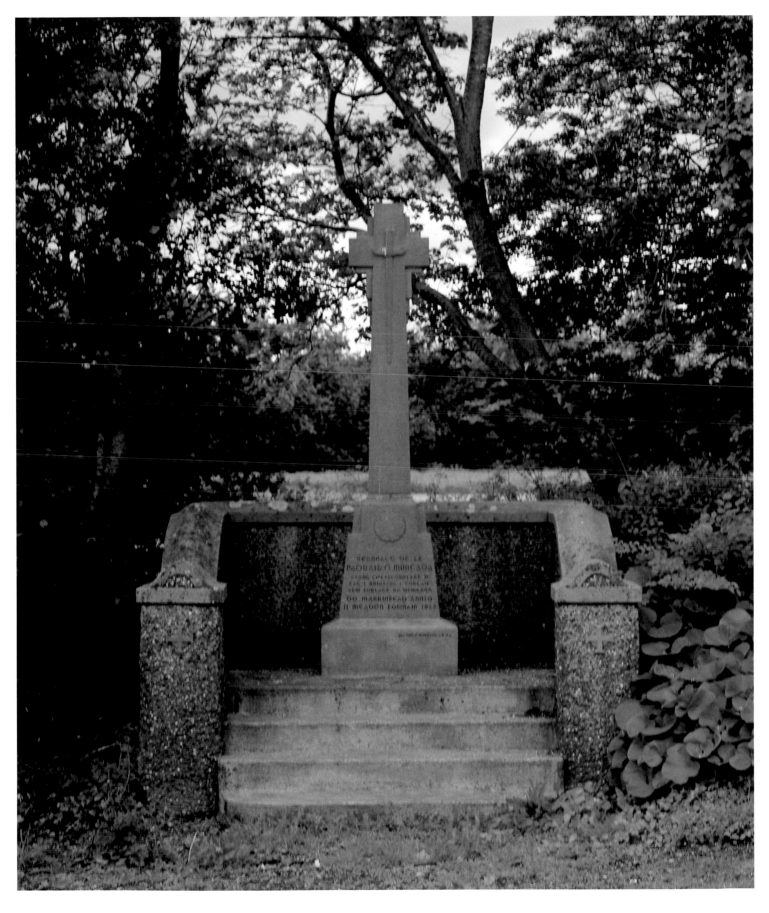

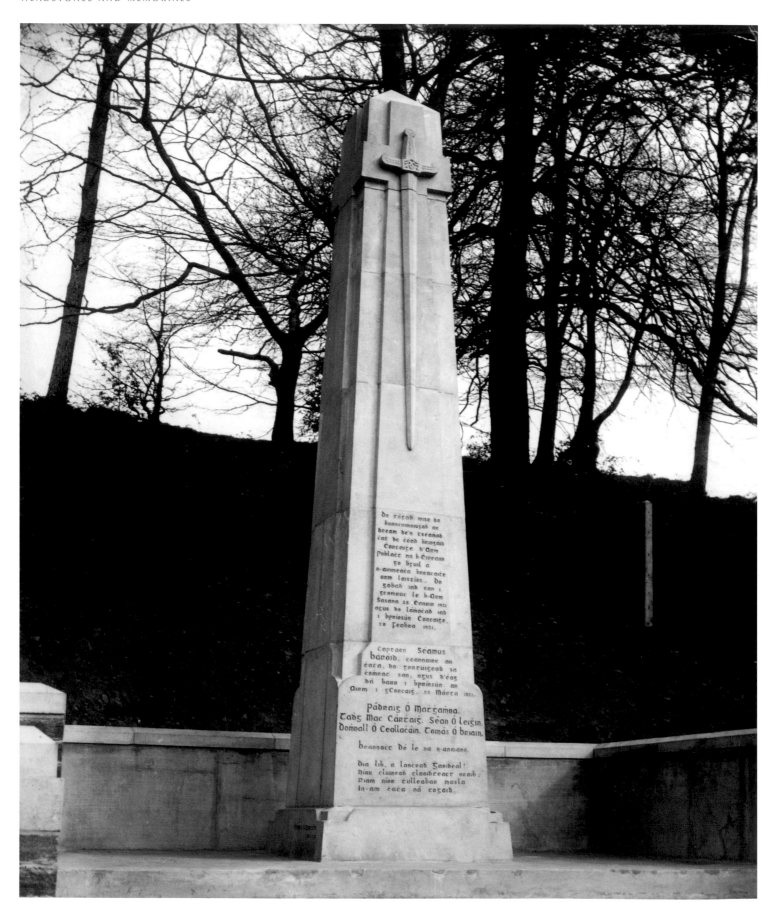

*War of Independence Memorial,
Dripsey*
1938, limestone, 548 x 99 cm, signed
(Dripsey, Co Cork [site of ambush])

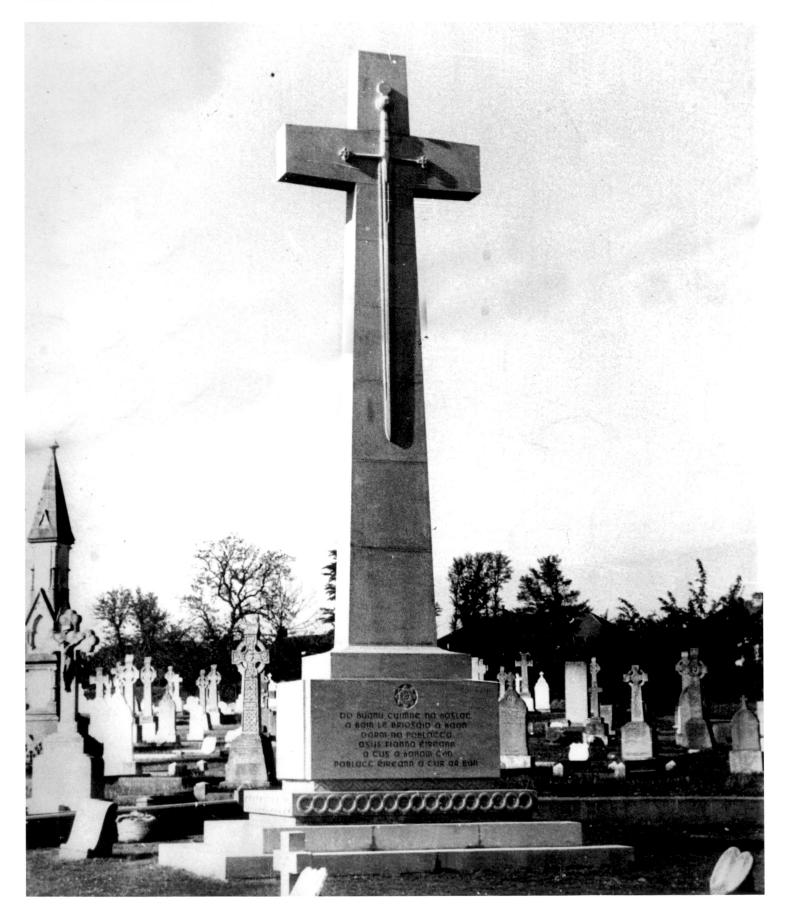

War of Independence Memorial,
St Finbarr's – IRA, Cork No.1 Brigade
1963, limestone cross, 578 x 198 cm
(St Finbarr's Cemetery, Cork)

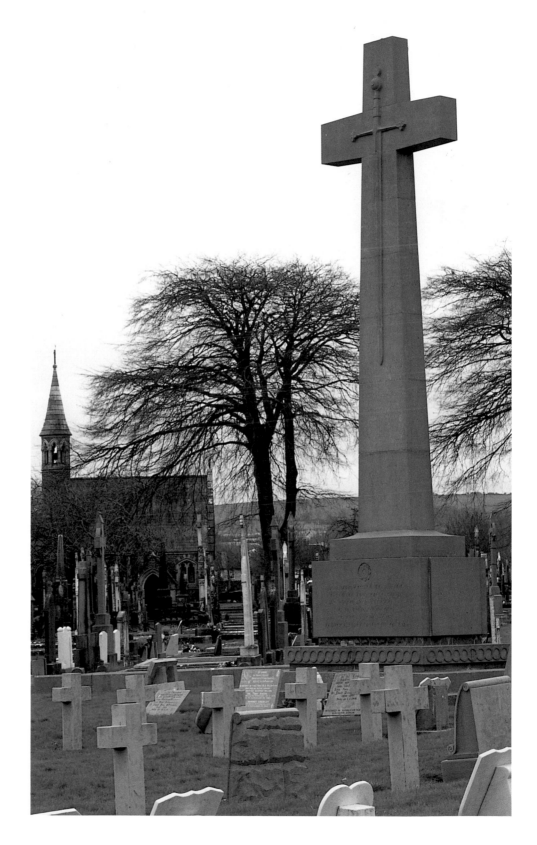

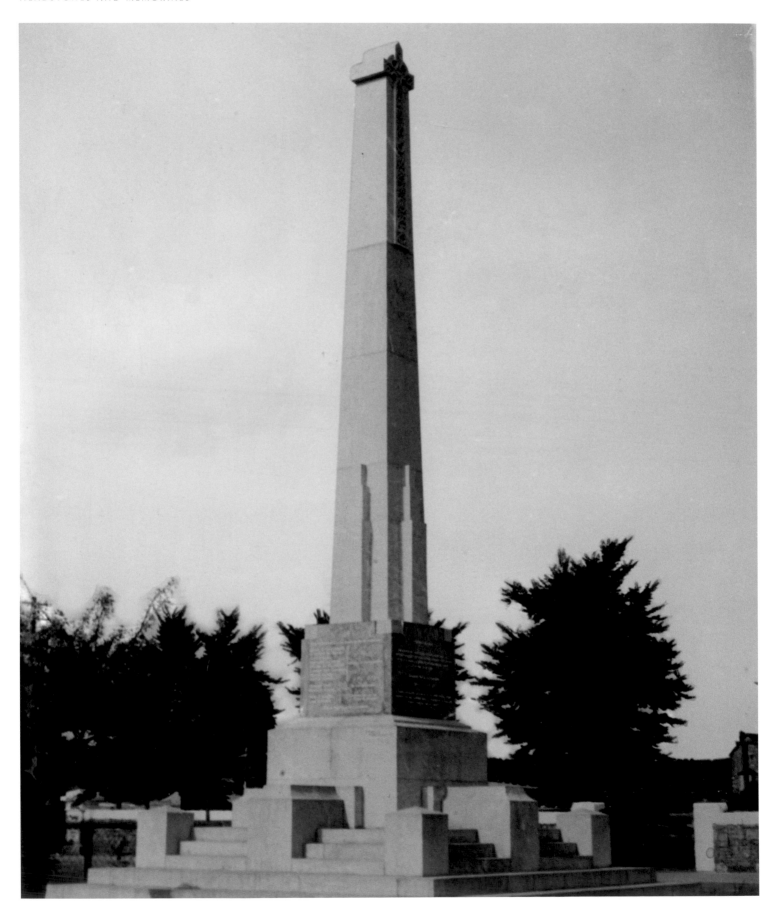

War of Independence Memorial, Midleton designed 1932 / erected 1939, limestone obelisk, 10.67 m h, signed (Midleton, Co Cork)

72

75

78

73
74

76
77

79
80

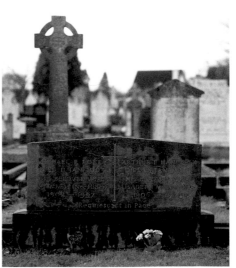

IN MEMORY OF
GERALDINE GAMBLE
BORN 14 JAN. 1911
DIED 8 SEPT. 1971
AND HER HUSBAND
HENRY CHRISTOPHER GAMBLE
BORN 23. DEC. 1908
DIED 4 AUG. 1990
THEIR SON IN LAW
DR. MICHAEL DUNNE
BORN 6. SEPT. 1939
DIED 20. OCT. 2003

81

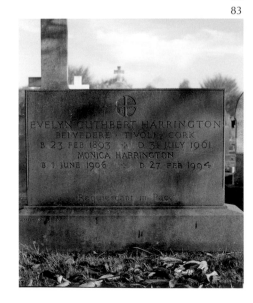

82
83

78 *
Laurence Egar
limestone, 145 x 68 cm
note: signed; inscription: first name and dates
by SM; later addition by another carver

79 *
Daniel Flynn
limestone, 153 x 71 cm
note: signed; 2 names and AR DHEIS DE GO
RAIBH A N-ANAM by SM; further inscription by
another carver

80 *
*Michael F Foley and
Arthur E Hancock*
limestone, 52 x 71 cm, signed

81 *
Geraldine Gamble
limestone, 135 x 72 cm, signed

82 *
William D Hamilton M.D.
limestone, 85 x 91 cm, signed
carving: salmon above inscription
[see page 126]

83 *
Evelyn Cuthbert Harrington
limestone, 71 x 122 cm, signed

84 *
Francis William Harrington
limestone, 66 x 81 cm, signed

85 *
Patrick Joseph Hegarty
limestone, 173 x 74 cm, signed
carving: elaborate cross on rear of headstone;
diaper pattern sides; carpenter's tools on
footstone
[see pages 128-129]

86 *
Michael Joseph Henchy
limestone, 152 x 91 cm, signed
carving: cross above inscription

87 *
Seán Hendrick
limestone, 160 x 76 cm, signed
carving: panel of wild rose above inscription;
second inscription by Ken Thompson

88
A Henley
limestone, 132 x 71 cm, signed

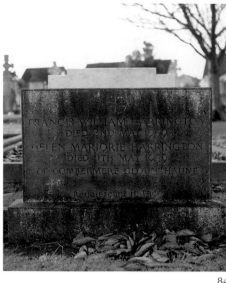

84

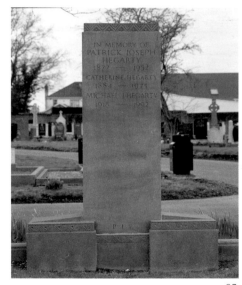

85
86

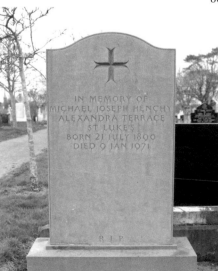

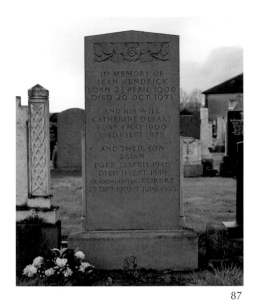

87

92

89 *
John Herrick
limestone, 132 x 91 cm, signed

90
M Higgins
limestone, 122 x 104 cm, signed
note: first 2 names by SM; later inscriptions by
another carver

91 *
Henry Patrick Hilser
limestone, 157 x 56 cm
note: designed by Ursula Hilser
carving: roof and pine trees on side stones
[see page 127]

92 *
Michael Holland
limestone, 127 x 53 cm, signed
carving: cross and lettering in high relief
[see page 130]

93 *
John J Horgan, LLD
limestone, 129 x 91 cm, signed
[see page 131]

94
C Kavanagh Murphy
limestone, 38 x 117 cm, signed

95
JJ Kearney
limestone, 122 x 69 cm, signed
carving: circle containing profile of Virgin and
10 panels from litany on sides

96 *
Michael Keating
limestone, 183 x 117 cm, signed
note: completed by Ken Thompson after death
of SM

97
MJ Kelly
limestone, 135 x 53 cm, signed
carving: ship's wheel base beading

98
B Kennedy
limestone, 171 x 76 cm, signed

99 *
*Kathleen Lyndon
and Gertrude Lyndon*
limestone, 51 x 122 cm, signed
carving: cross dividing four inscribed names

89
91

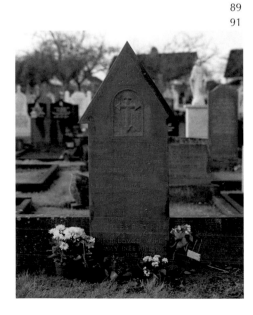

93
96

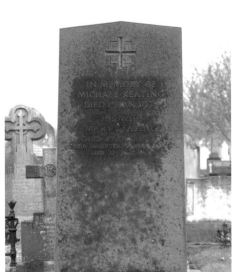

99

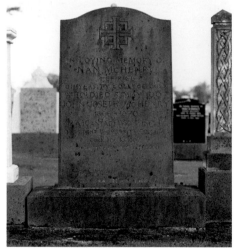

102
103

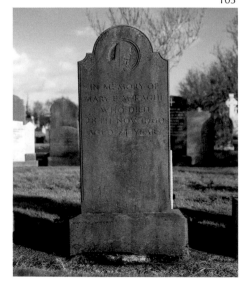

100
E MacCarthy
limestone, 66 x 79 cm, signed

101
E McGrath
limestone, 94 x 79 cm; 2 panels, each panel
81 x 26 cm, signed
inscriptions: include Patrick ('Pa') McGrath,
former Lord Mayor of Cork
carving: above inscription is monogram 'IHS';
high-relief crosses on side panels

102 *
Nan McHenry
limestone, 122 x 17 cm, signed
note: also JJ McHenry, former president, UCC
carving: celtic cross on rear

103 *
Mary E McKague
limestone, 127 x 61 cm, signed
carving: profile of Virgin above inscription

104
B Martin
limestone, 129 x 69 cm, signed

105 *
Conn Murphy
limestone, 152 x 74 cm, signed
[see page 132]

106
Rev F Murphy
granite stone with leaded lettering, 122 x 53 cm

107 *
Patrick A ('Weesh') Murphy
limestone, 147 x 74 cm, signed
inscription: TOGTHA AG CUMANN LÚ CHLEAS
GAEL DO'N PHOBAL AGUS DO'S NA HIDÉIL
NÁISIUNTA I RITH IOMLÁN A SHAOIL. SÍOCHÁIN
DÉ LEO
carving: circle with cross and GAA crest
[see page 133]

108
J O'Brien
limestone, 122 x 71 cm, signed
carving: decorative band at lower edge

109
M O Coindealbhain
limestone, 91 x 66 cm, signed
carving: decorative band at lower edge

110 *
James O'Connell
limestone, 155 x 76 cm, signed

105

107
110

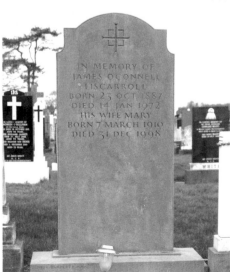

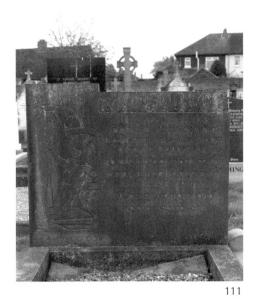

111

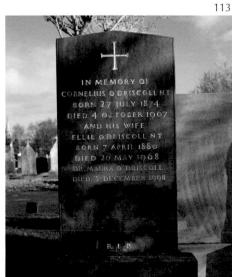

112
113

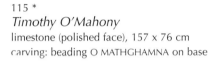

111 *
Tadhg Ó Cruadhlaoich
limestone, 99 x 71 cm, signed
carving: war pipes left of inscription; decorative
border of treble clefs
[see page 134]

112 *
James O'Dowd
limestone, 114 x 76 cm, signed

113 *
Cornelius O'Driscoll N.T.
limestone, 137 x 71 cm, signed

114
S Ó Laoghaire
limestone, 135 x 69 cm, signed
inscription: 4 names and BEANNACHT DÉ LENA
ANAM by SM; other inscriptions by another
carver

115 *
Timothy O'Mahony
limestone (polished face), 157 x 76 cm
carving: beading O MATHGHAMNA on base

116 *
Domhnall Ó Maolcatha
limestone, 94 x 46 cm, signed
carving: deep-cut stylised cross above inscription

117 *
Párthalán Ó Murchadha
limestone, 137 x 53 cm, signed
[see page 135]

118 *
Michael O'Riordan
limestone, 137 x 61 cm
[see page 136]

119
JA O'Sullivan
limestone, 152 x 69 cm, signed

120
P O'Sullivan
limestone cross, 127 cm h, signed

121 *
Mary Pyne
limestone, 122 x 58 cm, signed
carving: italic lettering; decorative features

122 *
St Vincent's Hostel
limestone, 107 x 74 cm, signed
note: gravestone for those who lived there

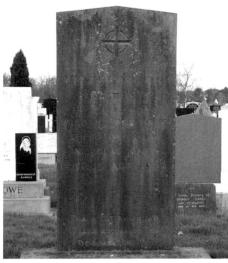

115

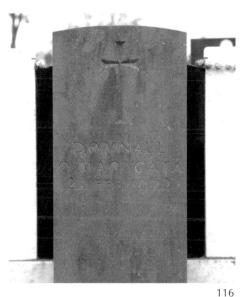

116
117

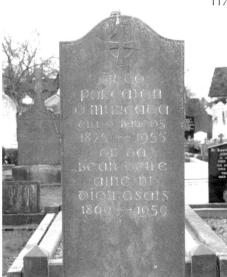

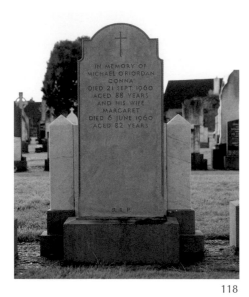

118

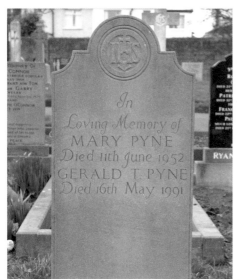

121
122

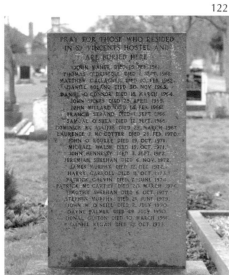

123 *
Carola Sierick
limestone, 45 x 60 cm, signed

124
J Sisk
limestone, 183 x 71 cm

125
D Stewart
limestone, 112 x 61 cm, signed

126 *
Daniel F Sullivan
limestone

127
Marcella Tierney
limestone, 163 x 76 cm, signed

128 *
George Frederick Waters
limestone, 74 x 86 cm, signed

129 *
Anne Winning
limestone, 84 x 104 cm, signed

130
J Woodward
polished limestone, signed

131
Lt. Col. G Wright
green marble, 37 x 61 cm

———

St Finbarr's Cemetery – Musicians' Corner

132 *
[Sir] Arnold Bax, Composer
1953, limestone, 122 x 84 cm, signed
carving: lyre above inscription; decorative celtic
work on sides of stone

133
A Fleischmann
limestone, 142 x 85 cm, signed
carving: organ pipes

134
S Neeson
limestone, 79 x 14 cm, signed
carving: harp

———

123

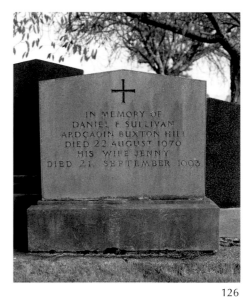

126
128

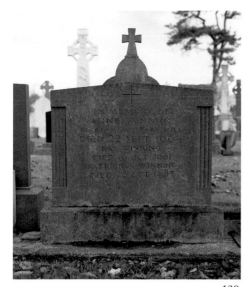

129

138

St Joseph's Cemetery, Ballyphehane, Cork

135
C Hayes
limestone, 121 x 106 cm, signed

136
W MacCarthy
limestone, 145 x 69 cm, signed
carving: profile of Virgin encircled

137 *
Murphy Family, Killeens
limestone
carving: 2 angels, cross in centre and decorative border

138 *
Domhnall Ó Corcora [Daniel Corkcry]
limestone, 152 x 69 cm, signed
carving: circular celtic motif above inscription
[see page 137]

139 *
Seán Ó Cuilleanáin
limestone, 185 x 91 cm, signed

140
A O'Sullivan
limestone, 124 x 70 cm, signed

————

Waterfall graveyard, Bishopstown, Cork

141 *
Jermiah O'Crowly
limestone, 238 x 95 cm, signed
carving: hare above inscription
[see page 138]

————

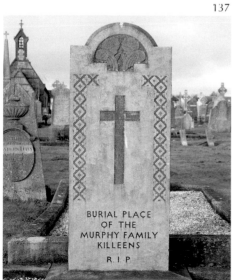

132
137

139
141

CORK COUNTY

Ballincollig	St Mary's & St John's
Ballydesmond, near	Kiskeam graveyard
Ballyhooly	see Fermoy
Ballymacoda	see Youghal
Ballyvourney	St Gobnait's graveyard, Cúil Aodha
Bandon	St Patrick's graveyard
Bantry	RC graveyard
Blarney, near	St Mary's Cemetery, Kerrypike
Buttevant	St John's graveyard
	St Mary's Cemetery
	St Mary's churchyard
Carraig na Bhfear	Dunbolg graveyard
Castlehaven	see Skibbereen
Castleventry	see Clonakilty
Charleville	Holy Cross Cemetery
Clonakilty	St Mary's graveyard
Clonakilty, near	Castleventry graveyard
Clonfert	Newmarket graveyard
Cobh	St Colman's Cemetery
Crosshaven	St Patrick's graveyard
Cúil Aodha	see Ballyvourney
Dunbolg	see Carraig na Bhfear
Faraghy	see Kildorrery
Fermoy, near	Ballyhooly churchyard
Glantane	see Mallow
Gougane Barra	
Kanturk	St Patrick's Cemetery
Kerrypike	see Blarney
Kildorrery, near	Faraghy graveyard
Kinsale	St Eltin's graveyard
Kiskeam	see Ballydesmond
Leap	Myross graveyard
Mallow, near	St John's graveyard, Glantane
Milford	
Minane Bridge	
Mitchelstown	RC graveyard
Myross	see Leap
Newcestown (Na Reatha)	St John the Baptist churchyard
Newmarket	see Clonfert
Rath Luirc	see Charleville
Sherkin Island	Franciscan Abbey
Skibbereen	Castlehaven graveyard
Youghal	Ballymacoda churchyard

Ballincollig
– St Mary's & St John's churchyard

142
A Higgins (brother of Joseph Higgins, sculptor, father-in-law of SM)
limestone, 41 x 97 cm, signed

144

147
148

near Ballydesmond
– Kiskeam graveyard

143
S Moylan TD
limestone, 90 x 122 cm, signed
carving: geometric pattern of lines and circles above inscription and ornate cross

Ballyvourney –
St Gobnait's graveyard, Cúil Aodha

144 *
Seán Ó Riada [composer]
limestone, 170 x 74 cm, signed
carving: spiral pattern at lower edge; inscription for Ruth Ó Riada by Ken Thompson
[see page 139]

145
D Ó Ceochain
limestone, 135 x 56 cm, signed
carving: profile of Virgin above inscription

Bandon
– St Patrick's graveyard

146
E MacCarthy
limestone, 127 x 56 cm
inscription: AND I TOOK ROOT IN AN HONOURABLE PEOPLE Eccles. 24.14.16
carving: cross beading

147 *
Aodh Ó Néill, Canonach
limestone cross, 304 cm h, signed

Bantry – RC graveyard

148 *
Rev Timotheus O'Leary
limestone obelisk, 254 x 40 cm, signed

near Blarney
– St Mary's Cemetery, Kerrypike

149
J Higgins
limestone, 61 x 36 cm
note: erected by SM to his father-in-law, the sculptor Joseph Higgins

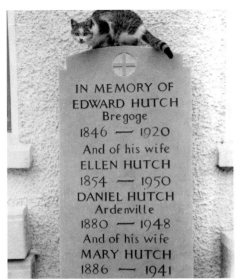

Buttevant – St John's graveyard

150
MJ Nagle
limestone, 180 x 76 cm, signed

———

Buttevant – St Mary's Cemetery

151
JP Geraghty
limestone, 110 x 69 cm, signed

152 *
Edward Hutch
limestone, 136 x 61 cm, signed
carving: encircled cross above inscription
[see page 140]

———

152

161

Buttevant – St Mary's churchyard

153 *
William Bernard Nagle
limestone, 135 cm; 2 side stones 99 cm (total
length 267 cm), signed
carving: 2 peacocks on centre stone
[see pages 142-143]

———

near Carraig na Bhfear (Carrignavar) – Dunbolg graveyard

154
E Healy
limestone, 137 x 61 cm
carving: cross in circle above inscription

155
James Murphy
limestone, 137 x 69 cm, signed
note: commemorates the sculptor's father
carving: alpha and omega on headpiece

———

Charleville (Rath Luirc) – Holy Cross Cemetery

156
Rev JC Burke
limestone, 61 x 198 cm, signed
carving: slabstone with cross, inscription on
perimeter of slab

157 *
Seán Clárach Mac Domhnaill
limestone cross, 304 cm h
inscription: DO SEÁN CLÁRACH MAC
DOMHNAILL, FILE AND FÁIDH AGUS FEAR

153
157

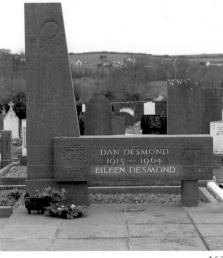

163
166

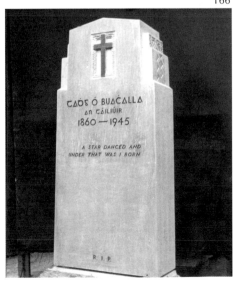

LÉIGHINN 1691-1754 DO TÓGADH AN CHROIS
CHUIMHNEACHÁIN SEO LE MUINNTIR RÁTH LUIRC
DE BHÁRR URRAMA DÁ NDEARNA SÉ ABHFUS
CHUN SPIRID CHREIDIMH NÁISIUNTACHTA DO
CHOIMÉAD BEO I NGAEDHLAIBH LE LINN AN-
RÓIDH AGUS CRUATAIN 5 ÚIL 1931
carving: above inscription is a celtic cross by SM
[see page 141]

————

Clonakilty – St Mary's graveyard

158
T Hurley
limestone, 66 x 81 cm, signed

159
T O'Donovan
limestone, 104 x 76 cm, signed

————

near Clonakilty – Castleventry graveyard

160
J Hurley
limestone, 155 x 71 cm, signed
carving: 2 doves flanking cross and (on rear)
alpha and omega flanking large cross which has
4 small crosses within angles formed by its arms

————

Clonfert – Newmarket graveyard

161 *
Captain Pádraig Mac Carthaig
limestone, 244 x 61 cm
carving: leaves and two-edged sword on front;
relief cross on sides
[see page 144]

————

Cobh, Co Cork – St Colman's Cemetery

162
E Forrest
limestone, 152 x 53 cm, signed
carving: Virgin's head encircled; first name and
date by SM

————

Crosshaven, Co Cork – St Patrick's graveyard

163 *
Dan Desmond TD
limestone obelisk, 213 x 109 x 203 cm, signed
SM and AL McSweeney A.R.I.B.A

167

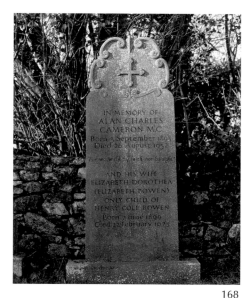

168
174

note: memorial erected by friends and
colleagues in the Labour Party
carving: Virgin and cross

near Fermoy – Ballyhooly churchyard

164
Maurice Talbot Cooke-Collis
limestone, 84 x 122 cm, signed
inscription: ALSO SYLVIA COOKE-COLLIS,
PAINTER.

165
WW Cowan
limestone, 84 x 102 cm, signed

————

Gougane Barra

166 *
Tadhg Ó Buachalla, An Táilliúir
[The Tailor]
limestone, 536 x 132 cm, signed
inscription: A STAR DANCED AND UNDER
THAT I WAS BORN
carving: decorative features, rough base

————

Kanturk – St Patrick's Cemetery

167 *
Dan Mehigan
limestone celtic cross, 167 x 60 cm, signed
[see page 145]

————

near Kildorrery, Mitchelstown – Faraghy graveyard

168 *
Alan Charles Cameron M.C.
limestone, 183 x 72 cm, signed
inscription: FOR WE WALK BY FAITH NOT BY
SIGHT; 2nd inscription: ELIZABETH BOWEN WIFE
OF (ALAN CAMERON) by Ken Thompson
[see pages 120, 146-147]

————

Kinsale – St Eltin's graveyard

169
P Crowley
limestone, 127 x 46 cm, signed

170
Rev P MacSwiney
limestone, 182 x 83 cm

171
J O' Connell
limestone, 147 x 81 cm, signed
carving: cross flanked by alpha and omega
above inscription

———

Leap – Myross graveyard

172
S Ó Donnabháin
limestone, 91 x 91 cm, signed

———

near Mallow
– St John's graveyard, Glantane

173
C O'Tuama
limestone, 148 x 7 cm, signed

———

Milford churchyard
near Charleville

174 *
Rev Daniel Duane
limestone, 127 x 70 cm, signed
carving: basket of loaves and a fish
[see page 148]

———

Minane Bridge

175
B Corrigan
limestone, 137 x 65 cm, signed

———

Mitchelstown – RC graveyard

176 *
Bridget Fitzgerald
limestone, cross 182 cm h, signed
[see page 149]

———

Newcestown (Na Reatha)
– St John the Baptist churchyard

177 *
An tAthair [Fr] Tadhg Ó Murchú
limestone, 148 x 97 cm, signed
carving: front and rear; ornate cross on front,
surrounded by 4 smaller crosses above
inscription

———

176

177
187

Sherkin Island – Franciscan Abbey

178
J O'Connor
limestone, 149 x 71 cm (footstone 30 x 97 cm),
signed
inscriptions: include Simeon O'Connor, friend of
SM

———

Skibbereen
– Castlehaven graveyard

179
M Hurley
limestone, 104 x 97 cm, signed

———

Youghal
– Ballymacoda churchyard

180
P Merriman
limestone cross with side panels, kerb and foot
stone, 198 x 170 cm, signed

———

CO CARLOW

St Mary's Cemetery, Carlow

181
Máire Ní Snodaigh
n.d., limestone, 198 x 76 cm

———

DUBLIN

Dean's Grange Cemetery, Dublin

182
J Brennan
limestone, 152 x 71 cm, signed

183
F J McCormack
limestone, 183 x 76 cm, signed
carving: masks of Tragedy and Comedy; crosses

184
Anew McMaster
limestone, 121 x 59 cm, signed

185
JP Reihill
limestone, 173 x 89 cm, signed
carving: diaper pattern on sides of stone

———

Glasnevin Cemetery, Dublin

186
Carl Gilbert Hardebeck
limestone, 122 x 62 cm, signed
note: erected by private subscription, organised
by Seán Neeson
inscription: OIBRÍ DO-SÁRAITHE AR SON CEOIL ÁR
SÍNSEAR [He made our songs live again]
carving: harp

———

Mount Jerome Cemetery, Dublin

187 *
*Edward Arthur Henry,
Sixth Earl of Longford*
limestone, 135 x 74 cm, signed
carving: Longford crest above inscription; masks
of Tragedy and Comedy on sides

———

CO GALWAY

Bohermore – new cemetery

188
H Concannon
limestone, 91 x 75 cm, side stones, 79 x 23 cm,
signed

189
J O'Donnell
limestone, 122 x 71 cm, signed
carving: cross above inscription

———

CO KERRY

Dun Chaoin – old graveyard

190 *
Tomás Ó Criomhthain
limestone, 157 x 71 cm, signed
inscription: MAR NÁ BEIDH ÁR LEITHÉIDI ARÍS
ANN: AN T-OILEÁNACH: BEANNACHT DÉ LENA
ANAM

———

Dun Chaoin – new graveyard

191 *
Peig Sayers
limestone, 178 x 86 cm, signed
carving: celtic cross

———

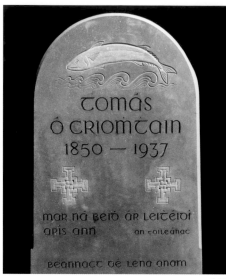

190

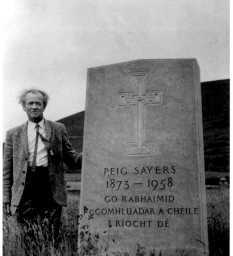

191
192

near Kilshehane
(Listowel-Tralee road)

192 *
Paddy Browne
limestone, 91 x 58 cm
note: in form of milestone on roadside between
Listowel and Tralee
inscription: LORD HAVE MERCY ON THE DEAD. IN
MEMORY OF PADDY BROWN. KILSHEHANE
CHURCHYARD 200 YRDS.
[see pages 150-151]

———

Listowel

193
O'Callaghan
1947, limestone, 188 x 74 cm, signed

———

CO KILKENNY

Kilmaganny graveyard
(near Carrick-on-Suir)

194
J McHenery
limestone, 134 x 87 cm, signed
carving: cross and bird with alpha and omega

———

CO OFFALY

St Brigid's Church of Ireland
graveyard, Clara

195 *
William Cochrane Mercier
limestone, 68 x 127 cm, signed
inscription: AND THE LORD PLANTED A GARDEN
carving: flowers right of inscription
[see page 152]

———

CO TIPPERARY

Donohill graveyard,
Tipperary town

196 *
*Daniel Breen 1894-1969
Irish Republican Army*
limestone, 169 x 76 cm, signed
carving: slabstone with celtic cross
[see page 153]

———

195

196
199, 198

Carrick-on-Suir – Friary graveyard

197
T Nugent
limestone, 86 x 152 cm, signed

——

CO WATERFORD

Ardmore – St Declan's graveyard

198 *
Sir John Keane, Baronet of Cappoquin
limestone, 84 x 76 cm, signed
carving: family crest on front cross on rear
[see page 155]

199 *
Eleanor Lucy [wife of John Keane]
limestone, 84 x 76 cm, signed
carving: cross on front
[see pages 154, 155]

200 *
Joan Jameson
limestone, 122 x 69 cm, signed
carving: palette and brushes

201 *
Bridget Catherine Drohan
limestone

——

Ferrybank, Waterford – Church of Ireland graveyard

202
TG Croker
limestone, 122 x 69 cm, signed

——

SOUTH AFRICA

203 *
Thomas Richard Kinsella
note: made and erected in South Africa

204
B Duffy
note: made and erected in South Africa

——

USA

205
Peadar Mac Suibhne
note: celtic cross designed by SM; made and
erected in USA

——

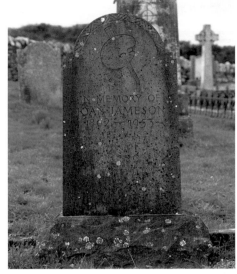

200

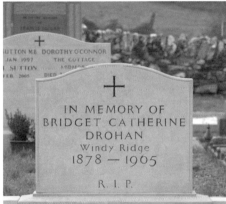

201
203

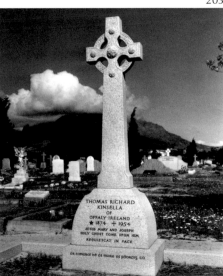

MEMORIALS

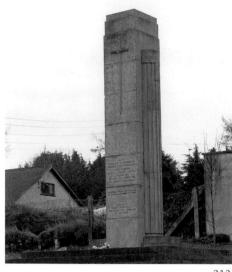

208

206
Tomás Ceannt Memorial
n.d., limestone plaque, 100 x 70 cm
note: erected by Dept of Defence
(Collins Barracks, Cork [set in wall above site of
Ceannt's execution and burial in 1916])

207
Lynch Memorial
1940, limestone cross, 335 cm h, signed
carving: medallion profile of Michael Patrick
Lynch on front; cow and calf on rear
(Dunbolg graveyard, Carraig na Bhfear, Co Cork)

208 *
St Eltin's graveyard – Gateposts
n.d., limestone
(St Eltin's graveyard, Kinsale, Co Cork)
[see page 156]

209 *
St Eltin's graveyard – Cross
n.d., limestone
(St Eltin's graveyard, Kinsale, Co Cork)
[see page 156]

210 *
United Nations Memorial
1970, limestone, 2 tablets, each 127 x 122 cm
note: commemorates members of Irish armed
forces who died while serving with UN forces
carving: UN world crest
(Glasnevin Cemetery, Dublin / commissioned by
Dept of Defence)
[see page 157]

211
War of Independence Memorial, Aglish
n.d., limestone, 177 x 81 cm, signed
inscription: DOMHNALL ALMAN, SÉAMUS
Ó BAOTHGHALAIGH, PÁDRAIG ALMAN
carving: cross in recessed rectangle; 2 swords
on sides
(Aglish Cemetery, Annascaul, Co Kerry)

212 *
*War of Independence Memorial,
Bandon – IRA, Cork No.3 Brigade*
1953, 427 x 76 cm, signed
carving: sword, laurel leaves, fluted half-columns
(Bandon, Co Cork)
[see page 158-159]

212

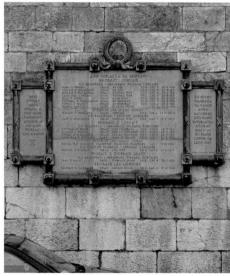

213
214

209
210

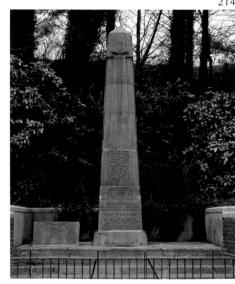

213 *
War of Independence Memorial, Cork
1947, limestone with bronze surround,
221 x 323 cm, signed
inscription in Irish to the men who died in gaol
during the War of Independence
carving: army crest
(Gaol Cross, University College Cork)
[see page 160]

214 *
War of Independence Memorial, Dripsey
1938, limestone, 548 x 99 cm, signed
inscription: FIRST CORK BRIGADE I.R.A.
carving: two-edged sword above inscription
(Dripsey, Co Cork [site of ambush])
[see pages 162-163]

215
War of Independence Memorial, Leemount
n.d., limestone cross, 260 cm, signed
inscription: DEDICATED TO PÁDRAIG
Ó MURCHADHA KILLED 11 MEÁN FOMHAIR 1922
carving: sword at centre of cross
(Leemount, Cork)
[see page 161]

216 *
War of Independence Memorial, Midleton
designed 1932 / erected 1939, limestone
obelisk, 10.67 m h, signed
inscription: OF ALL WHO DIED IN WAR OF
INDEPENDENCE
carving: Celtic interlaced motif
(Midleton, Co Cork)
[see page 166]

217 *
War of Independence Memorial, St Finbarr's – IRA, Cork No.1 Brigade
1963, limestone cross, 578 x 198 cm
inscription: NUMBER ONE BRIGADE,
NA POBLACHTA AGUS FIANNA ÉIREANN
carving: stylised motif (sword) based on Fianna
Fáil crest, above inscription
(St Finbarr's Cemetery, Cork)
[see page 164-165]

———

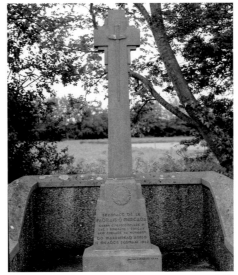

215

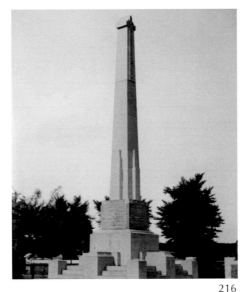

216
217

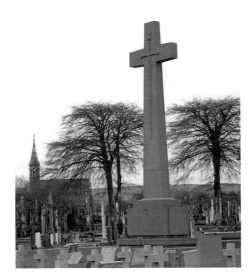

EDWARD CONOR
O BRIEN
Foynes Island
Born 3 Nov 1880
Died 18 April 1952

PANELS AND PLAQUES

Michael Collins
1965, bronze plaque, 65 cm diameter,
signed & dated
(Collins Barracks, Cork)

opposite

Bardas Chorcaí
1972, bronze tablet, 269 x 119 cm, signed
(City Hall, Cork)

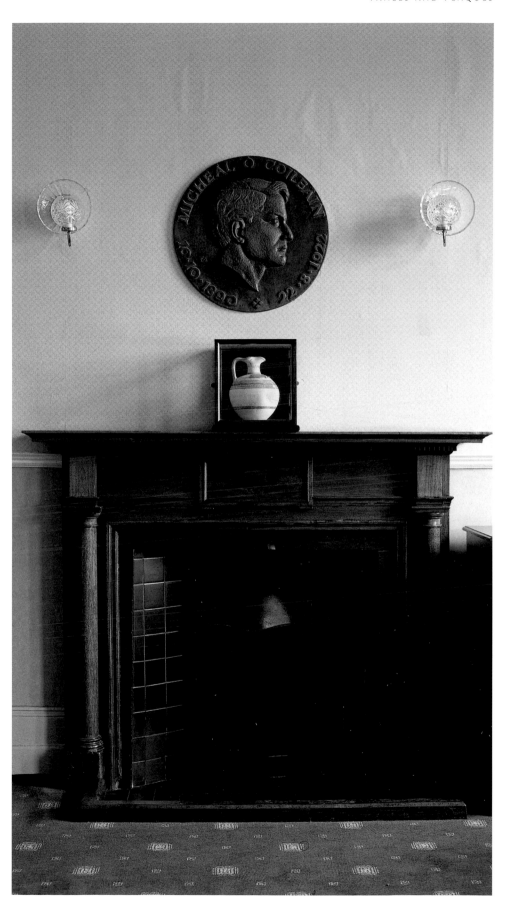

Michael Collins
1965, bronze plaque, 65 cm diameter,
signed & dated
(Sam's Cross, Clonakilty, Co Cork)

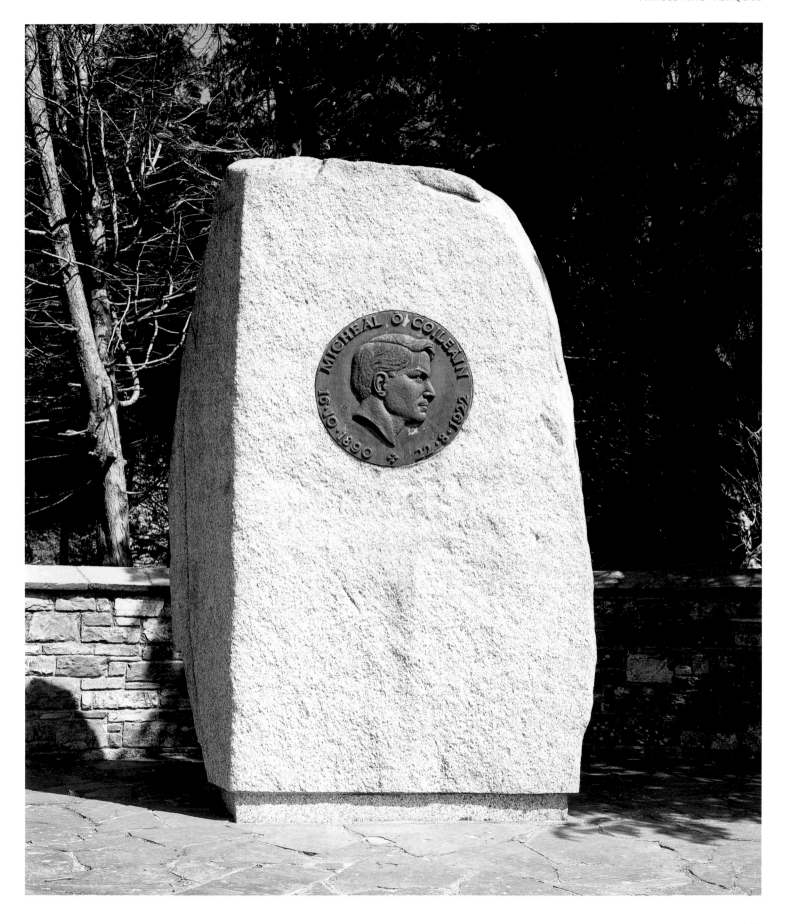

Cork School of Music
1956, 6 limestone panels (4 external; 2 internal),
each 46 x 46 cm
(Cork School of Music)

opposite

John Boyd Dunlop
1959, Portland stone panel, 75 x 100 cm
(University College Cork)

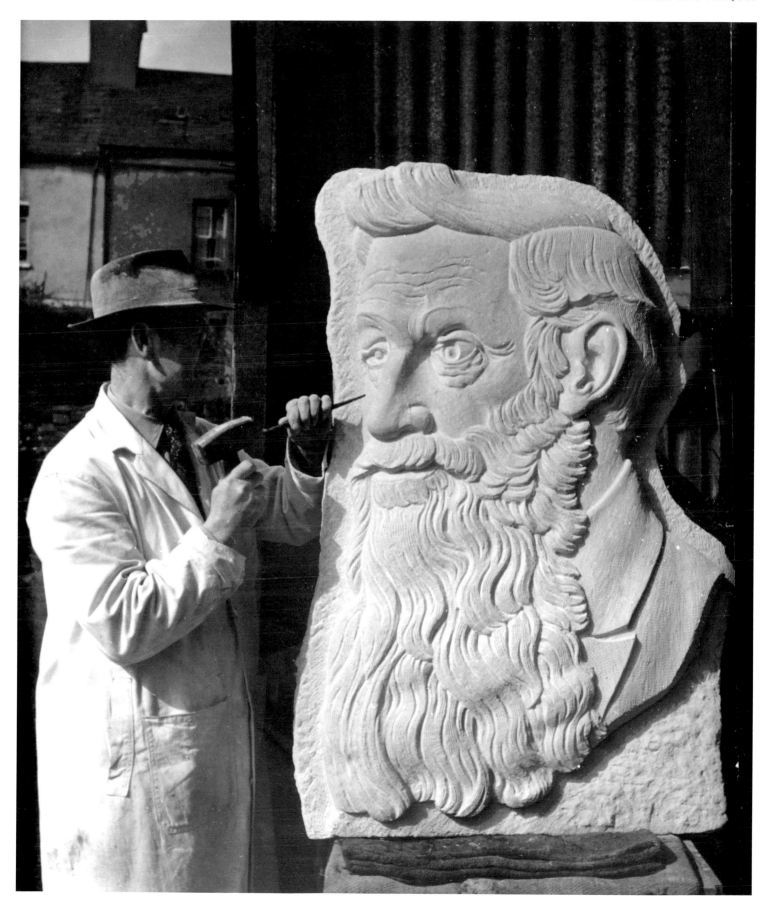

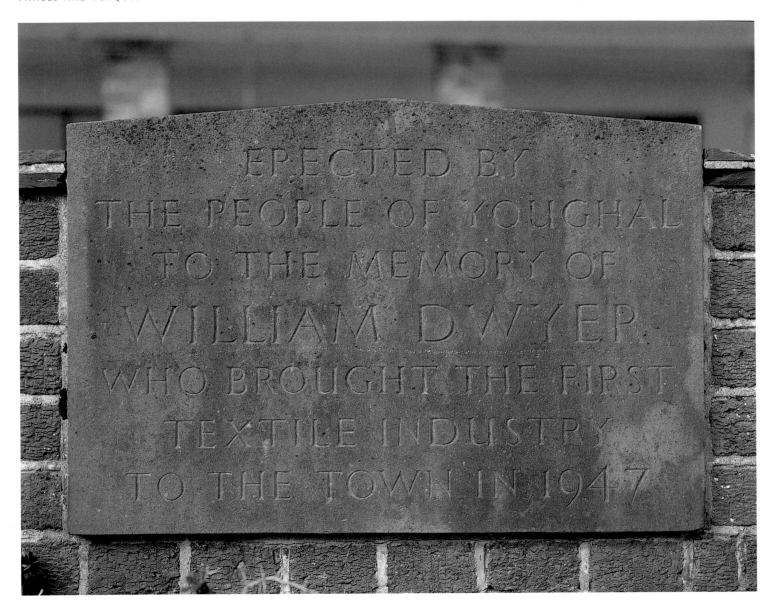

William Dwyer
1952, limestone commemorative plaque,
50 x 74 cm
(Blackwater Cotton Mills, Youghal, Co Cork
– now Perk's Funfair)

Four Evangelists
1955, limestone panels, 196 x 173 cm overall, signed
(Church of Our Lady and St John, Carrigaline, Co Cork)

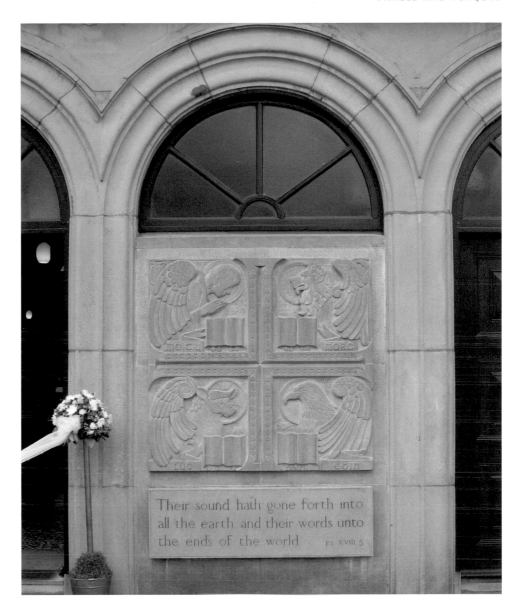

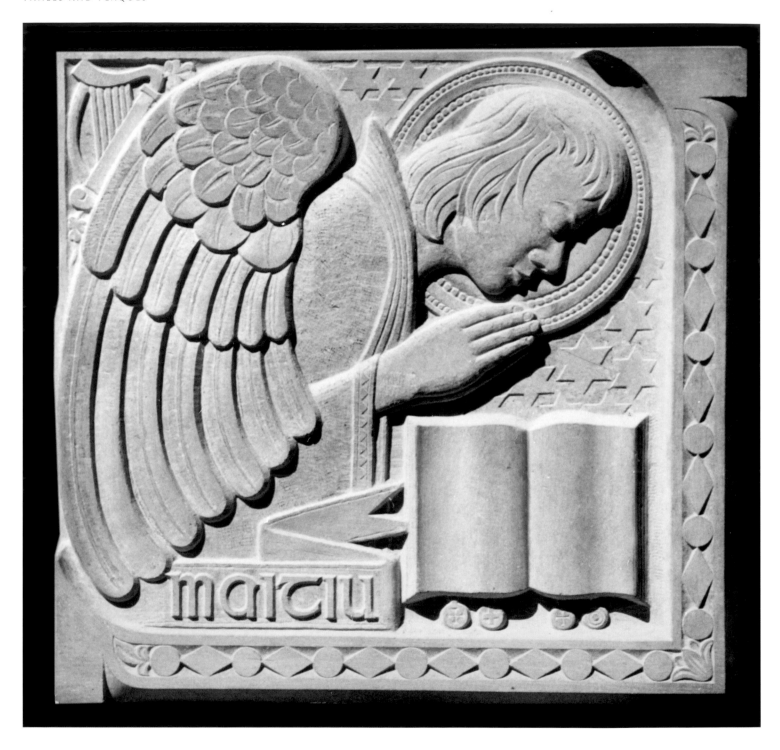

Four Evangelists – Matthew and Mark
1955, limestone panels, 196 x 173 cm overall,
signed
(Church of Our Lady and St John, Carrigaline,
Co Cork)

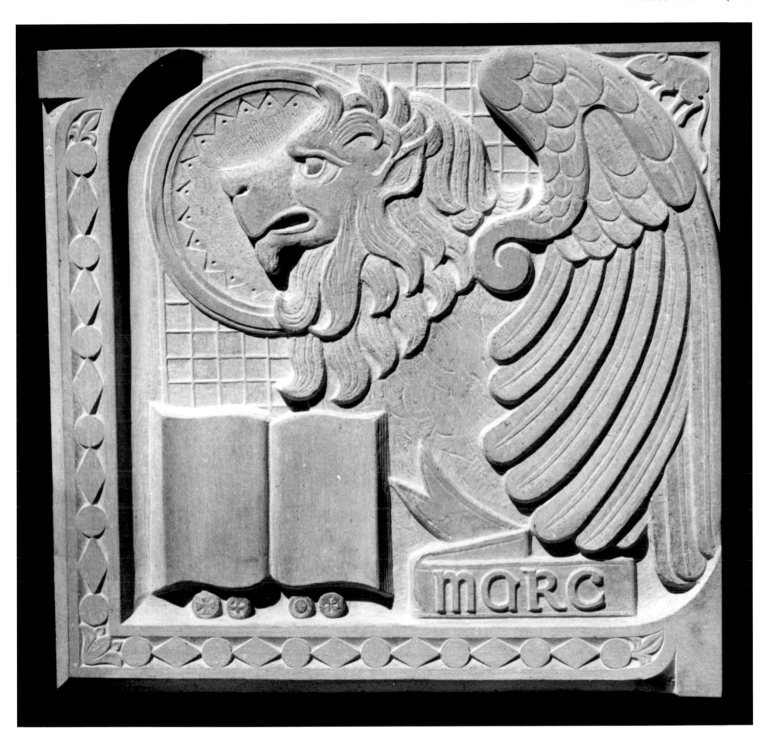

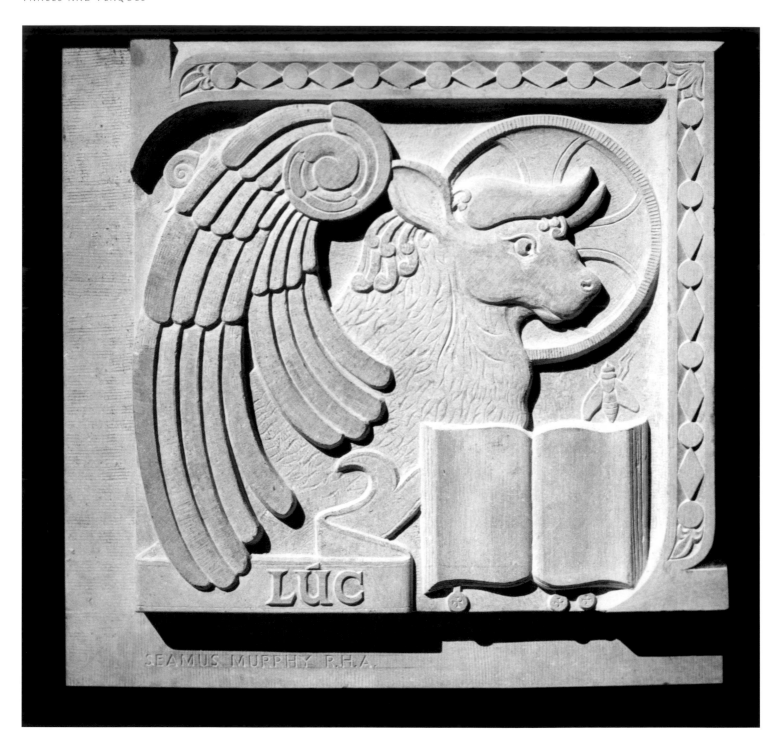

Four Evangelists – Luke and John
1955, limestone panels, 196 x 173 cm overall,
signed
(Church of Our Lady and St John, Carrigaline,
Co Cork)

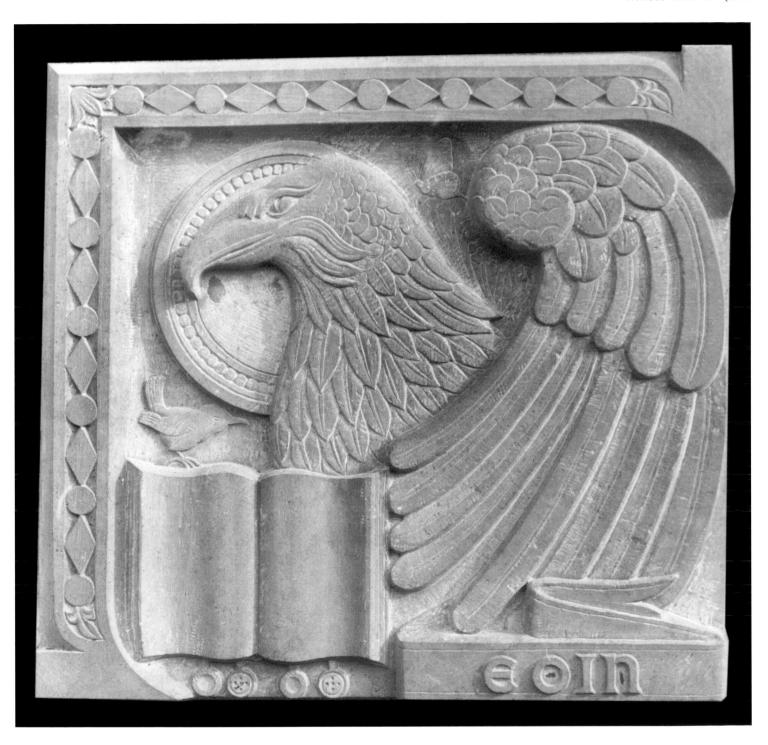

Arthur Griffith
n.d., bronze, 2 plaques and 2 tablets (1 each on
north and south sides), 41 cm diameter and
22 x 88 cm
(Griffith Bridge, Cork – formerly North Gate
Bridge)

opposite

John F Kennedy
1964, bronze plaque, 51 x 46 cm,
signed & dated
(City Hall, Cork)

Francis Ledwidge
1962, bronze tablet, 46 x 92 cm, signed
(Slane, Co Meath)

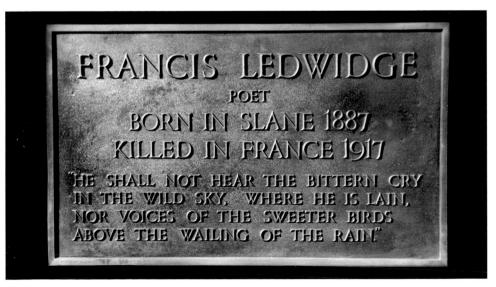

Baothghalach Mac Aodhagáin
n.d., limestone tablet, 46 x 84 cm
(Carraigadrohid Castle, Co Cork)

Pádraig Mac Cárthaigh
1947, bronze tablet, 46 x 70 cm
(8 Main Street, Millstreet, Co Cork)

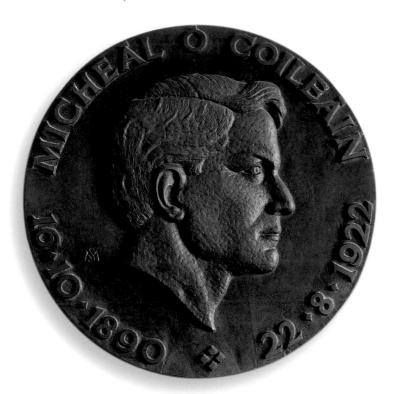

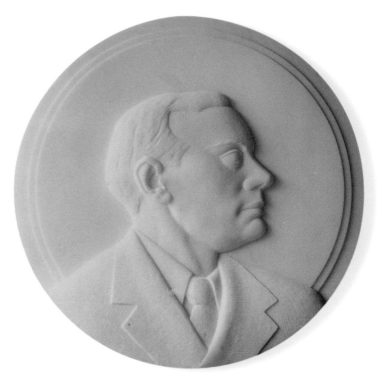

Michael Collins
1965, bronze plaque, 65 cm diameter,
signed & dated
(Sam's Cross, Clonakilty, Co Cork; Collins
Barracks, Cork)

Arthur Griffith
n.d., bronze plaque, 41 cm diameter
(Griffith Bridge, Cork)

Pádraig Mac Piarais [Patrick Pearse]
1939, circular plaster plaque, model for above,
45 cm diameter
(Scoil na nÓg, Glanmire, Cork)

Ó Donnabháin Rosa [O'Donovan Rossa]
1954, bronze plaque, 74 cm diameter, signed
(Office of Public Works / St Stephen's Green,
Dublin)

opposite

Pádraig Mac Piarais [Patrick Pearse]
1936, white marble plaque (exhibited at New
York World's Fair, 1939), 60 x 42 cm
(Pádraig Pearse Museum, Dublin)

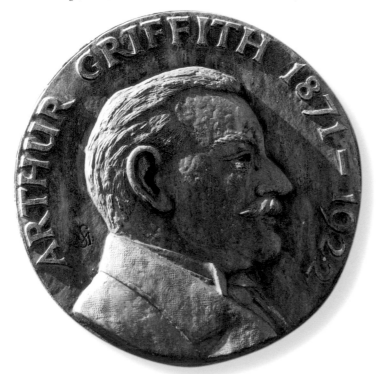

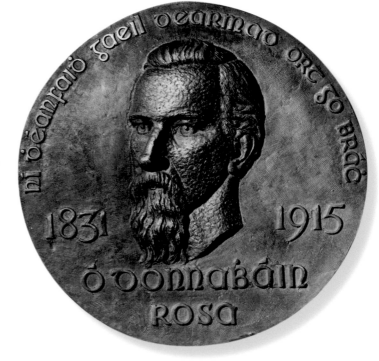

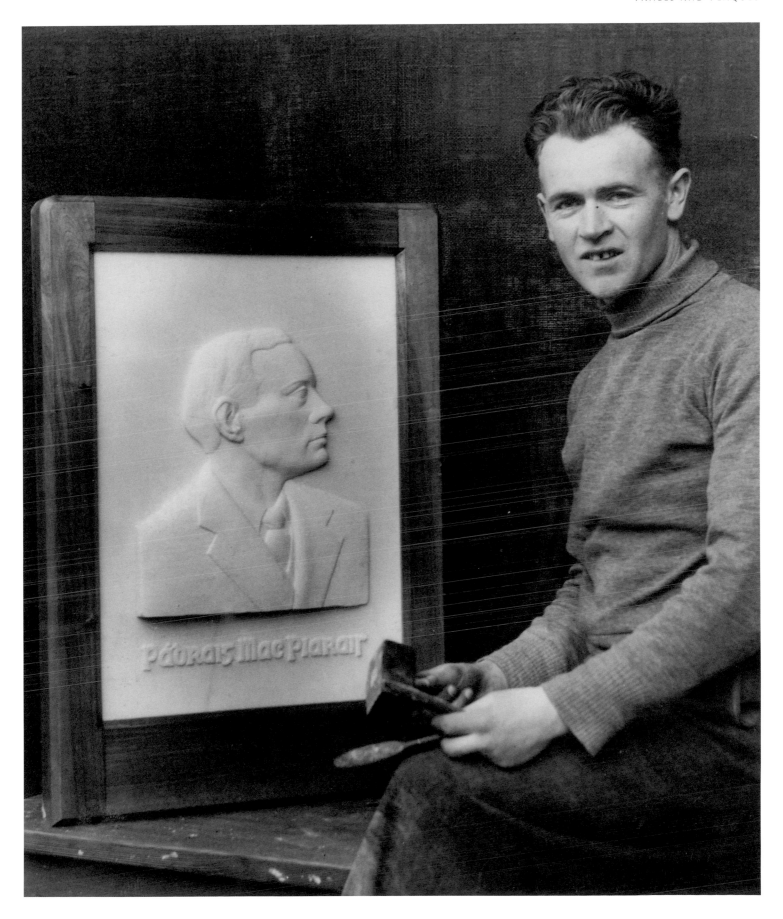

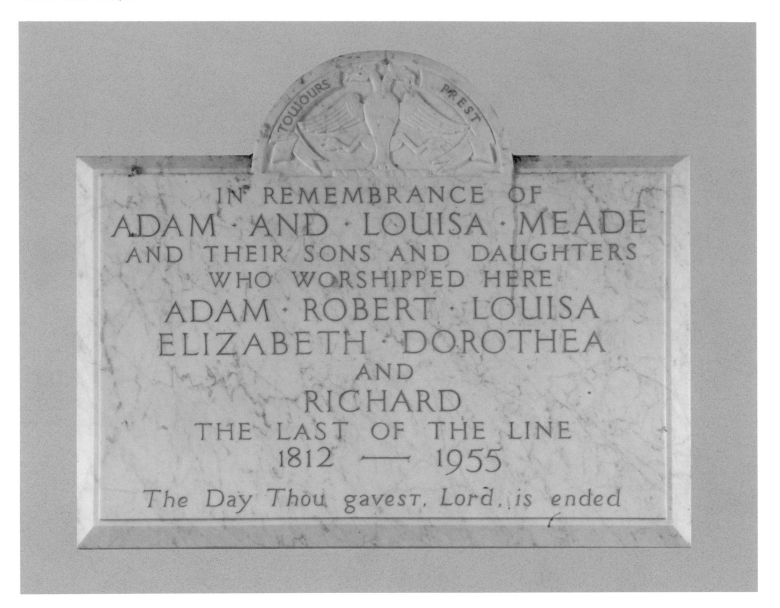

Adam and Louisa Meade
n.d., white marble tablet, 92 x 99 cm
(Ballymartle Church, Kinsale, Co Cork)

opposite

Mount Melleray Coat of Arms
1930, marble panel, 91 x 91 cm
(Mount Melleray Abbey, Cappoquin,
Co Waterford)

FACERE ET DOCERE

O'Brien panels, Foynes Memorial
limestone tablets
(former Church of Ireland church, Foynes,
Co Limerick)

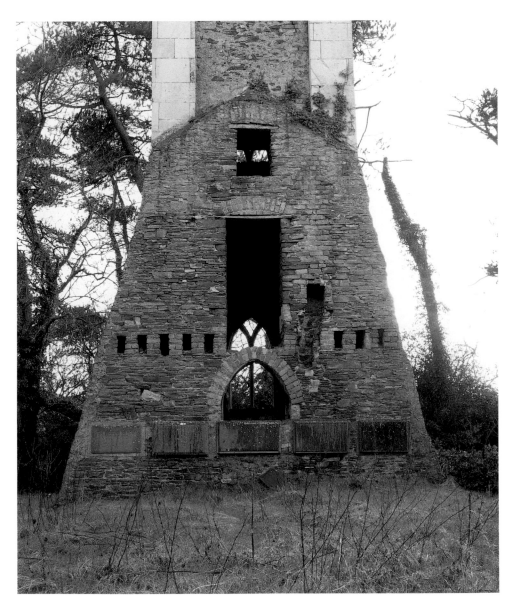

O'Brien panels, Foynes Memorial
(former Church of Ireland church, Foynes,
Co Limerick)

Turlogh Robert Vere O'Brien

Hugh Murrough Vere O'Brien

Margaret Ernestine O'Brien

see page 184 for
Edward Conor O'Brien

Ó Donnabháin Rosa
[O'Donovan Rossa]
1954, bronze plaque, 74 cm diameter, signed
(Office of Public Works / St Stephen's Green,
Dublin)

opposite

Presentation in the Temple
n.d., limestone tablet, 91 x 68 cm, signed
(Presentation College, Western Road, Cork)

Shandon Tower
1956, limestone plaque (with inscription by
Seán Ó Faoláin), 93 x 43 cm
(Theo & Valerie Goldberg Collection, England)

AT THE CLIMBING
OF ROOFS UPON
TO THE GREAT
R OF SHANDON,
DS FELL DOWN
ER'S STILLINESS
NTO THE WATER
WNED

The Twelfth Station
1935, white marble panel, 61 x 46 cm
(Bishop Edmund Fitzgibbon, Port Harcourt,
Nigeria)

opposite

United Dioceses
1962, limestone tablet, 118 x 94 cm, signed
(St Mary's Cathedral, Limerick)

TO THE GLORY OF GOD
AND IN MEMORY OF THE MEN OF THE UNITED
DIOCESES FALLEN IN THE WAR 1939 - 1945
✝ SPECIALLY OF THOSE WHOSE NAMES ✝
ARE CUT ON THIS MONUMENT
A.G. BEVAN A.B. R.N. H.M.S. DARING
J. D. BISHOP FLYING OFFICER R.A.F.
W. J. P. GOODBODY CAPT. CT. LON. YEO.
A. W. GRENFELL LIEUT. 10th K.R.R.C.
G. B. GRENFELL FLYING OFFICER R.A.F.
C. R. C. HERBERT PILOT OFFICER R.A.F.
C. B. V. HOLDEN CAPT. 9th J.A.T.S.
W. J. W. KINGSTON FLT. LIEUT. B.C. R.A.F.
B. D. J. MACGILLYCUDDY 2nd LIEUT. RY. RGT. A.
✝ D. M. E. MCGILLYCUDDY M.C. M.M. ✝
CAPT. 47th D. GUARDS
M. I. MASSY FLT. LIEUT. R.A.F.V.R.
D. W. T. MAXWELL LIEUT. SEAFORTHS
J. MODLER CPL. IRISH GUARDS
R.G. PRESTON GUNNER 15th COAST RGT. R.A.
A. RUTTLE PTE. MANCHESTER RGT.
J. H. RYAN TROOPER N. I. H.
C. R. P. SWEENY M.C. MAJOR RY. ULSTER RIFLES
R. THOMPSON SGT. NAVIGATOR B.C. R.A.F.
H. F. TURPIN LIEUT. R.T.R. 6th AIRBORNE
J. WELPLY LIEUT. 6th AIRBORNE

PANELS AND PLAQUES

(locations in parentheses)

* illustrated here
** plaster version in Crawford Gallery collection

218 *
Adam and Eve
1931, white marble plaque, 25 x 38 cm

219
Aesculapius
1942, white marble plaque, 20 x 36 cm

220 *
Bardas Chorcaí
1972, bronze tablet, 269 x 119 cm, signed
inscription: BARDAS CHORCAÍ 1920-1924,
and in Irish and English: THE MEMBERS OF THE
FIRST COUNCIL OF THE COUNTY BOROUGH OF
CORK TO HAVE A REPUBLICAN MAJORITY
(City Hall, Cork)
[see page 186]

221 *
James Samuel Blemens
1969, green marble tablet with incised gilded
lettering, 27 x 39 cm
(St Fin Barre's Cathedral, Cork)

222
Bon Secours
1956, polished limestone foundation stone,
51 x 127 cm
(Bon Secours Hospital, Cork)

223
Carmelite Saint
1975, marble panel, 16 x 30 cm, signed
note: a number of bronze casts have been taken
from this piece

224
Clock Gate, Youghal
n.d., limestone tablets, 61 x 122 cm
note: 1 tablet in Irish, 1 in English
commemorating two martyrs
(Youghal, Co Cork)

225 *
Michael Collins
1965, bronze plaque, 65 cm diameter,
signed & dated
(Sam's Cross, Clonakilty, Co Cork; bronze cast in
Collins Barracks, Cork) **
[see pages 187, 188-189, 204]

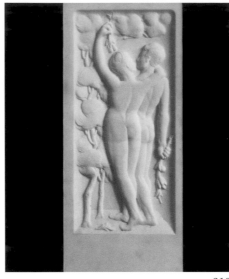

218

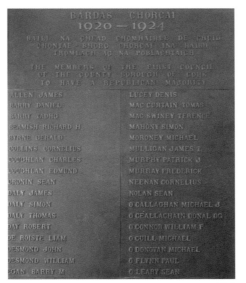

220
221

226
Cork County Council
1968, 5 polished black limestone panels, each
335 x 183 cm
note: names of chairmen of Cork County
Council since 1899, surmounted by Council
arms; inscriptions after 1975 by Ken Thompson
(County Hall, Cork)

227 *
Cork School of Music
1956, 6 limestone panels, each 46 x 46 cm
note: panels from old School of Music
remounted on red sandstone wall in new
building in 2007, with 4 externally and 2 in foyer
(Cork School of Music)
[see page 190]

228
Cork School of Music
1956, 2 Connemara marble panels,
each 58 x 74 cm
note: panels remounted in new building in 2007
(Cork School of Music)

229
Cummins Coat of Arms
1968, limestone, 45 x 91 cm
inscription: O COMAIN 1968 SEAMUS AND BETSY

230
Thomas Davis
1942, bronze tablet, 61 x 91 cm
inscription: HE SERVED HIS COUNTRY AND LOVED
HIS KIND THOMAS DAVIS WAS BORN IN THIS
HOUSE ON OCTOBER 14TH, 1814.
(72 Main Street, Mallow, Co Cork)

231 *
John Boyd Dunlop
1959, Portland stone panel, 75 x 100 cm
(University College Cork)
[see page 191]

232 *
William Dwyer
1952, limestone commemorative plaque,
50 x 74 cm
inscription: ERECTED BY THE PEOPLE OF YOUGHAL
TO THE MEMORY OF WILLIAM DWYER WHO
BROUGHT THE FIRST TEXTILE INDUSTRY TO THE
TOWN IN 1947
(Blackwater Cotton Mills, Youghal, Co Cork –
now Perk's Funfair)
[see page 192]

233
Elvery's Sports Shop
n.d., limestone plaque, 76 x 60 cm
(Patrick Street, Cork – not visible)

225a

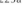

231

234 *
Foundation Stone
1957, limestone foundation stone, 83 x 64 cm
(Church of the Descent of the Holy Ghost,
Wilton, Cork)

235
Foundation Stone
1954, limestone foundation stone, 91 x 66 cm
(All Saints Church, Drimoleague, Co Cork)

236 *
Four Evangelists
1955, limestone panels, 196 x 173 cm overall,
signed
note: 4 carved panels forming cross, above
inscription plaque
inscription: THEIR SOUND HATH GONE FORTH
INTO ALL THE EARTH AND THEIR WORDS UNTO
THE ENDS OF THE WORLD PS. XVIII 5
(Church of Our Lady and St John, Carrigaline,
Co Cork)
[see pages 193-197]

237 *
Arthur Griffith
n.d., bronze plaques and tablets, 41 cm
diameter and 22 x 88 cm
note: 2 plaques with profile of Griffith, name
and dates; 2 tablets with old and new names of
bridge, Irish on north side, English on south side
(Griffith Bridge, Cork – formerly North Gate
Bridge)
[see page 198]

238
JA Haydn
n.d., limestone tablet, 86 x 161 cm
(St Mary's Cathedral, Limerick)

225b
227

239 *
John F Kennedy
1964, bronze plaque, 51 x 46 cm,
signed & dated
(City Hall, Cork) **
[see page 199]

240
TPC Kirkpatrick
1955, limestone tablet, 139 x 86 cm
note: commemorates the work of Dr Kirkpatrick
(Dr Steevens Hospital, Dublin)

241
TJ Lane
1969, bronze plaque, 55 x 45 cm,
signed & dated
note: commemorates the work of Dr Lane
(Meath Hospital, Dublin) **

232
234

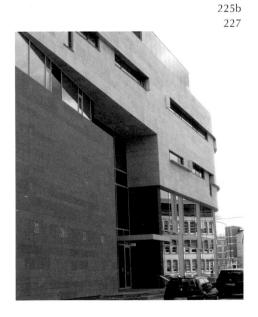

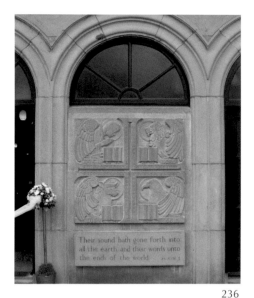

236

237
239

242 *
Francis Ledwidge
1962, bronze tablet, 46 x 92 cm, signed
inscription: FRANCIS LEDWIDGE POET BORN IN
SLANE 1887 KILLED IN FRANCE 1917 'HE SHALL
NOT HEAR THE BITTERN CRY IN THE WILD SKY,
WHERE HE IS LAIN, NOR THE VOICES OF THE
SWEETER BIRDS ABOVE THE WAILING OF THE RAIN'
(Slane, Co Meath)
[see pages 200-201]

243
Seán Lemass
1971, limestone tablet, 76 x 130 cm
(Cork Airport, old terminal building)

244 *
Baothghalach Mac Aodhagáin
n.d., limestone tablet, 46 x 84 cm
(Carraigadrohid Castle, Co Cork)
[see page 202]

245 *
Pádraig Mac Cárthaigh
1947, bronze tablet, 46 x 70 cm
(8 Main Street, Millstreet, Co Cork)
[see page 203]

246 *
Pádraig Mac Piarais [Patrick Pearse]
1936, white marble plaque, 60 x 42 cm
note: exhibited at New York World's Fair, 1939
(Pádraig Pearse Museum, Dublin)
[see page 205]

247 *
Pádraig Mac Piarais
1939, circular plaster plaque, 45 cm diameter
note: model for white marble plaque exhibited
at the New York World's Fair, 1939
(Scoil na nÓg, Glanmire, Cork)
[see page 204]

248
Male head in profile
1957, plaster plaque, 62 cm h, signed & dated
note: 1 plaster version extant **

249
Male head in profile
1961, plaster plaque, 33 cm x 23 cm, signed
note: 1 plaster version extant **

250 *
Maria Assumpta National Schools
1957, limestone name plaque
(Ballyphehane, Cork)

242

244

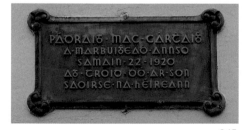

245
246

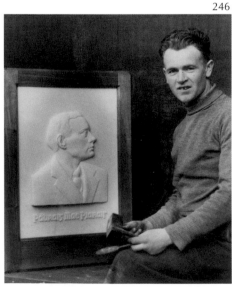

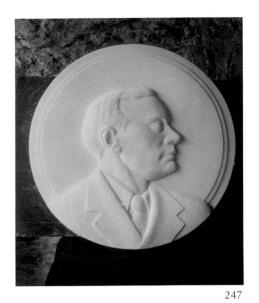

247

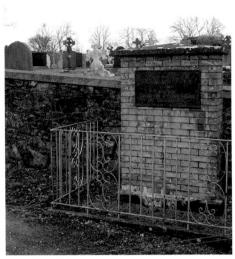

253

251 *

Fr Theobald Mathew O.F.M.
1947, limestone tablet, 31 x 53 cm
(18 West Beach, Cobh, Co Cork)

252 *

Adam and Louisa Meade
n.d., white marble tablet, 92 x 99 cm
note: commemorates Meade family
(Ballymartle Church, Kinsale, Co Cork)
[see page 206]

253 *

Brian Merriman
1968, bronze tablet, 46 x 84 cm
note: presented by Cummann Merriman
(Feakle churchyard, Co Clare)

254 *

Mount Melleray Coat of Arms
1930, marble panel, 91 x 91 cm
(Mount Melleray Abbey, Cappoquin,
Co Waterford)
[see page 207]

255

Connie F Neenan
1970, bronze plaque, 58 x 46 cm, signed
note: 1 plaster version extant; 1 bronze cast
made
(St Finbarr's GAA Club, Cork) **

256

New Ross Town Arms
1957, limestone plaque, 62 x 52 cm
(John Redmond Memorial Railway Station,
Wexford)

257 *

O'Brien panels, Foynes Memorial
limestone tablets
(former Church of Ireland church, Foynes,
Co Limerick)
[see pages 184, 208-209]

258 *

Edward Conor O'Brien
limestone tablet, 53 x 84 cm, signed
inscription: EDWARD CONOR O'BRIEN FOYNES
ISLAND BORN 3 NOV 1880 DIED 18 APRIL 1952
carving: inscription flanked by two anchors
(Foynes, Co Limerick)
[see page 184]

259 *

Wm Dermod O Brien P.R.H.A.
1953, limestone tablet, 56 x 90 cm, signed
inscription: TO THE GLORY OF GOD AND IN
MEMORY OF WM. DERMOD O'BRIEN PRHA

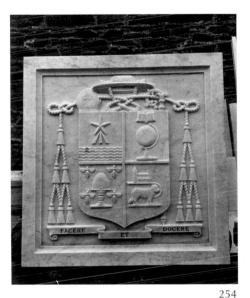

254
257

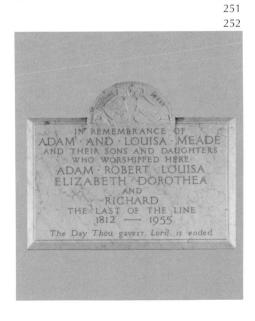

250

251
252

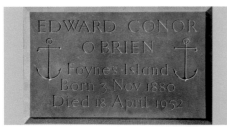

258

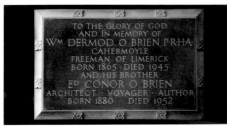

259

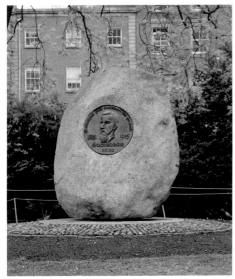

262
263

CAHERMOYLE FREEMAN OF LIMERICK BORN IN 1865 DIED 1945 AND HIS BROTHER ED CONOR O'BRIEN ARCHITECT, VOYAGER, AUTHOR BORN 1880 DIED 1952.
(St Mary's Cathedral, Limerick)

260
HM O'Brien
n.d., limestone tablet, 53 x 92 cm
(St Mary's Cathedral in Limerick)

261
Daibhaidh Ó Bruadair
1970, limestone tablet, 76 x 129 cm, signed
(Springfield Castle, Drumcollogher, Co Limerick)

262 *
Ó Donnabháin Rosa [O'Donovan Rossa]
1954, bronze plaque, 74 cm diameter, signed
note: three-quarter mask in high-relief, set in granite boulder
inscription: NÍ DHÉANFAIDH GAEIL DEARMAD ORT GO BRÁCH
(OPW / St Stephen's Green, Dublin)
[see pages 204, 210]

263 *
Dhiarmaid Ó Loinsigh [Diarmaid Lynch]
1966, bronze tablet, 63 x 27 cm
(Ballyfeard, Co Cork)

264
Alfred O'Rahilly
1955, limestone tablet, 76 x 122 cm, signed
inscription in Latin
carving: low-relief profile
(University College Cork) **

265 *
Presentation in the Temple
n.d., limestone tablet, 91 x 68 cm, signed
(Presentation College, Western Road, Cork)
[see page 211]

266 *
Rochestown College
1961, bronze tablet, 92 x 45 cm
(Rochestown College, Cork)

267 *
Scoil Ite
1967, bronze tablet, 32 x 81 cm
inscribed in Irish and English to Máire and Eithne Mac Swiney
(now Shiela's Hostel, Belgrave Place, Wellington Road, Cork)

268 *
Shandon Tower
1956, limestone plaque, 93 x 43 cm

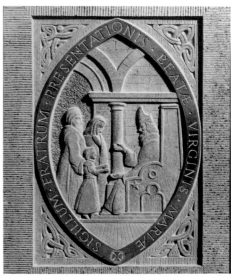

265

266

267
268

270a

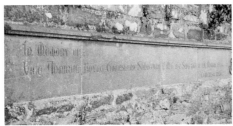

270b

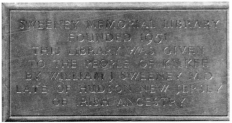

271

inscription by Seán Ó Faoláin
(Theo & Valerie Goldberg Collection, England)
[see pages 212-213]

269
Canon Sheehan
1944, red marble tablet, 56 x 66 cm
inscription: THE SCHOOL HONOURS THE
MEMORY OF CANON SHEEHAN 1852-1913 PRIEST
AND AUTHOR WHO LOVED IRELAND
(Technical School, Mallow, Co Cork)

270 *
*Vice-Admiral Boyle Townshend
Somerville*
c.1945, memorial tablet
inscription: In memory of Vice-Admiral Boyle
Townshend Somerville CMG b 7 Sept 1863
d 24 March 1936 Comharsa Maith
(Drishane House (front gate), Castletownshend,
Co Cork)

271 *
Sweeney Memorial Library
1963, limestone tablet, 76 x 141 cm
(Kilkee, Co Clare)

272 *
The Twelfth Station
1935, white marble panel, 61 x 46 cm
(Bishop Edmund Fitzgibbon, Port Harcourt,
Nigeria)
[see page 214]

273 *
United Dioceses
1962, limestone tablet, 118 x 94 cm, signed
note: Roll of Honour, Second World War
(St Mary's Cathedral, Limerick)
[see page 215]

274
Cornelius Verolme
1961, white marble plaque
(location unknown)

275
Wall of Nations
n.d., polished limestone plaque
inscriptions: Ó CATHAIR CHORCAÍ IRELAND
PÁDRAIG MACCRAITH ARD-MÉARA 1954
(JFK (formerly Idlewild) Airport, New York)

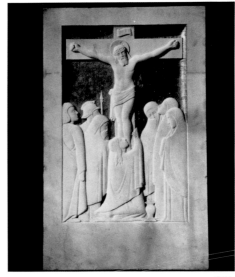

272

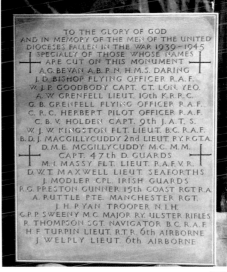

273

Ruth Ripley 1934, white marble, 50 cm h, signed (Crawford Art Gallery, Cork)

PORTRAIT BUSTS

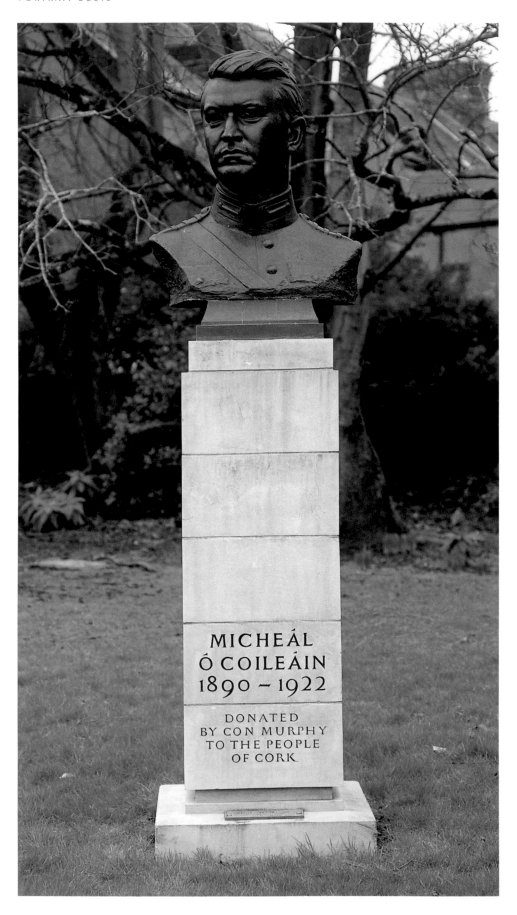

MICHEÁL
Ó COILEÁIN
1890 – 1922

DONATED
BY CON MURPHY
TO THE PEOPLE
OF CORK

Michael Collins
1966, bronze cast, 104 cm h
(Fitzgerald Park, Cork)

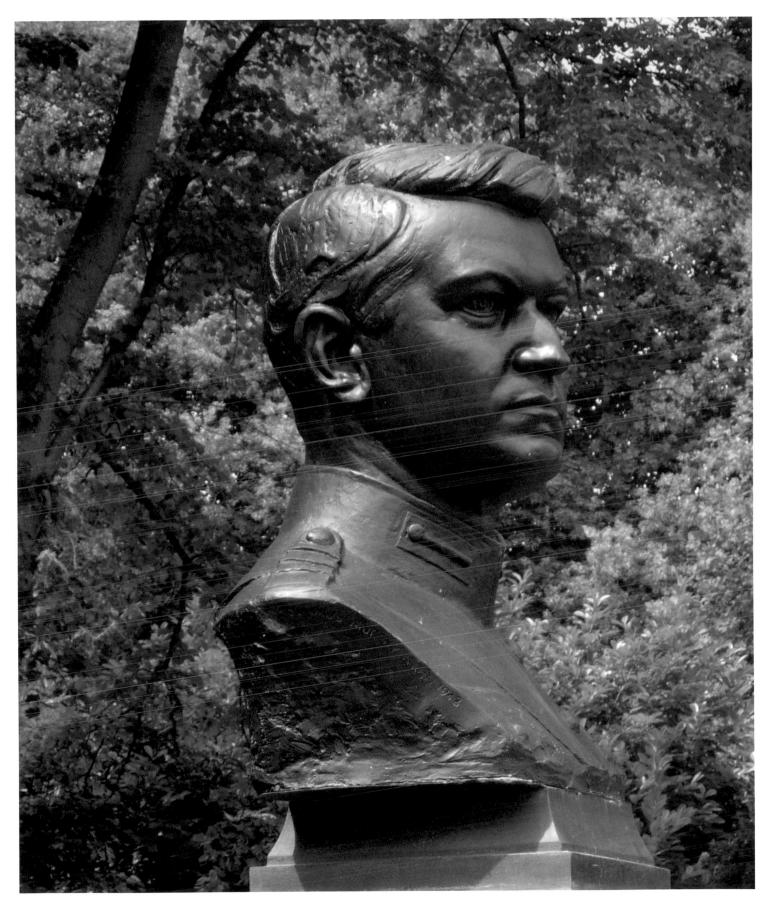

Eamonn de Valera [when Taoiseach]
1944, bronze, 51.5 cm h, signed
(Iveagh House, Dublin; de Valera Museum and
Bruree Heritage Centre, Co Limerick / Office of
Public Works long-term loan)

SM working on bust of de Valera, 1944

SM and de Valera at the Royal
Hibernian Academy, Dublin, 1960
Eamonn de Valera [when President]
1959, bronze, 49 cm h, signed & dated
(Ennis Library, Co Clare)

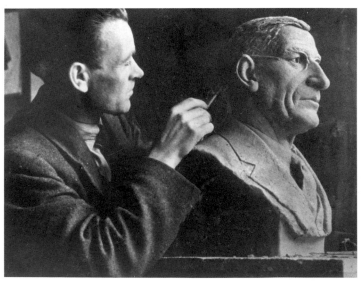

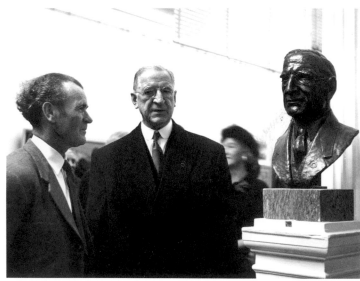

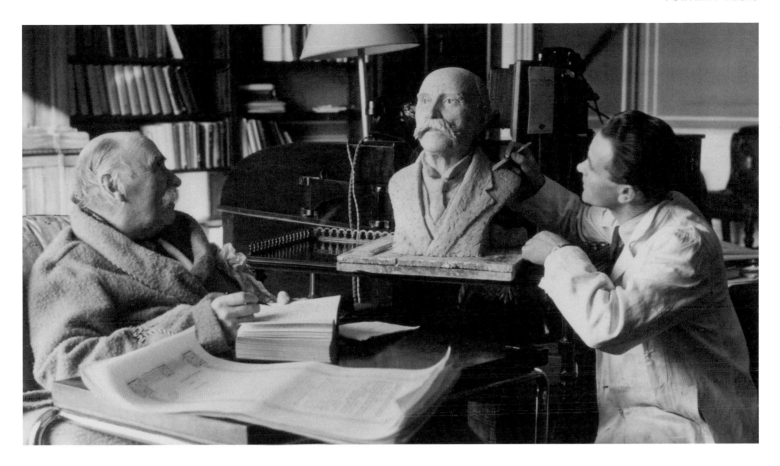

Douglas Hyde [when President]
1941, bronze, 45 cm h, signed & dated
(Office of Public Works / Áras an Uachtaráin;
Trinity College Dublin)

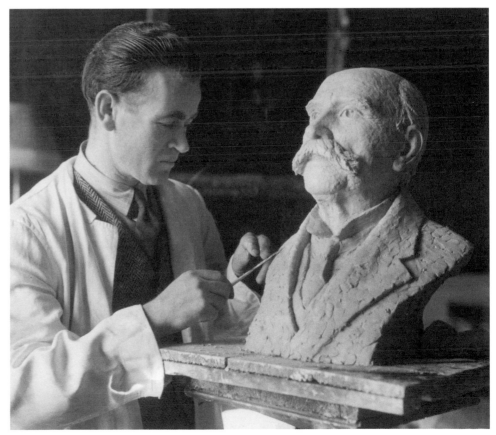

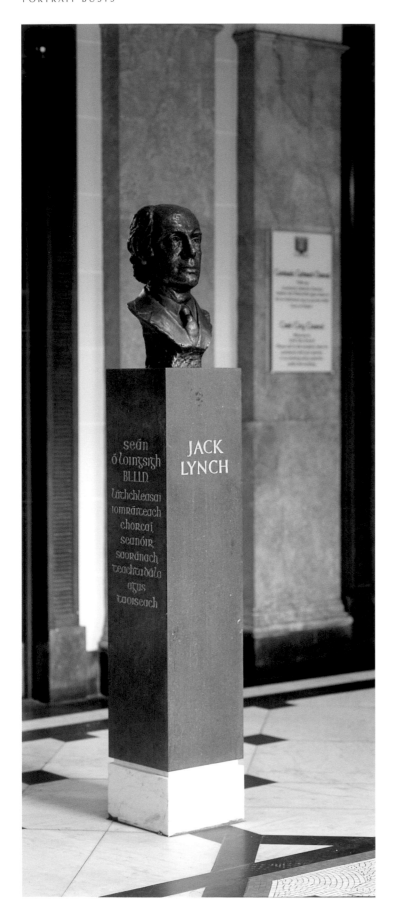

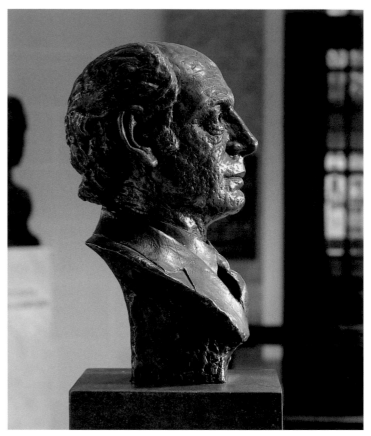

Jack Lynch
1973, bronze, 53 cm h, signed
(Cork City Hall; AIB, 66 South Mall, Cork;
Fíanna Fáil HQ, Cork; Cork Airport) **

Count John McCormack
1960, bronze, 67 cm h, signed & dated
(Athlone, Co Westmeath)

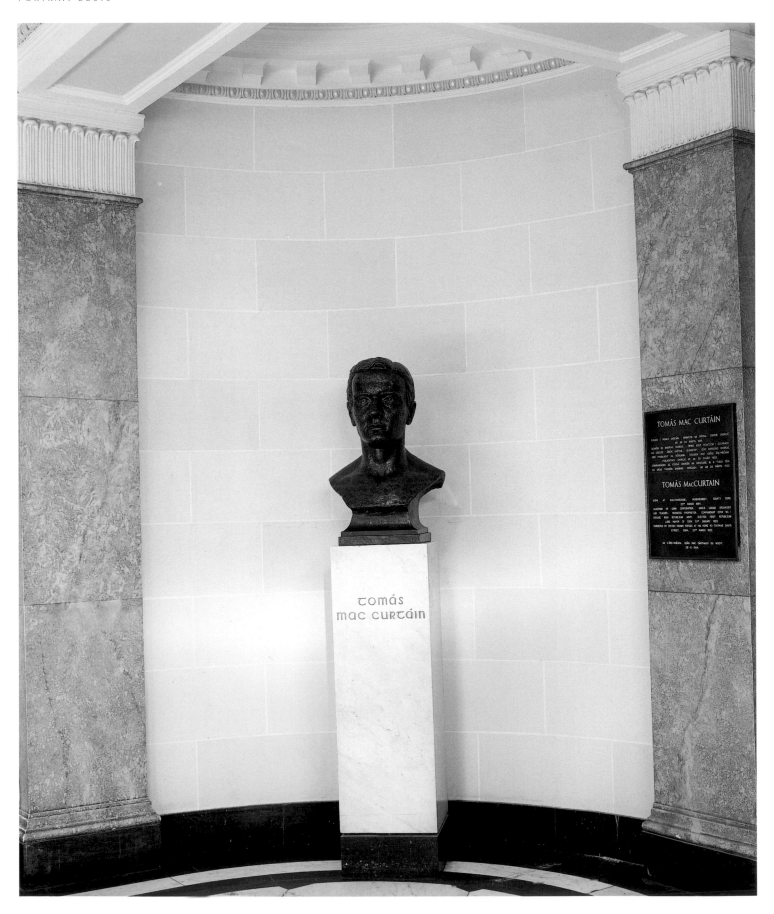

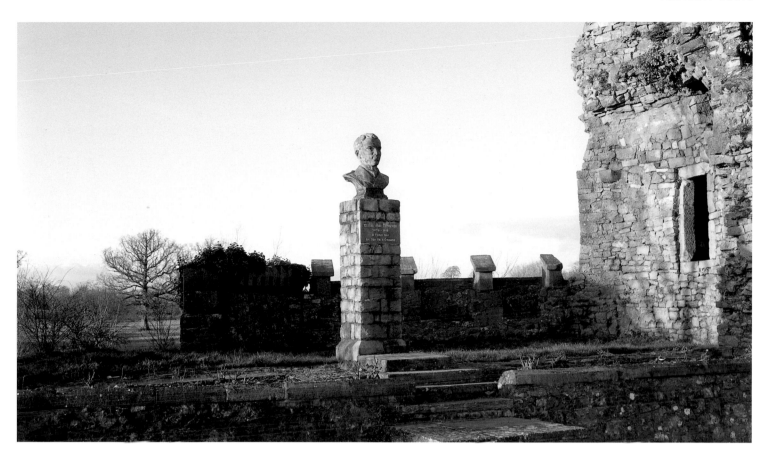

Tomás Mac Donnachádha
[Tomás MacDonagh]
1966, bronze, 61 cm h, signed & dated
(Golden, Co Tipperary)

opposite

Tómas Mac Curtáin
[formerly Lord Mayor of Cork]
1963, bronze, 76 cm h, signed & dated
(City Hall, Cork)

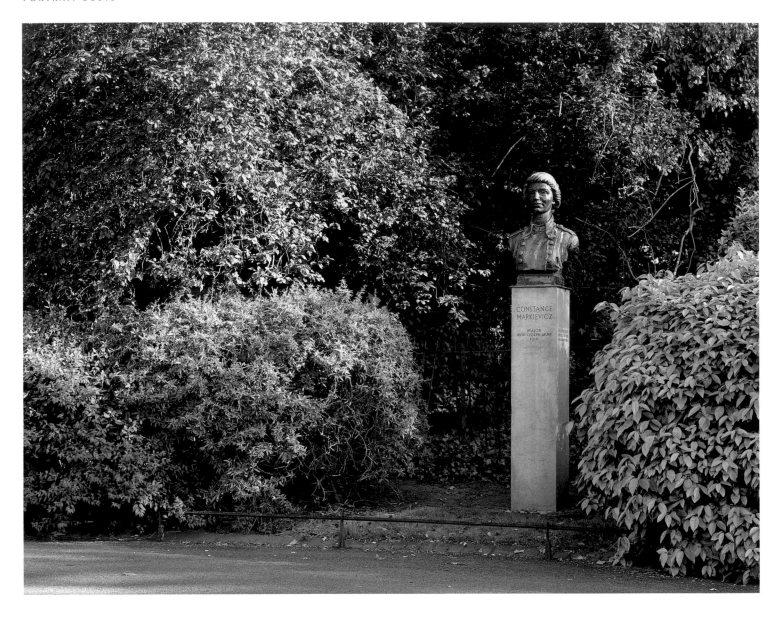

Countess Markievicz
1954, bronze, 91 cm h, signed & dated
(Office of Public Works / St Stephen's Green,
Dublin)

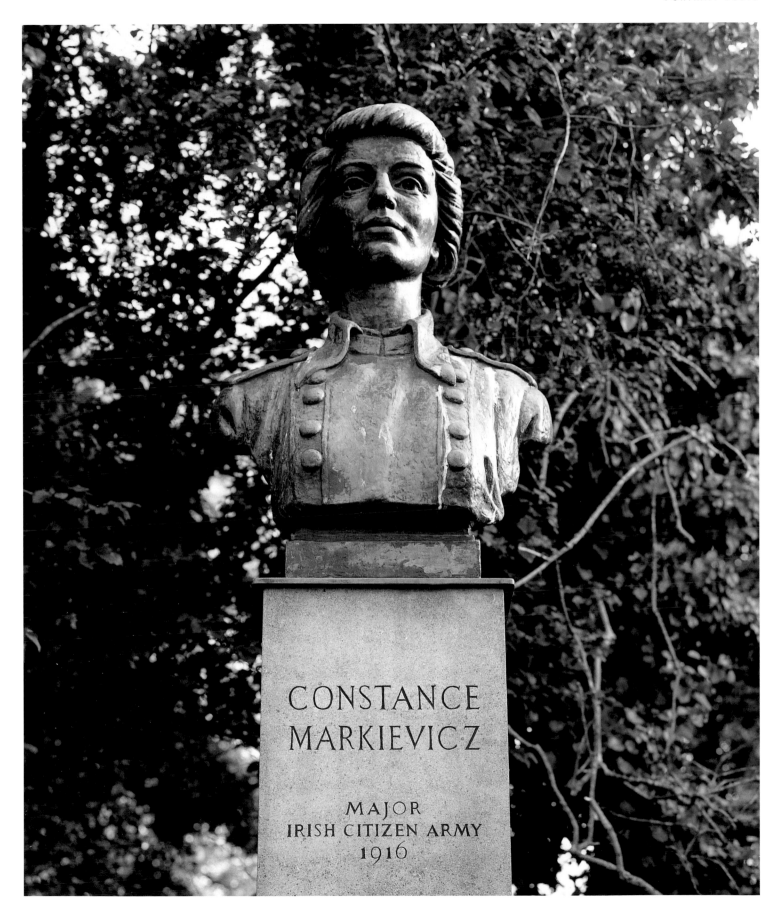

CONSTANCE
MARKIEVICZ

MAJOR
IRISH CITIZEN ARMY
1916

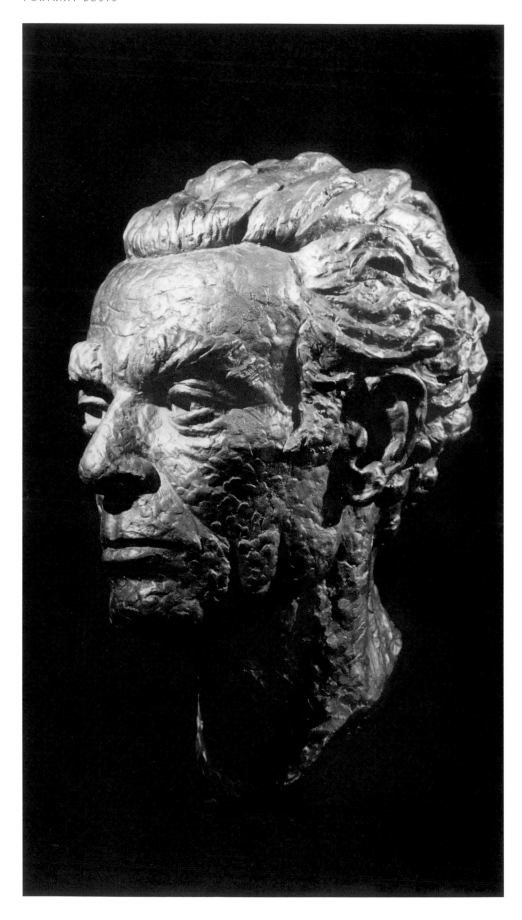

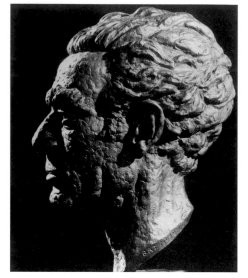

Bat Murphy [sculptor's brother]
1973, bronze, 51 cm h, signed & dated

opposite

Tadhg Ó Búachalla [The Tailor]
1936, bronze, 43 cm h, signed & dated
(AIB; Office of Public Works / Farmleigh House,
Dublin)

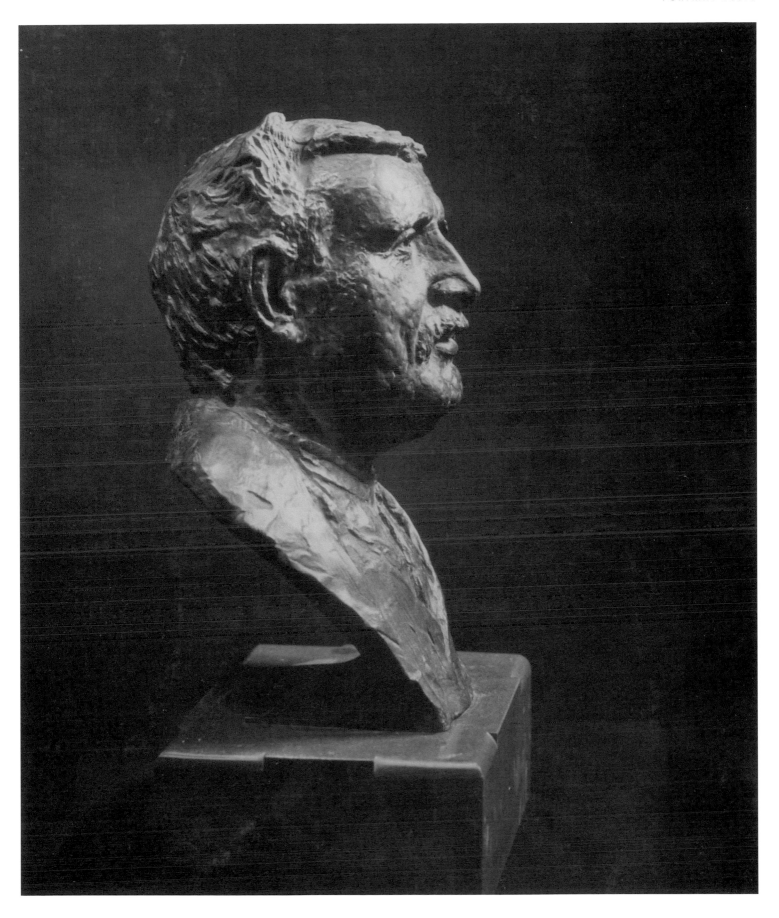

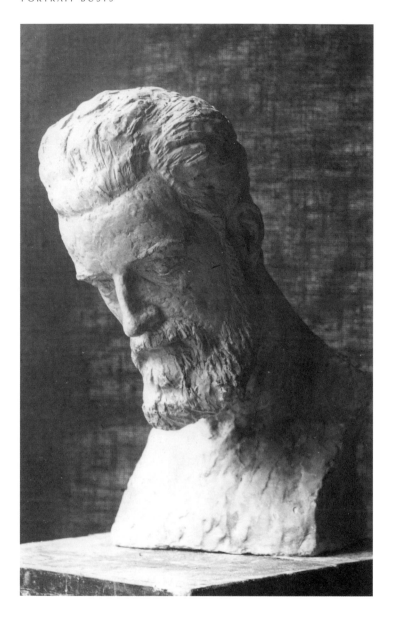

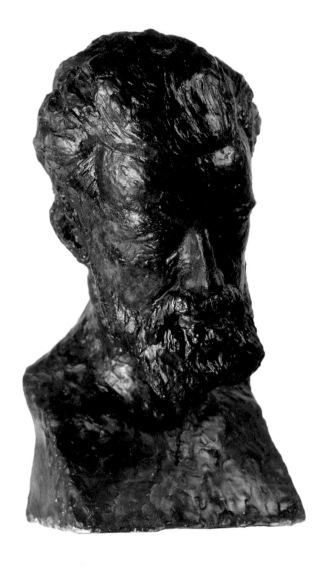

Roderic O'Conor
1930, bronze, 48 cm h, signed & dated
(Crawford Art Gallery / Great Southern Art
Collection)

opposite

Frank O'Connor
1957, bronze, 49 cm h, signed & dated
(Cork City Library; National Gallery of Ireland;
RTÉ; University College Cork)

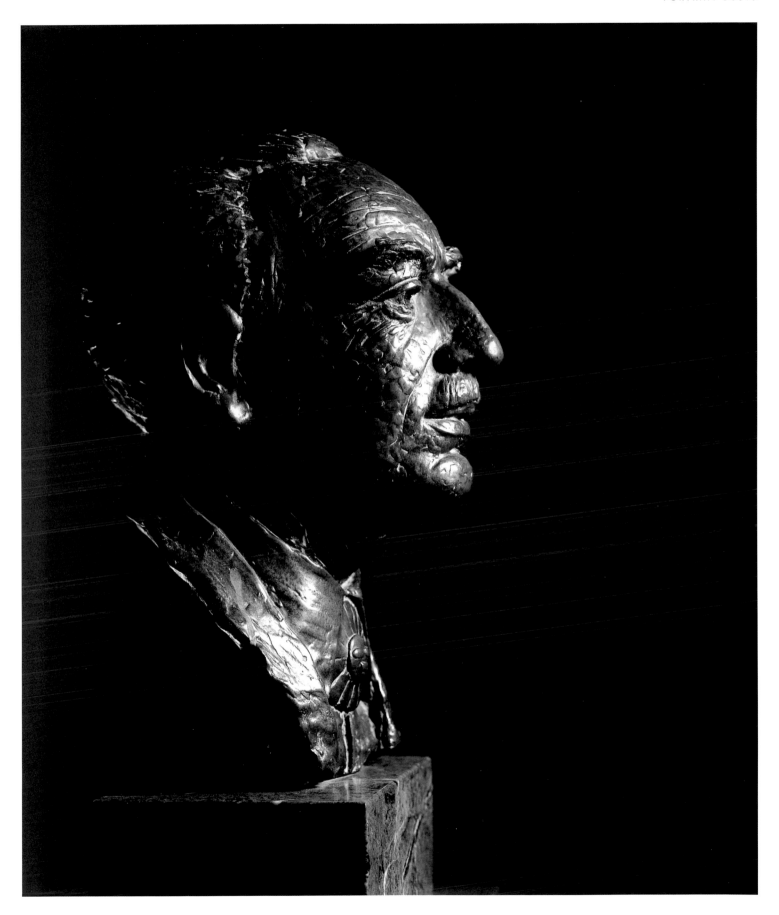

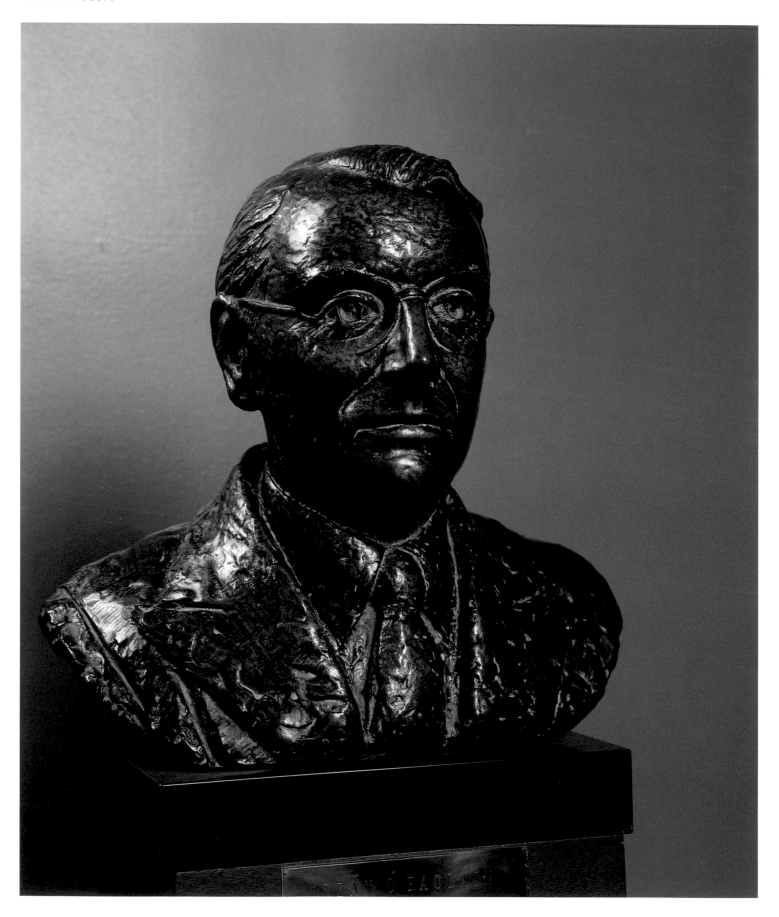

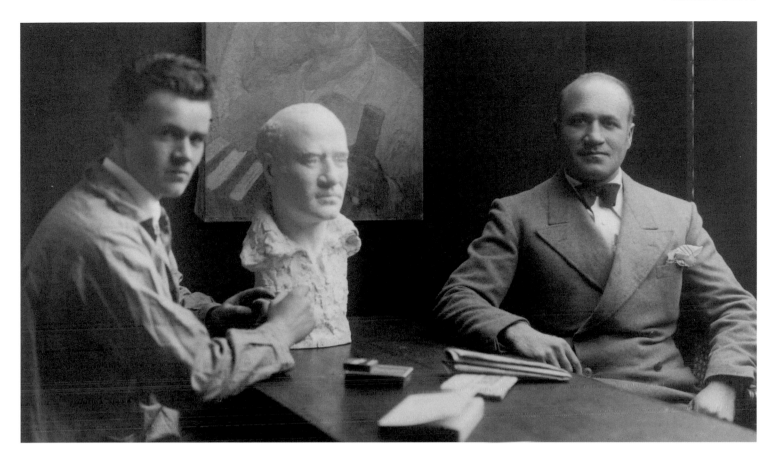

Billy Papke, Duc de Montparnasse
1931, life-size, plaster
(location unknown)

opposite

Seán Ó Faoláin
1947, bronze, 35 cm h, signed & dated
i(Cork City Library; University College Cork)

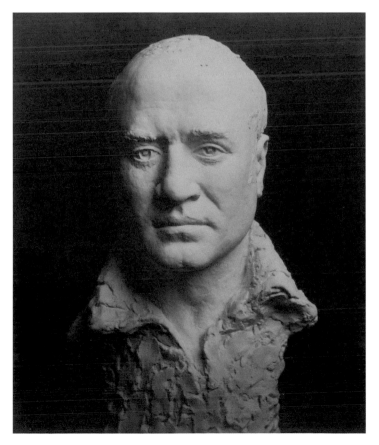

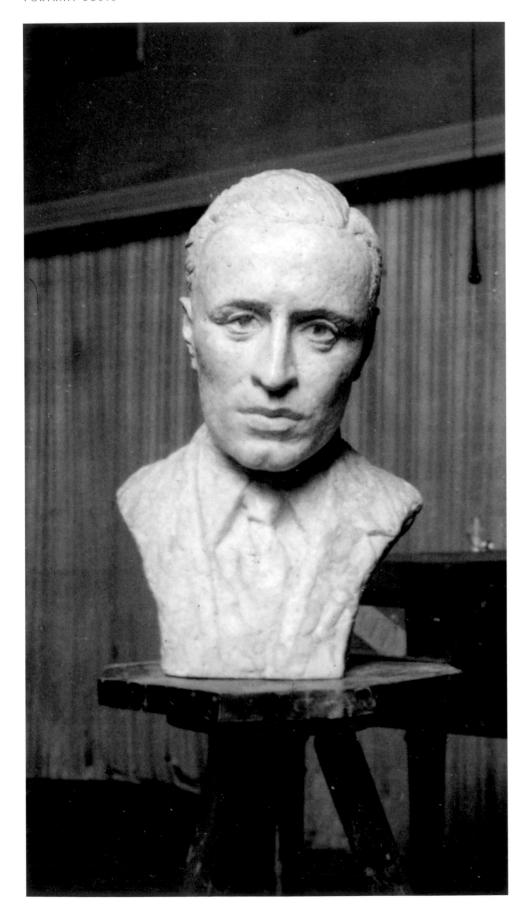

Kenneth Ripley
1932, plaster, 45 cm h, signed & dated

Ruth Ripley
1934, white marble, 50 cm h, signed
(Crawford Art Gallery)

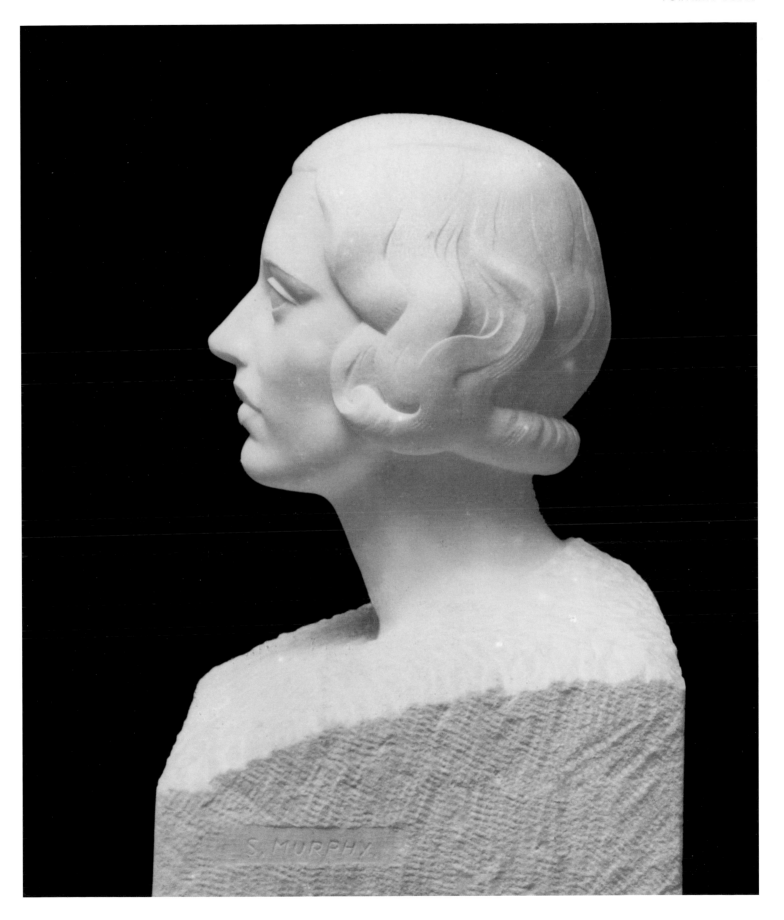

Maurice Walsh
1957, bronze, 44 cm h, signed

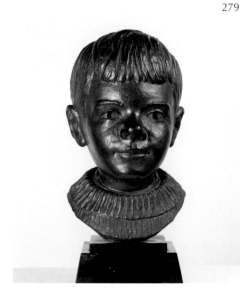

276

280

PORTRAIT BUSTS

(public/corporate collections in parentheses;
otherwise private collections)

* illustrated here
** plaster version in Crawford Gallery collection

MURPHY FAMILY

276 *
Bat Murphy [sculptor's brother]
1973, bronze, 51 cm h, signed & dated
note: 2 plaster versions extant; 1 bronze cast
made **
[see page 234]

277 *
Bébhinn [sculptor's daughter]
1955, white marble, 52 cm h, signed
inscription: BEBHINN 1955
note: 1 bronze cast made
(Scoil Mhuire, Wellington Road, Cork)

278
Colm at 3 [sculptor's son]
1962, bronze, 39.5 cm h, signed & dated
note: 1 plaster version extant; 1 bronze cast
made **

279 *
Colm at 6 [sculptor's son]
1965, bronze, 44 cm h, signed
inscription: COLM AT 6
note: 1 plaster version extant; 1 bronze cast
made **

280 *
James Murphy [sculptor's father]
1957, bronze, 45 cm h, signed
inscription: MY FATHER 1957
note: 2 plaster versions extant; 5 bronze casts
made
(AIB, Douglas, Cork) **

281
Joseph [grandson of Joseph Higgins, sculptor]
1961, bronze, 37 cm h, signed
inscription: JOE IN 1961
note: 1 plaster version extant; 1 bronze cast
made
(location unknown) **

282*
Maighréad [sculptor's wife]
1945, bronze, 50 cm h, signed
inscription: MAIGHREAD 1945
note: 1 plaster version extant; 1 bronze cast
made **

277
279

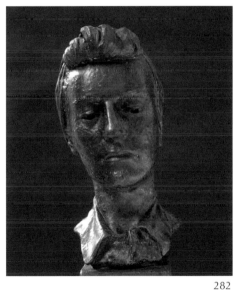

282
283

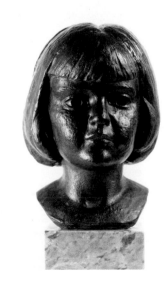

243

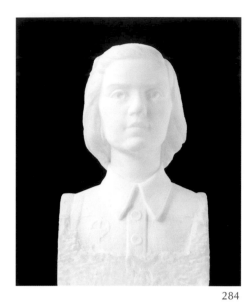

284

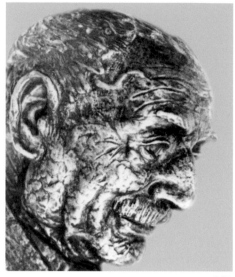

291

283 *
Orla at 3¹/₂ [sculptor's daughter]
1952, bronze, 36 cm h, signed
inscription: ORLA AT 3¹/₂
note: 2 plaster versions extant; 2 bronze casts
made **

284 *
Orla at 8 [sculptor's daughter]
1956, white marble, 45.5 cm h, signed
inscription: ORLA AT 8
note: 1 plaster version extant; no bronze cast
made **

285
Orla at 10 [sculptor's daughter]
1958, bronze, 49 cm h, signed
inscription: ORLA 1958
note: 1 plaster version extant; 1 bronze cast
made **

286
Robert Marten [sculptor's grandson]
1972, plaster and varnish, 57 cm h
note: 1 plaster version extant; no bronze cast
made **

OTHERS

287 *
Tomás Ághas [Thomas Ashe]
1965, bronze, 62 cm h, signed & dated
inscription: TOMÁS ÁGHAS 1884-1917
note: plaster version illustrated
(De La Salle College, Waterford) **

288
Terry Barry
1957, bronze, 43 cm h, signed
inscription: TERRY 1957
note: 1 plaster version extant; 1 bronze cast
made

289 *
General Tom Barry
1971, bronze, 53 cm h, signed
note: 1 plaster version extant; 2 bronze casts
made **

290
Senator J Brennan
1941, bronze, life-size, signed & dated

291 *
Mick Brew [stone-cutter]
1958, bronze, life-size, signed
note: 2 bronze casts made

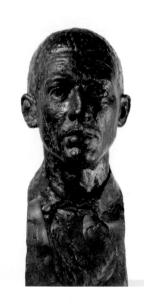

293
295

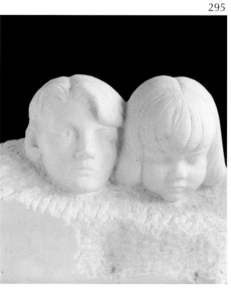

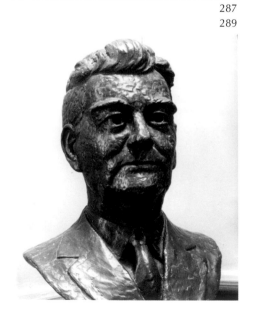

287
289

292
James Brown
1948, bronze, life-size
(Four Provinces House, Dublin)

293 *
Teddy Bucovictz
1932, plaster and varnish, 46 cm h,
signed & dated
note: 1 plaster version extant; no bronze cast
made **

294
Erskine Childers
1975, bronze, 49.5 cm h, signed & dated
note: 2 plaster versions extant; 1 bronze cast
made
(Office of Public Works / Áras an Uachtaráin) **

295 *
Children
1947, white marble, life-size, signed
note: This work was begun by Joseph Higgins
(SM's father-in-law), but was unfinished upon his
death in 1925, and completed by SM. Head of
boy modelled on Neil Hendrick, son of Sean
Hendrick, to whom *Sone Mad* is dedicated.

296 *
Peadar Clancy
1967, bronze, twice life-size, signed & dated
note: erected by the Co Clare Associations of
New York and Connecticut and comrades and
friends in the USA
(Town Square, Kildysart, Co Clare)

297 *
Robin Clapham
1946, bronze, 43.5 cm, signed
inscription: ROBIN

298
Prof Paddy Coffey
1967, plaster and varnish
52 cm h, signed & dated
note: 2 plaster versions extant; no bronze cast
made **

299
Michael Collins
1948, white marble, 104 cm h
note: bronze copy in Fitzgerald Park, Cork
(Dublin City Gallery – the Hugh Lane) **

300 *
Michael Collins
1966, bronze cast, 104 cm h
note: copy of 1948 marble bust
(Fitzgerald Park, Cork / presented to Cork

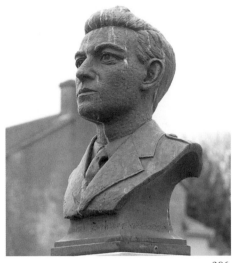

296

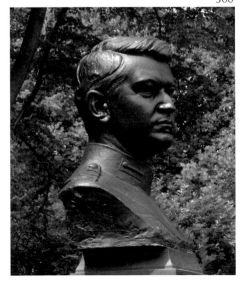

297
300

Sculpture Park by Conn Murphy)
[see pages 224-225]

301 *
Cal Condon
1964, bronze, 46 cm h, signed
note: 2 plaster versions extant; 1 bronze cast
made (plaster version illustrated) **

302 *
James Connolly
1960, bronze, 64.5 cm h, signed & dated
note: 1 plaster version extant; 1 bronze cast
made
(Dáil Chamber, Leinster House; commissioned
by the State) **

303 *
Daniel Corkery
1936, bronze, 42.5 cm h, signed & dated
(Crawford Art Gallery)

304 *
Eric Cross [author of *The Tailor and Ansty*]
1943, bronze, 44.5 cm h, signed
inscription: E CROSS 1943
note: 1 plaster version extant; 1 bronze cast
made **

305
[Kazi] Crowley
1968, bronze, 43 cm h, signed & dated
inscription: KAZI
note: 1 plaster version extant; 1 bronze cast
made **

306
Betsy Cummins
1966, bronze, life-size, signed
inscription: EILISH O COMAIN 1966

307 *
Thomas Davis
1942, bronze, life-size, signed & dated
note: 1 plaster version extant. Photo shows
Taoiseach Eamonn de Valera unveiling bust,
Mallow, October 1942.
(Mallow Historic Society, Co Cork; replica in
Áras an Uachtaráin)

308
Monsignor Pádraig de Brún
1959, bronze, life-size, signed & dated
inscription: MON P DE BRÚN
(NUI Galway)

309 *
Eamonn de Valera [when Taoiseach]
1944, bronze, 51.5 cm h, signed

301

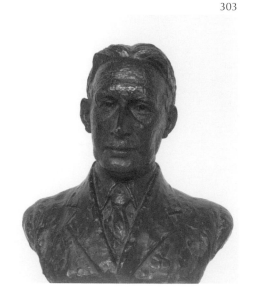

302
303

note: 3 plaster versions extant; 2 bronze casts made (plaster version illustrated)
(Iveagh House, Dublin; de Valera Museum and Bruree Heritage Centre, Co Limerick / Office of Public Works long-term loan) **
[see page 226]

310 *
Eamonn de Valera [when President]
1959, bronze, 49 cm h, signed & dated
note: 1 plaster version extant; 5 bronze casts made
(Ennis Library, Co Clare)
[see page 226]

311 *
Pádraig Fallon [poet and playwright]
1974, bronze, 37 cm h, signed & dated
note: 2 plaster versions extant; 1 bronze cast made (plaster version illustrated) **

312 *
The Farmer
n.d., red sandstone, 47 x 39 cm
(Royal Hibernian Academy, Dublin)

313 *
Séamus Fitzgerald
1966, bronze, 49.5 cm h, signed
inscription: SEAMUS FITZGERALD 1966
note: 1 plaster version extant; 1 bronze cast made
(Chamber of Commerce, Cork / on loan from Fitzgerald family) **

314 *
An Gobán / The Stonecutter
1949, bronze, 64 cm h, signed
note: 1 plaster version extant; 3 bronze casts made

315
Gerald Y Goldberg
1950, bronze, life-size, signed & dated

316
Prof Denis Gwynn
1952, plaster and varnish, 47 cm h,
signed & dated
inscription: DENIS GWYNN
note: 1 plaster version extant; no bronze cast made **

317 *
Myrtle Hardwick [née Prendergast]
1954, bronze, 57 cm h, signed
note: 1 plaster version extant; 1 bronze cast made
(Crawford Art Gallery / presented by Mrs M Hardwick, Fountainstown, Co Cork, 1989)

304

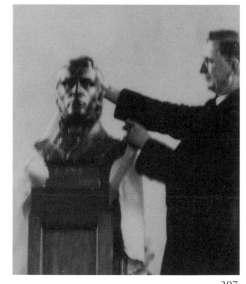

307
309

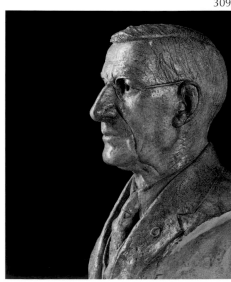

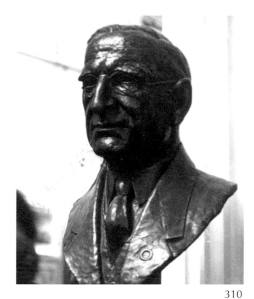

310

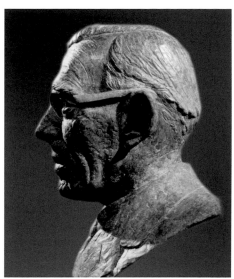

313

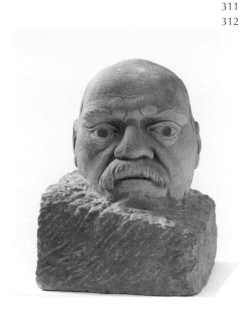

311
312

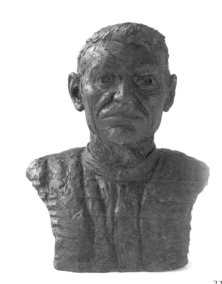

314
317

318
Dr Richard Hayes
1941, bronze, 49 cm h, signed & dated
inscription: DR RICHARD HAYES
note: 1 plaster version extant; 1 bronze cast made
(Limerick City Hall) **

319 *
Head of a Woman
n.d. plaster, 23 cm h **

320
Head of a Woman
c.1933, marble

321
Head of a Woman, Paris
1932, plaster and varnish, 47 cm h
note: 1 plaster version extant; no bronze cast made **

322
Abbey Hennessy
1961, plaster, life-size, signed
inscription: ABBEY 61

323 *
John J Horgan
1961, bronze, life-size, signed & dated
(Cork Harbour Commissioners, Horgan's Quay / presented by John Reihill)

324 *
Douglas Hyde [when President]
1941, bronze, 45 cm h, signed & dated
note: 1 plaster version extant; 2 bronze casts made (plaster version illustrated)
(Office of Public Works / Áras an Uachtaráin; Trinity College Dublin) **
[see page 227]

325
Dr JB Kearney
1959, bronze, life-size, signed & dated
inscription: JB KEARNEY M.D.
(Cork University Maternity Hospital)

326
Rhoda Kearney
n.d., plaster and varnish

327
Veronica Kearney
1963, bronze, 54.5 cm h, signed & dated
inscription: VERONICA KEARNEY 1963
note: 1 plaster version extant; 1 bronze cast made **

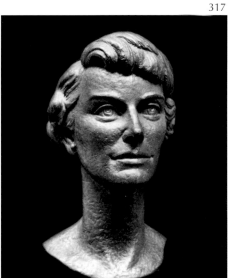

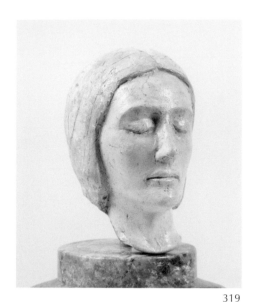

319

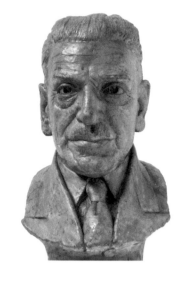

331

328

Dan Keenan

1938, bronze, 52 cm h, signed & dated
inscription: DAN KEENAN
note: 1 plaster version extant; 1 bronze cast
made **

329

President Kennedy

1964, white marble, 77 cm h, signed & dated
(American Ambassador's Residence, Phoenix
Park, Dublin / commissioned by the American
Embassy)

330

Séamus Lankford

1940, bronze, life-size, signed & dated

331 *

Seán Lemass [when Taoiseach]

1959, bronze, 50 cm h, signed
inscription: SEÁN LEMASS 1959
note: 1 plaster version extant; 2 bronze casts
made (plaster version illustrated) **

332

Judy Lord

1947, plaster, 41 cm, signed
inscription: JUDY LORD
note: 2 plaster versions extant; 2nd is a black
painted plaster **

333 *

Jack Lynch

1973, bronze, 53 cm h, signed
note: 1 plaster version extant; 4 bronze casts
made
(Cork City Hall; AIB, 66 South Mall, Cork;
Fíanna Fáil HQ, Cork; Cork Airport) **
[see page 228]

334

Dr AJ McConnell

[former Provost of Trinity College Dublin]
1962, bronze, 56 cm, signed & dated
inscription: DR A J MCCONNELL
note: 1 plaster version extant; 1 bronze cast
made
(Trinity College Dublin) **

335 *

Count John McCormack

1960, bronze, 67 cm h, signed & dated
inscription: JOHN COUNT MCCORMACK, BORN IN
ATHLONE 14 JUNE 1884 DIED IN DUBLIN 16 SEPT
1945 WORLD FAMOUS TENOR
(Athlone, Co Westmeath / commissioned by the
Friends of John McCormack) **
[see page 229]

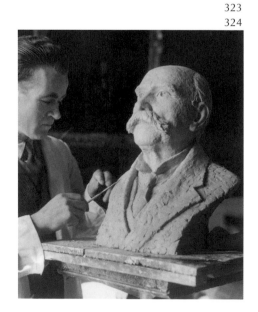

323
324

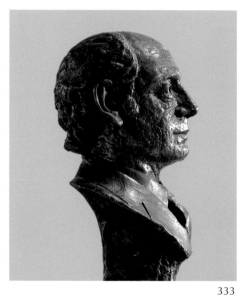

333
335

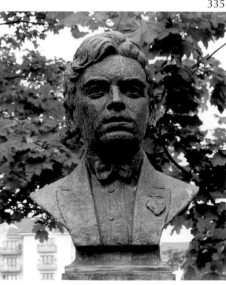

336 *
Tómas Mac Curtáin
[former Lord Mayor of Cork]
1963, bronze, 76 cm h, signed & dated
inscription: TÓMAS MAC CURTÁIN
(City Hall, Cork / commissioned by Cork
Corporation)
[see page 230]

337 *
Tomás Mac Donnchadha
[Tomás MacDonagh]
1966, bronze, 61 cm h, signed & dated
(Golden, Co Tipperary)
[see page 231]

338
Michael McDunphy
1941, bronze, life-size, signed & dated
(location unknown)

339
Seán MacEntee [when Tánaiste]
1960, bronze, life size, signed & dated
inscription: SEÁN MAC ENTEE

340
Peadar T Mac Fionnlaoich
1941, bronze, 46.5 cm h, signed & dated
inscription: CÚ ULADH
note: 1 plaster version extant; 2 bronze casts
made
(Colaiste Cú Uladh, Baile na Finne,
Co Donegal) **

341
Archbishop John Charles McQuaid
1941, bronze, 51 cm h, signed & dated
note: 2 plaster versions extant; 1 bronze cast
made
(Blackrock College, Dublin) **

342 *
Terence McSwiney
[former Lord Mayor of Cork]
1963, bronze, 69 cm, signed
note: 1 plaster version extant; 1 bronze cast
made
(City Hall, Cork / commissioned by Cork
Corporation) **

343 *
Countess Markievicz
1954, bronze, 91 cm h, signed & dated
inscription: CONSTANCE MARKIEVICZ, MAJOR
IRISH CITIZEN ARMY 1916.
A VALIANT WOMAN WHO FOUGHT FOR IRELAND
IN 1916. BEAN CROGA A TROID AR SON NA
H-EIREANN.

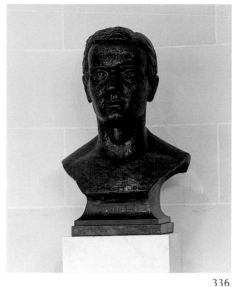

336

337
342

note: 1 plaster version extant; 1 bronze cast
made
(Office of Public Works / St Stephen's Green,
Dublin) **
[see pages 232-233]

344
Frederick May
1954, bronze, 49 cm h, signed
inscription: FREDERICK MAY COMPOSER 1954
note: 1 plaster version extant; 3 bronze casts
made
(National Gallery of Ireland; RTÉ; Long Valley,
Winthrop Street, Cork) **

345
John Montague
1972, plaster and varnish, 52 cm
note: 2 plaster versions extant; no bronze cast
made **

346 *
Conn Murphy
1966, bronze, 50 cm h, signed & dated
inscription: CONN MURPHY 1966
note: 1 plaster version extant; 1 bronze cast
made **

347
Prof JA Murphy
1973, plaster and varnish, 53 cm h, signed
inscription: PROF JOHN A MURPHY 1973
note: 2 plaster versions extant; no bronze cast
made **

348
W Lombard Murphy
1941, plaster, life-size
(location unknown)

349
John Murray
1970, bronze, 43 cm h, signed
inscription: JOHN MURRAY IN 1970
note: 1 plaster version extant; 1 bronze cast
made **

350 *
Connie Neenan
1966, bronze, 57 cm h, signed
inscription: CONNIE NEENAN
note: 1 plaster version extant; 3 bronze casts
made. Photo shows Jack and Máirín Lynch at
unveiling of bust. **

351
Geraldine Neeson
1947, plaster, life-size

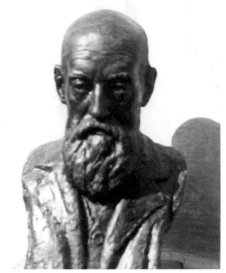

352 *
Nolan
1930, bronze
note: archive photo; no other details available

353
Peggy O'Brien
1972, bronze, 49 cm h, signed & dated
inscription: PEG
note: 2 plaster versions extant; 1 bronze cast
made **

354
WM O'Brien [ITGWU 1918-1946]
1961, plaster and varnish, 48 cm h, signed
inscription: WM O'BRIEN 1961
note: 1 plaster version extant; 1 bronze cast
made
(City Hall, Limerick) **

343

352

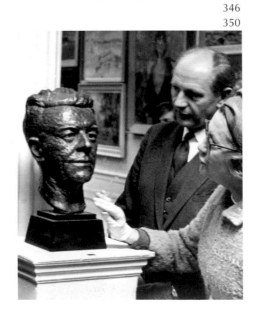

355 *
*Tadhg Ó Búachalla
(The Tailor)*
1936, bronze, 43 cm h, signed & dated
note: 1 plaster version extant; 7 bronze casts
made (plaster version illustrated)
(AIB; Office of Public Works / Farmleigh House,
Dublin) **
[see page 235]

356 *
Lennie O'Callaghan
1936, plaster
note: archive photo; no other details available

357
Máirtín Ó Cadháin
1972, bronze, 45 cm h, signed & dated
inscription: MÁIRTÍN Ó CADHÁIN
note: 2 plaster versions extant; 3 bronze casts
made
(Radio na Gaeltachta / commissioned by Máirtín
Standún) **

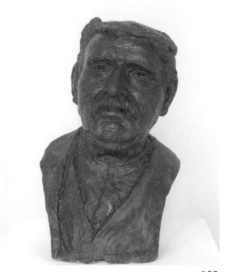

346
350

355
356

358 *
Frank O'Connor
1957, bronze, 49 cm h, signed & dated
inscription: FRANK O'CONNOR
note: 1 plaster version extant; 4 bronze casts
made
(Cork City Library; National Gallery of Ireland;
RTÉ; University College Cork) **
[see page 237]

359 *
Olga O'Connor (Meditation)
1932, bronze, 47 cm h, signed & dated
inscription: OLGA O'CONNOR
note: 1 plaster version extant; 1 bronze cast

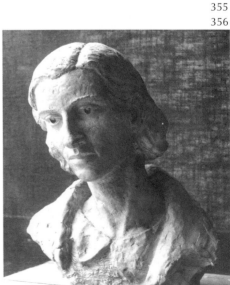

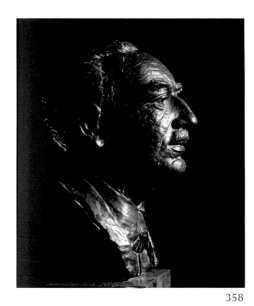

358

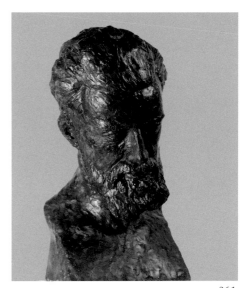

361

made (plaster version illustrated)
(AIB Bank, 66 South Mall, Cork)

360 *
Roderic [Roddy] O'Connor
1932, plaster
note: archive photo; no other details available

361 *
Roderic O'Conor
1930, bronze, 48 cm h, signed & dated
inscription: RODERIC O'CONOR PAINTER
note: 1 plaster version extant; 1 bronze cast
made
(Crawford Art Gallery / Great Southern Art
Collection)
[see page 236]

362
Cearbhall Ó Dálaigh
1975, bronze, 51 cm h, signed & dated
inscription: CEARBHALL Ó DÁLAIGH
note: 1 plaster version extant; 1 bronze cast
made **

363
Tadhg Ó Donnachádha
1950, bronze, life-size, signed & dated
inscription: TORNA
(University College Cork)

364
Mary Rose O'Driscoll
1959, bronze, life-size

365 *
Seán Ó Faoláin
1947, bronze, 35 cm h, signed & dated
inscription: SEÁN Ó FAOLÁIN
note: 1 plaster version extant; 2 bronze casts
made
(Cork City Library; University College Cork) **
[see page 238]

366
Seán T O'Kelly [when President]
1957, bronze, 53 cm h, signed & dated
note: 1 plaster version extant; 1 bronze cast
made
(Office of Public Works / Áras an Uachtaráin) **

367
Eoin Pope O'Mahony
1968, bronze, 49 cm h, signed & dated
inscription: EOIN O'MAHONY K.M.
note: 1 plaster version extant; 1 bronze cast
made
(Royal Irish Academy, Dublin / commissioned
by Nora O'Mahony) **

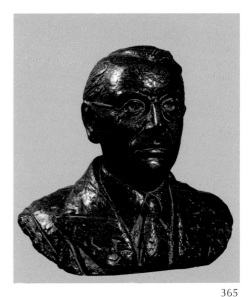

365
370

359
360

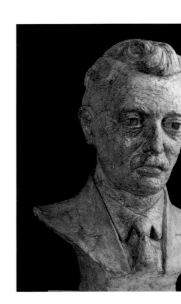

368
An tAthair Tadhg Ó Murchú
1960, bronze, 52 cm h, signed & dated
note: 1 plaster version extant; 2 bronze casts made
(Newcestown School, Co Cork) **

369
Dr MW O'Reilly
1968, bronze, 53 cm h, signed & dated
inscription: M W O'BRIEN
note: 1 plaster version extant; 1 bronze cast made **

370 *
Seán Ó Riada [composer and musician]
1972, bronze, 65 cm h, signed & dated
inscription: SEÁN Ó RIADA
note: 2 plaster versions extant; 1 bronze cast made (plaster version illustrated)
(RTÉ) **

371 *
Seán Ó Ríordáin
1957, bronze, life-size, signed& dated
note: 4 bronze casts made
(University College Cork)

372
Deirdre O'Shea
1975, bronze, 45 cm h, signed
note: 1 plaster version extant; 2 bronze casts made. This was Séamus Murphy's last work, left unfinished in clay. It was subsequently cast in bronze **

373
Peter O'Sullivan
1974, bronze, 42 cm h, signed
inscription: PETER
note: 1 plaster version extant; 1 bronze cast made **

374 *
Billy Papke, Duc de Montparnasse
1931, life-size, plaster
note: He was the world middleweight boxing champion in 1908 and 1910. In 1936 he killed his wife and then himself.
(location unknown)
[see page 239]

375
Mrs JP Rehill
1959, bronze, life-size, signed & dated

376
JP Rehill
1960, bronze, life-size, signed & dated

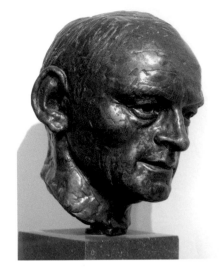

371

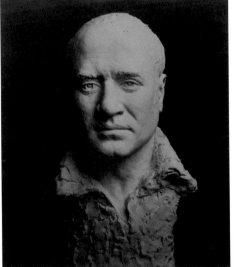

374
377

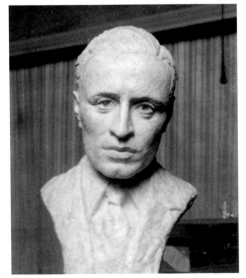

377 *
Kenneth Ripley
1932, plaster, 45 cm h, signed & dated
inscription: KENNETH RIPLEY
note: 1 plaster version extant; no bronze cast made **
[see page 240]

378 *
Ruth Ripley
1934, white marble, 50 cm h, signed
(Crawford Art Gallery)
[see pages 222, 240, 241]

379 *
Liam Robinson
1952, plaster, 52 cm h, signed
inscription: LIAM ROBINSON
note: 1 plaster version extant; no bronze cast made **

380 *
John Rohan
1972, bronze, 59 cm h, signed
inscription: JOHN ROHAN
note: 2 plaster versions extant; 1 bronze cast made **

381
Maeve Ryan
1965, bronze, life-size

382
Jefferson Smurfit
1969, bronze, 46 cm h, signed & dated
inscription: JEFFERSON SMURFIT
note: 1 plaster version extant; 1 bronze cast made
(K Club, Straffan, Co Kildare) **

383
James Stack
1973, bronze, 55 cm h, signed
inscription: JAMES STACK 1973
note: 2 plaster versions extant; 1 bronze cast made
(Cork Opera House) **

384 *
Leon Uris [writer]
1972, bronze, 55 cm h, signed
note: 1 plaster version extant; 1 bronze cast made **

385 *
William Vincent Wallace [composer]
1971, bronze, 106 cm h, signed & dated
note: plaster version illustrated in archive photo
inscription: WILLIAM VINCENT WALLACE

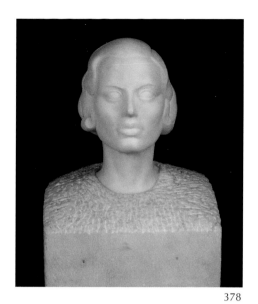

378

(COMPOSER) BORN WATERFORD 1812 DIED IN THE PYRENEES 1865. 1 verse of 'In Happy Moments'.

386*
Maurice Walsh [writer]
1957, bronze, 44 cm h, signed
inscription: MAURICE WALSH
note: 1 plaster version extant; 1 bronze cast made (plaster version illustrated) **
[see page 242]

387
Woman in Shawl
1940, bronze, 54 cm h, signed
note: 1 plaster version extant; 1 bronze cast made **

———

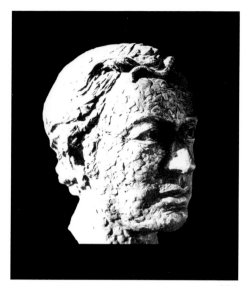

384

379
380

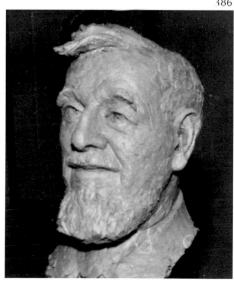

385
386

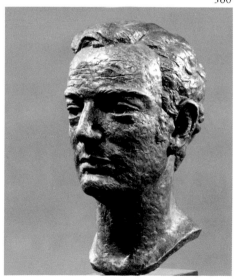

Dreamline 1934. Portland stone, 74 cm h (Fitzgerald Park, Cork)

ALLEGORICAL AND OTHER WORKS

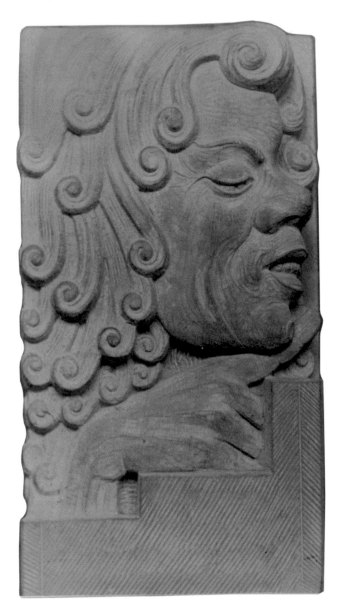
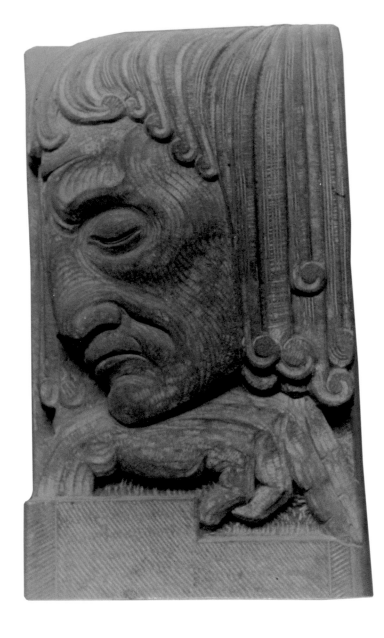

Comedy and Tragedy
n.d., red sandstone corbels, 61 x 30 cm
(location unknown)

opposite

Daydream
1931, white marble, 55 cm h
(Crawford Art Gallery)

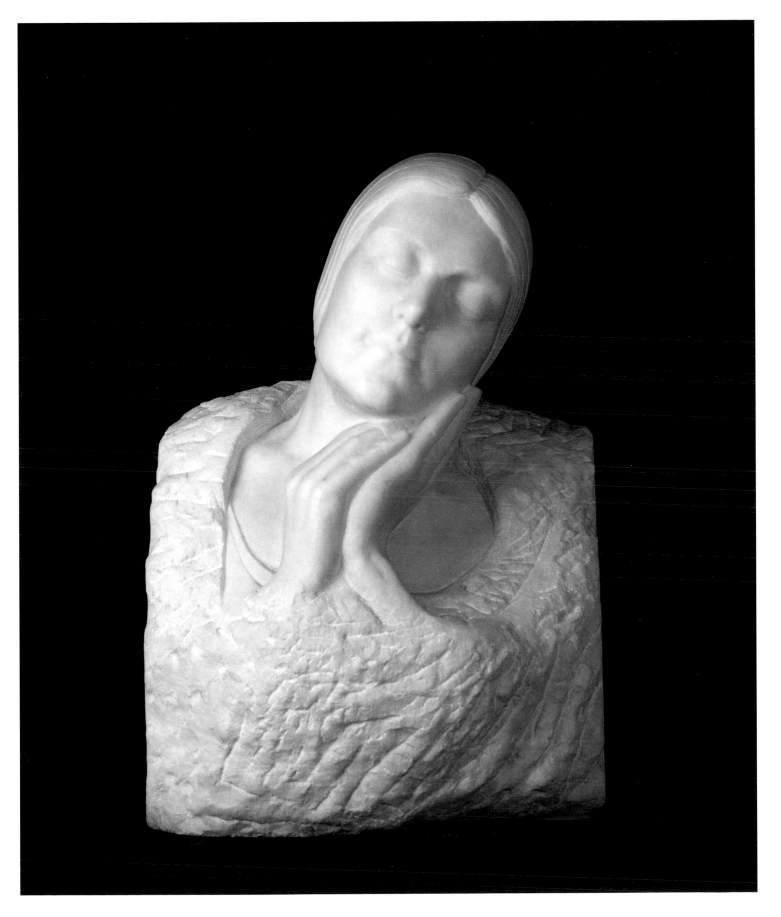

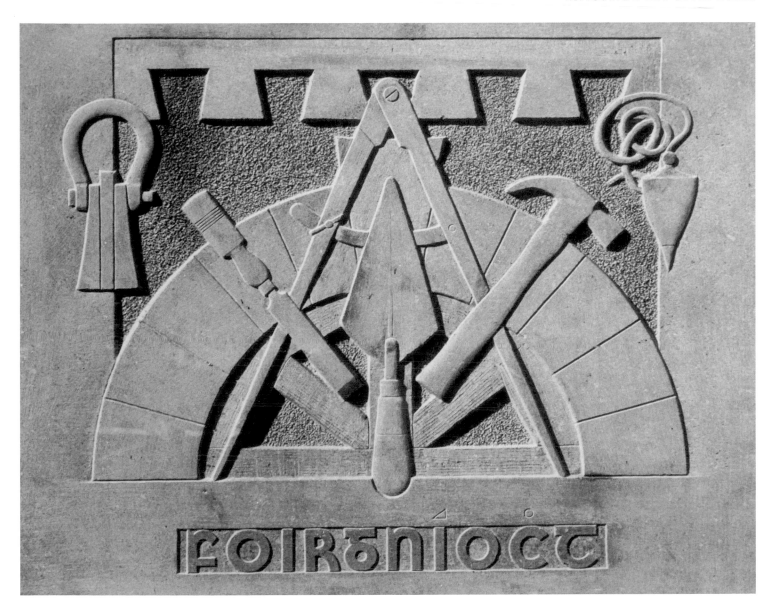

Crawford Technical School
1967, 3 limestone panels
(placed one above the other), each 74 x 94 cm
(Crawford College of Art & Design, Cork)

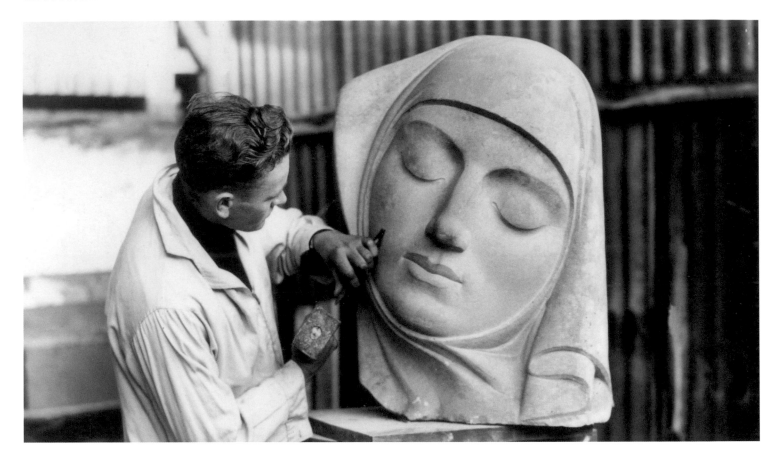

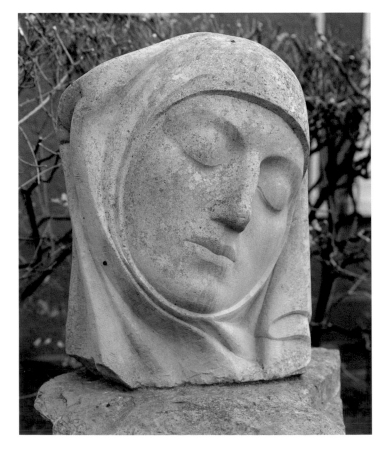

Dreamline
1934, Portland stone, 74 cm h
(Fitzgerald Park, Cork)

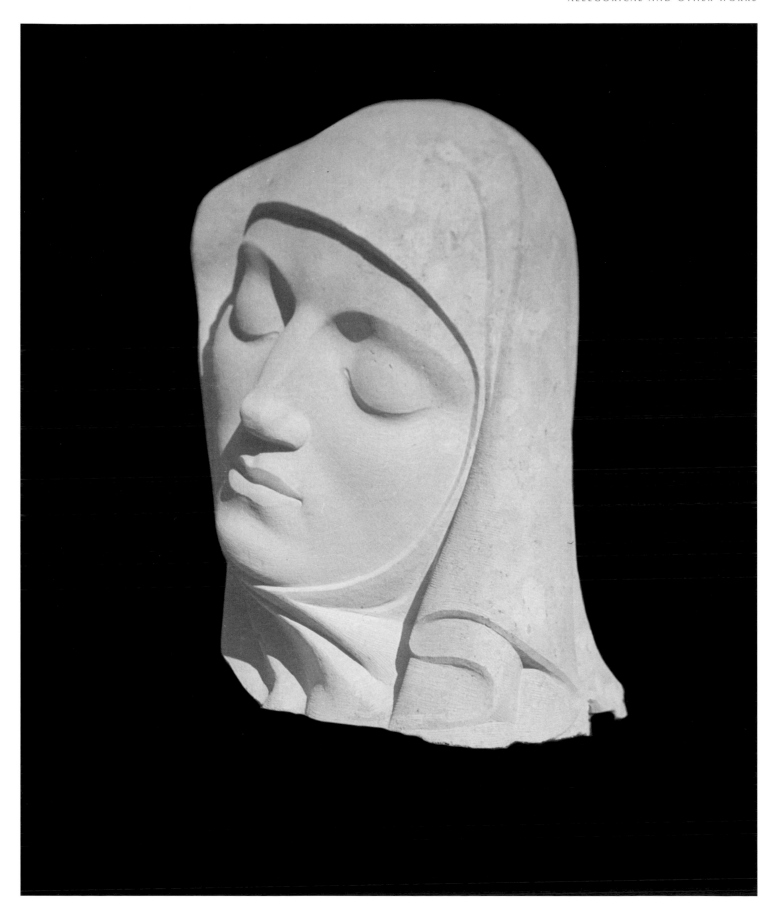

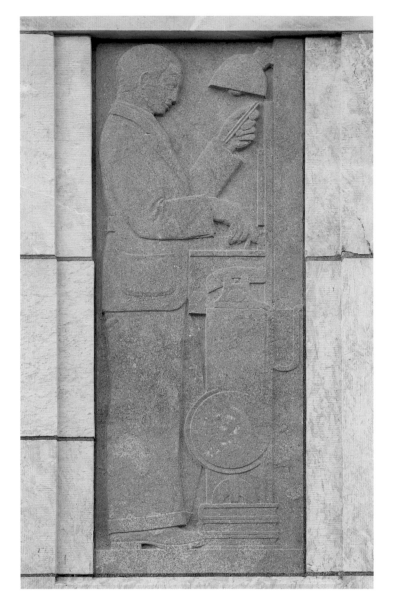

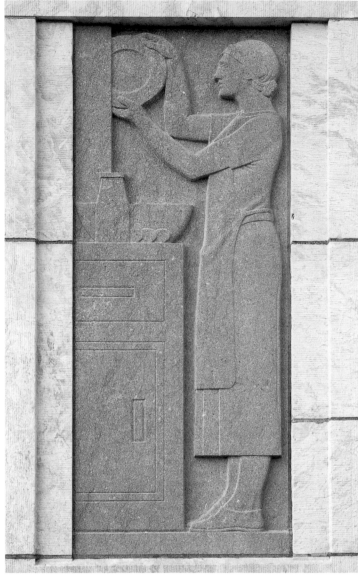

Man at Bench, Woman Cooking
1935, 2 limestone panels, each 91 x 33 cm
(School of Commerce, Cork)

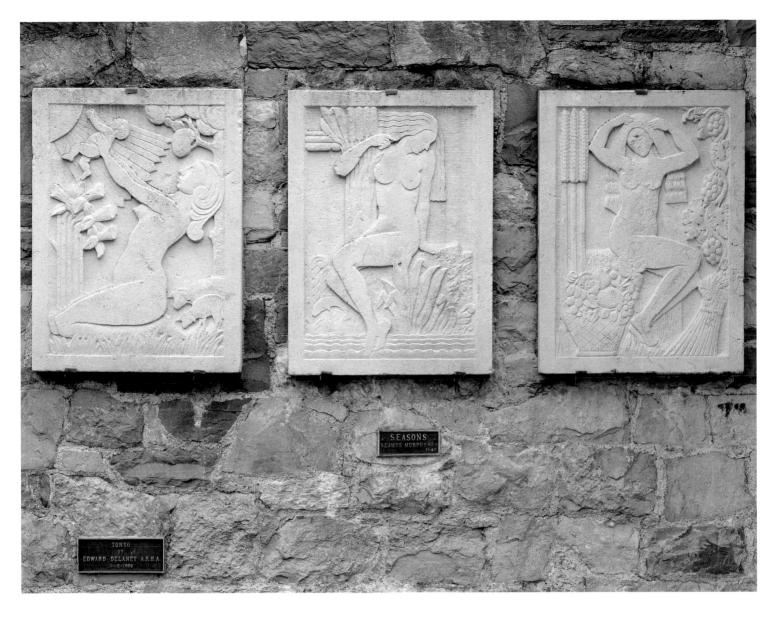

Seasons (Spring Summer Autumn)
1940, 3 Portland stone panels (*Winter* broken
before being installed), each 90 x 65 cm
(Fitzgerald Park, Cork)

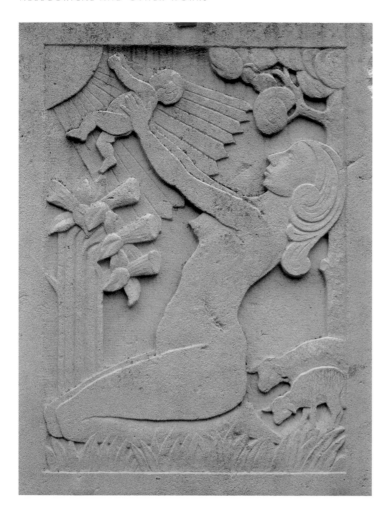
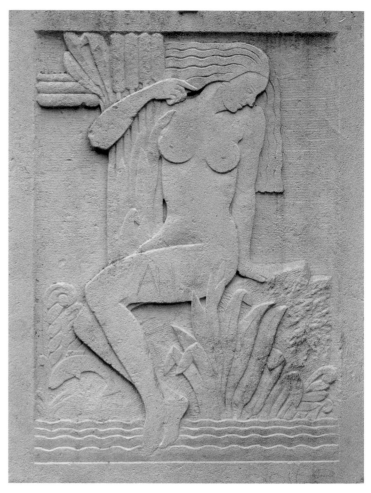

Seasons (Spring Summer Autumn)
1940, 3 Portland stone panels (*Winter* broken
before being installed), each 90 x 65 cm
(Fitzgerald Park, Cork)

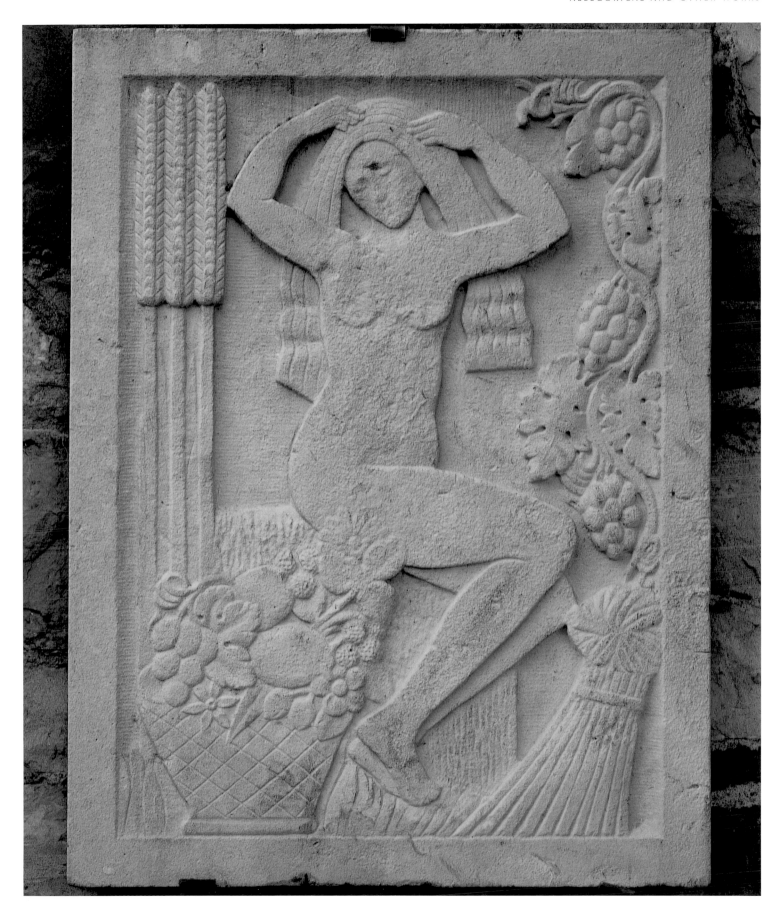

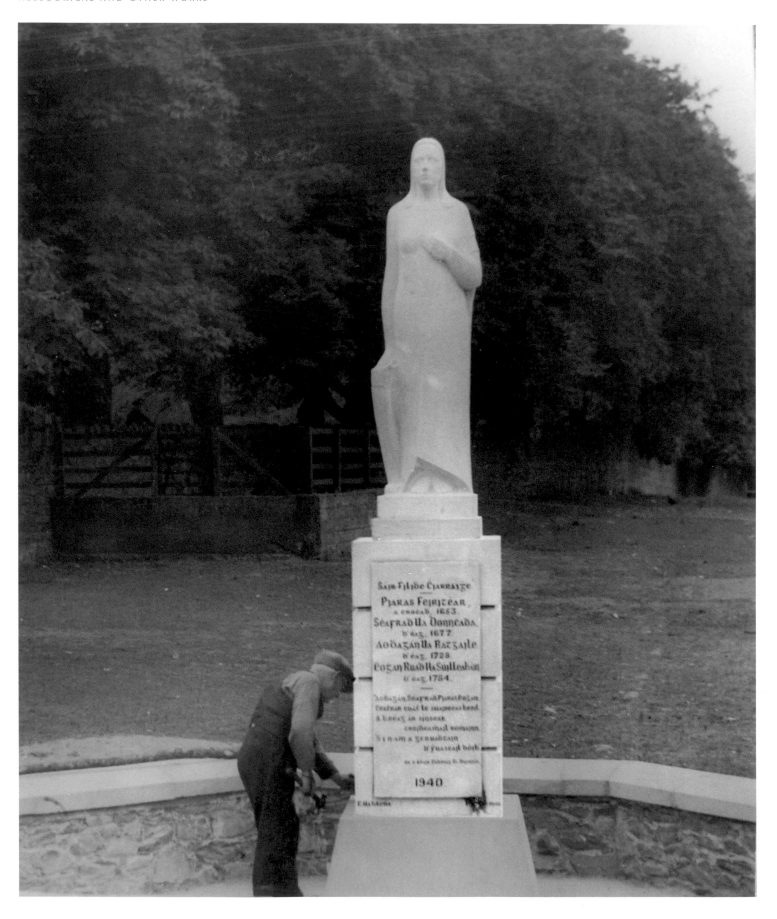

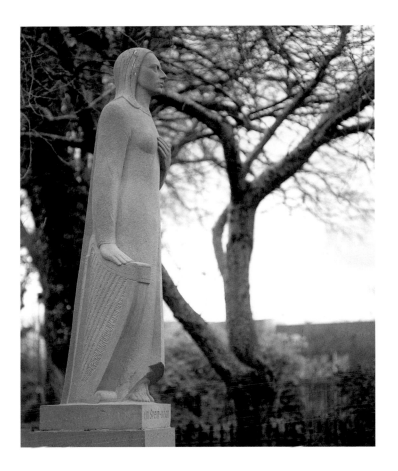

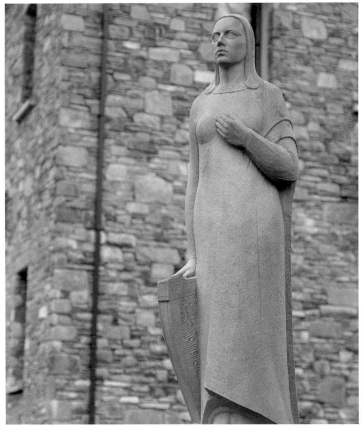

An Spéir Bhean
(Kerry Poets Memorial)
1940, limestone, 183 cm h, signed
(inscription carved by T Ó hAodha)
(Killarney, Co Kerry)

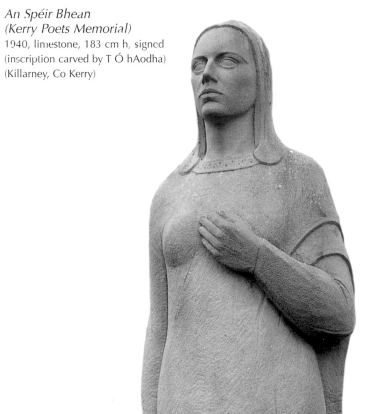

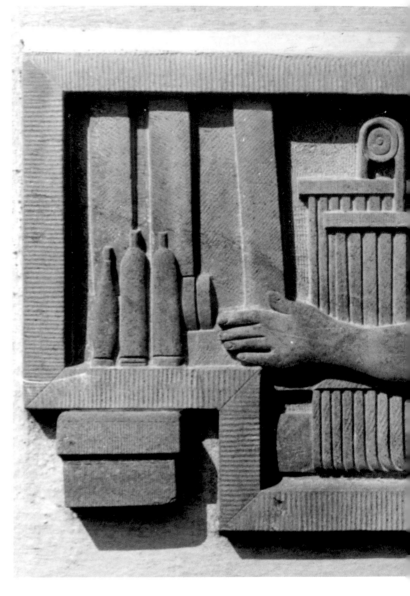

Weaving
1947, limestone panel, 61 x 138 cm
(Seafield Fabrics, Youghal, Cork)

opposite

Spinning
1948, limestone panel, 71 x 214 cm,
signed & dated
(formerly Worsted Mills, Midleton, Co Cork;
panel moved to Sunbeam Mills, Cork, when
former closed)

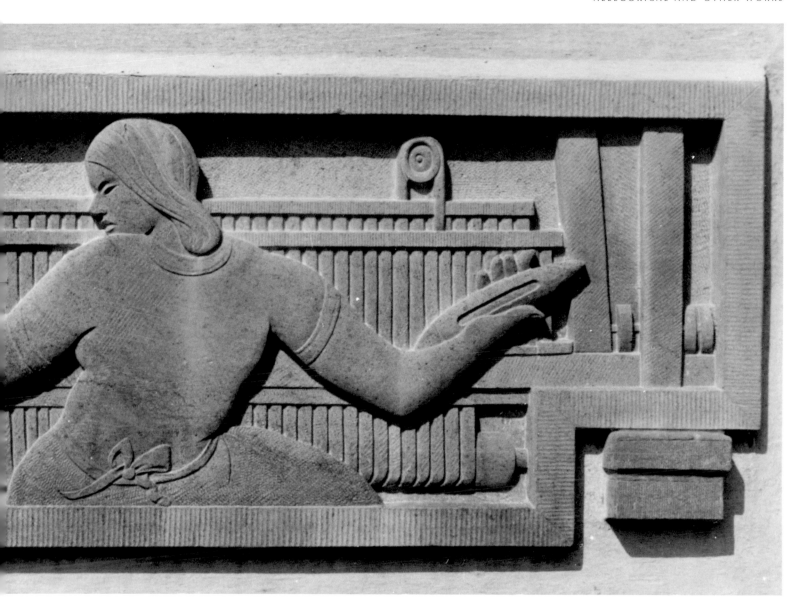

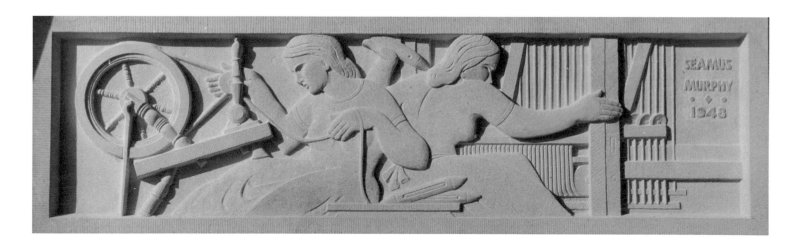

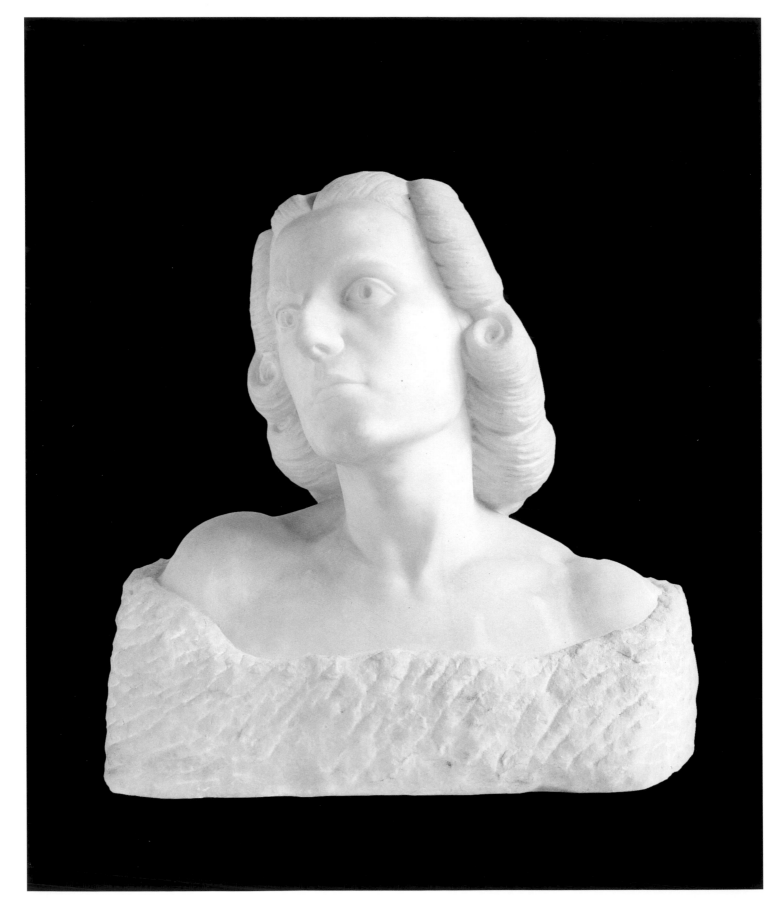

Dolphins
n.d., 2 Portland stone pieces
(Glenkeen, Glanmire, Cork)

opposite

Sylphide
1943, white marble, 42 cm h, signed & dated

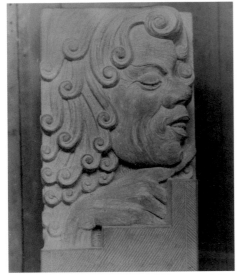

389a

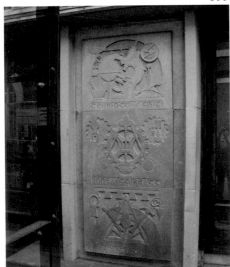

389b
390

ALLEGORICAL & OTHER WORKS

(locations in parentheses)

* illustrated here
** plaster version in Crawford Gallery collection

ALLEGORICAL WORKS

388
Cotton
1967, Portland stone panel, 51 x 152 cm
(formerly Blackwater Cotton Mills, Youghal,
Co Cork)

389 *
Comedy and Tragedy
n.d., red sandstone corbels, 61 x 30 cm
(location unknown)
[see page 256]

390 *
Crawford Technical School
1967, 3 limestone panels, each 74 x 94 cm
note: 3 relief panels placed one above the other,
with chiselled limestone surround
inscription (top panel): CEIMHIOCHT A FISIC,
bearing symbols of chemistry and physics
inscription (centre panel): INNEALTÓIREACHT,
bearing symbols of engineering
inscription (bottom panel): FOIRGNÍOCHT,
bearing symbols of building construction.
(Crawford College of Art & Design, Cork)
[see pages 258-259]

391 *
Daydream
1931, white marble, 55 cm h
(Crawford Art Gallery)
[see page 257]

392 *
Deirdre (of the Sorrows)
1933, bronze, 23.5 cm h, signed
note: 2 plaster versions extant; 4 bronze casts
made
(Crawford Art Gallery / Great Southern Art
Collection)

393 *
Dreamline
1934, Portland stone, 74 cm h
(Fitzgerald Park, Cork)
[see pages 254, 260-61]

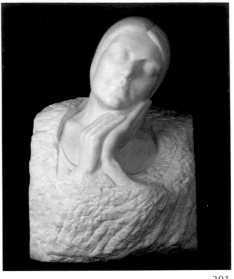

391

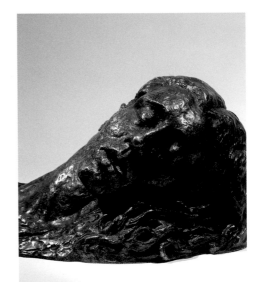

392
393

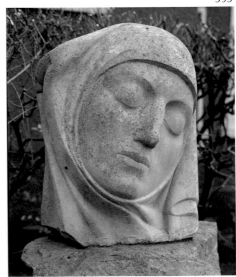

394

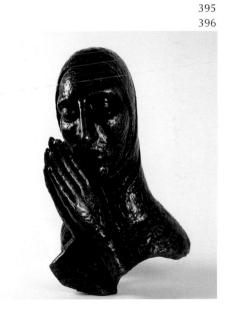

395
396

394 *
Man at Bench, Woman Cooking
1935, 2 limestone panels, each 91 x 33 cm
(School of Commerce, Cork)
[see page 262]

395 *
Meditation [Olga O'Connor]
1932, bronze, 47 cm h, signed & dated
inscription: OLGA O'CONNOR
note: 1 plaster version extant; 1 bronze cast
made (plaster version illustrated)
(AIB Bank, South Mall, Cork) **

396 *
Prayer
1933, bronze, 53 cm h, signed & dated
note: 4 bronze casts made
(Crawford Art Gallery / Great Southern Art
Collection)

397 *
Seasons (Spring Summer Autumn)
1940, 3 Portland stone panels, each 90 x 65 cm
note: *Winter* broken before being installed
(Fitzgerald Park, Cork / presented by Mrs Mary
Horgan)
[see pages 263-265]

398 *
An Spéir-Bhean (Kerry Poets Memorial)
1940, limestone, 183 cm h, signed
note: inscription carved by T Ó hAodha
(Killarney, Co Kerry)
[see pages 266-267]

399 *
Spinning
1948, limestone panel, 71 x 214 cm,
signed & dated
(formerly Worsted Mills, Midleton, Co Cork;
moved to Sunbeam Mills, Cork, when former
closed)
[see page 269]

400 *
Sylphide
1943, white marble, 42 cm h, signed & dated
note: 1 plaster version extant; no bronze cast
made. Model was Maighréad Uí hUiginn
(Higgins), later wife of SM.
[see page 270]

401 *
Weaving
1947, limestone panel, 61 x 138 cm
(Seafield Fabrics,Youghal, Cork)
[see pages 268-269]

397

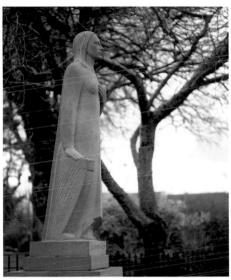

398

399
400

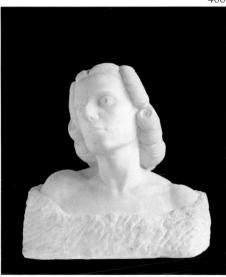

401

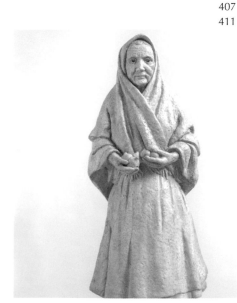

407
411

DEATHMASKS

402
Arnold Bax [composer]
1953, plaster and varnish, 33 cm h
note: 2 plaster versions extant **

403
Patrick Kavanagh
1967, plaster and varnish, 32 cm h
note: 3 plaster versions extant **

404
Frank O'Connor
n.d., plaster, 29 cm h
note: 6 plaster versions extant **

405
Seán Ó Riada
1971, bronze, 37 cm h, signed
note: 3 plaster versions extant
(Cork Public Museum) **

406
Seán Ó Riada – Hand
1971, plaster, 26 cm long
note: several plaster versions extant
(Cork Public Museum) **

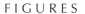

FIGURES

407 *
After Mass
1936, polished limestone, 92 cm h

408
Peter Broderick [stone polisher]
1935, plaster and varnish, 95 cm h
note: 1 plaster version extant **

409
Jimmy Bruen [golfer]
1948, plaster, 60 cm h, signed & dated
note: 2 plaster versions extant **

410
Tom Burke
n.d., plaster and varnish, 67 cm h
note: 1 plaster version extant **

411 *
Mary Anne, the Onion Seller
1937, bronze, 91 cm h
note: 1 plaster version extant; 2 bronze casts
made
(Peace Park, Grand Parade, Cork) **

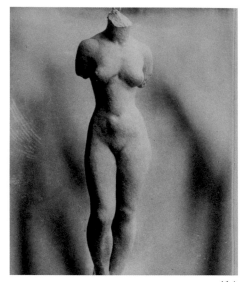

414

415
418

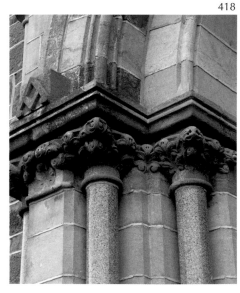

412
Monk
n.d., plaster and varnish figurine, 39 cm h
(Crawford Art Gallery)

413
Seated King
n.d., plaster and varnish, 36 cm h
note: 1 plaster version extant **

414 *
Study of a Nude
1932

415 *
Warrior
n.d., plaster and varnish, 72 cm h
note: 1 plaster version extant; no bronze cast
made. Designed for the New York World's Fair,
1939. **

OTHER WORKS

416
Birdbath
n.d., limestone

417
Bob and Joan
n.d., bronze, 48 cm h
note: modelled from original life-sized lead
figures (sculptor unknown) which stood on the
gate piers of the Green Coat School, Shandon,
Cork **

418 *
Carved Capitals
n.d., red sandstone, 30 x 46 x 46 cm
note: 4 capitals on either side of cathedral door
(St Carthage's Cathedral, Lismore, Co Waterford)

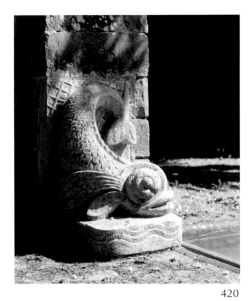

420

423

419
Carved Gatepost Cap
n.d., limestone
(Midleton Park Hotel (formerly Sherwood),
Co Cork)

420 *
Dolphins
n.d., 2 Portland stone pieces
note: commissioned by Declan Dwyer for
swimming pool at Glenkeen, Glanmire, Cork
[see page 271]

421
Hare
n.d., polished limestone, 41 x 18 cm, signed422
IPA Medallion
n.d., silver, 7 cm diameter
note: relief profile of child modelled from
sculptor's son
inscribed: IRISH PAEDIATRIC ASSOCATION
(location unknown)

423 *
Madraí
1950, limestone drinking trough, 12 x 61 cm
inscription: MADRAÍ
(Pairs Shoe Shop, Patrick Street, Cork)

424
Sundial
n.d., limestone

425
Wool and Needles
n.d., white marble paperweight, 9.5 x 14.5 cm

A

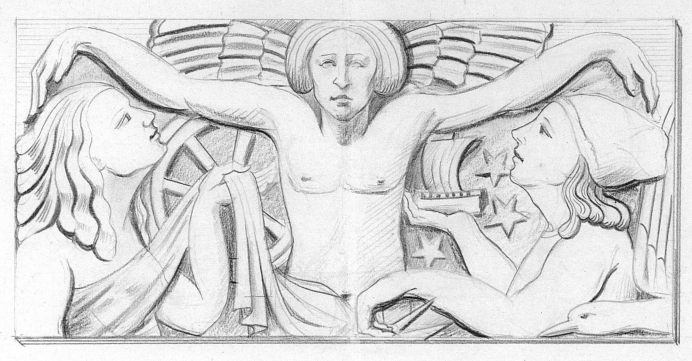

B

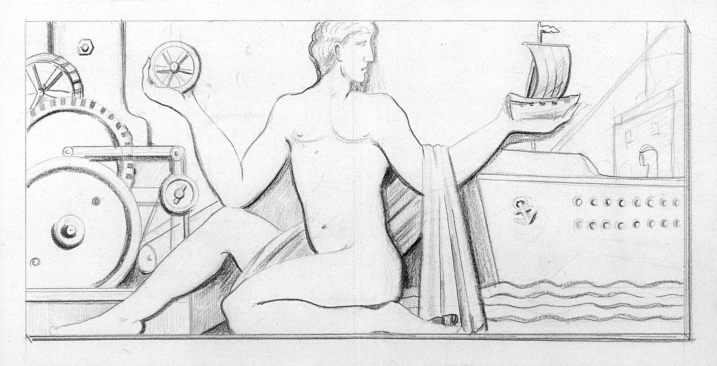

DRAWINGS AND WATERCOLOURS

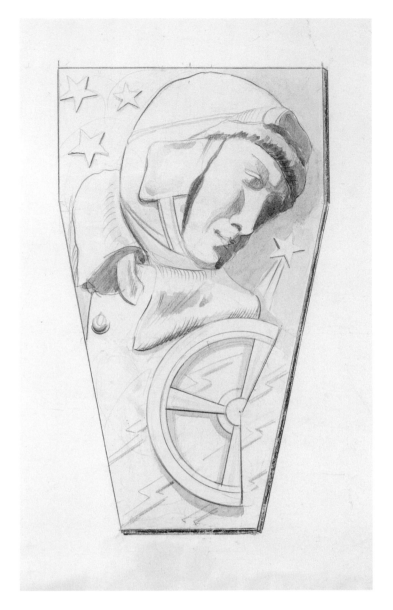

Aviation Pilot
n.d., pencil and blue wash on paper,
37 x 24 cm (detail)

Tomás Ceannt Memorial
(for Collins Barracks, Cork)
n.d., pencil and blue wash on paper (detail)

opposite

Design for PJ Hegarty's grave
n.d., pencil and blue wash on paper,
52 x 74 cm (detail)

Aviation
1932, pencil and blue wash on paper,
286 x 375 mm (detail)

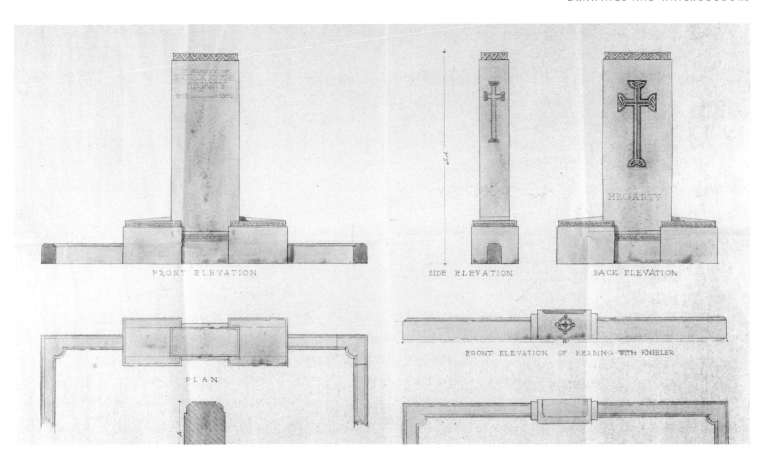

FRONT ELEVATION SIDE ELEVATION BACK ELEVATION

PLAN FRONT ELEVATION OF KERBING WITH KNEELER

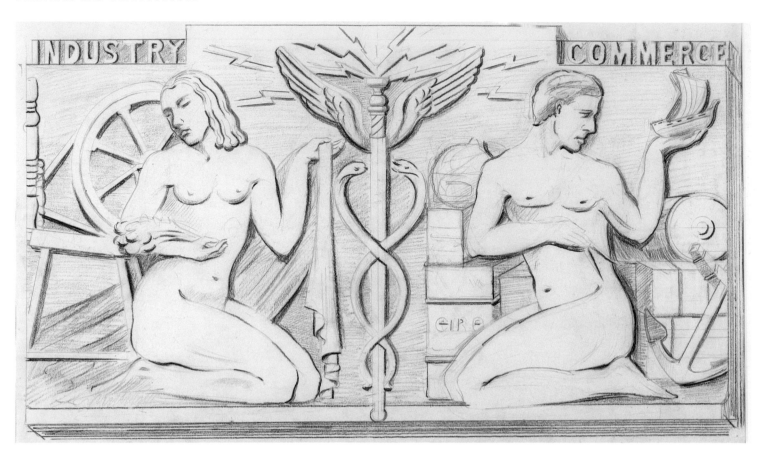

INDUSTRY COMMERCE

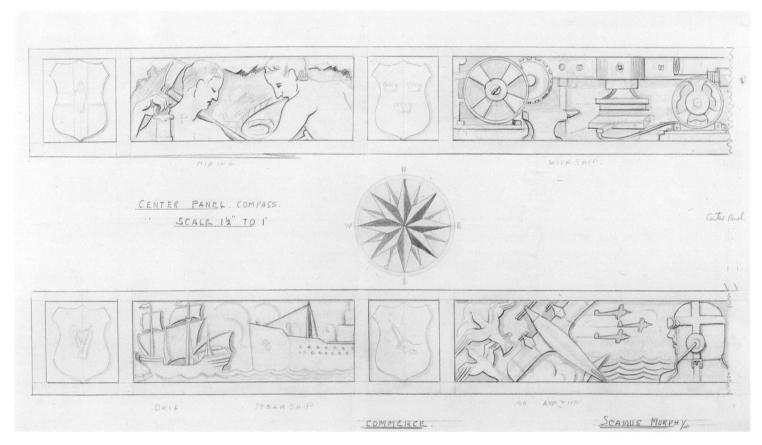

MINING WORKSHEP

CENTER PANEL. COMPASS.

SCALE 1½" TO 1'

Center Panel

BRIG STEAMSHIP AIR AVIATION

COMMERCE. SEAMUS MURPHY.

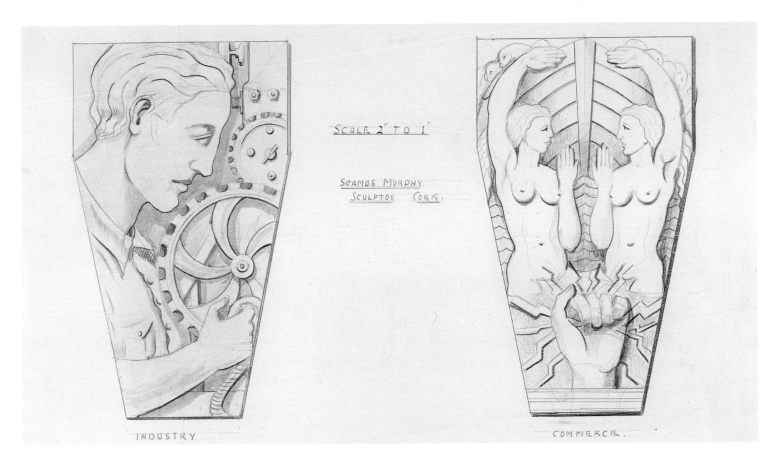

Dept of Industry & Commerce

Industry & Commerce I
1941, pencil and blue wash on paper,
38 x 56 cm (detail)
note: man and cog represent industry; two
women and fist in foreground represent
commerce

Industry & Commerce III
1941, pencil and blue wash on paper,
38 x 56 mm (detail)
note: singular figure holding ship

opposite

Industry & Commerce V
1941, pencil on paper, 38 x 56 cm (detail)
note: woman with spinning wheel; man holding
boat and anchor

Industry & Commerce II
1941, pencil and blue wash on paper,
38 x 56 cm (detail)
note: central compass, mining, galleon

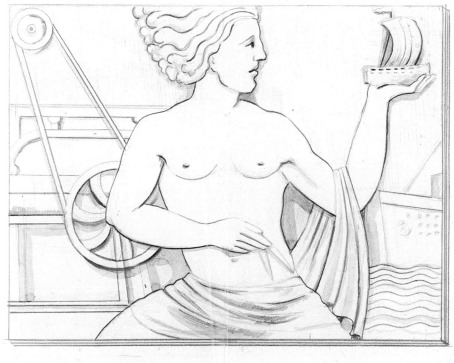

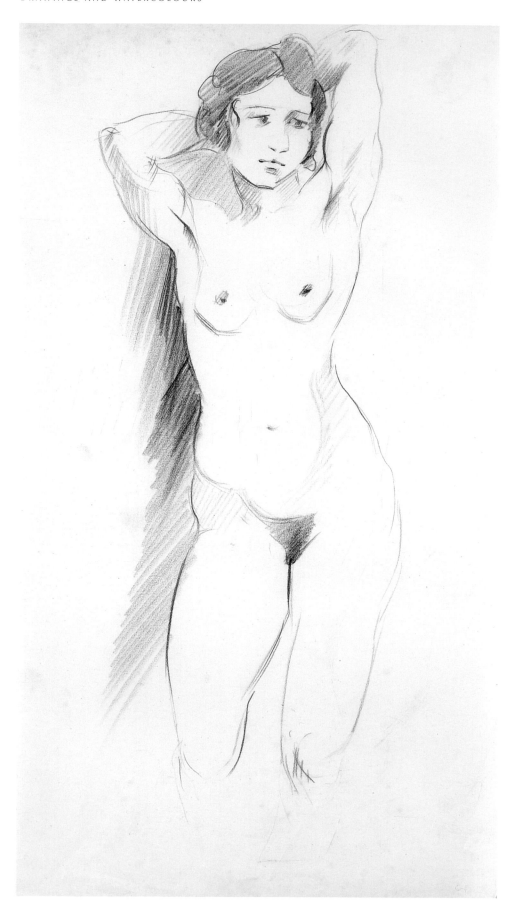

Half-length female with hands behind head
1932, pencil on paper, 42 x 22 cm

opposite

Old Murphy's Farm
1929, watercolour, 19 x 26 cm

Passing Clouds
n.d., watercolour, 21 x 29 cm

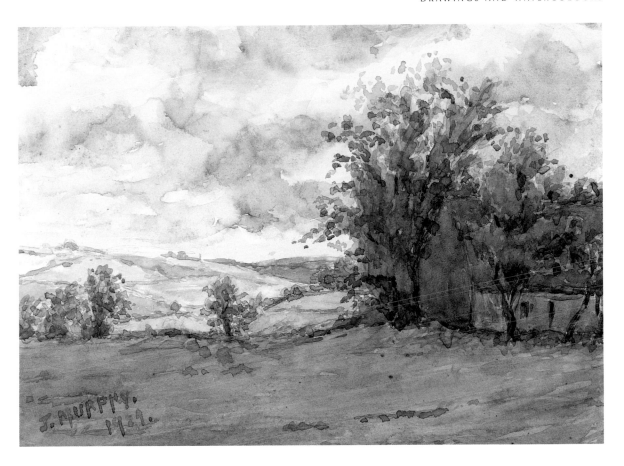

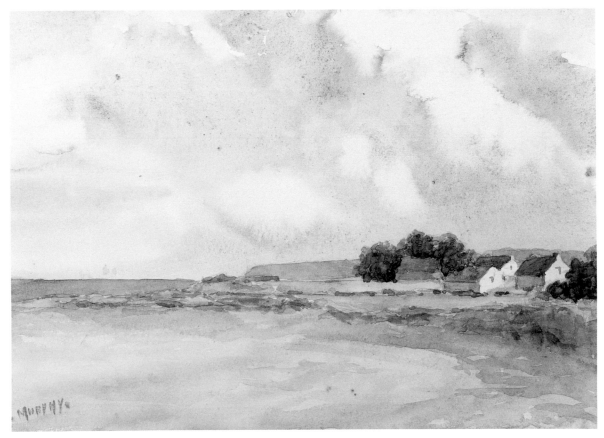

426

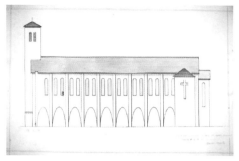

429

DRAWINGS AND WATERCOLOURS

Selected drawings and watercolours from the exhibition *Séamus Murphy – Selected Works* at the Crawford Art Gallery, Cork, 2007.

Drawings of Blackpool Church from the exhibition *Séamus Murphy and Blackpool* at the Cork City & County Archives, 2007 (drawings © CCCA, 2007).

* illustrated here

DESIGN DRAWINGS

426 *
Aviation
1932, pencil and blue wash on paper,
286 x 375 mm
[see page 279]

427*
Aviation Pilot
n.d., pencil and blue wash on paper,
37 x 24 cm
[see page 278]

428 *
*Blackpool Church
– Angels for Children's Altar*
n.d., pencil on paper, 76 x 28 cm
note: one of two drawings
[see page 113]

429 *
*Blackpool Church
– East Section-Elevation*
c.1944, drawing, 40 x 55.5 cm
inscription: Section showing pillars to carry trusses
[see page 106]

430 *
Blackpool Church – Plan
c.1944, drawing, 43 x 74 cm
[see page 106]

431*
*Blackpool Church
– South Elevation* [early version]
c.1944, drawing, 38 x 37 cm (detail)
[see page 106]

432 *
*Blackpool Church
– South Elevation* [later version]

427
428

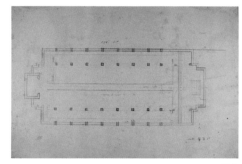

430

431
432

433

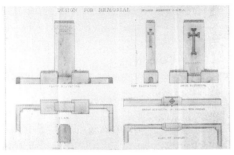

434
435

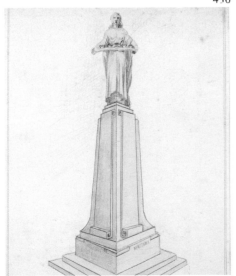

436

*c.*1944, drawing, 39 x 36 cm
[see page 107]

433 *
Tomás Ceannt Memorial
(for Collins Barracks, Cork)
n.d., pencil and blue wash on paper
[see page 278]

434 *
Design for PJ Hegarty's grave
(for St Finbarr's Cemetery, Cork)
n.d., pencil and blue wash on paper,
52 x 74 cm
[see page 279]

435 *
Design for Spinning panel
(for Worsted Mills, Midleton)
1948, pencil on paper, 15 x 38 cm

436 *
*Female figure on pedestal
with open scroll*
1937, pencil and blue wash on paper,
38 x 25 cm (detail)

DEPT OF INDUSTRY & COMMERCE DRAWINGS

In 1941 SM was shortlisted for the new Dept of Industry & Commerce headquarters on Kildare Street, Dublin. The commission was subsequently awarded to Gabriel Hayes.

437 *
Industry & Commerce I
1941, pencil and blue wash on paper,
38 x 56 cm (detail)
note: man and cog represent industry; two women and fist in foreground represent commerce
[see page 281]

438 *
Industry & Commerce II
1941, pencil and blue wash on paper,
38 x 56 cm (detail)
note: central compass, mining, galleon
[see page 280]

439 *
Industry & Commerce III
1941, pencil and blue wash on paper,
38 x 56 mm (detail)
note: singular figure holding ship
[see page 281]

437

438

439

440
441

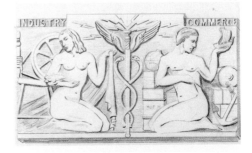

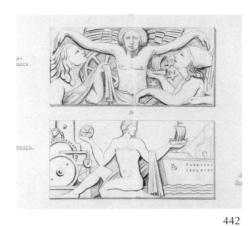

442

446

443

444
445

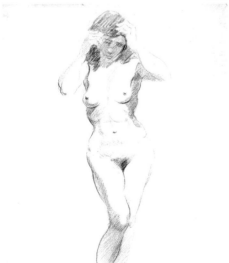

440 *
Industry & Commerce IV
1941, pencil on paper, 38 x 56 cm (detail)
note: commerce with winged helmet; industry
with bees

441 *
Industry & Commerce V
1941, pencil on paper, 38 x 56 cm (detail)
note: woman with spinning wheel; man holding
boat and anchor
[see page 280]

442 *
*Hermes organizing
Industry and Commerce*
1941, pencil on paper, 38 x 56 cm (detail)
[see page 276]

443 *
Neptune and Eire
1941, pencil on paper, 38 x 56 cm (detail)

444*
*The Telephone
/ Hermes with Caduceus*
1941, pencil and blue wash on paper,
38 x 56 cm (detail)

————

LIFE DRAWINGS

445 *
*Contraposto female
with hands on head*
1932, pencil on paper, 42 x 36 cm (detail)

446 *
Female torso and thighs
1932, red and brown pencil on paper,
43 x 24 cm

447 *
*Half-length female
with hands behind head*
1932, pencil on paper, 42 x 22 cm (detail)
[see page 282]

448 *
Rear view of female against a wall
1932, pencil on paper, 32 x 19 cm

————

447
448

WATERCOLOURS

449
Farm in a Hilly Landscape
1929, watercolour, 27.5 x 18.5 cm

450
Head of Roderic O'Conor
1932, red pencil on paper, 28 x 23 cm

451
Hay Shed
1931, watercolour, 30 x 20 cm

452 *
Gable of white cottage on blue background
n.d., watercolour, 22 x 32 cm

453 *
Old Murphy's Farm
1929, watercolour, 19 x 26 cm
[see page 283]

454*
Passing Clouds
n.d., watercolour, 21 x 29 cm
[see page 283]

455 *
Scaview with Stooks
1929, watercolour, 19 x 29 cm

456
Stooks
n.d., watercolour, 19 x 27 cm

457
Wheat and Rushes, Grapes and Acanthus leaves
1940, pencil and wash on paper, 56 x 27 cm

———

452

453

454

455

287

Séamus Murphy

(1907-1975)

1907 Born at Greenhills, Burnfort, near Mallow, Co Cork, son of James Murphy and Margaret Sheehan

1912-21 Attended St Patrick's National School, and St Luke's, Cork. Pupil of Daniel Corkery who gave him his first drawing lessons.

1921 At Corkery's suggestion, entered Crawford School of Art to study modelling.

1922-30 Apprentice stonecarver at John Aloysius O'Connell's Art Marble Works, Watercourse Road, Blackpool. Specialised in architectural and foliage carving. Attended Crawford by night

1931 Awarded the Gibson Bequest Scholarship

1932-33 Studied in Paris at the Académie Colarossi and with Andrew O'Connor, the Irish-American sculptor

1934 Opened a studio and stoneyard at Blackpool, Cork

1944 Elected associate of the Royal Hibernian Academy Married Maighréad Higgins, daughter of sculptor Joseph Higgins (1885-1925) and Katherine Turnbull

1950 *Stone Mad* first published – an account of the work of the stonecarvers and stonecutters with whom he had trained

1954 Elected a full member of the Royal Hibernian Academy

1964 Appointed Professor of Sculpture at the Royal Hibernian Academy, Dublin

1969 Awarded Honorary LL.D by the National University of Ireland

1973 Appointed to The Arts Council / An Chomhairle Ealaíon

1975 Died in Cork. Buried at Rathcooney (near Glanmire), Cork

2007 *Séamus Murphy Sculptor Centenary* – six-month programme featuring exhibitions, publications, new documentary, screenings, etc Dedication plaque unveiled at Cork City & County Archives, Blackpool, marking centenary

SOLO EXHIBITIONS

2007 *Séamus Murphy (1907-1975) – Selected Works* Crawford Art Gallery, Cork
Séamus Murphy and Blackpool Cork City & County Archives, Blackpool, Cork
With These Hands (photographs of Séamus Murphy's works by Dara McGrath) Cork Public Museum
Séamus Murphy at Work Frank O'Connor Public Library, Mayfield, Cork

1982 *Séamus Murphy 1907-1975* (retrospective exhibition), Crawford Art Gallery, Cork; Douglas Hyde Gallery, Dublin

1973 *Exhibition of forty-two portrait heads*, Adare, Co Limerick

1956 *Séamus Murphy – Sculpture* Cork Public Library

SELECTED GROUP EXHIBITIONS

1975 *Rosc 75*, Cork

1967 Two-man exhibition (with William Harrington), organised by Cork Arts Society

1953-59 Exhibited regularly with the Institute of Sculptors of Ireland

1939 Irish Pavilion, New York World's Fair

1935 Three-man exhibition (with Marshall Hutson and Michael O'Sullivan), University College Cork

from '35 Exhibited regularly at Royal Hibernian Academy, Dublin

SELECTED BIBLIOGRAPHY

2007 *SÉAMUS MURPHY (1907-1975) – SCULPTOR*
Peter Murray (ed.), with essays by Orla Murphy,
Peter Murray, Gearóid Ó Crualaoich, Ken
Thompson, Ann Wilson
(Crawford Art Gallery, Cork / Gandon Editions,
Kinsale)
Peter Murray, 'Rediscovering Séamus Murphy', *Irish
Arts Review*, Spring 2007
Séamus Murphy, *Stone Mad*, adapted by Johnny
Hanrahan, directed by Pat Kiernan, produced by
Pat Talbot (Everyman Palace Theatre, Cork)
Ann Wilson, 'Séamus Murphy and the Art of
Tombstones', *Forum*, Journal of Letter Exchange
(Oswestry, Shropshire, UK) March
Ann Wilson, 'Art Patronage in the New Irish Free
State', *Artefact*, Journal of Irish Association of Art
Historians (forthcoming)

2005 Séamus Murphy, *Stone Mad*, new edition (Collins
Press, Cork), reprinted 2007

2002 Theo Snoddy, *Dictionary of Irish Artists: 20th
Century*, 2nd edition (Merlin Publishing, Dublin)

1982 *SÉAMUS MURPHY 1907-1975*
Bébhinn Marten (ed.), intro by Louis Marcus; texts
by John Biggs, Oisín Kelly, Díarmuid Ó Donobháin,
Maighréad Ó Murchadha, Ken Thompson (Cork)

1980 *THE CORK REVIEW*
Paul Durcan (ed.), special issue devoted to the life,
work and times of Séamus Murphy
(with drawings by William Harrington and
contributions by John Behan, Eric Cross, Eiléan Ní
Chuileanáin, Eilís Dillon, Paul Durcan, Benedict
Kiely, Sean Lucy, Louis Marcus, Gerald McCarthy,
John Montague, Séamus Murphy, Robert
O'Donoghue, Seán Ó Mórdha, Domhnall
Ó Murchadha, Seán Ó Ríordáin, Seán Ó Tuama

Ken Thompson, William Trevor, Leon Uris)
(Triskel Arts Centre, Cork)

1966 Séamus Murphy, *Stone Mad*, expanded edition with
illustrations by William Harrington (Routledge &
Kegan Paul, London)

1953 *Dublin Magazine*, July-Sept

1950 Séamus Murphy, *Stone Mad*, with illustrations by
Fergus O'Ryan (Golden Eagle Books, Dublin)

1944 Séamus Murphy, 'Letter Cutting', *The Bell*, vol. 7,
June (reprinted in *The Cork Review*, 1980)

1943 Colm McGowan, 'Conversation with a Sculptor',
The Bell, vol. 6, June, pp. 300-10

DOCUMENTARIES

2007 *SÉAMUS MURPHY – WORDS INTO STONE*
by Pádraig Trehy (in production)

2001 *THE HEADSTONES OF SÉAMUS MURPHY*
by Pádraig Trehy
(© Medaza Films / Cork Film Centre), 15 mins

1969 *STONE MAD – A PORTRAIT OF SÉAMUS MURPHY*
by Seán Ó Mórdha for RTÉ *Anthology* series
(© RTÉ Libraries & Archives), 35 mins

1959 *THE SILENT ART*
by Louis Marcus (© Louis Marcus)
(original film elements preserved in the Irish Film
Archive of the Irish Film Institute), 14 mins

WEBSITES

www.seamusmurphyscluptor.com
www.seamusmurphy.ie

LIST OF ILLUSTRATIONS

As all illustrations are included in the Index, and as the latter part of the book is thematically structured and catalogued, this List of Illustrations covers only essay illustrations (pp1-65).

Works are in private collections unless otherwise stated.

Archive photos courtesy Murphy family.

—